8/31

Criti‹

D0374773

Nominated for the Shamus Award
Best Paperback Original

"It's a well-paced story with a difficult-to-solve mystery at its core. LaPierre's portrayal of Port Silva, a fictional community near Mendocino, gets the feel of northern California just right, not only in the descriptions of the rugged coastline and dense woods but also in the people and plotline.... This is a solid series that deserves more attention."

—*Booklist*

"LaPierre hits the bull's-eye, presenting even the most minor characters with equal parts compassion and judgment against a gorgeous backdrop, and topping the whole show off with a surprise ending."

—*Kirkus Reviews*

"LaPierre understands human relationships and always manages to intrigue the reader."

—Anna Ashwood Collins
MysteryInternational.com

"Acting in tandem and separately, Verity and Patience pursue paper trails and more tangible ones along California's Lost Coast. Along with the misfits, iconoclasts, and dropouts that inhabit this intriguing stretch of land, the reader meets a heartbreaker of a young girl and unexpected heroes. Janet LaPierre's consistently excellent series—in-depth characterization, a California setting as vivid and unique as any, and well-plotted, engrossing stories built around an admirable heroine—merits recommendation from librarians, booksellers, and reviewers."

—Bob Hahn
BookBrowser.com

DEATH DUTIES

ALSO BY JANET LaPIERRE

DEATH
DUTIES

A Port Silva Mystery

JANET LaPIERRE

2004 · PALO ALTO · McKINLEYVILLE

PERSEV⟨ERANCE PRESS / JOHN DANIEL⟩ & COMPANY

This is a work of fiction. Characters, places, and events are the product of the author's imagination or are used fictitiously. Any resemblance to real people, companies, institutions, organizations, or incidents is entirely coincidental.

A PERSEVERANCE PRESS BOOK
Published by John Daniel & Company
A division of Daniel & Daniel, Publishers, Inc.
Post Office Box 2790
McKinleyville, California 95519
www.danielpublishing.com/perseverance

Book design: Eric Larson, Studio E Books, Santa Barbara
www.studio-e-books.com
Set in Minion

Cover photo: Morgan Daniel

10 9 8 7 6 5 4 3 2 1

LIBRARY OF CONGRESS CATALOGING-IN-PUBLICATION DATA
LaPierre, Janet.
 Death duties / Janet LaPierre.
 p. cm. — (A Port Silva mystery)
 ISBN 1-880284-74-x (pbk. : alk. paper)
 1. Women private investigators—California, Northern—Fiction. 2. Suicide victims—Family relationships—Fiction. 3. Port Silva (Calif. : Imaginary place)—Fiction. 4. Grandfathers—Death—Fiction. 5. Mothers and daughters—Fiction. 6. California, Northern—Fiction. I. Title. II. Series.
 PS3562.A624D43 2004
 813'.54—dc22
 2003023448

This book is dedicated to the State of Jefferson

*which I would enlarge by perhaps
three northern California counties more
than its founders envisioned*

AUTHOR'S NOTE
Port Silva, California is a fictitious town. Stretch the Mendocino coast some twenty miles longer, scoop up Mendocino village and Fort Bragg, toss in a bit of Santa Cruz. Set this concoction on a dramatic headland over a small harbor and add a university. Established 1885. Elevation 100 feet. Population 24,020, a mix of old families, urban escapers, students, academics, and tourists in season.

DEATH DUTIES

PROLOGUE

CHRISTINA ANN LARSON, age four and a half, squatted in front of the low table and looked at the books spread out there. Which one? she asked herself silently, and put a finger on first one bright cover, then another. *Goodnight Moon* was for babies. *Green Eggs and Ham?* No, he was tired of that one. She touched the brightly clad little elephant. *Babar?* But he didn't really like Babar. He liked Frances better, the little badger girl.

"No, no, no," she muttered, and leaned forward to reach for the fat book that had no pictures on its cover, only words: *Story Poems.* This was his favorite of all her books, and maybe it would make him laugh.

Clutching the book to her chest, she stood up and moved across the room, bare feet making no noise on the braided rug. Her grandfather sat in his leather chair on the far side of the family room, facing the glass panes of the French doors to the deck and the yard. She herself couldn't see anything interesting out there, only gray, drippy fog that made her cold just to look at.

"Grampa?"

She wasn't sure he'd heard. Then he turned his head and looked at her. Anyway she thought he was looking at her; his glasses were so dark she couldn't see his eyes.

"Grampa, will you read to me? Please?"

Didn't say anything, not yes. But not no. She leaned against his bony knees and looked up at him, at his straight, unsmiling mouth and the little white prickles of whisker on his cheeks and chin. He still didn't say anything, but looped an arm around her and pulled her up onto his lap, where she breathed in his usual smell of cigarette smoke and the stuff he put on his hair. And something different, too, like the old clothes she played with in the attic.

She wriggled into a more comfortable position and settled back

against his wide chest. "Here, read me about Custard," she instructed, and set the book on her lap, letting it fall open to the page with the drawing of the dragon.

"Chrissy Ann, you can read that to yourself. You know the whole thing by heart."

"We-ell. Maybe I do. But I like to hear you read it. Please?"

"We-ell," he echoed, and tucked her closer with one arm as his other hand reached for the book. "Let's see. 'Belinda lived in a little white house, with a little black kitten and a little gray mouse, and a little yellow dog and a little red wagon, and a realio, trulio—' "

"Christina!" The swinging door to the kitchen hit the wall, and Chrissy's mother stood there in the doorway, her long hair loose over her shoulders and her apron tied high over the belly-bulge where Chrissy's baby sister or brother was growing. "What are you doing? You come here right now. Now!"

As her grandfather's big hands lifted her from his knees and set her on her feet, the book fell to the floor. She crouched to pick it up and stayed there, looking at him, looking at her mother's red and angry face. "Mama, I was just—"

"Your grandfather is tired. You mustn't bother him." Her mother stood straighter, brushed her hair back with one hand, and reached with the other for Chrissy. "I'm sorry, Edgar. She's been told not to bother you."

As she was being towed off by her mother's firm grip, Chrissy looked over her shoulder at her grandfather, but he had turned his face away and was gazing out into the fog again.

"OKAY, HERE'S YOUR very own library card," said Verity Mackellar.

"Thank you," said Sylvie Medina with a broad grin, and then, to the woman behind the counter, "Thank you."

"You're quite welcome, dear. Use it well," the librarian added, as she moved to answer the ringing telephone.

"You have ten minutes to pick out books," Verity told Sylvie, and winced as the long-legged, skinny little girl set off at a trot, dodging tables and chairs and people on her way to the children's section.

"Your daughter certainly takes after you."

Verity turned to stare at the speaker, a slim woman several inches shorter than her own nearly six feet in height. Early thirties, thought Verity, and noted thick blond hair blunt-cut by some scissors-genius, diamond ear studs, leather coat open over roll-neck cashmere sweater and narrow tweed trousers. Not your average Port Silva library patron.

"I don't see...Sylvie is not my daughter, exactly." Verity decided that the green eyes inspecting her must be weak. Her own long braid was strawberry blond, her skin fair, her eyes a grayed blue, while Sylvie's ink-black hair framed a narrow, olive-skinned face with huge eyes so dark brown as to seem black.

"Christina Larson. Chris, to former teammates," said the woman, holding out a manicured hand. "Sorry, but she moves like you, holds her head like you. Does she play soccer like you?"

Larson. Verity returned the woman's firm grip, then pushed her hands into her jeans pockets and tipped her head, considering. Maybe twenty years earlier, a summer sports league at the Y, and Chris Larson a pigtailed blonde with braces and a killer kick, two years older than Verity. Chris was a tough teammate, and for the gap in age, a good friend. Summer friend. Verity's family came from the Bay Area

to Port Silva each summer, and Chris, too, had been a summer visitor, staying, Verity suddenly recalled, with her divorced father. Along with her younger sister, a whiny little brat.

"Of course, I remember you. And your dad was our coach, with the patience of a saint. How is he? How are you?"

"He died last week, in hospice in Santa Rosa. I'm in town to get his house ready to go on the market. And here right now to pick up a few novels for company while I do that." Cradling several library books in the crook of an arm, Chris moved away from the counter as she spoke, and Verity, after a glance toward the children's section, followed.

"I'm sorry. He really was a nice man."

"Thank you. And your family?"

"Dad died, too, five years ago, and Mom moved up here afterwards. She has a small business."

"Is she Patience Smith, Investigations? I thought she might be, Patience is not a very common name, and I've heard...I've been hoping I'd run into you. Verity, can we go somewhere for coffee, to talk?"

Something more than a casual encounter here, it seemed, and something also about rumors. Verity's "Sorry" sounded curt, as she'd meant it to. "Sylvie has a piano lesson in about five minutes. And here she comes."

Sylvie zoomed across the room and screeched to a halt beside Verity, bearing an armload of books.

"Hello, Sylvie," said Chris. "I'm Chris Larson, and I knew your— Verity—when we were both about your age."

"Hi." Habitually wary of strangers however well turned-out, Sylvie's inspection of this one was lengthening to the edge of rudeness when she finally offered a brief smile. "Verity's my found mom, and I'm her found kid."

Chris Larson's answering smile softened her rather somber face. "Then you're both lucky, I'd say. Verity, I wouldn't bother you, but it's important. Something my dad asked me to do. Maybe while Sylvie's at her lesson?"

Over several summers, Andy Larson had helped Verity learn to manage her skinny, rapidly growing body, something her own wheelchair-bound father was unable to do. "Okay," she said reluctantly. "Her teacher works at home just a few minutes away. I'll take her there, and then meet you at Coffee Essence, on Main Street."

The three of them went out the front door and headed for the

parking lot. Sylvie, running ahead, gave wide berth to a haggard-looking old woman in a greasy padded jacket and watch cap who stood beside the path and rattled the change in a coffee mug. At the edge of the parking lot another woman pushed a shopping cart with a piece of plastic tarp protecting or maybe concealing its contents.

'You'd think the town could do something about these people," said Chris. "Look, there are actually a couple of tents on the library lawn."

"Nobody knows what to do," said Verity. "There's no money for shelters except for those a couple of churches maintain in their basements. And there's no housing in this town for low-income working people, never mind derelicts. Here's my car. I'll see you shortly."

———//———

While the girl prepared her latte, Verity scanned the mirror behind the counter and spotted Chris at a table near the back of the room, shoulders slumped and head bent over her coffee cup. Verity's sense of debt to Andy Larson, and her natural curiosity, were countered by one of Patience's maxims: An investigator who mixes the personal and the professional is asking for two kinds of trouble. Words that by now should be etched into her very bones, she told herself grimly.

She tipped a bit of sugar into her latte, added chocolate sprinkles and nutmeg, and carried the hot mug and a glass of cold water to the rear of the room, to settle into the chair across from Chris and put on a polite, inquiring expression.

Chris's smile was brief. "I have a daughter about Sylvie's age—nine?"

"Eight. Just."

"I envy you her enthusiasm. I have to bribe Jennifer to get her to her music lesson. How did the two of you manage to 'find' each other?"

"It's a long story," said Verity, her tone making clear that she had no intention of telling it. "As for the lessons, music seems to be part of her natural language, and she loves learning more of it. But I'll need to get her home for a snack as soon as the lesson is over. Do you want to tell me why you're interested in Patience Smith, Investigations?"

"I have something that needs investigating, locally. So I, um, asked around, and I checked the telephone book, to see if there might be any private investigators here in Port Silva. As I said, the name rang a

bell. Weren't she and your father in the same kind of business, back when we knew each other?"

"They were. Tri-County Investigators, based in Berkeley." Verity stirred her latte and took a sip, her eyes on Chris's face.

"See, this is important to me, but I can't do it myself. I share custody of my two children with my former husband in Los Angeles, and he'll snatch any evidence of lack of care on my part as a chance to get full custody. But I can pay well; I had a 'good' divorce, as they say, and I'm a successful screenwriter."

Cut to the chase, screenwriter, Verity thought but resisted saying.

Chris squared her shoulders and lifted her head. "Okay. Twenty-eight years ago, when my parents and I were living with him here in Port Silva, my grandfather, Edgar Larson, was accused of child molesting. He didn't do it, but he was—shunned, anyway. And a few months later he killed himself."

Twenty-eight years ago Verity was three years old. But Patience might have some memory of this event. "Was he actually charged?"

Chris shook her head and pushed her empty coffee cup away, to clasp her hands tightly together on the table. "No. According to my father—I wasn't five years old yet—there were two anonymous calls to the police department. And my grandfather was questioned, several times, at the police station. Dad said that a little girl had been abducted and murdered earlier in the year, and her murderer not yet found. So the town was on edge, and rumors flew and grew. Small towns can be really shitty like that."

Verity caught a gap in this. "Her murderer *was* subsequently found?"

"Not exactly," said Chris in bitter tones. "But Dad told me that not long after my grandfather blew his own head off, another little girl was killed the same way, out toward Comptche. A man who'd been living near her home disappeared shortly after her death, and it turned out he had two convictions for molestation and had just approached yet another little girl, who escaped and told her parents about him."

"Not, of course," she added, "that this did my grandfather, or even his memory, any good at all."

Verity waited, hoping that she was radiating quiet receptivity. It was a skill of her mother's that she was trying hard to acquire.

"God, I need a drink!" Chris ran both hands through her hair.

"Meanwhile, whoever accused my grandfather ruined not only his life, but my parents' marriage as well, and pretty much screwed up my childhood, something I hadn't fully realized until my dad and I talked about it. You, my mother believed the accusation. Or she couldn't not believe it, couldn't trust him. She was, she is, a nervous, edgy woman, and she was six months pregnant when the whole mess started."

"And you were all living with him?"

She sighed, and nodded. "He'd sold his small timber company when my grandmother got sick. After she died, he was lonely, and my dad was not happy with his job in L.A. as a small attorney in a very big firm, so we moved to Port Silva to share Grampa's big house. My mother hated it here," she added.

"But I loved it. I loved Grampa, he was my best friend. And all of a sudden, Mama wouldn't let me near him, wouldn't let him touch me. I think that's what really killed him."

"Chris, what is it you want to do, to have done, about all this?" Verity looked at her watch. The scheduled lesson would be finished soon; but Sylvie was Charlotte's final pupil of the day, and the two of them enjoyed each other's company.

"And you see, it's not just me, it's my dad." Chris was in full spate now. "He'd had a really lonely life, never remarried, probably never got over my mother. He gave up law and taught junior high, I think so he'd have summers free to spend with his kids, the only time he got to see us. And my bitch of a little sister, who was less than three years old when they divorced, always insisted he wasn't really her father and threw a fit about coming.

"Then the cancer hit him, and surgery, and all the other shit that goes with it but nothing was enough. He's lying there dying, and the thing that hurts him most, that keeps him from sleeping even with all the drugs, is that he feels guilty about my grandfather. And I am going to the nearest bar for a double martini as soon as I finish this maudlin story, okay?"

Verity pushed her untouched glass of water across the table, and Chris snatched it up for a long swallow.

"My dad felt he should have made a fuss at the time. Should have shown his father that he loved him and believed him. Should have fought for him. Instead, as he remembered it, he just…chickened out. So he asked me to do this for him, to find out what happened, who accused my grandfather, and I said I would."

She gulped another mouthful of water. "Will your mother help me?"

"Chris, it was all so long ago. The chance of finding out anything now is very small."

"I'll pay twice the usual rate. Three times."

Verity hesitated, then shook her head. "If we take the case, it will be for the usual hourly fee and expenses."

"We? You're an investigator, too?"

"I work for Patience part-time. Maybe one day we'll change the firm's name to 'Patience Smith and Daughter.'"

Chris's face creased in the first hint of a smile since she'd begun her narrative. "Good choice. Who'd ever believe 'Patience and Verity, Detectives'?"

"I'd think those names would inspire trust," said Verity.

"Well, I'd trust. I do trust. And if you can find out for me who accused my grandfather, and why…"

"Why's always hard, Chris."

"Believe me, I know that. But if you do find out who did it, I promise you a ten-thousand-dollar bonus, along with my thanks. And my father's blessing."

Verity pushed her chair back and stood up. "I'll talk it over with Patience. Where are you staying, at your father's house?"

"Oh God, no, it's just too bleak there. I'm at Inn of the Woods, south of town."

Where she'd easily spend half of ten thousand in one week. "Okay, here's what I'll need you to do. Write down every single thing you can remember about your grandfather and his life here. What he did, who he hung with, what his hobbies were. Everything. And I'll call you tomorrow."

———//———

Hank Svoboda, his tall, solid body enveloped in a denim apron, poured a dollop of white wine into the skillet, clapped on its lid, and turned down the flame.

"There," he said, and then, "can I top you off?"

Patience, seated at the kitchen table, used her right hand to push her wineglass in his direction. Her left wrist was in an elastic brace. "Thank you," she said, and when he'd filled her glass, "and thank you."

"Welcome." He took off the apron, tossed it over a chair, and

picked up his bottle of beer. "Middle-aged lady goes off playing Sam Spade, she should probably line up some kitchen help for after. You're just lucky Port Silva crime is slow right now and I was able to fit you into my schedule."

"Oh, hush," said Patience without heat. Her recent job in San Francisco, posing as a dithery companion to an old woman who didn't know which of her relatives might be planning to kill her, had ended well enough...after a confrontation that left her with multiple bruises and a badly sprained wrist. "My client is unhurt, her nasty granddaughter and the girl's boyfriend are in jail, I didn't have to shoot anybody. And I got a nice bonus."

"I've been giving some thought to retirement lately," said Hank. "Maybe you should do the same. Let Verity do the hard work."

"Don't be silly; I'd just get bored and fat sitting around. And this job depended on looking elderly, plump, and not very bright, a role that I fit into nicely but would hardly have suited Verity. Who just drove up, I think," she added, cocking her head to listen.

Moments later the kitchen door opened and Sylvie came in, Verity right behind her with an armload of books. The little girl was placing her feet carefully, and her face wore a dimmed-down expression, as if her eyes were looking at something beyond the room. The click of the door's latch brought her head up and her gaze into focus.

"Oh. Hi, Patience. Hi, Hank."

"Hi, ladybug," said Hank. "Looks to me like you had a long, hard day. I bet you need a snack."

Sylvie seemed to shake herself, and gave him a low-wattage version of her grin. "I can get it. I know where the peanut butter is."

"Good girl." Verity shrugged off her jacket, plucked Sylvie's from her skinny shoulders, and hung both on hooks near the door. "Hi, Mom. And Hank. Smells good in here." She got a pair of glasses from a cupboard and filled one with milk, while Sylvie slathered peanut butter and jelly on two slices of bread, put the result on a plate, and looked around vaguely.

Verity, who'd been watching her, pulled a music folder from the stack on the table. "Come on, kid. We'll take your snack down to the studio, and you can fool around with the piano after you finish."

"Charlotte said I did good today," Sylvie said to Patience over her shoulder, and followed Verity to the door.

As footsteps on the outside stairs receded, Hank gave a small nod.

"Looks to me like Charlotte Birdsong and piano lessons are working better than therapy."

"Oh, Lord, that poor therapist. Would you believe that an eight-year-old girl-child could sit still as a rock for half an hour, week after week, and say not a single word? And not only does Charlotte get Sylvie rattling on, she's a lot cheaper."

Verity was back quickly, to pour a glass of wine and settle with it into a padded wicker chair. "She'll be okay," she said, mostly to Hank. "Sometimes, at the end of a long day like today—school and then the library and then a piano lesson—I think the strangeness of it all hits her, and she feels disoriented."

"Reasonable enough, for a little kid who lost her mother less than a year ago," said Hank.

"True. But she's got a new piece of music, which will occupy all her attention for a while, so I can talk to the two of you about what happened to me today." She had a sip of wine and settled back into her chair, stretching her legs out. "Mom, guess who I ran into at the library. Chris Larson."

"Larson. Oh, your summer friend, the one you played soccer with."

"Right. Her dad was the coach at the Y. Andy Larson, a really nice man."

"I remember. Your father liked him."

Hank was frowning. "I think I knew him. Math teacher at the junior high, retired a couple years back? Helluva good teacher, two of my girls had algebra with him."

Verity sat straighter. "He died last week, in Santa Rosa. Does either of you remember his father? Edgar Larson?"

Patience shook her head. Hank, leaning against the counter, ran a hand over his brush-cut gray hair. "Verity, the name maybe rings a bell but it's a faint one."

"He'd owned a small timber company here. In 1973 someone accused him, anonymously, of child molesting. A few months later he killed himself."

With a grimace, Hank pulled out a chair and sat down heavily. "I remember. It was just after I'd joined the force. I wasn't involved in the case, didn't know him myself, but the town was a lot smaller then, and something…Yeah, I remember. There'd been a child raped and killed, a little girl, some of the other officers knew her family. Then

the department received a telephoned anonymous complaint against Larson, said he was seen fondling a little girl."

"And the department investigated?"

"Yeah. As I recall when it, the chief—Walt Henderson, he's dead now—tried to handle it quietly, but people got wind of what was going on, and some folks got real stirred up."

"I bet," said Verity. "Sorry," she added quickly. "I wasn't there, so I shouldn't be making judgmental noises. Was there any evidence?"

"Verity, like I said, I wasn't in on the investigation. I don't remember details." Hank rolled his beer bottle between his hands and focused on it. "I was twenty-seven, twenty-eight years old, with a wife and two little kids. In a new job. I was probably some upset myself, what with a couple of daughters to think about."

He sighed. "Then the old man killed himself, and for the people who'd been yelling loudest, that meant he was guilty."

"Wasn't there another, nearly identical crime later, with an iden tified suspect?"

"Yeah, but by then Mr. Larson was dead."

"Verity, what is this all about?" Patience asked.

"Chris Larson—she's a screenwriter in L.A., recently divorced with two kids—Chris promised her father she'd try to clear her grandfather's name. She wants to hire us to investigate."

Patience was shaking her head. "I don't think so. Stirring up a mess from almost thirty years ago isn't my idea of good work. We'll just reopen old wounds."

Hank, too, was shaking his head, but more firmly. "I don't know, maybe it's time to shine a light on this. As we're talking, I'm remembering my dad's feeling about it. Dad was a diesel mechanic, and he'd worked some in the woods with Larson's crews. He thought the old guy was absolutely straight, couldn't believe he'd have touched a child in any dirty way. And he wasn't alone in his opinion."

Verity looked at Patience, who sighed but lifted a hand in an openpalmed gesture of surrender: your call.

"Chris thinks it's time," Verity told Hank. "And I guess I agree. I'll see her tomorrow or Thursday and get all the information she can give me. Then maybe I could talk to your dad?"

"Sorry, but he's been gone for ten years. I bet my mother would be happy to talk to you, but she's off on a tour of southwestern historic sites with my sister. Tell you what," he said after a moment's thought,

"just give me a little time, and I'll try to think who else might be useful, and still around."

The telephone rang, and Verity, who was nearest, picked it up. After a moment she said, "He is," and handed the instrument to Hank. With a twitch of his mouth that could have been smile or grimace, he moved into the hall, and spoke briefly in a low voice.

"Well," he said, as he returned to the kitchen to set the telephone in its cradle. "I'm sorry, but I won't be able to have supper with you ladies after all."

Verity was about to ask why, but a look from her mother quelled her. "We're sorry, too," said Patience, "but I'm sure we'll enjoy the pork chops." She picked up her glass for a sip of wine.

Flushing slightly, Hank nodded to the pair of them and left, closing the door quietly behind him. When his footsteps had stopped rattling the deck's wooden stairs, Verity raised her eyebrows at her mother. "And what was *that* about?"

"Family problems," said Patience, "his. And no business of mine." Or yours either, said her expression. "Please go call Sylvie for supper."

CHAPTER 2

"I DON'T SEE why I have to go to school anyway." Sylvie's lower lip was out, but her eyes were pleading. "Lily didn't make me go to school."

Verity folded the top of a paper lunchbag and tucked it into the backpack lying on the kitchen counter. "Sweetie, Lily had time and teaching skills that Patience and I lack." She picked up the backpack and held it out until Sylvie, reluctantly, slid it on. "So you go to school." She tossed a glance out the kitchen window, and then bent down to zip the little girl's fleece jacket and brush a kiss against her cheek. "It's cold out today. Be sure to wear your jacket at recess."

Sylvie turned and trudged, head down, toward the door. Halfway there, she turned and gave Verity another sad look. "Yesterday there were three people on the bus with gooshy colds. I hope I don't catch one."

"Well, I suppose I..." Patience, seated at the round kitchen table with a cup of coffee and the newspaper, looked up quickly and caught Verity's eye. Verity closed her mouth and took a small step back, shoving her hands into the pockets of her jeans. "Sylvie, are you having trouble with any of the other kids on the bus?"

"Um. No. Mrs. Romero doesn't let anybody make trouble on her bus."

"Are you having problems with kids at school?"

Sylvie sighed loudly. "There are just too many kids, Verity. And too many of them are boys."

"So do you want me to come to school and talk to somebody about the boys?"

A long pause. "Well. No. They're just dumb. If I ever have a baby and it's a boy, I'm going to give it away."

"I think I hear the bus," said Patience in mild tones.

"Shit," said Sylvie just under her breath, and hurried out the door.

Verity stood staring after her for a long moment. "Mother, I hate it when you do those meaningful glances. I'd rather you just say what you mean."

"No, you wouldn't," said Patience.

Verity rolled her eyes as she turned to the table to collect the lidded, stainless-steel mug she preferred for coffee-sipping. "I don't know, maybe we should look around for a different school, a smaller one."

"I will eschew meaningful glances and say right out loud I think that's a bad idea. She's done well at John Muir, and Mrs. Lee mentioned no problems at the last teacher conference. In my opinion, Sylvie's talk this morning was just a normal kid's try-on. If you don't agree, why not go ahead and have a chat with the principal?"

"She didn't want me to do that." Verity grimaced as she heard her own words. "Sorry. Would you like another cup of coffee?"

"Yes, please."

Verity collected Patience's mug and moved to the stove, to turn on the flame under the still-hot kettle and set up mug, filter, and ground coffee. Watching her daughter perform this small task with more concentration than it deserved, Patience restrained a sigh. Whole-hearted and headlong as always, Verity was deeply in thrall to a child who might, or might not, be able to remain with them.

In either case, Verity needed someone else in her life, someone besides an aging mother and a demanding girl-child. And if she, Patience, pointed this out, Verity would pour coffee right over her weary gray head.

"Thank you," she said a short time later as a steaming cup was set before her. "Here's a truism, Verity. Children begin in the cradle learning how to manipulate adults, it's how they survive. Sylvie has an eight-year head start and you need to catch up."

Verity slumped into a chair on the other side of the table. "When I'm not looking at her woebegone little face, I believe I can do that."

"I believe you can," Patience agreed. "And as for work—have you decided about Chris Larson?"

"Yup, called her this morning. I'm seeing her after work tomorrow at Inn of the Woods, where she's staying, to iron out the details."

"Really! Not exactly an impoverished single mother, is she?"

"It would seem not. Do we have a company policy against rich clients?"

"Not yet," said Patience.

Verity eyed her mother, thinking she looked less bright-eyed and energetic than usual. A bit washed-out, in fact. About to ask if the bruises and sprain were interfering with her sleep, Verity bit back the words. Patience disliked being the object of what she called "hovering," and most questions about her well-being fell under that label. "Okay," said Verity, getting to her feet. "Before I trot off to my day job at Pure and Simple, I'm planning to go by the cop shop and talk to Hank about the Edgar Larson investigation, such as it was. Or do you think I should call him first?"

Patience's expression remained bland. "He certainly seemed willing to help, but it never hurts to be polite."

"Yes, ma'am," said Verity.

———

"Hey, Verity!" Officer Dave Figueiredo, who had stepped into the glassed-in reception area at the sound of the door buzzer, gave her a mock salute and a cheerfully lascivious grin. "You looking for Johnny? Or would I do today?"

Verity felt a familiar twinge of irritation at the implied connection. Large, affable, and *much* smarter than he looked, Detective John Hebert was a sometimes-pleasure, sometimes-irritation in Verity's life, as she suspected she was in his. Now she tossed a quick, assessing glance at Figueiredo: a little shorter and probably a year or two younger than she was, he had close-cut black hair and black eyes and the kind of male energy that made the air around him seem to vibrate. If—*when, when*—she managed to climb out of the chaste plod of her present life, she might check him out. "Neither of you would quite meet my needs at the moment, Dave. I'm here to see Captain Svoboda."

He slapped himself on the forehead. "Right. He said you'd be coming in. He's in his office, just go on back."

The lock of the inner door released with a click, and Verity pushed through into the hall. Quiet back here today; her passage drew several nods and a wave or two from people at desks. Hank's door, near the end of the hall, was open; she rapped on the frame and stuck her head inside.

"Verity. Come in." Hank rose from behind a paper-strewn desk and came to give her a brief hug. "You're lookin' good."

"Thank you, sir. So are you." Hank Svoboda had never been a

handsome man, but middle age and a neatly pressed blue uniform underlined the good sense and sturdy dependability that had made him, among other things, an exemplary small-town cop. Verity couldn't imagine what "family problems" had brought coolness between Hank, a longtime widower, and Patience—nor could she imagine asking him about it.

Now he pulled out a chair for her. "I dug through the files and found what we have on Edgar Larson. Not that there was much; he was a right solid citizen, like my dad said. Before the investigation of the anonymous accusations, only thing was some trouble at the time he sold his company, some unhappy employees. We—or they, I wasn't on the force then—had to break up gatherings once at his office, once at his home. In 1967, that was."

"What were they unhappy about?"

Hank sat back down behind his desk, his weight bringing a pro-testing creak from his chair. "Apparently he'd run a real personal kind of business, not quite a co-op but had that feel. And he was known for being a good steward of the forests."

"Ah. And the new owner?" asked Verity.

"Cal-Tex was—maybe still is—the kind of company makes you think of locusts. You know, eat down to bare dirt and move on. Some of the employees had been with Larson Timber for twenty years and were figuring to be there a while longer."

"Oops. But the child molestation business was six years later, which is quite a long time for anyone to hold a grudge."

"Yeah, and I don't know that any of them did. There's no record of anybody being arrested at either protest, but chances are the *Sentinel* carried the protest story. Might be you could find some names in back issues for, let's see, it was September and October of that year."

Verity pulled a notebook and pen from her bag and wrote down the dates. "Thanks. Now, what can you tell me about the anonymous accusations, and the investigation that followed?"

"There were two calls, in early May of 1973." Hank handed her sev-eral sheets of paper. "I made copies for you. Since Larson is dead and you're acting for his granddaughter, I don't see any reason you shouldn't have anything we've got. Not, like I said, that it's much," he added with a grimace.

Verity laid the letter-sized pages on the edge of the big desk to ex-amine them. On top were photocopies of four-by-six-inch telephone

slips. The first, dated 5/5/73, listed a message from "male?? hung up when asked name": *Mr. Edgar Larson was seen recently at Shorebird Beach messing with a little girl. She was maybe four or five years old, crying, and he had his arm around her and it looked like his hand was in her panties.*

Verity peered at the signature, and said, "Mack Smith?"

"Guy near retirement, on desk duty. Been dead for years now."

The second telephone slip was dated 5/6/73. Marked merely "anonymous—female," the message was similar: *Edgar Larson is a dirty old man. A friend of mine saw him holding a little blond girl on his lap and sliding her back and forth like he was dry-fucking her.*

"Nasty!" The signature on this slip was just a scribble; Verity peered at it more closely, then handed it to Svoboda. "Do you know who signed this?"

He peered in turn, and after a moment, nodded. "Young woman, maybe nineteen or twenty, working here as a clerk when I came on the force. She left around the end of the year, when her husband got out of the service and took her off to—Oregon, maybe? Idaho?"

Verity set the message slips aside and looked at the two remaining pages, which were copies of printed forms with spaces for names, questions, and answers. The first, dated May 6, bore a two-line scrawl: *Mr. Edgar Larson states that he has not gone near Shorebird Beach in years, because of the unleashed dogs. He has never molested a child there or anywhere else.* At the bottom of the page were signatures: *Walter Henderson, Chief; Edgar Larson.*

"I guess the department didn't use tape recorders in the 'seventies," Verity remarked.

"Probably some guys did. The chief didn't. He didn't even use a typewriter."

The second page was similar to the first, dated five days later. The scrawled message was slightly longer: *Mr. Edgar Larson states that he has a four-year-old granddaughter, and could have been seen any number of times holding her on his lap. States such holding has never been inappropriate or abusive. Have informed Mr. Larson that it may be necessary eventually to interview granddaughter.* The same signatures followed.

Verity spread the four pages out and looked them over. "That's it? No report of an interview with Chris?"

"No mention of any," said Hank, tugging thoughtfully at the lobe

of his right ear. "Walt Henderson was a local boy from down around Elk, been chief for a long time. Edgar Larson was, or had been, a respected local businessman only ten, twelve years years older than Walt. It looks to me like Walt couldn't ignore an anonymous accusation against Larson; but he handled the thing himself, and apparently didn't see the need to take it any further."

"Was he an honorable man? A good cop?"

"He was. But he was a stubborn, old-fashioned guy and did things his own way. Or didn't do them. And didn't talk about them," Hank added. "Did this grown-up granddaughter say anything to you about being questioned by the police?"

"Chris—Christina—Larson. No, she didn't. Would she have remembered something like that when she was not quite five years old?"

Hank shrugged. "You're closer to five than I am. What do you think?"

"I'd think she would. I certainly plan to ask her about it." Verity folded the papers and tucked them into her bag. "Hank, from what you've said, it doesn't seem to me that Chief Henderson would have talked about this. But obviously somebody did."

"Right and right. Like I said before, there were guys on the force that knew the family of the little girl who was killed earlier. They probably didn't keep quiet."

"Do any of them still work here?"

With a faintly apologetic grin, he shook his head. "The older guys are all retired, most of 'em dead or moved away. The younger ones all went on to something else someplace else, except me. Just a stick-in-the-mud, I guess."

"Yeah, you poor old thing. You're a picture of underachieving discontent," Verity told him.

"Is that what I am? Ah, well. Too late to do anything about it. Okay, wait a minute." He shuffled through papers on his desk, unearthed a five-by-eight-inch lined yellow pad and tore the top sheet off.

"Two retired cops who stayed in the area," he explained as she looked at the names and addresses he'd written. "Jake Jacobs is an unpredictable bastard who might set his dogs on you, but he was tough and smart when he was on the force, and I've got no reason to think that's changed. Virgil Quinn was a nice enough guy, but never

any ball of fire, and I hear he's getting frail. You can tell either one of 'em I gave you their names."

"Thanks," she said, and kept her eyes down and her mouth shut for just a moment as she tried to choose the best words for what had to be an awkward question. "Hank, there's one more thing."

"Yes, ma'am."

"Was there any doubt that Edgar Larson's death was a suicide?"

Hank sat back in his chair and spread his hands wide. "Verity, so far as I knew then, and from what I've read in the files since, everybody was as sure as you ever can be about that. There's hardly ever an eyewitness to suicide."

"I know, but—"

"No, I'm not being smart-ass. If you want, I'll get you copies of the police and coroner's reports. Mr. Larson was killed by a bullet in the head, or actually in the mouth, from a .45 revolver he'd owned for years. A neighbor out checking damage after a freak two-day rainstorm noticed the French doors to Larson's deck were open, looked in and saw the body. The gun was right there on the floor.

"Now," he added, "to be fair, I should say that the revolver had one of those checkered butts that don't take prints worth a damn. And while there was no obvious sign of intruders, the room was a mess from the rain and wind, which had apparently blown the doors open. The old man had been living on his own; his family had moved out temporarily."

"Right," she muttered.

"His son told the guys on the case that Edgar had asked them to go," Hank added.

"Was there a note?"

Hank frowned. "There was. At least, the report says the drop-leaf of his desk was open and the note was there. But it's not in the file. One possibility is that somebody gave it to the newspaper, I suppose. But the fact that it's missing now doesn't change the verdict then."

"Oh, well. Just thought I'd ask," she said, and got to her feet. "Thank you, Hank. This gives me a base from which to talk to Chris, at least."

"Welcome," he said, rising to walk with her to the door. "Just be a little careful with this, okay? Turn over old rocks, you can't be sure what will crawl out."

———//———

Verity decided that the best place to spend the time before she began her stint at Pure and Simple, the restaurant where she helped cook lunch, would be the newspaper office. The Port Silva *Sentinel* had been publishing weekly since 1890, with the occasional year-or-so-long pause. It was now housed two blocks off Main Street in a one-story wooden building with a false front and a very large basement, which was where the bound volumes of past editions were kept. Fortunately, the place was dry and heated, each volume was clearly marked as to dates included, and Verity was tall enough and strong enough to get the books out and carry them to the table.

"We're working on getting this all on film," advised the woman who had admitted Verity to the basement after first having her sign the visitors' log. About the same size and shape as Hank Svoboda, she clearly had no trouble slinging the big volumes around. "But it will take a while, and it's a big expense for a little old weekly. Since we started with the beginning issues, you'll have access here to all issues after, let's see, 1950. I'll check back now and then," she added with a stern look. "Remember, these old pages are fragile."

"Thank you. I will."

According to Chris Larson's account, Edgar Larson must have been born around the turn of the century. Verity decided to do a quick scan of issues from the earliest available, and found very little specifically about him. His wife, however, had been an active presence in her town, serving on the school board, on the planning commission, on the board of the Port Silva Historical Society. There were several pictures of Sarah Larson, usually in a group of other women; she was short and slightly plump, with a smiling, round face and hair that was either fair or gray. In a photo accompanying a 1958 story about the steeple repair fund for Shepherd of the Sea Lutheran church, it was Edgar beside her, very tall and straight, his bony, long-jawed face softened by a smile as he looked not at the camera but at his wife.

Larson Timber was mentioned occasionally, in listings of timber harvest plans and several times as contributor to charities like the Port Silva food bank or the "Help the Neediest" fund at Christmas. Verity wondered whether those donations were his idea, or his wife's.

She skipped forward to the late 1960s and was distracted from her purpose: this was northern California, after all. The Vietnam War was in full swing, American presence by late 1967 having risen from an initial several thousand "advisors" to some 500,000 troops. Domestic

protests were flaring nationwide, and the liberal hot spots of Berkeley and San Francisco were less than two hundred miles south of Port Silva. Week after week, along with photos of uniformed local boys serving or mourned, the *Sentinel* had pictures of protesting throngs on Main Street facing off against smaller, equally angry-looking but generally older groups—maybe parents of some of those boys? And there were complaints by locals about invasions of rural property by draft dodgers and "dirty hippies" from Berkeley in their VW buses.

"Some other time," she told herself, and then in the stretch of two months in 1968 came upon reports of the assassinations of Martin Luther King, Jr. and Robert Kennedy. She had not known, or at least not remembered, that the two dreadful events were so close in time.

Verity returned with muted enthusiasm to her original chore. She found notice of the sale of Larson Timber in late August of 1967; a few weeks later, reports appeared in two editions about demonstrations by Larson workers. Two were named in the second report, and she dutifully wrote their names down. And that was it until the February 1970 obituary for Sarah Kohl Larson, age sixty, a lengthy and affectionate piece.

Enough background, time to get to the real meat, Verity decided, and found the volume for the first half of 1973. There was a story in late February about the brutal murder of a small child, with briefer and briefer follow-ups and then an editorial about the need for vigilance in a troubled world. The edition for the second week in May, following closely after the days when the accusations against Edgar Larson were made, had no mention of them. Nor did the next week, or the next.

Mid-July, the story finally surfaced, the newspaper reporting only that a "local businessman" had been anonymously accused of child molestation some weeks earlier. Toward the end of the piece, the writer stated that the police were investigating but that the accusers had not come forward with their own names nor any corroboration of the claims. An editorial cautioned citizens against rumor-mongering.

She moved ahead, and in early September found the report of Edgar Larson's suicide. It was a very low-key piece, giving the fact and manner of his death without mentioning rumors or making explanations. Accompanying the story was only the second photo she'd found of the man: very lean with square shoulders and a bleak, straight-ahead gaze, his long jaw now covered by a grizzled beard.

Aware that time was running short, she flipped pages quickly to find, in late October, a report of a second brutal child-murder followed in the next edition by the identification of the presumed murderer, a transient with a list of convictions for sexual crimes. A quick-thinking seven-year-old, her alert parents, and the work of several sheriff's deputies plus Officer Jacobs of the Port Silva police had uncovered the identity of the man, who promptly disappeared.

No doubt Jake Jacobs, Hank's "unpredictable bastard," who should be high on her list of interviewees. About to close the book, she returned instead to the story of Larson's death, and his picture there. Whatever it was that had made him beloved of a small girl was not apparent. She pushed this volume aside, sat frowning blankly into dust-mote–filled emptiness for a long moment, and then got to her feet to shift the heavy books around until she found again the one containing the 1958 *Sentinel* with the picture of Edgar Larson smiling down at his wife. Had blond, four-year-old Christina brought that same smile to his stern face?

"You about finished here?"

The hefty librarian must be very light on her feet; she'd come into the room without noise, without even disturbing the air. Verity resisted the urge to reach out and defensively close the volumes open there on the table.

"Yes, I am, thanks. I'll just reshelve these...."

"Never mind, I'll take care of them." She closed the nearest and turned it to look at its spine. "These particular books are real popular these days. You're the second girl this week come in to look at 'em."

Verity got to her feet, picked up her bag, and repeated her thanks. The woman merely nodded, and stood there like a dragon silently guarding its treasure as Verity left the room. As the door closed behind her, she set off quickly for the stairs, and the visitors' log for the *Sentinel* archives on its small lectern in a corner of the front office. She quickly flipped it open, scanned the recent signatures, and found Chris Larson's name scrawled on the third line above her own. Chris had been to the archives on Monday, two days earlier.

And she herself was going to be late for work if she didn't get a move on. Eyes on her watch as she ran out the front door and down the steps, she nearly knocked down a smaller woman who had just turned in from the street.

"Oops, sorry," she said, and then stepped back for a better look at

her victim, at yellow-streaked mousy hair framing a tight face with hard brown eyes and a thrust-out chin. "Never mind, I take that back. What the hell are you doing here?"

"Oh no, it's the red haired gorilla who ate up from the journalists. I live here, remember? And the *Sentinel* archives are open to the public."

"You're not a journalist, you're a twisty little fake who likes to terrorize small children."

"That's a lie, I was just doing my job!" said Lori Bergman. She caught Verity's expression and took two quick steps backward. "Like I am now, I'm a stringer for—"

"You shoved a microphone in the face of a seven-year-old girl and asked her if she knew who killed her mother."

"I don't think that's how—"

"And if you ever come near Sylvie Medina again," said Verity softly, "I'll give you *serious* reason to scream assault." She turned on her heel and set off with long strides to her car. Long, deep breaths, too, to get her temper under control. She and Bergman had managed to stay out of each other's way for about six months, which it turned out was not long enough.

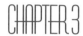

CHAPTER 3

FROM THE TIME she was tall enough to stand at the stove and stir a pot, Verity Mackellar had cooked. She began at home while she was in second or third grade, because her mother worked odd hours and their tiny kitchen couldn't accommodate her father's wheelchair. In high school, she helped out on weekends in the restaurant of a family friend. In college, she'd found a cooking job whenever money was short.

Some months after her move to Port Silva, she'd fallen into casual if breathless conversation with a woman in an aerobics class, and had been immediately befriended and almost as quickly hired by Ronnie Kjelland, owner of Pure and Simple, a small restaurant near the south end of Main Street. Verity no longer worked the Thursday through Saturday dinner shift regularly; but the weekday lunch, with its briefer menu and mostly local patrons, made her feel that she was in touch with her adopted town and provided a regular, if small, income.

Now, as she pulled into the parking lot behind the restaurant, her mind was not on grilled chicken breast on focaccia or roast lamb salad, but on Edgar Larson. Was Ronnie a native? She didn't think so, but she certainly meant to find out.

Inside, Verity hung up her jacket, washed her hands, tucked her long braid down the back of her shirt, and headed for the kitchen, a room where every inch of counter and floor space had an assigned purpose. Pure and Simple served breakfast from 5:30 A.M. to 10:00. Lunch started at 11:30. The breakfast staff was headed by Mona Dugan, a no-nonsense middle-aged woman who kept her small crew busy and in order and even managed to get a bit of lunch prep done. But the timing was tight, and the lunch menu necessarily uncomplicated.

"There are half a dozen places in town that do a perfectly good

breakfast," muttered Ronnie Kjelland, who was seasoning a tray of boneless chicken breasts that would be grilled for sandwiches and salads. "One of the things that keeps me working on the new place is that I've promised myself I will never ever cheat on breakfast there!"

"Good," said Mona, who had shed apron and hair net and was shrugging on a coat. "My old man says he's tired of me rolling out of bed in the middle of the night and leaving him there cold and lonesome."

"God, Mona, don't even think of abandoning me until the new place is done! Let me buy him an electric blanket."

Mona smiled rather grimly as she opened the back door. "One day at a time. See you tomorrow."

"You're looking very cheerful," said Verity as she tied her apron. "Have you had good news about the new place?" With visions of restaurant grandeur, Ronnie had been tussling with a raft of city officials for more than a year to get permission to remodel the former home of an early mayor, a charming old house with a garden, decks, and an ocean view.

Ronnie grinned broadly. "Yup. It's all come together: asking price of the building, engineer's report, architect's plans, bids from two contractors, run-down on equipment costs. Best of all, a notarized statement from the Preservation Committee guys that they don't consider the structure suitable for landmarking," she finished in triumphant tones. "And that banker friend you recommended was a jewel; I'd never have got there without her help."

"She's one of the smartest people I know," said Verity, "and she's particularly interested in seeing that women get a fair shake in business deals." She looked around, spotting the huge mound of washed and spun lettuces. "Want me to make the dressing?"

"It's done. You can get started on the pasta sauce, I thought garlic lamb sausage and mushrooms in a tomato cream. I roasted red peppers yesterday, for tortilla chicken salad; I'll mash up some guacamole now. Say, Verity?"

Before turning to answer, Verity snatched up a leftover breakfast biscuit and tossed it into the microwave for ten seconds. "Yum, these I can't resist. Yes?"

"Maybe you'd like to have a look at the papers, in the box out front behind the desk. If this looks as good to you as I think it will, maybe you'd be interested in coming in with us? Just a small chunk if you

like. Or even a big one, and we could have two V's in the name," added
Ronnie, who was in fact Veronica. "Might be kind of classy."

Verity retrieved the biscuit, broke it open with her fingers, and
tucked a pat of butter inside. "Thanks, Ronnie, but I'm not in a posi-
tion to do any investing right now." In fact, the San Francisco house
Verity owned with her ex-husband had just sold for the incredible
price of "one mil six," to quote the realtor. In addition to being newly
single, Verity was about to be, at least by her former standards, newly
rich. She didn't plan to alter either situation any time soon.

"Well, keep it in mind, okay? It'd be good to have your brains on
board, not to mention your cooking skills."

Mona's biscuits were otherworldly and some day, Verity vowed,
she would come in early to learn the secret. Now she wiped her but-
tery mouth, washed her fingers, and located a basket of cleaned
mushrooms in one of the kitchen's three refrigerators, a package of
locally made sausages in the meat keeper of another. She took the
mushrooms to the on-wheels butcher block and plucked her favorite
chef's knife from the rack there. "Ronnie, did you grow up in Port
Silva?"

Ronnie shook her head, then swiped a thick lock of pale blond
hair off a face flushed from kitchen heat. "Nope, in Walnut Creek. But
my husband did, and always wanted to come back, so we moved up
here in 1995, when Russ's dad died and he decided he could do just
fine as a telecommuter. Why?"

"I'm interested in people who knew the Larson family, Edgar
Larson in particular. He was owner of a small timber company, and
died in 1973." She scooped a mound of sliced mushrooms into a bowl
and went to work on another batch.

Ronnie shrugged. "Just one more Scandihoovian name to me, the
woods are full of 'em. And Russ would've been just a little kid in 1973.
You might talk to Russ's mom, Margaret. She's lived here forever, and
she's in the phone book. Just be prepared."

"I beg your pardon?"

"Russ always insists her bark is worse than her bite."

"Ah. Thanks."

"No prob. Say, how's that adopted kid of yours doing? I saw her
bounce out of the school bus today, when I was dropping Jessica off,
and I swear she's grown about two inches since the last time I saw her."

Verity had given up dodging the term "adopted." Sylvie's own
"found kid" was the most accurate term for their circumstance, but it

wasn't easy to define without going into details she rarely chose to share. "By the time she hits sixth grade she's going to be taller than most of the teachers, poor baby. I remember that state well."

"Does she enjoy school? Jennian really liked Mrs. Lee last year, even though she thought she was strict."

"Sylvie likes Mrs. Lee, and she's doing fine with her. Her only real complaint about school is that there are always too many people around. She was home-schooled previously," Verity added in response to Ronnie's raised eyebrows.

"That has always struck me as a bad idea, especially for the parent."

———//———

The turnout for lunch was light, perhaps because of the weather—cold and blowy with no rain yet, but the taste of it in the air. This mean year, Verity thought glumly, had produced a rare February without its usual taste of spring: two or three warm, sunny days dropped like a surprise gift into the gray damp of winter.

She put quick finishing touches on a big plate of chicken salad, topping the chicken chunks and black beans with strips of roasted pepper and grilled onions, adding a big scoop of guacamole and a ring of tortilla chips. Then she turned to the hot skillet to sauce the lamb and vegetables sizzling there and scoop the result onto a plate of steaming linguini. She set the two plates on the pass-through shelf and surveyed the room as the waitress delivered them to the last patrons as yet unfed, a young man at the counter who was probably a university student and a woman in late middle age sitting by herself at a small table.

Verity took another look at the woman. She'd seen her come in, noting her height and considerable bulk. Now she got a good look at the broad face and imposing nose, the mass of thick gray hair escaping from a bun, and identified their owner. She'd seen her with Ronnie's husband, Russ, who had the height and the nose but not yet the bulk. Here, she'd bet, was Margaret Kjelland, who had lived forever in Port Silva and looked like a person who'd have made it her business to know everyone.

Ronnie, bless her, was at the front door, turning the lock before reversing the sign there to CLOSED fifteen minutes early. On her way back across the room, she paused to exchange a word or two with several diners, then sat down at the table of the gray-haired woman. Proof, thought Verity. Good.

When Ronnie returned to the kitchen, Verity had shed her cook-

ing garb, put away perishables, and was ready to leave the area to the dishwashers. "Ronnie, if that's your mother-in-law out there, and if you don't mind, I think I'll stop and chat with her about Edgar Larson."

Ronnie's head came up sharply. "Well, that's Margaret, all right, at her queenly best today. But you're a big girl. I'll let you introduce yourself."

In the rest room, Verity washed up a bit and then inspected her naked face in the mirror. Nice broad forehead, decent cheekbones; but for a day in the city, or for a social occasion, she always added a little darkening of lashes and brows, a bit of eyelid color, a touch of lipstick. Not today, she decided, and pulled a blue scarf from her bag, knotted it over her bright hair, and nodded at the result. Nice, ordinary young woman, no threat to elderly dowager types or anyone else. And so to work.

Ronnie's mother-in-law was dropping brown sugar cubes into a cup of well-creamed coffee as Verity approached. "Mrs. Kjelland?"

The woman looked up, removing the half glasses with which she'd been reading a paperback book. "I'm finished, thank you," she said, gesturing at her empty plate. "But I'll sit here a few minutes more with my coffee."

Verity turned and beckoned to the high school girl who was waitressing as a work-study student. When she'd cleared the table, Verity pulled out the vacant chair and sat down. "I'm Ronnie's friend and part-time cook, Verity Mackellar. I'd be grateful if you could give me a moment of your time."

Margaret Kjelland frowned and tucked the glasses away in a small case. "Mackellar. I don't know any...oh. Of course, Patience Mackellar. I've met her at historical society events. Are you related to Patience? You don't look much like her."

Ordinary well-mannered young woman, Verity reminded herself. "She's my mother. I look quite a lot like my father."

"That's always a relief," said Margaret. "Patience has this odd business, private investigating. Are you a part-time investigator as well as a part-time cook?"

"I am, and—"

"Seems a peculiar combination. So what do you want from me, may I ask?"

Verity sat back, smiled gently, and said, "I'm presently helping

Christina Larson, the granddaughter of Edgar Larson, with her research for a family history. She was very young when her grandfather died, and she's trying to get the facts about the end of his life. 〜〜〜 been active in the community."

The older woman took a thoughtful sip of coffee, set the cup down, and sat back in her chair, lacing her fingers together across the shelf of her bosom. "I'd heard the Larson girl was in town. And of course, there was that provocative death notice in the *Sentinel* today."

Verity was caught off guard by this. "Death notice?"

"For poor Andrew Larson, or so the heading said. At any rate, I believe, and I'm sure others will agree with me, that such an investigation is not a good idea. She'd do better to leave the whole business alone."

"Why do you say that?"

"Don't be silly, my dear. She's surely told you that Edgar Larson was most likely a child molester." Before Verity could get the next question out, Margaret waved one hand.

"Oh, it turned out he probably wasn't the beast who raped and murdered that poor little Dillon girl. But the good Lord knows any community is likely to contain more than one vile man who lusts after children. After Penny Dillon was found, everyone was terrified; I kept my own little daughter practically on a leash. And we were all suddenly watchful as hawks," she said with some satisfaction. "So it's really no surprise that another pedophile was uncovered."

Or invented. "I understand that Edgar Larson's accusers were anonymous."

"People are afraid to get involved in something so nasty, but it's better to report a crime anonymously than not at all. And when we thought about it, it made sense. Edgar Larson was a stiff, unfriendly man who was emotionally dependent on his wife. She was a lovely woman, Sarah; my mother and she were good friends. Then she got very sick, and finally she died."

"But his son came to live with him. And his granddaughter."

"Indeed," said Margaret Kjelland, as if a point had been proved. "A pretty little girl, right there in his own house. Fortunately her mother was there, too, and I understand kept a very close eye on her child."

Here it was again, the investigation the police had apparently not undertaken, the question Verity had not thought to ask.

"How did you hear about the accusations?"

The other woman made a sound that could only be called a snort. "Thirty years ago Port Silva had no university, few tourists, and hardly any wealthy retirees from wherever. We were an old, stable, small town, and anyone who paid attention heard everything."

"Did you, or anyone, ever hear who the anonymous callers were?"

"No-o," she said, drawing the word out. "Which was strange. My thinking is that if Walt Henderson—he was police chief at the time, and a more stubborn man never lived—if he'd pursued the matter with a real investigation, they'd have been found out."

Verity sat back and simply looked at the older woman.

"But then Edgar Larson killed himself! The ultimate proof, most people felt."

Most people. "Wasn't there anyone in town who felt guilty after Edgar's death? For hounding a man to suicide?"

Margaret Kjelland stiffened, reddened, and then sighed. "Some did, yes. Until the day she died, my mother refused to believe in Edgar's guilt. There were others, too, mostly people her age. Edgar's age."

"Mrs. Kjelland—"

"But answer me this, Miss Part-time Detective. Edgar Larson had few close friends, but no known enemies, either. Who out there would have had reason to make such charges against him, anonymously or otherwise, unless they were true?"

"Now I've said all I care to say about this." She pushed her chair back and heaved her bulky body to its feet. "I can understand Christina Larson's situation. I know her father just died, and he was a good man, no one held Edgar's deeds against him. But she'd be better off to leave the past to the past."

Verity met the older woman's glare and lowered her own gaze. "Perhaps you're right."

"Of course I'm right." She was unmollified by this show of respect. "And if you're a friend of that young woman's, you'll make it clear to her and not meddle further."

———//———

Verity left the restaurant almost immediately and headed for the Y, where she knew she'd find a drop-in exercise class. Tense with irritation at Chris and even more at herself, she felt the need of a workout. By the time she drove onto Raccoon Lake Road more than an hour

later she was sweaty, physically weary, and had forgiven Christina Larson for not answering questions she hadn't been asked. For her own sins, however...

Sounds of piano came to her from the studio as she got out of her car: Sylvie, practicing. Good. She hurried into the house and found Patience in the kitchen unpacking a pair of grocery bags.

"Hi, Mom," she said, and dropped a kiss on the smaller woman's cheek. "I should have taken a list along and done the shopping. How did you manage?"

"By telephone. Silveira's delivers, for a very small fee. How are you?"

"Terrible." Verity tossed her bag on the table and went to the end of the counter where newspapers accumulated. "I tried to get some information about Edgar Larson, quietly and politely, from a local senior citizen, and wound up being told to be a good little girl and leave dead pedophiles to molder away as they deserve. Basically. Is the *Sentinel* here?"

"Under the *Chron*, I think. Who was the citizen?"

"Ronnie's ma-in-law, Margaret Kjelland," said Verity through her teeth as she paged through this week's edition of the local newspaper.

"Margaret Kjelland has delusions of grandeur nearly as broad as her backside," said Patience, drawing a look of astonishment from her daughter. "Her often-expressed opinion that only natives should belong to the Port Silva Historical Society is the main reason I stopped attending meetings. You can be sure she'll spread the news of the Larson investigation far and wide. But that would have happened soon, anyway."

"Well, yes. Listen to this. *Died last week in Santa Rosa, Andrew Kohl Larson, Port Silva native and longtime resident. Of cancer. Andrew was preceded in death by his mother, Sarah Kohl Larson, in 1970, and by his father, Edgar Emil Larson, in 1973. He is survived by his daughters, Christina Ann Larson and Elizabeth Mary Larson Polk, of Los Angeles, as well as four grandchildren. Burial will be private in his parents' plot in Port Silva Nondenominational Cemetery. A public memorial for both Andrew and Edgar will follow, date to be announced. Full obituary next week.*"

"Oh, my," said Patience.

Verity dropped into a chair at the table. "I can see why Mrs. Kjelland called that 'provocative.' If I'd talked further with Chris before

running around playing detective, I might have thought to be more, well, subtle."

Patience put the last package of something or other in the refrigerator and took out a bottle of chardonnay. "Get glasses, dear, and we'll enjoy a moment of adult calm before Sylvie roars in."

Verity obeyed with alacrity, Patience filled the glasses, and when they were both sitting at the table, she raised hers in salute. "Provocative it was clearly intended to be, and we'll need to remember that Chris Larson doesn't intend to be a silent observer. But this investigation by its nature is going to be right out in the open. You have no approach but that of talking to people, so you may as well let the rumor mill work for you."

"Yes, ma'am." Verity had a sip of wine, and sighed. "I almost forgot. I need to go to San Francisco this weekend. Can you cope?"

"Oh, I think so." Patience tugged briefly at the sling she still wore occasionally to support her injured wrist. "I can drive short distances without too much trouble. Or I can get help from Harley or Hank. What's the occasion?"

"Corey called me this morning on my cell phone. The house is sold, and she needs signatures. It went for—and I quote—'one mil six.'"

"Good heavens," Patience said faintly. "I hope there's a good tax person among your friends."

"Oh, yeah, don't worry. I'm just not looking forward to the event, the long drive and all. I asked Corey if faxed signatures wouldn't do, but she said I was to get my ass down there like a grown-up."

Patience regarded her daughter for a long moment. It was not the drive, but the prospect of seeing her ex-husband again that had Verity on edge. "Here's an idea. Why not take Sylvie along?"

Verity stared at her. "Sylvie?"

"She'd love it. She'll behave like an angel for the chance. And I'll have a nice peaceful weekend, catch up on a few things and do some reading."

"I was planning to stay with Corey, and she doesn't have any children."

Patience grinned. "Well, it could restrict any plans you and Corey might have for hitting the bars and clubs. But you may have noticed that Sylvie is quite capable of enjoying herself without other children."

"Well. Don't mention it yet, okay? I'll have to check with Corey."

"Of course. And how was Hank this morning?"

Verity inspected her mother's face for irony but found none. "Fine. He gave me what information they had, which wasn't much. There's little doubt the death was suicide; there was definitely a note, although it's no longer in the file. As I was leaving, he warned me to be careful as I go about turning over old rocks."

"Good advice."

"He clearly thought so. Then before going to work, I stopped by to read some back issues of the *Sentinel*." Verity sipped her wine for a thoughtful moment before relating the small items of information she'd gleaned from the dusty old pages.

"The clerk there was a large woman who moved around like a silent blimp and probably has X-ray vision," she added.

"Ah, yes. Estelle Carson, another, though lesser, pillar of the historical society. Between her and Margaret, the town will be well-informed. The Larsons were Lutherans, you say?"

"Yes. At least they contributed money to the steeple fund at Shepherd of the Sea Lutheran Church."

"I know Reverend Schultz slightly," Patience told her. "He's somewhere in his sixties, just barely old enough to have been at the church when Edgar was. I'll talk to him, if you like. If you choose to go on with this."

"I won't decide definitely until after I see Chris tomorrow afternoon. But Ma, it's going to be difficult. Edgar Larson would be a hundred years old now, which makes it unlikely there'll be any of his peers still around."

"No, but there'll surely be some younger people who had occasion to know him. I'll give it some thought."

"I'd appreciate it. If you have the time."

Patience made a face. "I had a call about work today, a referral from that last job, but it was in San Francisco again, and I didn't feel much like traveling. I didn't much like the sound of the job, either. So I'm available, for the moment anyway."

Verity drained her glass and got to her feet. "How's Sylvie?"

"Hungry. Cheerful. Noisy. With nary a word about troublesome kids, not even the male ones. Now," she added, with a look at her watch, "who's cooking tonight?"

CHAPTER 4

THURSDAY'S LUNCHTIME stint at Pure and Simple was hectic, as usual on the days when the restaurant would also serve an evening meal. Verity did her work quickly and quietly, purposely avoiding the chitchat that might lead Ronnie to ask her to stay to help with dinner prep. When the last patron had departed, she whipped through her remaining chores and was out the door in record time with no more than a "See you tomorrow."

Inn of the Woods, Chris Larson's chosen retreat, sat on a high, wooded bluff to the east of California Highway One, the Coast Highway, three miles south of town. The two-story lodge and perhaps a dozen satellite cottages were determinedly rustic in appearance, with dark brown board-and-batten siding and green trim; by what might look like happy accident, each cottage was placed to enjoy a view of the Pacific framed by mature trees or towering rhododendrons. Non-rustic stuff like tennis court, swimming pool, spa, and parking lot lay to the rear of the lodge. The lot was fairly well-filled for this chilly time of year, mostly by SUVs ranging in dimensions from moderate to behemoth. Verity pulled into a slot between a jowly Mercedes and a barn-sized Lincoln Navigator, and decided her new little Subaru Forester would barely make the cut here.

Propped on an easel beside the front entrance to the lodge was a sign in large but graceful letters. GUESTS' VISITORS: PLEASE MAKE YOURSELVES KNOWN TO THE CONCIERGE. Verity obediently gave her name at the desk inside, where a trim young woman whose attire hovered between business suit and uniform typed briefly on a keyboard, eyed a monitor whose screen Verity could not see, and nodded. "Ms. Larson is expecting you. She's in Hummingbird, to the right along the crushed-granite path. You'll see the sign."

A pale, cloud-streaked sun was lowering toward the bank of fog

lurking on the horizon, and the usual late-afternoon breeze ruffled
the gunmetal gray ocean with tiny whitecaps. In their forested set-
tings, the brown cottages appeared smaller than they actually were,
and wisps of smoke from a couple of chimneys were the only signs of
occupancy. Highway noise did not reach here, Verity noted, nor did
any sounds of exertion or merriment from the activity areas behind
the lodge.

She moved along a broad white path that appeared to have been
swept clean of leaves or needles, to find a painted metal bluebird
marking the walkway to the first cottage. Next came a gray-and-white
grebe, and then the hummer, a ruby-throat. Verity touched the door-
bell.

"Oh, Verity, you're here! Come in, come in." Chris Larson wore
plain gray sweats today; her face was untouched by makeup, her eyes
reddened and her hair rumpled. She looked, in fact, like a very tired
version of Verity's long-ago soccer friend.

Chris waved her guest into a spacious room with peach-tinted
walls and a velvety taupe carpet; silver-and-pink figured draperies
framed a set of French doors in the far wall and a small deck beyond.
The merrily burning fireplace, faced in stone and fitted with glass
doors, filled one corner of the room; a cocktail table in front of the
hearth was flanked by two low easy chairs, while a couple of pillow-
strewn sofas stood nearby. Much of the long outer wall to the right
was devoted to a complicated built-in unit with many shelves and
louvered folding doors housing television, music system, printer/fax
machine, telephone gear. After a moment Verity spotted the comput-
er, a laptop, on a small dining table or perhaps desk against the front
wall.

The place lacked any hint of kitchen but had a separate bedroom;
she caught a glimpse of a huge unmade bed before Chris pulled that
door shut. Midpoint on the interior wall was another built-in unit, a
hutch serving as bar and liquor cabinet. Verity was interested to note
that the lower half of its back was a sliding panel, half open now to re-
veal two glasses on the inner, the bedroom, side. How the well-off
live; maybe she could work in a touch or two like that when she
remodeled her studio.

"Nice place," she said to Chris, surrendering her jacket. "Quiet and
private. Except it seems any visiting lover would have to register with
the concierge."

"I don't think so. Not that I presently have one of those," Chris added as she draped Verity's jacket over the back of the nearest sofa. "Verity, I'm so glad you've decided to help me. And I've racked my brain for every little thing I knew about my grandfather—which unfortunately isn't much. So let's sit down with a drink and talk about it."

Chris clearly meant "drink" seriously. After pulling the sliding panel shut, she took a bucket of ice from the small refrigerator in the bottom of the hutch, and set it beside a half-full bottle of Stolichnaya vodka. "Not for me, thanks," Verity said.

"Oh, come on. I really need a drink, and I don't like to drink alone."

Verity hesitated. She had learned, over the past year or two, what a bad idea it was to mix depression or misery with alcohol; but she'd also come to some understanding of the need. And since the Inn was noted for its food, Chris would probably not be driving anywhere soon. "Maybe just a glass of wine, then. I have to drive home, and Port Silva's cops must have the national record for issuing DUIs." She hoped her friend would take this truth as the warning it was.

Chris settled Verity in one of the fireplace chairs with a glass of merlot before plucking a letter-size pocket folder from the papers strewn across the table there and handing it over. "I'm embarrassed by how little I know about my own family, but I guess that's the American way. On the bright side, though, this is a small, fairly stable town, my grandparents lived most of their lives here, and I think there are still people around who will remember what happened twenty-eight years ago. I hope so, anyway. I made notes and printed them out. You can have a look at what's there while I fix my drink."

Verity reached into her bag for her notebook, a small, plastic-covered substitute for the leather Filofax she'd carried in her San Francisco days, and settled down to read. Edgar Larson, she learned, was born in San Francisco in 1900 to an immigrant Swedish couple; his parents moved with him to Port Silva when he was a small child. Here on the north coast his father had worked in the woods; his mother had opened a bakery and pastry shop. Both had become pillars of Shepherd of the Sea Lutheran church, a connection that Edgar and his wife had maintained. Right, thought Verity, and they were partly responsible for the survival of its handsome steeple. Set on a low hill overlooking the sea, the white-painted wooden church was one of a

number of local buildings that might have been transplanted intact from New England.

Friends of Edgar: as Verity had anticipated this morning, Chris knew of no surviving friends. Relatives the same: Edgar had been an only child, and so far as Chris knew, no members of his wife's family remained, either, at least not in Port Silva. Friends of Andy Larson: Chris noted that she had and would provide Andy's personal address book.

Memberships: Chris thought maybe Rotary or Lions. But according to Andy Larson, his father had spent the last years of his wife's life seeing her through a lengthy illness, with little time or energy left for any earlier civic connections.

And the business: Larson Timber Company. Sold in 1967, to Cal-Tex Corporation. Chris's notes said that county records would have specific information on the matter.

That sale, according to the notes, had left Edgar fairly well off, with no need for any kind of paying job. But most healthy old people found something to do with their time, and there was no mention of that here. "Chris, what about your grandfather's life after your grandmother died, after you and your parents moved up here? I know you were just a small child, but do you remember his leaving the house in any regular fashion? For some kind of charity work, for instance, or a hobby, like fishing. I'm wondering just what he did with his time."

Chris sank into the second easy chair, stretched out wearily, and took a sip from her chunky glass of ice and vodka. "I know he spent a lot of time with me. Baby-sitting, probably; before she got into her second pregnancy, Mom worked part-time in Dad's office. He liked to cook, I remember that. And I remember that he and my dad would sometimes go out together...I bet birdwatching!" she said triumphantly. "My dad was a birder, right up until his last illness. And Grampa liked being outdoors. He'd spent most of his life in the woods, after all." With a crooked smile, she lifted her glass in a half salute—to her grandfather, or the woods, or maybe just to booze. Reassessing the woman's bloodshot eyes and scruffy appearance, Verity suspected the drink in her hand was not her first today.

Well, no doubt there were local, well-established birding groups. Verity had a sip from her own glass and reflected upon a job that was likely to take a while. Presumably Chris Larson could afford to pay for it. Noting that the folder was not empty, she tilted it over the table and out fell a small leather book, the address book.

"I'm afraid that won't be of much use for our purposes," Chris said with a shrug. "I've marked five names, people who I know were Dad's close friends or at least regular acquaintances, and there's not a Port Silva native in the bunch. And I don't think he talked to anybody about his father until me, when he knew he was dying. He was a shy man, my father."

"Well, I'll have a look anyway." Verity set the book aside. "There's another possible source you haven't mentioned: your mother."

"Oh Jesus, no way! My mother banished all memories of Port Silva *and* my father a long time ago. She's going to throw a fit if—when—she finds out what I'm doing."

Too bad. "Chris, tell me what, exactly, you hope to get from my efforts. Are you thinking of a lawsuit?"

"Not at all." She lifted her chin and met Verity's probing gaze, widening her own eyes. "As I told you the other day, I want to find out who falsely accused my grandfather of being a child molester. If that person is still alive, I want an apology, a public apology, maybe in the newspaper. I want my grandfather's name cleared."

Verity picked up her glass. "I stopped by the police station yesterday morning, to talk to a friend there. I learned that there were two anonymous telephone calls, made on consecutive days, saying your grandfather had been seen molesting a little girl—a little blond girl. Could that perhaps have been you, maybe in a situation that was misunderstood?"

"Jesus Christ, haven't you been listening to me at all?" Chris took a deep breath. "I was almost five, not two. I remember my life then, I know that my grandfather never did a single thing that made me feel funny. I sometimes dealt with abused kids while volunteering at a battered women's shelter in L.A., and believe me, a four- or five-year-old knows that funny feeling even if she doesn't know exactly what's happening."

"Okay. Your grandfather was interviewed, or interrogated, at least twice. Did the police talk to you?"

"No." Chris's voice was less emphatic this time. "It was a confused time, but I'm sure I'd remember that."

"Okay, next question. Suppose I pursue this, and what I find indicates that your grandfather was a molester, even though you were not a victim?"

"No fuckin' way!" Chris glared, and then subsided. "Verity, I know

he could never have hurt a child. And my father knew that, too. Dad said that everybody respected Edgar Larson."

At least two people didn't. Or maybe, Verity thought, they had played a nasty trick for reasons of their own. In either case whether the accusations were more or less honest, or made from pure mean-ness—Edgar Larson's suicide had effectively silenced his accusers. Who had probably put the events of twenty-eight years ago out of their minds with either satisfaction or shame, and would not care to be reminded.

Verity straightened in her chair and took a deep breath. "Chris, my police friend could find only one incident that had brought Edgar Larson to official police attention before the molest accusations, and that was a demonstration, or rather two demonstrations, against his sale of the company. By his employees, these were.

"Now these were before my friend's time. But there was no record of anything further, not at the station nor in the back editions of the *Sentinel* for the time. And I've looked up the two employees who were the only names mentioned in the paper; both are dead. One has sur-viving family in town, and his widow says the quarrel was made up with no hard feelings."

And Margaret Kjelland had said that part of the proof against Edgar Larson was that he'd had no enemies. Deciding that there was no point in repeating this, Verity put her wineglass down and prepared to rise. "So I'm sorry, but I don't think this is something I can—"

"No, please!" Chris leaned forward so quickly that a bit of icy liq-uid splashed from her glass onto the leg of her pants. She dabbed at the splotch with the sleeve of her sweatshirt, her eyes on Verity. "I'm not looking for revenge, truly. But I was a pretty rotten daughter to a man who deserved better, and I made a promise to try to do this last thing for him."

Verity was only gradually developing the kind of inner ear that Patience had seemingly been born with, the skill that separated truth from bullshit or at least from slanted truth. Her first rule of thumb, Patience had explained, was that everyone—all clients—lied at least a little bit about something. A second was that even honest people were often unclear as to their own motives.

Verity's continued hesitation brought Chris to her feet in a move-ment that rocked the table, tipped the stemmed glass and sloshed the

remaining half ounce or so of red wine over the papers there. Ignoring the mess, Chris snapped, "What's the matter, I'm not paying enough? Or is it you're not interested in a job where you don't get to shoot anyone? Somebody told me that's what you did a while back."

So she had, a fact that still made her mouth go dry when it was tossed at her out of the blue. Over the months since, she had dealt with it alone inside her own head, then with Patience, finally with a good friend who was also a therapist. That bloody scene no longer intruded on her mind's eye except in the now-rare nightmare, and she had absolutely no intention of dragging it out to be viewed by an alcohol-stoked stranger.

Verity got to her feet, took a long breath, and blew it out. "Ms. Larson, I think you'd better look elsewhere for help."

"Oh, shit," a white-faced Chris said in a near whisper. "Look at this mess, look at the mess I'm in. I'm sorry." She sank back into her chair and put her head in her hands. "I didn't mean all that, that stuff I said. I'm sorry. I haven't seen my kids in two weeks, and the last time I talked to my son on the phone he said he wants to live with his dad. My agent is threatening to quit if I don't do a face-to-face over a con-tract, so I have to go back to L.A. for a few days, I'm leaving early tomorrow morning. But… Verity, you didn't see the note! You have to see the note."

Chris snatched up the file folder and upended it, sending a smudged and bent-edged envelope to the table. Verity picked it up and drew out a single worn-looking sheet of paper folded in half. The writing on it was in black ink, somewhat faded; the letters were strongly formed with forceful vertical strokes.

> *They've left me nothing. I can't sit on a bench in the park and watch my granddaughter play with the other children. Walking the beach trail or headlands, if I see a small child fall down I can't permit myself to pick him up and dust him off. No longer can I stand straight and look another man in the eye and know he'll look back at me, man to man.*
>
> *I damn them to hell, whoever they are.*

"That is my grandfather's suicide note." Chris's low, tight voice gave each word a separate space. "My father managed to get the police to give it back to him after they'd investigated Grampa's death."

Verity folded the note and slid it back into its envelope. Perhaps she should have stayed in banking.

"Please, forgive me and promise you'll help."

Choose a reason. Beyond the stark misery of that note, Verity reminded herself of the usefulness of a ten-thousand-dollar bonus. She put suicide note, address book, and Chris's printed notes in the wine-spattered folder and took a sheet of paper from her notebook.

"Patience is not available right now, and I have some other commitments I'll need to work around. But I'll see whether I can pick up a trail on this. Here's a copy of our standard contract I'll ask you to sign."

"Thank you, Verity." Chris gave the contract a brief glance, picked up a pen from the table, and scribbled a signature. "Here. And here..." She unearthed a card case from the clutter on the table. "My L.A. address and attendant info."

"I probably won't have anything much to report until some time next week. How do you want me to do that?"

"I'll be in touch as soon as I get back from L.A., or I'll call you from there."

Verity shrugged on her jacket, picked up the folder, and hefted it thoughtfully. Where was her mind today, anyway? "Chris, do you have any of your grandfather's papers? Correspondence, business or personal records, things like that."

Chris picked up her glass to drain it. "My dad started clearing out the last of Grampa's stuff last year after he got sick. Thinking about selling the house, I guess. Anyway, there are a couple of boxes of file folders and account books and stuff in the living room that I haven't had time to look at. If you like, I could go by the house and..."

She paused, shook her head. "No, I won't have time tonight. Tell you what," she said, getting to her feet. "I'll give you a key and you can go have a look for yourself."

As Chris moved to the desk, and her handbag, Verity said, "Give me a note with it, please, saying I have your permission to enter the house. That way I won't upset any neighbors."

"The only neighbor who's noticed my comings and goings is a nosy old guy across the street and slightly south of Dad's house, a Mr. Simms. He's lived there forever."

"Do you know of any other longtime residents on the block?"

"There's an old lady next door, to the north of the house...Mrs.

Carter, maybe? Something like that. She looks pretty frail, comes out
on her porch with a walker, but I think she may have lived there dur-
ing my dad's time at least." Chris scrawled a few words on a sheet of
paper, put the note and a key in an envelope, and handed it over.
"Thanks. And good luck."

"We'll hope. Oh, one more thing. If you take any further personal
action on this—like the obituary with its mention of a planned dou-
ble memorial—would you please let me know? So we don't trip each
other up?"

Chris hesitated, then shrugged and nodded. With a nod of her
own, Verity stepped out the door and went on her way, wondering at
her own soft-heartedness—or more appropriately, softheadedness.
Crunching along the white path toward the lodge, she decided that it
was her memories of Andy Larson that had swayed her, rather than
any feeling for the person his daughter had become. She was not sure
she trusted Chris Larson. Or liked her.

As she walked past the lodge to circle around to the parking lot,
she glanced inside and saw that the lobby was empty, nobody behind
the massive mission-style table that served as desk. The computer was
on, imagine that. Ears cocked for footsteps, Verity stepped to the in-
ner side of the table, typed "Larson" on the keyboard, and watched
the information appear. Los Angeles address, length of stay—open,
she noted; cottage name and price: whew.

She scrolled down and found the list of approved guests: Patience
Mackellar, Verity Mackellar, a Lisa Solomon, a Jason Harrington (the
latter a local attorney, Verity thought). A Mark Ferris. And John He-
bert! What on earth was he doing on Chris Larson's guest list?

She hit the X and moved quickly back to the correct side of the
desk and quietly out the door. Was Chris seeing Detective John He-
bert the Port Silva cop? Or just Johnny Hebert? She certainly meant
to find out. If it was Johnny who'd talked to Chris about Verity's re-
cent past, she was going to make him very sorry.

Noting with interest that the path to the parking lot led right past
the door to the Inn's highly regarded restaurant, Verity hesitated only
briefly before slipping inside. The "concierge" had been pretty clearly
a well-behaved, not to say uptight, sort, unlikely to indulge in casual
chat about the Inn's guests. But restaurant people, now… And Verity
knew quite a few of the local food folk, a peripatetic lot who moved
from job to job at the drop of a ladle.

There was no one yet on duty at the reservations desk. Pleased with her continuing good luck, she moved briskly across a rustic/fancy dining room and through a pair of swinging doors into a kitchen she hoped Ronnie would never see but that did of envy. There were half a dozen people working, and one of them was familiar.

"Hey, Paul!"

A young man with close-cut fair hair and neat features looked up from the long work counter, grinned, and came to greet her. "Verity! How's life at Pure and Simple?"

"Not as much fun as when you worked there."

"I bet. You looking for a job?"

"Nope, this place is too high-toned for the likes of me. I was here at the Inn seeing a client, and thought I'd check out the layout on Ronnie's behalf, and maybe have the pleasure of seeing a familiar face. Do you like working here?"

"It's okay. Ol' Super-chef can be a pain in the butt, but he's good at his job. And the place does not stint on good ingredients. Here, have a bite of this local cheese we've discovered." He tore off a piece of baguette, smeared it thickly with something well-streaked with blue, and handed it to her.

"Yum," she said. "I should tell Ronnie about this."

"Believe me, she can't afford it. Who's your client?"

"Chris Larson, in Hummingbird cottage. Have you seen her?"

"Ah yes, Ms. Larson. The party girl." He caught Verity's glance and flushed. "Sorry, don't mean to slang a friend of yours. She's attractive, she tips well, and she seems determined to have a very good time, although of course I know that only by hearsay."

"No doubt," said Verity with a grin. Paul was gay, although not always inclined to advertise the fact. "And no problem; she's someone I knew when I was a kid but hadn't seen for years. Incidentally, if you're looking for a new berth in about a year, Ronnie's dream place should be up by then."

"Might be, who knows? Ronnie's a good boss, for a broad."

"She'll be delighted to hear that. Thanks for the snack."

"Hey, come in for dinner sometime. I'll take good care of you."

———//———

Verity liberated her vehicle from its big brothers, pulled out onto the highway and headed north. Divorce, she'd observed, often sent women thrashing about in search of a new sexual role, with slut or nun

two of the more prominent possibilities. For a woman with child-custody problems, however, sluttishness seemed an unwise choice. Even in upscale places like the Inn—maybe particularly at places like the Inn—the lower-level help, at least, could be both observant and chatty.

All of which was Chris Larson's problem, and not the one Verity had been hired to deal with. Moving slowly through early-evening traffic, she decided to swing by the Larson house on her way home and pick up whatever looked useful. Unless some more interesting activity presented itself—not a likely prospect—she could spend some time this evening looking over the material Chris had mentioned.

The house, on a quiet street in an older section of town west of the highway, was an unassuming brown-shingled two-story. Verity parked in the driveway and picked her way up a front walk thick with needles from the Monterey pines bracketing the house.

She unlocked the front door, reached inside to find a light switch just where she'd expected it to be, and stepped into a large, dusty living room furnished sparsely with pieces that might have been new forty years earlier and had not aged gracefully. Andy Larson, nice guy and good teacher, had not put much emotion or energy into this space. Perhaps, Verity thought, or hoped, he'd had another room in this big house, a den or study or something, where he actually lived.

She stood right where she was, the door behind her open to the street, until she'd spotted the three cardboard boxes in the far corner of the room, shoved up against a full bookcase. The first two were loosely filled with age-darkened, bent-edged file folders; the third contained books and several photo albums.

Three boxes of old, boring stuff, and probably spiders and silverfish as well. The sensible thing would be to set up at the dining room table here for at least a preliminary look. But this house was cold and damp, a repository of loneliness and sorrow. Not a place she wanted to be.

Streetlights had come on outside, their effectiveness muted by a misty fog. Verity went out to open the back of her car, and set about hauling the boxes out one at a time. As she shoved the second box in, a pickup truck drove slowly past, the driver, its sole occupant, just a vague shape. Neighbor keeping an eye, no doubt. Verity straightened and stood facing the street, shoulders squared and head up in non-

furtive fashion: I have business here. The truck drove on, and she went back to the house, picked up the third box, and took it to join its mates.

She returned to the house, stepped just inside, and listened. If there were ghosts here, they were silent ones. She flicked the light switch off, pulled the door shut behind her, and locked it. About to get into her car, she paused and turned to glance around her at the neighborhood.

It was hard to be sure in the thickening dusk, but most of the dozen or so houses on the block appeared to be of about the same vintage as the Larson place, probably built in the 1920s and 1930s. Two of the larger ones were sheathed in clapboard siding; some of the smaller ones, like that across the street under one of the streetlights, were finished in stucco. Medium-sized front yards, many fenced, she noted, and probably larger backyards, at least on this side of the street. Lights had come on in the house just to the north of the Larson place, and in several others up and down the street.

So, old houses, and in two of them according to Chris, and possibly more, old people who might have been neighbors of Edgar Larson. As she was considering what to do about this, a few drops of rain blew against her face on a wind that was freshening and promising more. As a stranger, looming out of the dark and rain, she'd probably not be greeted warmly and told old tales. But tomorrow, or soon anyway, she'd come back here.

CHAPTER 5

"OKAY, YOU GUYS won't forget that this is chorus day? So I'll need somebody to come and get me because I'll be too late for the bus?"

"One of us will be there, Sylvie," said Patience. Verity's mouth was full, but she raised a hand and nodded.

"And if we should both be busy, we'll send Harley," Patience added. Harley Apodaca, the twenty-year-old college student who did computer work for Patience Smith, Investigations, had recently moved in as house-sitter for a wintering-in-Hawaii Mackellar neighbor. Since then, he'd become a virtual family member as well as a virtual uncle—or big brother—to Sylvie.

"Okay. But only Harley."

"Only Harley."

"So g'bye then." Sylvie kissed Verity, who was nearest, waved at Patience and hurried out the door.

"Wise little city kid," said Verity approvingly.

"Lily trained her well." The telephone rang, and Patience got up from the table to answer it. When the caller had identified himself, she said, "Just a minute" to the telephone, "This will take a few minutes" to Verity, and headed for the hallway and her bedroom, where she closed the door. "Now, David, how can I help you?" she said, and sat down.

When she returned to the kitchen some time later, Verity tossed a casual look at her, and frowned. "What?"

"That was David Simonov." Patience put the telephone back in its rest and sat down at the table Verity had cleared except for coffee cups.

Verity stiffened. "What did the little bastard want?"

"He said he wanted to check up on how Sylvie is doing; I told him very well, with examples. He said he'd like to have her with him, but he's away too much and couldn't afford a housekeeper."

"He's after the money again," Verity snapped, "and he'd take Sylvie to get it. Mother, we can't let him!"

"Verity…"

"You remember what she was like after two months with him? Skinny and hollow-eyed and—miserable?"

"Don't yell at me, Verity."

"Sorry." She slumped against the sink counter, looking not much older than Sylvie.

"Or at David, either; it's counterproductive."

"I…hear you."

Patience took a sip of coffee and made a face. "I'm not as fond of cold coffee as you are," she remarked in tones meant to lower emotional temperatures. Since David Simonov had given over all parental rights to Sylvie's mother when she divorced him, making no effort to see the child in the ensuing five years, his legal claim to his daughter might be open to question. She and Verity, however, had no claim whatever; the present arrangement was personal, irregular, and under the supervision of the executors. Making waves would risk further involvement of two or possibly three counties or even the state.

"He is Sylvie's father," she went on. "Every now and then he remembers that and thinks about asserting his rights."

"Which he doesn't really want."

"That's mostly true but not particularly useful. I reminded him gently that the banker and the Baptist minister whom Lily appointed to oversee her estate take their job seriously, and seem pleased with the current arrangement. That deflected him for the moment, and we'll hope it's a long moment. Now you should do what your mother tells you, which is, have your run and get ready to go to work."

———//———

In big cities or small towns, people like to lunch out on Fridays. At Pure and Simple this Friday, the tables were all taken and the counter seats fully occupied from 11:30 on, several people always waiting near the door with impatient feet and hungry faces. The waitresses dashed from kitchen to dining room and back with no time for friendly chat with customers, and Ronnie was harried and short-tempered, snapping and banging pots around in very cheflike fashion.

At a quarter to four, sweaty and weary with a knife-nick on one thumb and a grease burn on the other forearm, Verity trudged out to her car and gave serious thought to heading right home, to put her

feet up and have a glass of wine or a cup of tea. Patience planned to pick up Sylvie, and Chris Larson's business could wait.

"But you're taking the weekend off," she reminded herself aloud as she settled behind the wheel. Of the various chores she had lined up, the visit to Edgar Larson's former neighbors looked the most straightforward, and at least it was close to home.

The block between Cypress and Acacia on B Street had seven houses on the east side of the street, six on the west. Verity noted this as she slowly drove the length of the street before circling the block and coming back to pull into the driveway at the Larson house, number 1131, on the west side. One big house at the Cypress end of the block, 1101, had obviously been divided into rental units, with the former front lawn paved for parking. The small stucco house across the street, 1104, was empty, with a FOR SALE sign on a post in its yard.

The others, except for the Larson place, were clearly occupied, with cars in several driveways, yards more-or-less kempt, children's wheeled toys tucked up against some porches. Although the familiar marine layer blotted out any direct sunlight and the air was heavy with damp, two preteen boys tossed a football back and forth in the yard at 1107 and a much younger girl rode a small bike with training wheels up and down the flat driveway at 1136.

The two places with what Chris thought might be longtime owners were 1139, on the west side next door to the Larson house, and 1128, across the street. The former was a two-story Victorian with a wraparound porch, its wooden siding painted a bright, fresh white and its extensive gingerbread trim a distinctive gray-green. This place and the Larson house, and presumably some of the others on this side of the street, had long, sloping backyards with views out toward the bluffs and the ocean beyond.

The single-story stucco cottage at 1128 was the residence of one Mr. Melvin Simms, the "snoopy old guy" Chris had mentioned and Verity had looked up in the telephone book. With a car in the driveway and a light on inside, this might be the place to start. She squared her shoulders, put a pleasant expression on her face, and moved up the walk to the porch steps.

The doorbell was answered immediately by a short, skinny man of perhaps seventy with a fringe of lank gray hair below a bare, freckled scalp. "Well, my good luck. I was hoping that whatever that pretty girl

was doing on our street, it might bring her to my door. Mel Simms, at your service, and who might you be?"

"Hello, Mr. Simms. My name is Verity Mackellar, I just sold my house in San Francisco, and I was told that the house across the street might soon be on the market. So I thought I'd have a look at the neighborhood."

"Young lady, you've come to the right place. Except for that old bat Grace Carden across there at 1139, I'm senior resident of the block. Come in, come in."

Verity stepped into the tiny entry hall and then into a living room which was more like an old-guy's den, with scattered newspapers and an overflowing ashtray and a general layer of dust. The furniture was a mix of maple-and-chintz early American with imitation Danish modern, pride of place occupied by a possibly leather recliner facing a huge television set.

"So, Miss Mackellar—it is Miss?"

"It is."

"So, sit down, sit down. Can I get you a beer or anything?"

"It's a little early for me, thanks, and I'm driving. But you go right ahead."

"I'll just do that." As she perched on the edge of an armchair, he scurried off toward the back of the house and returned a moment later, a brown bottle in his hand, to settle into the recliner.

"Well, it's a nice, stable street. Two or three of the houses are rentals now, but the renters are married couples—or some kinda couples anyway, who knows these days? There's quite a few kids, and at least two teenagers, but mostly they behave. Though there was a time, not too long ago, that this one noisy Irish bunch…" He had a drink of beer and launched into a rambling tale of a large and ill-behaved Catholic family.

When he paused for another drink, Verity broke in. "I understand that the house at 1131 has never before been on the market. I suppose you must have known the owners?"

"Hell, yes, the Larsons. Ol' Edgar Larson built the house himself, sometime in the 'thirties. That was long before my time, acourse, but he was still living there in 1960 when me and my wife bought this place. Stiff-necked sumbitch was Edgar, wouldn't have a beer or play a game of cards or tell a joke. Guy was hell for strong, though, even when he was old as I am now. Once, right out there in the street, I

seen him all by himself lift this great bastard of a tree limb off the car it'd fell on."

Simms blinked, and took a long, assessing look at Verity. "Probably shouldn't tell you this, if you're thinking of maybe making an offer for the place, but Edgar killed himself in 1973, right there in that house." His eyes were bright under eyebrows like unkempt gray caterpillars. "Blew his own head right off. Turned out he'd been messing with little girls. Everybody else was real surprised, but me, I'd seen how mean he could be with kids and I always thought there was something funny about how much time an old guy like him spent with his own little granddaughter."

"How awful. Were you the one who found him out and turned him in?"

"Oh Jesus, no! There was anonymous calls to the police. Nobody ever found out who made 'em, but it sure as hell wasn't me."

At least one of them wasn't, Verity noted, remembering that the second caller had been female. "Maybe it was somebody else in the neighborhood," she suggested.

Simms took another pull at his beer bottle, staring past her into thought or memory. "I don't know. Thing is, I'd of said he had most folks around here buffaloed." He shook his head as if at a familiar but nevertheless odd circumstance, looked at his watch, reached down with his free hand for a lever, and reclined the recliner about halfway.

"'Scuse me, but it's time for my nap. Man my age wears out early."

"Of course." Verity stood up and moved toward the door. "Thank you for your time."

"No problem, no problem. Good luck with your house hunt."

And Verity was alone on the small front porch trying to decode the mixed message Mr. Simms had been sending. Was he frightened, regretful, or simply tired, as he'd said?

Think about it later. She set off across the street for the big white Victorian that had been owned since sometime before 1960, according to Mr. Simms, by a Grace Carden.

The woman who answered the bell was somewhere between fifty and sixty years of age, surely too young to be Grace Carden. Of medium height and trim in wool pants and sweater, she had gray-streaked dark hair, a firm jaw, and piercing light brown eyes that measured Verity's height, determined her age, priced every item of her clothing, and probably calculated her I.Q. No point in subterfuge here.

"I'm Verity Mackellar, a friend of Chris Larson's who's working for her. I wonder if I might talk to Mr. or Mrs. Carden?"

"Mr. Carden is long gone, and Mrs. Carden is in the kitchen. I'm Jane Carden Tolleson. I don't know Chris Larson, but I will find of her father." Jane Tolleson took another good look, and stepped aside. "You'd better come in. I'm sure my mother will be interested in whatever it is you're doing."

Verity followed the other woman down the long hall to a big, brightly lighted kitchen where a cast-iron stove set into a fireplace was aglow with warmth. An angular old woman sat straight-backed beside a round table, a cane hooked over the arm of her padded oak captain's chair and her gaze fixed on the doorway as if waiting for the actors to appear. "Mother, this is Verity Mackellar, who's working for Chris Larson. Ms. Mackellar, my mother, Grace Carden."

"Sit down, dear." Grace Carden's hair was wispy-white and her skin a map of wrinkles, but the brown eyes were unclouded. "My, you're a pretty thing, but you look tired. Jane, get this girl a cup of tea. Or a glass of wine?"

As Verity hesitated, Grace said, "I always have a glass of wine at five, and it's close enough." With a mild roll of her eyes, Jane produced wineglasses and a bottle of sauvignon blanc. "Now," said Grace, "tell me what Chris Larson is up to. I've been wondering ever since I read that interesting obituary notice for poor Andy."

Verity had a sip of wine, took a deep breath, and explained her purpose, and Chris's. "She feels she's honoring a deathbed request of her father's," she added. "And I'm here on the street because I found there are two neighbors remaining from the time of Edgar Larson's death, people who might have knowledge or at least an opinion."

"Well. It was all very sad, and unnecessary." Grace's voice was firm. "I suppose a charitable person could say those accusations were simply mistaken. I myself did not believe them for a minute."

"Mother..."

"Oh, all right." Grace shook her head and picked up her wineglass. "I had the grandchildren here a lot that summer, my older daughter's brood. One day, after the word of the accusations against Edgar had gotten around, I was outside with Kathy, she was only three, and Edgar came out in his yard and I...I put my hand on her to pull her back. He looked at me for about two seconds that felt more like two years, then turned away and went back into his house. When I went

over later to try to talk to him, he just shook his head and closed the door with me standing right there." A distant sadness darkening her face, she tipped the wineglass up.

"Mother, we were all just as bad. It was 'better safe than sorry' time, and none of us realized how badly it could end." Jane gave a palms-up gesture of helplessness. "What I remembered, too late, was the man who was around during my childhood. He was very tall, with this deep, rumbling voice, but I was never frightened of him. And Andy Larson was a lovely boy; he was two years older than me, and in my teens I had a terrible crush on him."

"Actually, I think I had a crush on Edgar," said Grace. "When Harry was being troublesome, as he often was, I'd look next door and think how lucky Sarah was, with nice, tall, quiet Edgar."

"Mother, he was at least ten years older than you!"

"Twenty, in fact, and what does that have to do with anything?" demanded Grace, her head up. "Anyway, I'm quite sure he never noticed me looking. Edgar Larson was a reserved man who'd worked hard all his life and never had time to learn humor, or lightness. That is, until his granddaughter came to live with him."

"Someone else told me it was Edgar's being so wrapped up in his granddaughter that led him to believe the accusations."

"Pah!" said Grace. "If you heard that around here, you must have been talking to that old creep across the street. Mel Simms."

"Hah!" said Jane, in the same tone. "Mel Simms had a flock of the most obnoxious children you could possibly imagine. Five, I think—"

"Four," said her mother.

"Okay, four, but it felt like a dozen. I went off to college before they were big enough to be let loose; but whenever I came home, they drove me mad."

"They drove everyone mad," Grace agreed. "Running wild through gardens, climbing our fruit trees and breaking branches, pilfering things from garages and sheds, letting animals loose. Finally there was a fire in Edgar's potting shed, and he gathered up the whole crew and herded them into his garage and I don't know how, but he actually terrified the little beasts into submission. Then he trotted them home to Mel and told him there'd better be no more trouble, and there wasn't. But Mel never forgave him."

"Mr. Simms assured me he was not responsible for the accusations against Edgar," said Verity.

"Oh, probably he wasn't," said Grace. "His poor wife was a nice woman, and she wouldn't have let him do that." She sipped her wine, and frowned.

"But you know, Mel's remark about Edgar and his granddaughter? That wife of Andy Larson's was a flighty piece. She didn't like small-town living, she didn't like having to work in her husband's office, and she resented the time Andy spent with his father. In fact, she didn't like Edgar."

"Mother, don't be ridiculous!" Jane's voice was sharp.

"I'm not accusing her of anything. Except, possibly, resenting the close relationship Edgar had with her little girl, and maybe talking to someone about it."

Not a viable line of inquiry, according to Chris. Verity had a restorative sip of wine. "I understand that Mr. Larson retired from his business to take care of his wife after she became ill," she said. "But from what I've heard, he was still a strong, vigorous man. Did he do anything else during those last years? Have any hobbies?"

Jane spread her hands. "I'm afraid I was too busy to notice. I was living not far from here, but I had three small children."

"He built things," said Grace, "like that playhouse in his backyard he made for Christina. He had an old truck, and lots of tools, and I'd see it at the church, or at the senior center. Sarah said he helped frame the new wing there."

She stopped and took a deep breath. "I was working full-time then, but on the occasional weekend, I'd sit with Sarah. She told me she made Edgar go out because he was a man who *needed* to be making something, doing something; just sitting around made him miserable. I didn't see him as much after she'd died, I think he was quieter coming and going. But I'm sure he was still doing work of some kind.

"I haven't thought about those days for years," she added softly, "and now they seem like yesterday. Poor Edgar. Jane, pour us all another glass of wine."

"Not for me, thanks," said Verity as she set her empty glass aside and got to her feet. "I have an eight-year-old at home who'll be expecting dinner. I'm grateful to both of you for your time and information."

"It was lovely to talk to you," said Grace, "and to talk about Edgar. I wish you and Christina good luck."

CHAPTER 6

THE HOUSE WAS brightly lighted against misty early dark, and there was an extra vehicle in the parking area. As Verity pulled close to park her own car, she recognized the elderly Volvo sedan belonging to Johnny Hebert—whose name was on Chris Larson's visitors' list.

A fact which did not interest her much at the moment, she realized as she climbed wearily out of the car. The cardboard boxes from the Larson house awaited her attention tonight—or sometime soon. What she yearned for now was a quick meal and an early bed.

She ran up the deck stairs to the back door to find the kitchen warm but empty, voices coming from the living room. "Hello?" she called out, and Sylvie came running before she'd even shed her jacket.

"Verity, Johnny's going to take us to hear some singing!"

Stifling a groan, Verity gave Sylvie a quick hug and followed her into the living room. Patience was tucked into a corner of the couch, feet up on a hassock; a young fire blazed in the fireplace, and Detective John Hebert was on one knee in front of it, poker in hand.

"Hi, Verity." Johnny got to his feet and set the poker in its stand. Six feet four or five and broad with it, he habitually carried himself with an easy slouch that made his size less noticeable. Tonight, however, in jeans and boots and red plaid shirt, heavy-lidded eyes glinting blue in the firelight and broadening grin a flash of white teeth against his black beard, he looked like a very large pirate.

"Hello, Johnny," she said. "I wish you'd waited for me before issuing invitations. I've had a long day and I'm tired."

The grin faded. "I'm sorry. Wasn't thinking, I guess," he added, with a glance at Sylvie.

With two downcast faces before her, Verity registered the tone of her response and regretted it. Only thirty-one and she was turning into a regular bitch.

"Eight Voices is doing a special performance tonight," Johnny went on, "and this high school kid I've been tutoring had some tickets to sell."

This was a group specializing in Renaissance music; Verity had heard of them, had in fact heard them on the local classical music station.

"One of the women in the group is from a Port Silva family," Patience offered from her corner.

"That's why the special appearance, " Johnny said. "They're doing a full concert tomorrow night at the university, but tonight's will be shorter, some of their usual material plus some old folk songs, in the little Saarinen Theater at the high school. It won't be a late night."

And there was the clincher. Someone in Sylvie's earlier life, proba bly her mother, had filled her head with old and not-so-old folk songs. While she played with paints or crayons, set the table, cleaned her room, her achingly pure soprano told of Barbara Allen, Lord Randall, Betsy from Pike, Snagtooth Sal. She sang of Shenendoah, the valley so low, the tavern in the town, sailing over the sea to Skye. "I'm sorry I was so sharp, Johnny. It was nice of you to think of us, and we'd enjoy going. Right, Sylvie?"

"Oh yes!" Sylvie breathed.

"Patience says she'd rather stay at home by the fire," Johnny said, "but I thought I could take you and Sylvie for pizza first. The concert is at seven-thirty."

Verity tossed a quick look at her mother, suspicious of a match making attempt, but Patience looked both innocent and weary. One would hardly plot a tryst that included an eight-year-old chaperone.

"I'm going to bed right after supper," said Patience. "Please tread quietly when you come home."

———//———

At a few minutes past seven o'clock Verity and Johnny joined a small crowd on the high school grounds, Sylvie trotting ahead and back again like a puppy happily off leash. The earlier overcast had developed into a thick, drippy fog that lent a ghostly quality to the big gym/auditorium and created fuzzy haloes around the lights of the smaller building beside it. Verity peered up at the letters incised in the concrete above the doors: R. SAARINEN THEATER. "I didn't know this was here."

"It was built sometime in the 'fifties, I think, when the town and the high school were much smaller. It's not large—probably two hundred

fifty seats—but it's a nice site for small events. Hello, Marilyn," Johnny said, and handed three tickets to a trim, white-haired woman standing just inside the door, a friend and office-neighbor of Patience's whom Verity had met several times. "Looks like a good turnout."

"Full house, I believe," she said with a pleased smile. "You can never tell what folks will come to hear. Hello, Verity. Hi, Sylvie, I bet you'll enjoy this."

Full house indeed, Verity noted as they made their way into the crowded lobby and paused to hang their coats on one of the free-standing racks along the back wall. People stood chatting in clusters, with only a few moving toward the open inner doors and their seats beyond. Verity saw Margaret Kjelland with two other elderly women; a lithe, blond fitness instructor at the Y with a good-looking man holding her arm in proprietary fashion; Ynes Silveira of the supermarket Silveiras, whose regal bearing Margaret Kjelland must envy. Several people who dined frequently at Pure and Simple, but whose names she did not know.

Watching Johnny greet this person and that, Verity was chagrined to realize that she had few acquaintances and fewer friends in this community in which she'd lived for nearly a year. She'd been too busy, too wrapped up for the last few months at least in Sylvie's life and presence. Too damned self-centered.

"Katy!" cried Sylvie, and ran to hug the tall teenager who stood in the doorway to the auditorium proper. Katy Halloran was the daughter of Meg Halloran, who taught English here at the high school, and stepdaughter of Chief of Police Vince Gutierrez. More importantly, she was Sylvie's favorite, almost her only, baby-sitter.

"Hello, Katy," Verity said. "Is your mother here?"

"Nope. She says she spends enough time on this campus," Katy said with a grin. "She has tickets for the performance at the university tomorrow. But I'm here to usher, with…" she looked over her shoulder, and waved forward a smaller, blond girl with a shy expression and a mouthful of braces "…my friend, Becca. Becca's mom was a big star in plays here when she was in high school. Oh, let me give you a program," Katy said to a white-haired couple approaching with ticket stubs in hand, and moments later led them in.

"She had the lead in *Carousel*, and in *Show Boat*, too." Becca's voice was breathy and hesitant. "There's a picture from *Carousel* over there on the wall."

Verity followed the girl's glance, and saw a row of glass-front display cases crowded with pictures of costumed actors. Sylvie trotted over to have a look.

"Do you plan to be a musical star, too?" asked Verity.

"Oh, no!" Becca paled slightly at the very idea. She thrust a printed program at Verity and turned away to help a group of three patrons.

Katy had returned in time to hear Verity's question and her friend's reply. "Becca has a nice voice, but she doesn't like to be on stage. What she is, she's the only sophomore on the school chess team. Yes, ma'am, I can help you find your seat."

"I found the mom," called Sylvie from one of the display cases. "She looks just like Becca. Come and see, Verity."

Verity threaded her way through the crowd to view a display of photos of high school theatrical productions at the Saarinen Theater going back more than forty years. There were cast photos from the usual dramas, *Our Town* a frequent choice, and from the mid-sixties on, an almost-yearly musical. These last were labeled as joint productions of Port Silva High School and the Port Silva Dramatic Society.

"See, there she is," said Sylvie, touching a finger to the glass over a tiny-waisted, full-bosomed girl who gazed lovingly up at a tall, handsome boy: Julie Jordan, the female lead in *Carousel*, and her beau and then husband, Billy Bigelow. According to the cast list below the photo, this was Jeanie Verducci, and her face was indeed a bolder version of Becca's quiet, pretty features.

The face, and the name, were vaguely familiar, but Verity couldn't make an immediate connection. Somebody she'd seen around town? The taller girl standing a bit awkwardly to one side in the *Carousel* photo—Teresa Janacek—had a more interesting face. Broad across the cheekbones with long, slightly tilted eyes, it was the face of a girl who would grow into a striking-looking woman.

"That's the nursery lady," said Sylvie, following Verity's gaze. "Where Patience and I bought the rose bush for Ralph's grave. She was nice."

Ralph, whose terrier spirit had spurred his aging bones to one last cat-chase, and into the path of a car. Verity nodded silent thanks to the girl whose grown-up self had been kind to Sylvie in her sorrow.

The lobby lights blinked, and Verity looked up to see the crowd flowing more quickly into the auditorium and Johnny waiting for

them at the entrance. "Come on, Sylvie. Let's go listen to some music."

"What a good party!" Sylvie tucked her hand into his. "I'm glad we all came."

The program, Verity found when they'd settled into their seats, was called "Old Music, Profane and Sacred," by Eight Voices. It would begin with folk songs, and would continue with a plainchant and then a mass by a sixteenth-century composer, Palestrina. As the singers, four women and four men clad in dark trousers and flowing white shirts, stepped onto the stage and bowed, Verity sat back secure in the fact that the folk songs, at least, would be familiar.

But not all of these songs were exactly the ones her father had sung, either in tunes or words. While "The Bonnie Earl of Moray" was familiar, the next selection, a long, bloody love story called "The Douglas Tragedy," was not, until it concluded with the red rose and briar image she remembered from other songs.

Applause, some polite and some enthusiastic. "Barbara Allen," whose characters Verity had always found mildly irritating, was followed by "Three Ravens," a sad, graceful tale about a dead knight, which declined somewhat into "Twa Corbies." "That's the Scottish version," whispered Johnny. "There's an American one, not on the program, about a dead horse and some cawing crows."

More applause, before "Lavender's Blue" went on more directly than she'd remembered about young men and maids. Verity heard Johnny chuckle, and resisted looking in his direction. Next, two men and two women made a dialogue of "The Spanish Merchant's Daughter," the "No, John, No" of Verity's childhood, and followed it with an older version in which the word-play led to an adulterous bed rather than "church bells ringing." And in the final song, a wife's appreciation of her husband's physical attributes was much more frank than in the familiar Robert Burns version.

As the singers fell silent and bowed, Verity turned to look a question at Johnny. "Mostly sixteenth- and seventeenth-century songs," he said. "Usually heard in versions cleaned up quite a bit by later collectors."

When the applause had ceased, the singers disappeared into the wings for a ten-minute break. Johnny and Verity got up to let Sylvie out to go to the bathroom; most of the audience, like them, rose but remained standing by seats or in the aisles. "How did you know those old folk songs?" Verity asked.

"My mother was a musician, trained for opera but never got that far. She was the music teacher for the whole school district in this little town east of San Diego, so I was in every chorus or production she directed, from first grade through high school."

"I had no idea you were a singer."

"I can carry a tune. Those guys you just heard are singers."

She perched on the arm of the nearest seat and looked up at him, another person she thought she knew revealing an unexpected self. "Okay. But you can't tell me your mother taught those songs in the schools, to little kids."

He grinned. "Nope, but she had an extensive library of books and records. There've always been dirty songs, and the old ones were a lot more fun than the mean stuff you hear today. There was one, on a record by Oscar Brand, I think, that ended each verse with the refrain: 'And the poor little bastard had no hips at all.' Even to a bunch of seven-year-olds, that was a cleaned-up line and we made up our own version."

"I always knew little boys had dirty minds."

Lights blinked, and people settled back into their seats. When all was quiet, the stage lights came softly up and the opening notes of the plainchant floated into the air. Sylvie, beside Verity, sat straighter and made a small sound of pleasure. The brief piece was followed by a moment of silence. Then, as the voices of sopranos soared in the Palestrina and were joined by interweaving altos, tenors, and basses, Sylvie's hand gripped Verity's arm and kept its hold for the length of the mass.

The house lights came up, the singers bowed, and the audience began to applaud. Sylvie, however, simply gave a great sigh, and said, "Wow," in reverent tones.

They made their way slowly up the aisle, Verity towing a suddenly yawning Sylvie by the hand. In the lobby, people were pulling coats from the racks and shrugging them on as they moved toward the outer doors and the fog beyond. Verity found their coats and helped Sylvie into hers, and then headed for the door, where Marilyn Ritter once again stood. "Tell Patience," she said to Verity, "that she missed something wonderful."

The woman about to precede them out the door turned, and Verity recognized Margaret Kjelland. "Don't be ridiculous, it was in very poor taste. I didn't come to an event in the high school audito-

rium to hear a song in which a woman talks about her husband's *penis.*" Mrs. Kjelland spat out the last word in a fashion that provoked Verity to obscene images and an inclination to giggle.

Mrs. Kjelland caught sight of Sylvie, and her face reddened. "And it was certainly inappropriate for small children."

"Me? I'm not a small child," said Sylvie. "But I didn't hear anybody sing about a penis. Which song was that?"

Murmurs came from behind them, from people caught in the doorway by this interchange. Margaret Kjelland moved outside, stopped, and turned. "I believe it's Miss Mackellar. And the child I heard you'd taken in? And..."

Before Verity could reply, the older woman looked past her with a frown. "Young man, aren't you one of the local policemen? I hope our taxes aren't helping pay for the Mackellars' ill-considered private investigation."

Johnny settled a claiming arm across Verity's shoulders and pulled her close. "Detective Hebert, Mrs. Kjelland, here for purely personal reasons."

Verity, who could feel the rumble of laughter building in his chest, put her free arm around Sylvie. "And this is Sylvie Medina, who like Johnny and me has had a very nice time. Good evening to you," she said, and push-pulled her two companions off at a rapid pace down the sidewalk. When they had outdistanced the concertgoers and the lights, she stopped, leaned her head against Johnny's shoulder, and dissolved into laughter.

"You realize," she said, and stopped for another giggle, "you realize that you have compromised me right out here in public."

"Yes, ma'am," he said. "I guess I owe Mrs. Kjelland a vote of thanks."

"You guys? What's so funny?" asked Sylvie.

"Nothing. Everything." Verity dug a tissue from her bag and wiped her eyes. "Oh joy. I haven't felt so good in days. I bet it's safe to say that Margaret Kjelland has never permitted MTV to pollute her television set. And you'd better prepare Chief Gutierrez for a complaint."

———//———

At home there were lights on only in the living room; the fire screen was drawn tight against logs that were now mostly embers, and Patience's bedroom door was closed. "Get yourself a beer," Verity said in a low voice to Johnny, "and I'll put Sylvie to bed. There's something I need to talk to you about."

"G'night, Johnny," said Sylvie through a yawn, and added, "Thank you," over her shoulder as Verity led her away.

"You're welcome," he called softly after her.

Five minutes later Verity came into the living room, a glass of white wine in hand, to find him seated on the couch, legs stretched out and feet on the hassock. He lifted his beer bottle in a salute. "To Sylvie. Who has found her way into exactly the right family."

"True," said Verity, settling into the armchair facing him. "Okay. First, I want to thank you for the evening. Sylvie and I both enjoyed it."

"And second?"

"You must have heard by now, via the cop-shop grapevine, that Patience and I have been hired by Christina Larson."

"If that's a question, the answer is yes," Johnny said. In the fireplace, a log burned through and collapsed in a small flurry of sparks. "Pretty," said Johnny. "So, what's the next question?"

"Did Chris Larson ask *you* to help her find out who accused her grandfather? Excuse me: falsely accused."

"Why would you think that?"

"Because I saw your name on her very exclusive guest list at Inn of the Woods and figured you were either her friendly local policeman or one of her boyfriends. According to a member of the staff at the Inn, she has a number of those," Verity added, and immediately wished she hadn't.

He looked interested rather than offended. "Is your objection to Chris's having a number of boyfriends, or to the fact that one of them might be me?"

"Neither!" she snapped. "My objection is that someone has obviously told her things about me, and Sylvie, that I don't think are her business. Or anyone else's."

"Verity, I don't tell personal tales about my friends. I haven't said anything about you and Sylvie to anyone, including Chris Larson." He paused, and Verity prepared to apologize. "Not even in her bed, assuming I'd been there, which I wouldn't talk about if I had because it would be personal."

She glared at him, turned her attention to her wine, and after a moment met his glance again and managed a grin. "Peace?"

"Sure," he said with a shrug. "My first few months here in town, I rented a room from Andy Larson. He talked me into doing some

math tutoring at his school, I helped him out with minor repairs around his big old house, and we kept in touch after I moved out. He was a good man."

"I know. I'm really sorry I didn't go by to see him when I moved up here last year."

Johnny gave a rueful nod. "Anyway, I met Chris a couple of times at his house, when she visited with her kids. And she did come to see me earlier this week to ask me to help her. But I had to tell her no." Verity's surprise showed on her face, and he ducked his head. "A thirty-year-old anonymous accusation, even if false, is at most a civil matter, not a crime. If I go around questioning citizens about this, it looks like harassment or improper use of a city employee's time. Whereas if you do the same thing, the citizens will feel free either to answer or to tell you to go to hell."

She blinked at this, and tasted her wine. "I suppose they will."

He leaned forward, arms on knees, to look at her. "I grew up in a small town. And people in small towns can be just as nasty as people in, say, San Francisco, except maybe in a more personal way."

"You think I'm likely to get ridden out of town on a rail?"

"I hope you'll go at this job softly-softly, as much as possible, because the good people of Port Silva could finally make you feel that you don't like it here anymore. That would make me very sad."

She thought this over for a long moment. "I guess it would make me sad, too."

"Good." He drained his beer and got to his feet. "Patience told me you were going to the city tomorrow, so I guess I should hit the road and let you get to bed."

She got up, too. "I'm meeting my ex-husband at my lawyer's office tomorrow, to sign the final papers on the sale of my—our—house. Sylvie and I will stay over with a friend and come back Sunday. Unlike me, Sylvie is already packed and looking happily forward to the trip."

"With her along, you'll be fine." He took his empty bottle to the kitchen, and returned to take her shoulders lightly in his hands and brush his mouth against hers. "Sleep well."

He was across the room and out the door so quickly that she had no time to protest this latest move in the mild game-playing that went on between the two of them. Verity checked the fireplace screen and turned the deadbolt lock on the front door, glanced into the hall at two closed bedroom doors from behind which no sound came,

turned out every light but the small nightlight in the hall. Then she picked up her coat and bag and went out the back door, checking to make sure it locked behind her before heading across gravel and patchy grass to the studio.

Inside the small building, she found herself tired but not sleepy, no surprise. She hadn't seen her ex-husband in months and she'd have been happy to stretch that out to years. Perhaps his character had been improved by their separation, as she believed hers had. Perhaps they could have a civil meeting and not fall into tearing emotional strips off each other. But she wouldn't count on it.

She undressed quickly without turning on the heater. When Sylvie came to stay, Verity had willingly turned over to her the cottage's second bedroom and its double bed, thinking that a narrow, chaste cot in the quiet studio suited her present marital and emotional state and would be peaceful. Substitute "lonely," she thought now. Maybe she should have asked Johnny in for a little friendly sex. Except she was fairly sure just "friendly" was not the kind of sex Johnny had in mind.

On her way to the small bathroom, she tossed a glance at the bed and had a quick mind's-eye view of two large people struggling to achieve satisfying carnal connection on that stingy couch. For some reason, the image cheered her considerably.

———//———

The ringing finally penetrated Verity's sleep, but it sounded twice more before she identified its source as her cell phone. She pushed away the comforter, untwisted herself from the sheets, reached out to switch on the bedside table lamp, and registered the time on the clock there as she lurched to her feet and stumbled across the room. Three A.M. and who the hell…?

She snatched up the phone from the top of the piano and nearly dropped it. "Hello?"

"Verity Mackellar?"

A woman's voice, tentative and hurried.

"Yes. Who is this, please?"

"Jane Tolleson. Grace Carden's daughter," she added quickly. "The Larson house is burning, I thought you should know."

Why me? asked Verity's sleep-addled mind. "Uh, the fire department… Are you in danger?"

"No, the police roused us and we're in the Ocean View Motel. But Mother insisted I call you. She blames herself for the fire."

"I beg your pardon?"

Jane drew a long breath. "My mother recently noticed that a homeless man was sleeping in that playhouse behind the Larson house, but she didn't tell anyone." A pause. "She even put food out for him a few times, like her mother did for people during the Depression."

"And she thinks he set the fire?"

"She sees it as a possibility, and she's embarrassed, and frightened."

Of being thought too old, and dangerously foolish, by the authorities or even worse, by her neighbors. But someone needed to hear about this. "Jane, I should go see what's happening. Give me your number there, and I'll call you within, oh, half an hour if there's anything you or Grace needs to do."

Questions and possibilities raced around in Verity's mind like panicky small animals as she scrambled into underwear, socks, jeans, sweatshirt. Boots. She scooped up the cell phone again and dropped it into her bag, knocked her key ring onto the floor and bent to snatch it up, banging her head in the process. Klutz!

Out the studio door and halfway to the main house, she stopped and spun around to head directly for her car. Going inside to leave a note would waken Patience and possibly Sylvie, no point to that. She'd call later, and at any rate be back home before they got up. She slid into the Subaru, closed the door gently, started the nice quiet engine. And thought, Oh shit, I should have called Chris. No, not at three in the morning.

Verity was within a few blocks of Acacia Street before she registered the brightening sky ahead—not a wrong-coast, wrong-hour sunrise, but the pulsating glow of flames bolstered by big lights of some kind. She slowed and pulled to the curb and leaned her forehead against the steering wheel, taking in deep breaths of smoke-tinged air. She'd forgotten or chosen not to remember her own fear of structure fire, born one night when she was four or five years old and somehow escaped parental attention to watch, frozen with terror, as a neighbor's house burned.

"'But that was in another country,'" she said aloud. With a sense that there was more to that quotation than she cared to remember, she tipped her head back, opened her eyes. "So get your ass in gear and go look at the fire or go back home to bed."

She was unsurprised to find Acacia Street lined with cars, and with people who'd left their cars to proceed on foot only to be stopped at sawhorse barricades by a uniformed cop. On B Street, three huge fire trucks and several police and fire department cars were pulled up around the Larson house in what looked like a freeway pileup, while people who were presumably the street's residents stood in clumps on the east side of the street. Verity drove on down Acacia to its end, turned around and tucked her Subaru in just above A Street.

Instead of heading for B Street, she moved quietly along a sort of alleyway that ran behind the houses, slipping between the corner house and the Carden house to reach an observation point. People in black gear banded with bright yellow were swarming over the ground in purposeful haste with hoses and tools, their shouted instructions and the roar of the fire and hiss and smash of water from the huge hoses making a nearly unbearable wall of noise. The smoke-thickened air was no surprise, but who knew fires were so loud? It appeared to her that the lower part of the tall house was fully engulfed, but she couldn't tell about the second story, where smoke poured from windows but no flames were visible.

Sad, ghost-ridden old house, probably nobody would mourn it. Verity shivered and pulled her gaze away from the melee to look toward the sidewalk, where she saw Hank Svoboda in conversation with a tall, bareheaded man in firefighter's gear. She saw a cop she recognized but didn't know by name and then, leaning against a black-and-white talking into a radio, a large, unmistakable frame: Johnny Hebert.

Verity left her semi-sheltered spot and trotted toward the street. "Johnny?"

He looked up, keyed off the radio. "Verity? What are you doing here?"

"A neighbor called me. Johnny, what happened? Was it arson?"

He shrugged and spread his hands. "No way to know for sure yet."

"Was anyone hurt?"

"None of us. As for anyone else, I don't think they've been able to get inside yet to check."

"What? Oh, hi, Hank," she said, as Svoboda's big hand settled gently on her shoulder.

"Verity, this is a dumb place to be if you don't have to."

"I know." She explained that she'd been in the neighborhood

Thursday and again today, or yesterday, to pick up some Larson papers and talk to the neighbors. "It was Grace Carden's daughter, Jane, who called to tell me about the fire. I felt I should come have a look, on Chris's behalf."

The shifting glare from the fire made Hank's familiar face look sinister, and Verity shrugged her jacket closer and shoved her hands into its pockets. Across the street, five or six people were huddled together watching and talking; other onlookers were pulling away from similar groups, probably headed for home and bed. What a good idea.

"Hank, is it going to burn completely?"

"The fire department is slowing it down, basically has it under control. But I don't think there's going to be much left. Not much that will be usable, anyway."

"Will you, or the fire department, call Chris Larson? Or should I do that?"

"We'll do it in the morning. You could, too, if you want to." He gave her shoulder a squeeze. "I'd better get back to my observation post; I'm on medic duty, in case anybody gets hurt. I'll talk to you to-morrow."

I don't think so, she told him silently as he walked away. But he'd made her choice for her. Her watch told her it was almost four A.M., and a jaw-cracking yawn reminded her that she was deeply out of practice at being abroad in the middle of the night.

"You about ready to head for home?" asked Johnny.

"Just about. Are you through here for the night?"

"Yes, ma'am. Did you have something interesting in mind?"

"Johnny," she said, with a shake of her head. "I'm too tired for that game."

He grinned and wiped a hand across his smoke-grimed face. "Shall I walk you to your car anyway?"

"Please. There's something I should probably tell you." When they were beyond the worst of the noise and smoke, she stopped and turned to face him. Even in the dim, flickering light she could see his grimy face come alert, in cop's mode: what's up?

"Grace Carden...do you know her?"

"I know who she is. Why?"

"Jane—Grace's daughter—told me her mother knew that a home-less man had been sleeping in the Larson playhouse. She even put

food out for him. Now she's worried that he's the one who set the fire. Do you think…?"

"I think I can talk to her, and get what information she has, without having to let the whole world or her neighbors know about it. That what you wanted to ask me?"

"Yes. Thank you." When they reached her car, Verity dug out her cell phone and called the number Jane had given her, while Johnny waited. She spoke briefly, listened, turned off the phone and said, "They'll see you."

"Us," he said, and opened her door for her. "The black-and-white got commandeered, and I was going to have to catch a ride anyway."

"Terrific. Wait," she said, and fished a small towel from the center console, to drape it over the half-full bottle of water in the cup-holder. "Better wash your face before you try to make nice with an old lady."

At the motel Verity introduced Johnny to upright and fully clothed Jane and to an exhausted-looking Grace, who was propped up in one of the beds with a sweater over her shoulders and the blankets pulled high. Then she settled into a chair in the corner, to blend quietly with the wallpaper while Johnny's soft voice and earnest blue gaze coaxed answers from the old woman.

Yes, as she'd told Jane, she'd observed a man sort of slinking out of the playhouse several times in the very early morning, the only street person she'd ever seen in her own neighborhood. On the occasions when she'd put out food, it had disappeared quickly and the pan was returned next day.

Grace had first noticed the man in town, back before her broken hip kept her closer to home. He was always by himself, just walking around looking down, walking and walking. She thought he was about the age of her oldest grandson. She never spoke to him, nor he to her.

Medium height, she said in response to Johnny's question, and thin, with short, dark brown hair and a clean-shaven face. Since he kept his head down, she didn't know the color of his eyes. He was cleaner-looking than most of the street people. "Not a good reason for wanting to help him, I guess," she added.

No, she'd never seen him enter the Larson house. "I'd have reported that," she said, defensively. But the house had been empty for some time, and the weather dreadful, and she didn't spend *all* her time looking out the window.

"According to your very good description, he's a man who's lived on the streets here for a couple of years," said Johnny. "I understand he's on regular medication for mental problems, and so far as I know, he hasn't been involved in any disturbances."

"Oh, I'm glad." Grace settled further into her pillows, eyelids drooping and strained face easing as Johnny assured her he'd do his best to keep her story from becoming public knowledge. Verity, watching, vowed never to get within sight or hearing of the man with a secret she seriously wished to keep.

Jane tucked her mother's blankets tighter before showing the visitors out. Outside, she pulled the door shut and shook her head. "Mother hasn't yet drawn the obvious conclusion—that if this man did set fire to the house, he's probably still inside."

"Odds are he's not involved in whatever happened," said Johnny, and handed her a card. "Maybe we'll know something by midday tomorrow."

———//———

"I'm pretty sure the guy she described is Jerry Strauss, a youngish guy who's schizophrenic, bipolar, I don't know what for sure. Like I told Grace, he's okay so long as he keeps on his meds, and his family in San Francisco sends money so he can do that. Walks around all day head down, no talking, mostly no problem except now and then when somebody buys him a bottle."

Verity merely nodded as she pulled onto an absolutely empty Main Street to head south.

"Of course, we don't know that there's anybody in there, or if there is, that it's Strauss."

"I hope not, both for Strauss and for Grace. Was there reason to think the fire might be arson?"

"It was widespread throughout the ground floor, suggesting multiple starting points. I'd guess it'll still be some hours yet before anyone goes in for a good look."

"And only a few hours before I'm due to leave for the city," said Verity as she pulled to the curb in front of Johnny's house.

The interior light came on as he opened his door. "I think Hank might be pleased if you put that trip off. It's not likely, but not completely impossible either, that the fire has some connection with the work you're doing for Chris Larson."

Suddenly furious, she turned to glare at him. "That's ridiculous! I didn't even start work for Chris until Wednesday!"

"Verity—"

"If I think I can give statements, he can talk to Patience. I'll be back Sunday night." She put the car in gear. "I appreciate your kind handling of Grace Carden. Now go get some sleep while you still can."

He gave her a weary smile and got out. "Good night, Verity. Please drive carefully, tonight *and* tomorrow."

As she parked in the yard at home, the deck at the back of the house was suddenly lit, faintly, by the bulb over the back door. As if by magic, thought Verity, or by the touch of a very light sleeper. She pulled her jacket tighter and hurried across to the rear steps, to reach the top as Patience stepped out the door.

"It's okay," Verity said in a near-whisper. "I got a call that the Larson house was burning, and I went to see."

"Better come in and tell me about it, quietly. So I can field questions while you're away."

SHINING MORNING FACES, Verity thought as she looked around the table Monday morning. No doubt matching her own. Awakening at six A.M. with a sense of freedom from old failures and energy for new beginnings, she had showered and dressed quickly and trotted off to the house to do something nice for her family. Fresh-squeezed orange juice to start. Crisp bacon, fluffy scrambled eggs. Real biscuits.

"I'd say they're not *quite* up to Mona's standard," she said as she brought the second half dozen from the stove's warming rack to the table. "But close."

"I thought biscuits came out of a can," said Sylvie, her face smeared with strawberry jam.

"Mine do," said Patience. "Verity's don't, and we should be thankful."

"I *am* thankful," said Sylvie. And, after finishing the last bite of her biscuit, "We had a good time in the city. We went to the zoo, that was fun but foggy. You could hardly see the giraffes' heads."

"Very San Francisco," said Verity.

"And we had something like lunch at a really neat Chinese place where there were all these little dishes of stuff."

"Dim sum, I'd think," said Patience.

"Right, dim sum. And Corey has this big, really furry gray cat named George Saunders. He's a cat just to look at, not to play with."

"Persian," added Verity.

Sylvie bounced from her chair and picked up her dishes, to carry them to the sink. "And I got to see Verity's old husband, what's-his-name."

"Ted," Verity reminded her. "Ted Blake, Esquire."

"Is that some kind of horse?" asked Sylvie, who was on a new-words kick and had recently come upon a sign for an equestrian path.

"No, sweetie, it's a term indicating that the person is a lawyer."

"Well, he wasn't anything like a horse. He was just kind of...squinchy." Sylvie lifted her shoulders and squeezed her eyes shut and her mouth into a point.

"He wasn't happy about giving up the house, but he couldn't afford it on his own," said Verity to Patience. "Poor dear."

"No, 'poor dear' was his girlfriend," said Sylvie. "She was teensy, with yellow hair and a dress. Kind of like a doll."

"Her name is Tiffany, and she's a nursery school teacher," said Verity.

"She was pretty, I guess," said Sylvie, "but I know what Bart would have said about her."

She paused, and her audience waited.

"That she wouldn't say 'shit' if she had a mouthful."

Verity choked briefly on her own mouthful of coffee.

"Who is Bart?" asked Patience.

"Oh, he was my friend from before."

"He was—he still is—bartender at the Bull and Grizzly, the pub in Sylvie's old apartment building," said Verity. "We stopped by to see him yesterday."

"Good for you," said Patience. "And now, Sylvie, you have five minutes to brush your teeth and get your backpack together. Scoot."

"Okay, back-to-earth time," said Verity, sitting down at the table after the school bus had arrived and departed. She and Sylvie had reached home the evening before too tired to do much but unpack, clean up, and get to bed. "Please bring me up to speed on the Larson fire. Or would you like another cup of coffee first?"

"I think I've had enough caffeine for the moment, thanks," Patience told her. "The latest information is that poor Jerry Strauss died of smoke inhalation, with the help of a stratospheric blood-alcohol level. Hank says it's possible he started the fire with a can of kerosene that apparently came from the tool shed beside the garage. It's also possible that he simply got in and crept upstairs for a warm sleep, and some person or persons unknown, and so far as they've learned yet, unseen, did it."

"Poor guy. Grace Carden must be very much upset; maybe I should go talk to her."

"Johnny did that, I believe. And I spoke with Chris, who was sorry about the death but not upset about the house. She says it was old and

ugly, with more bad memories than good, and anyway it was fully insured."

Verity sat straighter at a change in tone. "And what else did she say?"

"Chris sees the fire as a response to the investigation," said Patience.

"Oh, for heaven's sake. Maybe she's been talking to Johnny."

"She was quite cheerful about it. She says it proves we're making waves and that should mean progress."

"Some progress, a dead body." Verity shot to her feet and went to look out the window, where wisps of fog drifted past. "Mother, our—my—investigation didn't even begin until Wednesday."

Patience was about to reply, but Verity, turning, didn't give her time. "Besides, Edgar Larson hadn't lived in that house for almost thirty years. What purpose could there be in burning it down, except maybe to frighten people?"

Patience said nothing, loudly. Verity sighed and rolled her eyes. "Okay, that's a gotcha. It certainly did that, and more. I'm still learning the rules of this game."

"I'm not saying Chris is correct, Verity. But it's a possibility we should keep in mind. As we go on to other areas," she added. "While you were away, I looked at your notes on the Larson neighbors."

"Not much there, I'm afraid. Basically, Mel Simms didn't like Edgar Larson and said he was a molester, Grace Carden admired Edgar and said he wasn't. However, Mel's a creep and Grace is a kind person, if not terribly sensible. Can investigators include judgments like that in their reports?"

"That's one of the advantages of being private, dear," Patience told her. "Now, moving right along. Yesterday I paid a call on the Lutheran minister, as you'd suggested, and it turns out he came to Shepherd of the Sea as pastor about two years before Edgar's death.

"Edgar Larson, it seems, was a *quiet* pillar of that church. Wouldn't serve on committees, but was the best possible source of advice or actual hammer-and-nails work for repairs or additions. Pastor Schultz said he thought at first that Edgar was aloof," Patience went on, "but decided later that he was shy. He'd left school after eighth grade to go to work, and in spite of his business success, his lack of education embarrassed him."

"What about the congregation's reactions to the accusations?"

"Mixed, depending on age. So Pastor Schultz preached a sermon based on Matthew, chapter seven, where Jesus tells the multitudes, 'Judge not, that ye be not judged.'"

"Ah."

"The second verse of that chapter says, 'For with what judgment ye judge, ye shall be judged; and with what measure ye mete, it shall be measured to you again.'"

"Ouch. That ought to give a believer reason to pause and consider."

"I'm sure that was exactly what Pastor Schultz—and presumably Jesus—had in mind." Patience got to her feet. "Now I need to shower and get myself together. I have a new client coming in this morning."

"Anything interesting involved?" asked Verity.

"Not riveting, I shouldn't think. She's a woman with some questions about the long-lost niece who recently appeared on her doorstep."

"Digging for dirt, what fun."

"Or the lack of it," said Patience.

"Right, I need to remember that. Okay, after two days of nothing but sitting, talking, eating, and drinking, I need a serious run before work. And can you be here for Sylvie at three? There are a couple of retired cops I thought I'd call on this afternoon."

"I'll be here."

"Good. Hey, maybe we should set up a duty roster, put it on the door of the fridge?"

"For that you'll need to buy some cute little magnets. I threw mine out years ago."

—*//*—

The clouds that had threatened since early that morning were still hovering, as if undecided. Patience put her truck in the small lot behind the Adams Street building and was pleased to be able to get to her door without having to deal with an umbrella as well as her computer case. Inside, she turned up the heat and cast an objective eye around her office, a smallish, nondescript room with blinds rather than curtains on its single window and no real color except in the Sierra Club wall calendar and the green of the desk blotter, now rather faded. For the moment, it could be improved by application of a dust cloth; maybe, some day soon, she'd bring in a potted plant, something green and vigorous like a philodendron.

Thirty minutes later the new client, a woman of about fifty,

rapped on the office door. A big-boned, well-padded five feet six or so, her short, curly hair unabashedly graying, Carolyn Duarte had a round face innocent of makeup and a direct, hazel-eyed gaze. Patience was unsurprised to learn that Ms. Duarte was a nurse.

"Office nurse now, for Dr. Jerome," she told Patience. "Pays less than hospital work, but it's easier on the feet."

Ms. Duarte had all her facts ready for presentation. "I had a sister five years younger than me, and we never got along. She made my parents' life hell until she ran off at age seventeen. After that she came back home maybe a half dozen times, asking for money, and then they stopped hearing from her at all. She didn't bother to turn up when my dad died, or when Mama passed a year later."

"Good coffee," she added, sipping the freshly made brew.

"Thank you. Did I misunderstand you when you called? Are you looking for help in finding your sister?"

"Oh, she's found," said the other woman flatly. "That is, she's dead. Her daughter tells me she was killed in a car crash some years back. She showed me newspaper clippings, with a picture."

"Ah," said Patience, and waited.

"Michelle Arnett, that's the daughter's name. My niece. She called me from San Francisco six weeks ago, and then came to, well, visit. She's staying with me for a while."

"You said you believe she *is* your niece."

"No doubt at all. Spittin' image of her mother, and that's a big part of what worries me. Ms. Smith, let me be frank with you."

"Please," said Patience. She sat back in her chair and had a sip from her mug of coffee.

"I never got married. I've worked hard all my life, saved my money. When I moved up here from Daly City twenty years ago I bought myself a nice house out on Redbud Lane, took in boarders for a while but don't need to do that anymore. I could retire any time but I like my job and don't have any hobbies or such."

"Ms. Duarte—"

"Point here is," said the other woman, leaning forward in her chair, "I'd be real happy to have somebody to share with, eventually maybe leave stuff to. But one thing I know about myself, I'm not a real good judge of people. A friend of mine got badly disappointed by a young relative she took in, this was way back in the 'seventies but she still remembers the hurt. So I need to find out where this girl's been, what she's done, before I…get fond of her."

"I understand," said Patience, as she pulled a legal pad from her desk drawer. "Before I decide whether I can do what's needed, I'll ask you for all the information you can give me about your niece."

"It's all right here." Carolyn Duarte pulled a business-size envelope from her shoulder bag and handed it across the desk.

Patience took a sheet of paper and two small photos from the envelope; she set the photos aside and unfolded the paper. "Well, this covers the basics nicely, even Michelle's driver's license and social security numbers."

"A hospital nurse gets pretty good at dragging information out of folks, or if necessary taking a peek in their wallets. Michelle chatted with me about when she was a little kid, and about high school in Sacramento, where she graduated. But stuff after that—community colleges, jobs—that's pretty sketchy. She moved around a lot, mostly in the Bay Area, this town or that. But I couldn't exactly ask her for addresses," Ms. Duarte added, a question-rise in the final word suggesting defensiveness.

"Anyway, Michelle says she's been working as a cocktail waitress, or sometimes as a clerk in health-food stores or bookstores. But she's skinny and her skin's kind of weathered-looking, like she'd spent a lot of time outdoors, and there's a bumper sticker on her little Toyota truck that says Laytonville. The license plate number is there in my notes, too."

Patience tried to remember what she knew about this very small town on Highway 101 maybe sixty miles north and east of Port Silva. Very little, actually, except that moving eastward from there brought one to the North Coast Ranges, a fork of the Eel River, and the Mendocino National Forest. Inhospitable country, she'd heard, both geographically and socially.

"With the information you've provided, we're likely to be able to find out fairly quickly where she's been and what kind of schooling or work she's been involved in within the state, at least," she told Ms. Duarte. "Unless she's been off the grid, which could have been the case in Laytonville."

"Well, do whatever you can. Knowing about those missing years, that's real important to me. I'm not a moralistic person; she might have been doing some strange things that still wouldn't bother me. But there's some things I couldn't stand for."

Interested in this moral division, Patience was about to ask for specifics; but Carolyn Duarte, no dummy, shook her head. "I don't

want to lay out my prejudices, you might call 'em, on this. I just want to know as much as you can find out about what she's been up to."

"Fair enough." Patience turned to the photos, laying them side-by-side on the desk. The first showed a small, jeans-clad woman with dark hair standing beside a white pickup truck. The second was a head-and-shoulders studio shot of a handsome, dark-haired young woman with strikingly pale eyes. "Michelle?"

"The one by the truck, that's Michelle. The other one's her mother, my sister, the last picture my folks had of her when she was around twenty, a couple years younger than Michelle is now. Like I said, Michelle looks just like her, with those funny eyes."

"I gather you haven't told her what you're doing."

"Oh no! No, that's one of the things I liked about your ad in the phone book. You said you were *quiet*."

"I certainly try to be," Patience told her. "Now, let me explain my fees and my contract."

Contract and check signed, Patience asked her standard final question. "I'd be pleased to know what brought you to me, Ms. Duarte. Was it the Yellow Pages ad?"

"No." Carolyn Duarte put the contract in her handbag and got to her feet. "Thursday afternoon I heard some women in Doctor's waiting room talking about your agency. They said you were…" She flushed slightly. "They said you were digging over old bones for some girl who wanted to know about her grandfather. The names weren't familiar; I've lived here a long time, but I've always pretty much kept to myself. But what I thought was, that's just the kind of person I want working for me, somebody who'll really dig."

"I think I can say that digging is what I'm good at." And curiosity is what moves me, she thought but did not say as she walked with her new client to the door, and opened it. "Was the other circumstance you mentioned, your friend's taking in a relative with sad results, something that happened here in Port Silva?"

"Yes, but it was before I moved here."

After Ms. Duarte's departure, Patience labeled a new folder for her new client, put the contract and notes inside, and plugged in her laptop to open an electronic file as well. And that, she realized, was about it for now. The next step would be to sic Harley and his computer onto Michelle Arnett.

Her own next step, however—she looked at her watch—was to

follow up something she'd come upon the day before in a cursory
look-through of the boxes from the Larson house. Maybe worth-
while, maybe not, but she had some time, and she knew where the
school district office was.

———//———

School district office manager Winnie Ahonen, widowed mother and
grandmother, was a Port Silva native with many local connections,
familial and otherwise. She knew of Andy Larson's death and Christi-
na Larson's subsequent appearance in town; she'd heard about Chris's
hiring of Patience Smith, Investigations. She remembered Edgar
Larson and the events leading to his suicide. She even remembered
the condolence note she'd written twenty-eight years earlier, the note
Patience had discovered in an envelope with its fellows. After five
minutes in Winnie's sensible presence, Patience felt she'd struck gold.

"Most of the notes were kind and personal, like yours," she said.
"Then there were two unsigned hate notes, nasty things. I can't imag-
ine why Andy Larson kept them."

Winnie sighed. "He was a sweet-tempered man; maybe he needed
them to remind him to be angry. Patience, I've been thinking of call-
ing you, although I doubt that I can be of any real help."

I bet you can, thought Patience. "Your note mentioned 'students'
stopping by after Edgar's death to say they'd miss him. Can you tell
me what Edgar Larson had to do with the school district?"

"He was one of several retiree volunteers who supervised the high
school parking lot. You know, kids and cars, six kinds of problems.
This was a very small district in the late 'sixties and 'seventies, always
short of money and personnel. These days, of course, we have paid
uniformed guards out there.

"Not that they do any better a job," she added.

Glory be, the high school. "Winnie, did you know Edgar Larson
personally?"

"We knew each other by name—Mr. Larson and Mrs. Ahonen,"
Winnie said with a brief, sad smile. "I was in my early twenties, just a
clerk. He was an impressive man, very tall with this rumbly bass voice.
Always polite in an old-fashioned way that didn't put women down."

Patience held her silence, and Winnie, after a moment, sighed
again. "I didn't believe the stories, the rumors. Not then, not later. Of
course, I didn't have children yet, so I wasn't instantly up in arms like
some women."

"How did the students get along with him?"

"So far as I know, no student ever complained about him. About others, but not Mr. Larson. The few times I happened to observe him at work, he was firm but polite with the kids."

"I know it's a long time ago, but can you remember whether there was any unusual turmoil on the campus that year? Drugs, gangs, something he might have stumbled into?"

"Gangs, not then, not in any organized sense. There are always drugs, but the volunteers had had police training on what to watch for. If Mr. Larson had 'stumbled into' something like that, he'd have notified the police, and I don't recall any on-campus drug busts that year. Unlike this year," she added with a grimace.

"After the accusations became public knowledge, was there any uproar?"

Winnie frowned and tapped a thumbnail against her teeth. "I'd forgotten, but the word got around not long before school was due to let out for summer vacation. I don't remember hearing any student fuss about it."

Patience's mind was making rapid assessment of the circumstance. Port Silva had only one high school, then and now. Students using the parking lot would have been those old enough to drive—juniors and seniors. She looked up to find Winnie watching her.

"What is it you're thinking of asking me for, Patience?"

"A list of graduating seniors for the 1972–73 year. Is that something you could legally give me?"

"It's certainly something we give out to universities, and groups doing surveys of one sort or another. And of course it was published in the *Sentinel* at the time."

"I should have realized that. I'll go look for it there."

"No, I'd think it can be considered a matter of public record. Isn't your daughter a Stanford grad and a member of their alumni society?"

"She is," said Patience, who had her doubts about the alumni association.

"Wait here and I'll get you a copy for her."

Winnie departed briskly and was back in five minutes with a computer print-out. "I got you two lists of graduating seniors, 1973 and 1974. I'd like to believe that no one on these lists could have done such a rotten thing."

"I can understand that," said Patience, getting to her feet and tucking the pages into her bag. "Thank you. Why were you going to call me?"

Winnie propped her rear on the edge of her desk and crossed her arms. "My father was a youngish grandfather, and he was wonderful with my kids. Now that he's eighty-one, and frail, he no longer drives. Saturday I took him to the senior center for a social event, and when I picked him up, he remarked that people there had been talking about Edgar Larson."

"What were they saying?" asked Patience.

"It's what he, my father, said that struck me. He told me the reason he mostly stays away from his great-grandchildren is that old men are always suspect. He feels anyone who saw him playing with my Jenny's four-year-old Dahlia, say—or more likely trying to hold onto her, she's a little eel—could misunderstand, and call the police. He doesn't dare even *talk* to small children in public, and most of his friends behave in the same way.

"And I think that's awful." She straightened. "Maybe clearing one old man's name will strike a small blow for good sense."

"Thank you," Patience said again.

"You're welcome. And good luck. See you in church next Sunday?"

"I'll try to be there."

As Patience stepped out into the hall, Winnie said, "Oh, wait a minute," and joined her, to lead the way down the hall to the library. Inside, she went to a shelf in a corner, ran a finger along a row of large volumes, and pulled one out.

"Here you go," she said, and handed over a Port Silva High School yearbook, 1972–73. "You may find this helpful, too. Just bring it back when you've finished with it."

"LAST TIME GEORGE came in for lunch, I *thought* he was more interested in the cook than the food," said Ronnie, as the two of them put away perishables and cleared the deck for the dishwashing crew.

"Uh-huh." George Gray, an associate professor of econ at the university, had a gym membership at the Y where both Ronnie and Verity worked out. George had stopped in today for a quick lunch and an even quicker chat with Verity.

"He's a nice guy, probably under forty, reasonably good-looking," Ronnie noted. "And tall enough. You going out with him?"

"Ronnie, he's divorced with a six-year-old son and he's looking for a wife. It's not a position I'm interested in." Verity took another good look around before closing the door of the larger fridge.

"Hey, what *do* you want? Some guy just interested in having sex?"

"Sounds good to me," Verity told her.

Ronnie stared, then grinned. "Well, hell. Sounds good to me, too. You find one that suits, maybe we could share."

"You shouldn't hold your breath." Verity headed for the rest room, pulling off her apron as she went. "See you tomorrow."

—————//—————

Before the restaurant doors opened for lunch, Verity had snatched a moment to try a call to ex-officer Jacobs. When giving her the unlisted number, Hank had told her he doubted Jacobs ever bothered to answer his phone; and so it went, a dozen rings and no connection.

Now, in her car, she tried again with the same result. If she wanted to talk to him, she'd have to track him to his lair, and in her present state of mind, the prospect appealed. She'd swing by the retirement home first to see the ex-cop Hank had classed as no ball of fire, and then hit the road.

The lobby at RoseHill Retirement Home was a big, warm room

with upholstered chairs, carpet on the floor, colorful bird and botanical prints on the walls, and pots of flowers and growing green things on most horizontal surfaces. At the desk Verity learned that Virgil Quinn was now in the assisted living section. As instructed, she made her way down one long hall and into another, where carpet gave way to tile floors and the aroma of fresh flowers was replaced by meaner smells. At the end of the hall, in a double-doored room that was apparently a games and television lounge, she found a male attendant who told her that Virgil and the other residents were presently tucked up in their rooms for afternoon naps.

"But if you want to come back in about an hour, he'll be real pleased to see you. Good-looking woman like you, though, you'll probably want to stay well out of his reach. Ol' Virgil seems to be trying to cop as many feels as he possibly can in the time he's got left."

"What fun," said Verity. "How's his memory, do you know?"

He shook his head. "Not much left upstairs. Sometimes his daughter can get a bit of sense from him, but mostly he just rambles."

"I guess I'll pass, then. Thanks."

His only reply was a grunt as he turned back to the shouting and arm-waving of whatever afternoon misery-show was on television.

Back in the car, after making a quick note about her stop at Rose-Hill, she checked her map and cast a wary eye at the sky. With any luck she could call upon Hank's "unpredictable bastard," Jake Jacobs, and get home before dark although possibly not before rain. Under black-bellied clouds riding rough gusts of wind, she drove north on narrow, curving Coast Highway One, green hills too steep for pasture on the right and a long, near-vertical drop to the gray Pacific on the left.

Westport, the last functioning coastal community before Highway One jigged eastward to join 101, was a tiny hamlet of perhaps three or four dozen houses, a few of these shiny-new, at least two others turn-of-the-century or older and undergoing restoration. There was also a tiny schoolhouse, a community church not much larger than the schoolhouse, a post office, and a store. Verity pulled up in front of the store to check her map again; the address Hank Svoboda had given her for Jake Jacobs was 27-something-something-something Branscomb Road, and she thought that road... There it was, heading east just past Westport, and according to the map, only partly paved. Wouldn't hurt to ask.

Inside the store, she fished a bottle of water from a cooler and

approached the counter, silently assessing two approaches: to ask
about Jacobs, or not? Not, she decided, recalling Hank's description
of the man; and said instead, as she handed a bill to the middle-aged
woman there, "The Branscomb Road. Is it close?"

"Just north of here, across from the state beach. Can't miss it." The
woman gave her change for the five and added, "You by yourself?"

"I am. Is that a problem?"

"Well, probably not if you pay attention. It's real narrow, basically
an old lumber road with nobody much around except now and then
a lumber truck roaring along. And no lights, of course. I don't much
like driving it, myself."

"Is it paved?" asked Verity.

"Yeah, but potholed. Those trucks do that. And it's real steep."

"I see. Thanks," said Verity.

"You're welcome. Good luck."

Verity returned to her car, pointed it north, and had barely left the
little town when she came upon the Westport–Union Landing State
Beach on the west and a respectably paved entry to Branscomb Road
to the east. She settled into alert-and-attentive mode, passed occa-
sional houses and then only a rare house, and was soon all alone in
tree-shaded, late-cloudy-day gloom.

This was lumber country, mostly redwood trees (and stumps) at
first, yielding to a mix of Douglas fir and cedar (also with stumps).
The road *was* steep, climbing and dipping and curving as it appeared
to run along a ridge between two deep valleys, with views on one side
and then the other of forested mountains. Roads branching off were
dirt, often blocked with a pipe gate or occasionally just a pile of rocks
or a pushed-up heap of brush. Not what you'd call welcoming.

She spotted a house, looking derelict, up a slope to the right, but a
row of five mailboxes at road's edge suggested dwellings back there
somewhere. Then more trees, and more curves requiring brakes and a
sensible slowing, and a dirt trail steeply down on the left with an old
barn or shed and a shabby trailer at the bottom.

Lights flared in her rearview mirror, something coming up fast. It
slowed, a moment later the road widened a few feet, and a grateful
Verity pulled over to let an empty lumber truck thunder past on huge
tires. Clearly someone who knew the road. Press on, Verity.

She'd traveled nearly five miles and was developing stiffness in
neck and shoulders when she saw a number on a roadside post:

27000. And shortly after that, a single mailbox at the road's edge: Jacobs. Hurrah!

She turned in past the mailbox and and stopped, caught by a memory so vivid that she blinked and took a deep breath to reorient herself: her arrival many months earlier at Christian Community, hidden deep in the Lost Coast and not at all welcoming nor, it turned out, safe. But here was a name on a mailbox, and a short, rutted driveway leading to a gate and a small brown house some fifty yards beyond. She took another deep breath and rolled slowly forward to the gate, and its sign: VISITORS HONK HORN AND STAY IN CAR.

"Yes indeed," she said aloud as three dogs appeared behind the gate and stood there staring at her, alarmingly silent. They were big and mostly dark, mixed breeds she thought; two had pointed muzzles and upright ears, the third a broad head with floppy, low-set ears and a wide mouth. When she touched the horn, they set up a combined roar that went on until a man appeared from behind them and quieted them with a word and a gesture.

Verity lowered her window. "I'm Verity Mackellar," she called out. "If you're Jake Jacobs, Captain Hank Svoboda gave me your name and said you might be willing to talk to me."

"Get out of the car."

He was lean but wide across the shoulders, his face shadowed by a broad-brimmed hat. So, back up or get out, she told herself, and got out. She closed the car door without latching it, and stood straight to look back at Jacobs.

A long moment of silence, and then, "Okay. I'll open the gate and you can drive in."

Yessir, she thought. She climbed back in, put the Subaru in gear, and rolled on through, thinking as she did so that her cell phone would probably be useless out here in the hilly wilds.

Jacobs closed the gate and set off in the direction of his house, the dogs at his heels. Verity drove slowly after him, and at a wave of his arm, parked to one side of the front steps of the small house, which proved to be a squarish single story with a roofed porch across its front. She swept it with a quick look: old, with board-and-batten siding that was probably redwood and original but mended here and there with pieces slightly different in color, the roof dark composition shingles and clearly not original. She got out warily, eyes on the dogs.

"Ace, Buck, and Chloe," said Jacobs. "Let 'em get a good sniff.

Friend, guys." Verity stood still while the dogs investigated her person, one of them paying particular attention to her crotch. Then they backed off and sat down in a row.

"Gonna rain any minute. Better come inside," he instructed, and preceded her up the shallow steps to open the door and stand aside.

Verity eyed the long-legged man and his dogs, and estimated as nil her chances of escaping the group should they wish to prevent her. Might as well be dry. "Thanks," she said, and walked past him and tried not to wince at the sound of the door closing behind her.

The room she stepped into ran the width of the house, with kitchen gear at one end and a stone fireplace with a cast-iron insert at the other. Her curious glance took in book-laden shelves on one wall, several frames whose pictures were just smears in the dim light, a high rack holding three long guns. Beyond these personal touches, the room was sparsely furnished and neat but smelled of wood smoke and dog.

As she stood there absorbing the solo-male look and feel of the place, Jacobs tossed his hat at a wall hook and went to poke up the fire before gesturing her to a chair near the fireplace. Although Hank had told her that the former cop was now in his middle fifties, his straight collar-length hair was more black than gray and his dark face looked weathered as much as aged. He was, she thought, at least part Indian.

Now he hooked thumbs in the belt-loops of his Levi's and rocked back on the heels of boots that made him slightly taller than she was. "You're not a cop. So, some kind of reporter?"

"I'm a private investigator."

"No shit? How'd you get close enough to ol' Hank that he's handing out names and addresses?"

"Through my mother. She's a private investigator, too." Verity dug a card from her shoulder bag and handed it across. "We're employed by Christina Larson, Edgar Larson's granddaughter. Chris is a writer, and she's working on a family history."

"Why isn't she asking the questions herself?"

"She lives and works in Los Angeles. She came to Port Silva to close up her father's house after his death but couldn't stay, so she hired us."

He pulled another chair close to the fire and sat down. "And I'm on her list, your list, because I was a working Port Silva cop when Edgar Larson killed himself. That about it?"

"That's right. She was a little girl living in her grandfather's house at the time of the events that led to his suicide. She remembers him very well."

"I remember *her*, saw her around town a time or two with her granddad. Cute little towheaded kid with big green eyes."

Verity sat straighter. "Did you talk to her about her grandfather?"

Jacobs leaned back with a snort. "That mother of hers wouldn't have let any cop near her kid. Not even to put a lock on the old man, who she didn't like much."

"Chris's father—Andy Larson, the teacher, who died very recently—never believed that his father, Edgar, had molested children. Chris doesn't believe it, either."

"Neither do I. Neither did Walt Henderson."

"Why not?"

His face briefly sad, he shook his head. "I worked for Edgar Larson some, when I was just a kid. And even, what was it? Twenty-seven, twenty-eight years ago, as a cop I'd seen more than my share of baby-rapers. Enough to know Edgar Larson wasn't one."

Verity tried to conceal her disappointment. "So that's it? You just believed in him?"

There was something more; she could tell from the way he relaxed back into his chair. "That and the fact that a couple ladies who had reason to know told me that Edgar Larson was a grown-up man who liked grown-up sex."

Verity stared at him. "Edgar Larson? He was a pillar of the community, from what I read in the papers. Active member of his church, a widower who'd been married to the same woman for forty years. Are you saying he patronized prostitutes?"

"No, ma'am, I'm not. Edgar Larson was a big, healthy man whose wife was an invalid for a long time. Over the years, he'd found one woman, and later another—and maybe more, for all I know—who enjoyed his help and his company."

"Married women?"

Jacobs shook his head. "Not exactly. One was a widow lady, the other had divorced a no-good husband years earlier."

"But this was a really small town then. How did he keep people from finding out?"

"So, P.I. Lady, where did you grow up?"

"In Berkeley!" Verity snapped.

"Right, town of one hundred thousand loud opinions," he said with a grimace. "Edgar Larson was a fairly big man in that little town, but he didn't make waves or noise. My guess would be, a few people did know but didn't think it was any of their business. The one lady told me she figured his wife knew."

"Okay," said Verity slowly, adjusting her mental picture of stern-faced, upright Edgar Larson. "Local respect faded pretty fast, though, when some anonymous persons accused him of being a molester."

"Yeah." Jacobs's face darkened, and he hunched his shoulders briefly. "What happened to that little Dillon girl sent everybody crazy. Couldn't hardly blame 'em."

"Couldn't one of those women have spoken up for...?" Verity stopped, and shook her head. "No."

"No," Jacobs agreed. "Doing is one thing. Standing up in the street and talking about it is something else. Edgar wouldn't have wanted it, anyway."

"Shit," said Verity.

"Yup."

Verity took her notebook from her bag and made a few notes. Maybe Chris would be pleased to learn that her grandfather had more of a life than she'd known. "Uh, Mr. Jacobs…"

"Jake."

"Jake, would you be willing to give me the names of those two women?"

"Nope. I talked to 'em, then Walt Henderson did. He promised them both that would be it. Didn't even put anything in the investigation file about it. Besides," he added with a sardonic grin, "I know one's dead, and the other probably is, too. Those ladies weren't real young even back then."

Maybe, in some unLutheran afterlife, Edgar had the company of his wife and his friendly ladies, too. "Did either of the women know who might have accused Edgar?"

"No." His tone left no room for discussion.

"Did you, or Chief Henderson, ever find out who it was?"

He took a deep breath. "Here's the way it was, and I'm not proud of it. We were all crazy to find that baby-butcher. My own boy was five, and knew to avoid bad guys, but my girl was only three." As Jake Jacobs got to his feet, his dogs sprang to the alert from three separate beds. "For me and I think the chief and a couple others, the accusa-

tions against Edgar were just a blip, a distraction. What we didn't realize, until too late, was how bad it was for Edgar."

Apparently not even Edgar's own son realized that. But at least... "But you, and some deputies, caught the real villain. Or at least uncovered him," she said.

"Oh yeah. We did that. Too bad it didn't happen until after another little girl got ripped apart. Now if you'll excuse me, I got a few things to take care of before the rain gets heavy."

Verity got to her feet, but she wasn't quite finished. "Was there—is there—anyone you suspect?" As he shook his head, she went on quickly. "Because if Edgar Larson was innocent of the charges, as you and nearly everyone else I've talked to believes, and since he had no enemies that I've been able to discover—why was he accused?"

Jacobs shook his head again. "Maybe, in the misery of that time, somebody saw him playing with his granddaughter and misread it. Or maybe he just happened to piss somebody off one day without even knowing it. Look, I'm not a cop now, I get to town maybe once in six weeks and that's too often."

He stood where he was, clearly waiting for Verity to move toward the door. When she did, he fell in behind her.

"One thing I would say, though," he said, as he reached past her to open the door. "Edgar Larson is long gone to whatever reward he deserved, and poking around in old meanness is like shoving a stick in a hornets' nest. Good-looking girl like you should have better things to do with her time."

Verity spun around so quickly that one of the dogs barked.

"Hey," Jake said with a grin, "I'm an old guy, got primitive ideas, and here you are out in the woods all by yourself. You're lucky I'm not twenty years younger."

She tipped her head, looked him over, and grinned back. "Or maybe not. Thanks, Jake."

"Any time, Red. You know where I live."

———//———

Verity was no more than five minutes away from Jake Jacobs's place when she found herself in a nasty combination of fog and misty rain that obscured the unmarked edges of the road and set up an uneasy movement in the canopy of trees. Shoulders hunched, she leaned forward to peer through the windshield, feeling that she might as well be all by herself in Tolkien's Mirkwood.

As she pulled up to Highway One, she found she'd left the fog for a straight-down, fairly heavy rain that wasn't much better for visibility but at least made a familiar, cheerful noise. The few people in trailers and motor homes at the Westport Beach across the way must be enveloped in water-sound, roar of ocean outside their windows and clatter of rain on their roofs.

Instead of turning onto the highway, she shot across to the state beach parking area and pulled into one of the many empty spaces in the lineup. She turned off her engine, noted that the force of the wind was from behind her, and lowered the right-hand window several inches to admit the roar of the waves crashing on the sand and rocks not far below.

Edgar Larson's house had been the equivalent of two blocks from bluffs above the ocean. As she recalled, the long backyard sloped gently westward with no structures directly between it and land's edge. Sitting in his family room with those French doors open, he'd have had the sea for company just as she did now. Verity closed her eyes, leaned her head back, and absorbed that sound while she played the exchange with Jake Jacobs over in her mind.

Edgar and his ladies. The possibility that the tall, strong, stern-looking old man had unwittingly run afoul of someone with a very low boiling point. The now-familiar admonition about the dangers of stirring up old troubles.

A shift in the wind sent a spray of raindrops in through the window and reminded her that it was getting late. Monday was the night that Patience and Hank usually chose for dinner out followed by a stop at the local cops' bar, and she'd be needed at home.

CHAPTER 9

"I'M GOING TO SCHOOL now, Verity," Sylvie announced. "Will you come to take me to my piano lesson after?"

"I will." She got up and went to hug the little girl, noting that the term "little" became almost daily less appropriate. "I'll wait for you out front."

Patience, who'd had a later night than Verity, came into the kitchen as the door closed on Sylvie. "Coffee!" she croaked, and sat down at the table. "Then," she said, after clearing her throat, "I'll tell you something interesting I learned yesterday."

"About your new client?"

"No." She folded her hands in her lap and sat quietly until Verity put a cup before her.

"Thank you. Thirty years ago the school district used retired men, volunteers, to patrol the high school parking lot. Edgar Larson was one of them."

"Holy shit," said Verity in reverent tones. "A whole new group of particularly plausible suspects."

"Or at least sources," said Patience, and lifted her cup for a cautious sip.

"Point taken, Mom."

"Good. My friend Winnie Ahonen gave me a copy of the graduation lists for 'seventy-three and 'seventy-four, as well as a copy of the 1972–73 yearbook. I haven't had time for more than a cursory look yet—I planned to do that this morning—but I'd think a few of those people would still be in town."

"Seems likely. You want to start now?"

"Not really. I want to drink coffee now, and then eat breakfast. After you get home this afternoon, perhaps. How did your interviews with the retired cops go yesterday?"

"One strike-out, one base hit," said Verity. "He's an odd guy," she added, when she'd finished with the details of Jake Jacobs's knowledge of and opinions about Edgar Larson. "Lives in a little one-story redwood house, probably turn-of-the-century but in good repair, with a new roof. Inside it's very masculine, long guns on wall racks and a fireplace for heat. But also a full bookcase, and a music system. Oh, and three dogs, big and tough-looking but very much under control.

"Anyway, he's out of the ordinary. And for a guy of probably mid-fifties, he struck me as kind of sexy."

"Astonishing," murmured Patience, and Verity winced and then grinned.

"Oops. On that note, I think I'll go for my run."

——//——

Sylvie was tired of being indoors. The classroom was too hot, and smelled like sweat and damp clothes. An off-and-on drizzle had turned morning recess into dumb exercises in the gym, and everybody had to eat lunch in the cafeteria instead of on the tables outside. With some time left after hastily gulping her sandwich and orange, Sylvie put on her jacket, slipped out a side door into the yard, and took several deep, happy breaths of air that was misty-damp but not actually rainy right now.

Hardly anybody was out here. Three big girls, fifth graders, had pulled a benched table close to the building and under the protection of the eaves, where they were eating and giggling. A little kid in a yellow slicker and boots was puddle-stomping in the grass between sidewalk and street, waiting probably for his mother to drive up to get him; a crossing guard stood nearby, huddled up in a thick jacket that made her shiny orange guard-vest look too small.

Sylvie swung her arms over her head and back down, and again, and again, crowing quietly with the last swing and taking off across the playground at a run. She skidded to a stop at the fence, considered scrambling up the chain-links as she'd seen one of the little kids do a few days ago. Decided against it and turned to run again, reminding herself to go around puddles, not through. With afternoon still to come, wet shoes and pant-legs would be gross.

She bounced against the opposite fence with one shoulder, not such a good idea because it sent the wire into a shivery shake and brought big drops of water flying from the links like sideways rain. Sylvie brushed at her hair and her jacket, grimaced, and looked

around, to note that the ground under one of the freestanding basketball hoops was puddle-free. Twice last week some fourth-grade girls, one of them her friend Jessica, had let her play with them and try to make baskets.

She needed a ball. She shoved chilly hands into her jacket pockets and looked around for the playground supervisor, a short, skinny woman with tight yellow curls and a mean voice. Something shiny-purple flashed into and out of sight at the far corner of the building; Mrs. Finney's raincoat, Sylvie was pretty sure, and she was pretty sure, too, that she knew what the woman was doing.

The box of balls was kept in the hall just beyond the side door. Sylvie trotted over and went in, saw nobody to ask but grabbed a ball anyway, cast a quick look up at the hall clock, and trotted back out to enjoy the remaining ten minutes of the lunch break.

She tossed the ball up and missed, retrieved it quickly and tossed again for another miss. Stopped and squinched her eyes shut and opened them and aimed and watched the ball roll slowly around the hoop before falling away.

"Shit!" she said, and took a deep breath and was about to try again when somebody bumped her from behind so hard she stumbled forward and almost lost the ball.

"Watch what you're doing!" she snapped, and turned to find herself facing the Mendes twins, Ricky and Robby.

"You got a dirty mouth for a girl," said Ricky, staring down at her from pale blue eyes with stubby, no-color lashes. Nearly a head taller than his brother, he was bigger-bodied, too—basically fat in Sylvie's opinion.

"My mouth is none of your business. Go away," she said, and had turned to aim for the basket again when another, harder push sent her flying. Holding grimly onto the ball, she hit the ground with her right shoulder and the right side of her face, and skidded.

"Hey, Ricky, quit it!" said Robby. "You want to get us both in trouble? Come on, the bell's gonna ring!"

Ricky ignored him. "You don't belong at this school. Gimme that ball."

As he bent to reach for it, Sylvie rolled away and got to her feet, clutching the ball tighter. "It's my ball! You leave me alone!"

"Oh, shit, Sylvie, you're bleeding." Robby sounded like he was going to cry.

''Who's gonna make me, bitch?" Ricky came closer, his head shoved forward out of his jacket-hood, his round face an ugly red. "You and that snoopy redheaded whore you live with? I don't think so."

Sylvie straightened, shifted her grip on the basketball, and snapped it at his face with all the strength of her wrists.

"Yow!" he howled, and toppled backwards to fall flat, both hands cupped over his nose.

"What's going on here? Little girl, shame on you! Where did you get that basketball anyway?" Mrs. Finney came running up and grabbed Sylvie by one arm.

"Don't!" Sylvie pulled free but made no effort to run away. Ricky, she was interested to note, was howling like a baby and pawing at his nose, smearing blood and snot all over his face. She cast a quick look at Robby, a boy she knew a little bit and even liked a little bit, for a boy. He was standing well back from his brother with a look on his face that said he was pretending to be someplace else.

With a snarled "You stay right there, hear me?" to Sylvie, Mrs. Finney bent to inspect Ricky. "Are you hurt? Can you get up?" With her tugging at him, Ricky struggled to his feet, shrugged her off with a choked "I'm okay," and dragged his jacket sleeve across his face. When he saw the result, a great bloody smear on the tan fabric, he turned a funny green color and grabbed at Mrs. Finney again.

"You poor boy," she said, "let's go inside and get you cleaned up. Then we'll talk to Ms. Rankin and see what she has to say about this kind of playground behavior. Come along," she added sharply to Sylvie, and reached out a hand that Sylvie eluded by taking a step back. Mrs. Finney glared for a moment before turning her attention back to the bleeding Ricky. "Come along, all of you," she instructed as the bell rang.

Ms. Rankin, the principal, was older than Verity, Sylvie thought, but not as old as Patience, and fairly tall. She sometimes played sports on the playground with the kids, and she brought her golden retriever to school with her; but when she said something in a serious voice, kids stood still and paid attention. After one of the male teachers had mopped Ricky up in the boys' bathroom and she herself had sponged Sylvie's face, Ms. Rankin gathered the three of them and Mrs. Finney into her office, pointed them to chairs, and settled herself on the edge of her desk.

"Now. What happened out there?"

"She threw a basketball at my face!" said Ricky, scowling at Sylvie. "I think she broke my nose."

"She did," said Mrs. Finney. "I saw the whole thing. It was totally vicious."

"I don't think that language is helpful, Mrs. Finney. Sylvie?"

Sylvie looked at Ricky, who glared back. She looked at Robby, and he looked quickly away and bent his face to the golden retriever, Emma, who had her head in his lap. She looked at Mrs. Finney, and read dislike in the woman's face. Who here was going to believe her?

Her face hurt. Her shoulder and knee hurt, where they'd hit the ground. She wished Emma would come to her, but Robby had his fingers hooked through the dog's collar. Sylvie blinked hard, clasped her hands in her lap, and shook her head.

"Sylvie?" Ms. Rankin bent to look into her face.

There was a tap at the door and Mrs. O'Neill, who ran the school office, opened it and put her head in. "I got Miss Mackellar and she'll be right along. But I couldn't get any answer at the boys' mother's house."

"She's gone to—she's not home right now." Robby spoke quickly. "We're staying with our dad. And our grampa. But they'll both be at work."

"I'm sure those numbers are in the file," Ms. Rankin said to Mrs. O'Neill, who nodded and left. Ms. Rankin turned again to Sylvie, with a questioning look.

"I need to wait for Verity," she said, and clamped her mouth tight again.

"All right. We'll wait."

———//———

A long time later, at least five minutes by the wall clock, there was another rap at the door: Mrs. O'Neill again. "I reached Mr. Mendes, Senior, at his work. He's very busy but he'll try to get hold of the boys' father and send him along. And here's Miss Mackellar."

Verity stepped through the door, in light-colored jeans and blue sweater and leather jacket, her hair pulled back into its long braid. Sylvie thought she looked tall and beautiful and not a person anybody would mess with.

"I'm Verity Mackellar," she said to the room at large and then, to

Ms. Rankin, "You've met my mother, Patience Mackellar. We're Sylvie's family."

"Martha Rankin," said Ms. Rankin, and reached out for a brief handshake. She introduced the others, and said, "As you can see, we've had a bit of trouble. We're trying to work out just what happened."

"Your girl threw a basketball at me and broke my nose," said Ricky Mendes with a loud, juicy sniff. "My brother saw it, and so did Mrs. Finney."

Nodding thanks for the chair Ms. Rankin had pulled forward, Verity chose to remain standing beside it, next to Sylvie's chair, and make a quick assessment of the room's occupants. Ms. Rankin was medium tall and athletic in bearing, with alert but warm brown eyes and a few threads of gray in her curly brown hair. The larger of the two boys, blood smearing his T-shirt and jacket, struck Verity as a lump; his slumped body was bulky-looking, his face broad and sullen, the pale blue eyes narrowed in anger. Or perhaps, she reminded herself, in pain. His nose must hurt.

The smaller boy was more neatly made, although he was huddled in the chair as if he meant to be invisible. His face, foreshortened as he bent forward over somebody's golden retriever, had a broad forehead, a neat, small nose, freckles. The other woman, the playground supervisor, was skinny-edgy and clearly irritated.

And Sylvie. Solitary and defiant was Verity's first impression, but now the tight shoulders had eased and the closed-in face opened slightly. Sylvie thought reinforcements had arrived.

And by God you're right, kid. "Okay, Sylvie. What happened that left both of you bloody? From the beginning."

"I went outdoors after lunch. There wasn't anybody around, but the rain had quit and it smelled good out there so I went and got a basketball, to practice shooting."

"Those balls belong to the school. The rule is, you have to ask *me* for a ball," said Mrs. Finney.

"You weren't there."

"Don't be ridiculous, of course I was!"

Ms. Rankin waved the other woman to silence. "Go on, Sylvie."

"I tried a couple shots and missed. Then I held the ball a different way and threw again and it rolled around and I thought it was going to go in." Sylvie grimaced and shook her head. "But it didn't, and I

said, 'Shit!' and Ricky Mendes pushed me hard from behind and said I had a dirty mouth."

"I didn't touch her," said Ricky.

"I told him to leave me alone. Then he pushed me harder and knocked me down, and said I had to give him the basketball."

"I did not!"

"Then he said something really bad, so I threw the ball at him. He didn't catch it," she added, with an easing of her mouth that did not quite become a smile.

"You're a liar," Ricky shouted, and lurched forward as if to rise from his chair, but subsided as Ms. Rankin was quickly in front of him. "My nose hurts," he whined. "I wanna go home."

"I didn't hear him say anything," said Mrs. Finney. "And I didn't see him push her."

"You weren't there," said Sylvie fiercely. "You were way down around that corner by the Dumpsters, where you go to smoke cigarettes. I saw you coming back from there when I was getting up."

Mrs. Finney drew a hissing breath, and Sylvie flinched.

"It's okay, Sylvie," said Ms. Rankin. "Robby? What do you have to say?"

Robby Mendes looked up, misery clear on his face. He took a deep breath, and said, "Ricky pushed Sylvie two times, and she fell down the second time and scraped her face. And he said mean stuff to her."

"He called Verity a snoopy redheaded whore," said Sylvie. "And he said she couldn't make him leave me alone." Her voice wobbled on the last few words, and she reached up to take hold of Verity's hand.

"Believe me, sweetie, I can. And I will," Verity told her and everyone else in the room.

Ricky shifted in his chair but said nothing. Robby gave a huge, shaky sigh. "Now my dad will be really mad at Ricky for getting in trouble, and me for telling."

As far as Verity was concerned, this was Ms. Rankin's problem, not hers or Sylvie's. She straightened to her full height, and Sylvie scooted quickly out of her chair, still holding on. "If there's nothing more needed from us at the moment?"

"I'd appreciate it if you could stay until the boys' father gets here. So we all finish on the same page," added Ms. Rankin.

"I don't think so. Sylvie, I'm parked right out front." Verity pulled the car keys from her jacket pocket. "Please go wait for me in the car."

Sylvie grabbed the keys and was out the door before anyone could voice a protest.

"I really think it would be better for everyone—"

Verity broke in. "I have to say that I'm not much interested in anyone but Sylvie. She's been threatened and physically assaulted by a boy twice her size, on a public school playground that was inadequately supervised. Now she needs to go home."

Martha Rankin nodded. "I'm sorry. Of course she does."

Verity relented a bit; this woman had a difficult job to do. "I'll be at home later, or Patience will. I think you have our number."

Another nod. "I'll be in touch."

———//———

Sylvie was in the car, the door closed but the window open. "I'm sorry," she called out as Verity came across the sidewalk. "I'm sorry they had to call you at work."

Verity looked down at her charge, thinking that while this was her own first experience in dealing with such a call, it was unlikely to be the last. She should probably consult with Patience on the basic ground rules. "Sweetie, I'm glad I was where they could get in touch with me. It was a slow day at the restaurant anyway; there's no point in my going back there. We'll just go home."

Her words were nearly drowned in the roar of the yellow king-cab pickup truck on big tires that roared past her and pulled to the curb just ahead. She waited a moment to make sure it wasn't going to back up, then walked around her own vehicle and was pulling its door open as the truck's driver jumped out and started toward the school, tossing a glance in Verity's direction.

He stopped as if he'd hit a wall, did an almost-comic double take and fixed her with a glare so ferocious that she slid quickly inside her car, closed and locked the door, and started the engine, pulling away from the curb before fastening her seat belt. As they reached the corner, she looked into the rearview mirror and saw him standing there still. Round, ordinary face, plain brown hair, but she had a brief sense of familiarity; had she seen him somewhere around town?

Sylvie had turned to look out the back window. "That's Robby and Ricky's dad."

Ah. The name Mendes clicked into place, with a flashback to a rude experience at the gas station/garage owned by an older, similarly round-faced man of the same name—uncle? father? There for a smog

check with her Alfa some months earlier, she'd been groped by the
man who was glaring at her now, and her response had knocked him
on his ass. Apparently his memory of the event was still fresh.

"No comment, Reddy, was immortal." Verity fastened her seat belt and
turned the corner, glad to have avoided an unpleasant confrontation.

"Yeah." Sylvie was suddenly the picture of exhaustion, slumped in
her seat as if held there only by the belt. At home, thought Verity,
there would be a bath, and a snack, and probably a nap. Or maybe
Patience, with questions. And surely a ringing telephone.

She swung left on Main Street, drove several blocks, and found a
parking place in front of Coffee Essence. "You wait here," she said to
Sylvie, who merely nodded. Verity was back in five minutes with a
paper bag, which she set in the small Styrofoam chest behind her seat.

"What did you get?" Sylvie asked.

"Something to wet our whistles." While Sylvie pondered this odd
phrase, Verity headed south through downtown; she turned off onto
the rutted road leading to an untenanted, unkempt bluff called Peli-
can Point, following the road to its end at a small, muddy lot over-
looking the ocean. A short distance further south, the bluffs were the
property of a large lumber company, but this section belonged to the
city and was seen by hopeful locals as the seed-ground of a new
waterfront park. Verity chose a favorite viewing angle, pulled to a
stop, set the brake, and turned off the engine.

"I thought we'd sit here for a while and watch the ocean. And
listen to it." She twisted around in her seat and reclaimed the paper
bag. "What would you prefer, a Coke or a ginger ale?"

"Coke, please," said Sylvie, who was allowed soft drinks only rarely.

"Here you go." Verity handed across the red can, and took from
the bag a tall, lidded cup: a caffè latte.

Sylvie popped the can open, took a small sip, tossed a sideways
look at Verity, and sipped again. After several long moments of
silence, she said, "Verity, I was telling the truth. About Ricky and Mrs.
Finney."

"Sylvie, I don't believe you've ever lied to me. But I need a little
background here, and I thought this might be a good place to get it."
She had a sip from her cup, and wiped foam from her upper lip.
"Good stuff. Okay, tell me about Ricky and Robby."

"They're in fourth grade. They're twins. Except I thought twins
looked alike."

"Identical twins do. Fraternal twins often don't."

"What's the difference?"

"Identical twins come from a single egg that splits, fraternal twins from two eggs. More about that at another time. How do you know *these* twins?"

"They were both in chorus, they both have really good voices. But Ricky kept making trouble, so he got kicked out."

"Ah." John Muir Elementary, a kindergarten through grade five school, had a chorus drawn from fourth and fifth grades. Sylvie was one of a few third graders allowed to participate.

"Did you have trouble with Ricky while he was in the chorus?"

"I guess." She had another sip of Coke, and shrugged. "He doesn't like girls. And the girls don't like him, because he's ugly and mean and does stuff like bumping you 'by accident' or grabbing your music and not giving it back."

"Sylvie, did you challenge him? Make fun of him?"

"No way!" Indignation that looked real. "I never even noticed him, why would I?"

Why indeed. In Verity's distant memory, not noticing little boys was a sure way to piss them seriously off. "Okay, what about the other one? Robby."

"Robby's nice, for a boy. He talks to me sometimes. He's scared of his dad. And he misses his mother, she's always going away and leaving him and Ricky." Sylvie had a good long swallow of Coke before adding, "Jessica says his mother's a slut. I don't know what that means, except it's not nice."

"It's a lot like whore, and Jessica shouldn't call anybody that. Especially not anybody's mother." These last words rang loud and foolish in Verity's ear, and she decided she was out of her depth here. Should have gone home to Patience.

"Okay, sweetie, just wanted to get my facts in order. We'll head for home in a minute. But you need to tell me about Mrs. Finney."

"Yuck," said Sylvie.

"Sylvie…"

"She's mean, and she lets kids she likes get away with stuff. She's supposed to 'keep order on the playground,' that's what she told us, but she doesn't. And nobody is supposed to smoke anywhere on the school grounds, but she does it all the time anyway."

"Have you had a problem with her before?"

Sylvie shook her head. "But I saw her one day smoking, when I was just running around like I sometimes do. I didn't say anything, but she saw me, too. So…"

"Right." Verity knew that Sylvie had spent most of her short life with adults, not all of them reasonable or trustworthy. More than most eight-year-olds, she was alert to adult reactions.

Now she tipped her Coke can high for another long drink. "That was good. But I can't drink the rest of it."

"That's okay." Verity opened the car door, got out, and reached back to take the can, which she emptied on a rock heap nearby. Sylvie got out, too, and the two of them walked nearer the edge of the bluff, to look out at the charging, white-capped ocean. "I really like the sound," said Sylvie.

"Mm. Me, too." Verity finished the latte and carried paper cup and Coke can to a chained in place metal container, then took Sylvie's hand to lead her back to the car. "Sylvie, I think it might be a good idea for you to stay home from school for a day. Or possibly two." She started the engine and backed around to regain the road.

"Goody. Why?"

"To let things cool down a bit."

"Okay. But I need to go to my piano lesson pretty soon."

Traffic was vigorous on Main Street, cars and trucks flowing busily in both directions; Verity stopped at the end of the road to wait her chance. "Maybe we should just forget the lesson for today. Go home and take a nap."

"I don't need a nap."

Verity turned to look, and saw that Sylvie, who never cried, had tears clinging to her lashes. "Sylvie, if you want to go to the lesson, we'll go, but you need a bath first, and clean clothes and maybe a bandage on your cheek. You look like you've been in a battle."

She straightened, and blinked away the last vestige of tears. "I was."

CHAPTER 10

IT WAS ALMOST two o'clock when Verity drove into the yard to park beside Patience's big gray Ford truck. Sylvie pushed her door open and jumped out, catching her own reflection in the side mirror. "Eeuuw, uck. I look really gross."

Verity, amused at this switch from battle-scarred warrior to image-conscious female, told her not to worry. "We'll all love you however you look."

"Uh-huh," Sylvie muttered, and set off for the house, leaving the backpack to Verity. "Bath first, kid," she called. "And then a quick snack. We have forty-five minutes."

Patience opened the front door as Sylvie reached it, and Verity saw the two of them pause and talk briefly before Patience gave the little girl a hug and sent her off inside. "Oh, my," said Patience as Verity reached her. "Come in and tell me about it."

"Give me a few minutes first. She's determined to go to her music lesson, scrapes and all, and I want to point her firmly at a bath and some clean clothes."

"So far, so good," she said a few minutes later. "I don't know whether she's going to sail right over this, or fall apart within the hour. I guess we'll find out. Meanwhile, here's my take, and Sylvie's, on the day's events." She sat down at the kitchen table to tell it.

"Good for you," said Patience when Verity ended with her decision to bring Sylvie home without further discussion or confrontation. "If Ms. Rankin doesn't call me within the next hour, I'll call her, and arrange to see her tomorrow."

"Lovely. You'll be better at that than I would."

"You've done your part, in your own good fashion," Patience said. "And I'd better go have a look at Sylvie's face. A bandage would probably be a good idea, if she doesn't object."

"Make it a pretty one, Ma. She saw her face in the wing mirror and was *very* unhappy."

Charlotte Birdsong, Sylvie's piano teacher, lived south of town in an historic area called Finn Park, an enclave of small houses and a central meeting hall built communally around the turn of the century by a group of Finnish settlers. "Shall I come in with you?" Verity asked as she pulled up in front of the house.

"No! Thank you," Sylvie added on a milder note as she opened her door and got out.

Verity watched her go a bit cautiously up the stairs, watched the door open to admit her, saw Charlotte wave and leaned over to respond with a wave of her own. Sylvie would tell her what had happened, or not; in either case, Charlotte would cope. She herself could sit here and dither, in full view of Sylvie should she happen to look out. Or she could sensibly run some errands.

She chose the latter move, and returned just in time to see Sylvie coming back down the stairs.

"Hi, sweetie. How was the lesson today?"

"Just lovely. Charlotte says it's good I work hard because talent by itself isn't enough."

"Good thinking. Ready for a nap now?"

"Oh no."

At home, they found a note from Patience on the table: *Ms. Rankin called, and I've gone to speak with her.*

"Okay, kid, I have some work to do down in the office. I want *you* to go lie down for a while. Please."

"But I…" Sylvie's voice faded into a huge yawn. "Okay."

———//———

When the truck drove up, Verity hurried out to meet it. "She's asleep in the studio."

"Wonderful." Patience followed her back to the office and took her coat off before collapsing into the chair beside the paper-strewn desk.

"Not a wonderful exchange with Ms. Rankin, I guess?"

"Ms. Rankin is a reasonable person, as am I. Mr. Mendes, known as Bobby, is not," Patience said. "His response to the playground fracas is that his boys are good boys and the whole fault lies with this throwaway mongrel female who should never have been admitted to the local school system in the first place."

"Whoa!" Verity, who'd settled onto the edge of the desk, stood up. "Are you kidding?"

"No, unfortunately. But Ms. Rankin says that although the man has a very short fuse, he does seem to care about his boys, and can sometimes be reasonable. She gave me details of his original reaction because she couldn't be sure this would be one of the times." Patience made a face. "She also told me that she'd talked him out of—threatened him out of, I'd guess—making a complaint to social services about Sylvie."

"Christ on a crutch!" Verity snapped, and bit her tongue, remembering her vow to clean up on Sylvie's behalf the part of her language that might be called blasphemous.

"Right," said her mother. "If that happens, Sylvie's father will be notified, and the outcome of that could be—"

"Deep shit for Sylvie."

"Quite possibly. Anyway, Ms. Rankin agreed that Sylvie could stay home until Friday. The one Mendes boy, the quiet one, will come back tomorrow if his father will let him."

"And the non-quiet one?"

"That's to be decided. The boys' mother, who dropped out of high school to marry Bobby Mendes when she was sixteen and pregnant, handles family problems by leaving town, so she's not available."

"Wonderful."

"Not incidentally, this business with Sylvie wasn't Ricky's first venture into bullying. Ms. Rankin is going to insist he get some counseling, and she's trying to decide whether it would be best to separate him from his brother at school. Apparently most school districts do that automatically with twins, but Muir made an exception at the Mendes family's request."

Verity was seeing in her mind's eye the faces of the two boys. With no brother or sister of her own, she had no visceral feeling for the sibling relationship, much less that of twins, but those boys clearly had. "So what do we do? We can't toss Sylvie right back in there unless we're sure—"

Patience cut her off. "We have a day or two to decide. Meanwhile, let's try not to send out great waves of anxiety she's sure to pick up on." She gestured at the cluttered desk. "Have you been looking over this stuff?"

Verity pulled the other chair over. "Only got as far as the yearbook. I was interested to see Bobby Mendes's round, nasty face there."

"We shouldn't let personal animosity affect our judgment."

"Why not?"

"Good question," said her mother. "Let's use this time well, it won't last long. I started with the list of 1993 grads, there are sixty-seven of them. I've X-marked the five names I recognized, and checked three others I found by some cross-referencing with the telephone book." She located the list among the other papers and handed it over.

Verity laid it on the desk and opened the yearbook beside it, Patience shifting her chair so that she could look as well. "Tom Bagley, and here he is. Big, pale, and earnest-looking, isn't he? No activities, aim was to get his own salmon boat. Maybe he made it, which is why I've never seen him. Greg Fong I don't know either. Transfer from Berkeley, it says here. Plans to be a cardiac surgeon."

"He runs Fong's Pharmacy. His father's originally, I think."

"Okay. Billy Galindo. Mean-looking guy. Wrestling; no life aims. But here," Verity said in pleased tones, "is Charlie Garcia, the world's nicest guy and best plumber. Auto Mechanics Club. Aim was to make a life with Mary. Which in fact he has, imagine that!"

"He's a fortunate man," said Patience.

"Okay, we come to Teresa Janacek. Sylvie told me you and she bought Ralph's rose bush from her. Did she grow into that interesting face?"

"Not really. Her name is Finch now, and she looks older than, what, forty-five. Weary. And not particularly happy. Definitely not in Charlie's league."

"Hmm. National Honor Society. Chorus, Orchestra and Chamber group. Musicals. Her aim was to go to Juilliard with her cello."

"Maybe the family business needed her," said Patience.

"Maybe. Now here's world-class dad Bobby Mendes," Verity said with a grimace. "Football. Baseball. Chorus, Musicals."

"I think he must be the son of Manny Mendes—Manuel Mendes, who owns that garage and service station on South Main."

"Ah, yes," said Verity. "Where I met Bobby some time ago. I told you about that."

"Yes, and it's too bad all round. Mr. Mendes is an honest, hard-working man. Sylvie says both his grandsons have good voices."

"And bad manners, Ricky at least. Says here Bobby's aim, apparently unrealized, was to play shortstop for the Giants. And from that we go on to one Jeanie Verducci. I met her daughter, a friend of Katy Halloran's, at the concert Friday night.

"Oh, my," Verity went on, "Jeanie was a busy girl. Listen up: NHS, Drama, Musicals. Prom Committee, Cheerleader, Tennis. Homecoming Queen. Her aim was Wellesley and then Georgetown Law."

"I'd guess *her* family needed her, too," said Patience. "Marilyn told me she was married to a man named DeMarco for a few years, but reverted to her maiden name afterwards."

"Verducci is an old name here," Patience went on, "sheep originally and now land and commercial property and other versions of money. I've never met Jeanie, but I know she's been on the city council for years, and rumor has it—Marilyn again—that she'll be mayor next go-round and then aim higher, probably the county board of supervisors for starters. Good Republican up-and-comer."

"Just what every town needs. So, on to Martha Young," said Verity. "Look here, is she earth-mother or sexpot?"

"I don't know that they're mutually exclusive," said Patience.

"Probably not. Chorus. Aim, to be a good mom to at least six kids. Well, hell, maybe she did just that and is happy as a clam. I've caught two more you didn't, Mom. Elizabeth O'Malley—see here?—is Liz Feldman of Peregrine Books."

Patience had a closer look. "So she is. Our good fortune."

"Now turn back to the *B*'s and look at Jana Burns. Isn't she the tall checker at Safeway? The one who tosses her head up all white-eyed like a startled horse? I always expect her to whinny."

Patience looked, and chuckled. "The very person. The name on her badge is Cardoza, I think." She turned the page, scanning faces, and stopped. "Verity, I'm not sure, but I think this one, Clare Makela, is the woman who owns Novak's Outfitters."

Verity came closer to peer over her mother's shoulder. "Beats me. I was in there only once and I didn't buy anything."

Patience scanned the rest of that page, turned it and the next and the next, the two of them examining the remaining faces. "Nope," said Verity finally, and Patience closed the book.

"So." She checked off the last two names and set the list aside. "Eleven names, and I think we'll stop there. That's better than ten percent of the total, which I suppose isn't a bad number for a small, rather poor town to have retained."

"Fifteen percent, in fact." Verity stretched and rolled her shoulders loose. "I dunno, Ma," she said, and flipped slowly once more through the pages of senior pictures, nearly all of them posed, formal, stiff.

"Look at those baby faces. Even Bobby Mendes. I wonder, how much responsibility does a person of, say, forty-five bear for something he or she did at eighteen?"

"That would depend on what it was he did. And perhaps on what he has done, or not done, since."

IF SHE HADN'T left Ronnie in the lurch for Sylvie's crisis the day before, Verity would have called in sick today. Heading reluctantly to her car, she heard a rustle and crunch and looked up to see Harley Apodaca burst through the bushes lining the north side of the lot and lope toward her.

"Harley, good morning. Problems?"

"Hi, Verity." He braked to a dusty stop, brushing leaves from his hair and shoulders. "I wanted to tell you I'll be in and out, mostly out, the next couple days, so just leave a message if you guys need me."

"Midterms?"

"God, I hope not! My mom just called to say she's coming home sometime next week." When she wasn't wandering the country-side in a motor home crammed with painting gear, Harley's artist mother lived in a small house on what remained of the family sheep ranch.

"And even if she stays part of the time with this old boyfriend, like usual, she wants her house cleaned up and aired out and like that. Which will take me a while."

"I can imagine," Verity said, trying to keep dismay from her face. Without Harley available as backup child-amuser, the next two days were going to be difficult. "Do we owe you any money?"

He shook his head. "Early this morning I sent Patience the stuff she'd had me working on, and she sent Sylvie over with payment. So we're square."

She put her laptop computer in the car and turned to give him a hug. "You give me a call if you need help cleaning house, okay?"

"Nah, I'm good with it. But thanks."

He departed, and Verity took his message to Patience in the basement office. "Bad news, Ma."

She listened, and sighed. "We'll survive—I hope. Harley's very proud of his mother, and she doesn't ask much of him."

"I haven't met her, but I've seen some of her work, and liked it a lot."

"You'd like her, too. A lesser person, raising a son like Harley on her own, would have turned him into a pet or a servant."

Verity looked at her watch and made a face. "I need to be at the restaurant in five minutes. And I'd planned to see some of the people on our list after work, if that's okay."

"Don't worry about Sylvie and me, Verity. We'll manage."

"And I'll carry the load tomorrow, okay?"

———//———

Lunch-seekers at Pure and Simple on Wednesday were mostly local, and for reasons known only to them, nearly all bad-tempered. Back to the kitchen came a plate of pasta with too much garlic, a grilled chicken breast declared underdone, a bowl of minestrone that "tasted canned." Too much rain, thought Verity, or too much frigid gray weather. Perhaps too many of them, like her, had slept badly the night before.

She'd hoped for a quiet moment with Ronnie, to ask whether her Jessica had had any trouble at school with the Mendes boys and find out what Ronnie, presumably the source of Sylvie's "slut" reference, might know about that clan. But Ronnie was as weary-looking and short-tempered as most of the patrons, growling sharp responses to questions and disappearing frequently to the bathroom or the telephone, leaving most of the cooking to Verity. When the last paying customer had departed and Ronnie had locked the street door, Verity went quietly but speedily about her remaining chores and was pulling on her jacket just after three-thirty when Ronnie said, "Verity? A minute?" and beckoned her into the now-empty dining room.

Prepared to apologize one more time for her abrupt early departure the day before, she watched Ronnie's fair skin flush even more deeply than usual as the blue eyes met her gaze and looked quickly away. Verity waited, caught between interest and mild dismay.

"I, um, I've decided to look for somebody more, uh, permanent. To cook lunches and help with dinners. And…I'm sorry." She spread her hands and fell silent.

"Ah, well, no need to be sorry. I've been fired from better jobs. May I ask, do you have my check ready?"

Ronnie's face grew even redder, giving Verity a moment's worry about her former friend's blood pressure. "Ronnie," she said more gently, "it's your business. You can hire and fire as you please. Just mail the check. And I'll probably see you around."

Ronnie wiped her sweaty forehead with the back of one hand. "No, I'm really sorry. The thing is, Margaret is putting money into the new place, quite a lot of money. And she's...unhappy."

"With me?"

A nod.

"Because of the job Patience and I are doing for Christina Larson?"

Ronnie gave a deep sigh. "She says it's going to upset people, cause trouble around town for no good reason. She says having you here will be bad for business."

"Tell your mother-in-law that by firing me, you've freed my time up for the investigation," said Verity with a wry grin. "Chris Larson will be pleased."

Ronnie managed a smile in her turn. "I'll tell her. And you take care, now."

Verity said she'd do that, and headed for her car, where she turned on engine and heater and sat for a few minutes in thought. Before leaving home this morning, she had put in a call to Jeanie Verducci at her listed residence phone. The response there was an answering machine, and Verity had chosen not to leave a message. Now she tried the number again, got the same response, and set the phone aside with a shrug. And mentally did the same with Bobby Mendes, for obvious reasons. This left nine people on her list, two of whom she knew personally.

——//——

Charlie Garcia, who had put the new bathroom in her studio some months earlier, was just getting out of his truck at his plumbing shop on A Street when Verity pulled up. Seeing her, he put both hands up in defensive posture. "I'm not responsible for leaks after six months."

"You society plumbers are all alike," Verity told him. "Charlie, do you have a minute, not about showers?"

"Sure, come on in. Better leave the door open, though; Mary went home early."

"It's not your body I'm after today, just your memory." She followed him inside and set the yearbook on the counter; he looked at it and then her.

"Nineteen seventy-three, back in the Ice Age. You want my autograph?"

"If this were mine, I would. You were the cutest guy in the book, Charlie, all big manly shoulders and shiny eyes and baby mustache. Yum."

He reddened, and grinned. "Whatever else you want, you got it."

"Thank you, sir. What's up here is that Patience Smith, Investigations is working for Christina Larson. She wants to know more about her grandfather, Edgar Larson, so I'm talking to people who were high school students when he worked there. Do you remember him?"

Charlie shrugged. "Sure I remember him. Stiff-necked old bastard who never played favorites. Didn't let the girls get away with any more than the boys, which made him different from some of the other old farts."

"He didn't give you any trouble?"

"Hell if he didn't. He caught me drinking beer in my truck one afternoon. It was late, gettin' on for dark, I thought he'd gone home. He called my dad instead of the cops."

"Ouch."

He rolled his eyes. "You bet."

"Did you hear the rumors about him? About molesting children?"

"Yeah. I thought it was a load of crap, and so did my dad. But— nobody thought it would end the way it did. Next time you see his granddaughter, tell her I'm still real sorry."

"Do you remember any feeling that there was turmoil around him, that he was making enemies?"

"Verity, I'm the worst possible person to help you, or Miss Larson, on that. I had about six after-school jobs, I was going steady with Mary, I didn't pay a whole lot of attention to anything connected with school except the classes. And not much to them. Sorry."

Verity picked up the yearbook. "That's okay. Thanks, Charlie. Say hi to Mary for me."

"If I can catch her," he said with a grin. "Four grown kids and three grandkids, and she's decided to go to college. I might have to learn to cook."

———//———

Peregrine Books was a small independent bookstore whose owner, Liz Feldman, maintained an eclectic stock as well as the usual bestsellers, and could rarely be stumped on a title or an author. Until yesterday's survey of the yearbook, Verity had not known that Liz grew

up in Port Silva as Elizabeth O'Malley, but the wild red—now gray-threaded—curls and freckled round face were unmistakable.

The bookstore was quiet. Liz was in the Children's Corner with a gray-haired presumed grandmother; a teenaged girl at the desk was handling the sale of a stack of paperbacks to another teenager. Liz, who had looked up at the sound of the door's polite bell, gave Verity a nod. Verity lifted a hand in a "no hurry" gesture and went to survey a table of new fiction, a display which reminded her that she was seriously behind in her reading.

Liz ushered the grandmother and her armload of books to the desk, turned her over to the girl clerk, and came to join Verity. "Lots of good stuff there," said Liz. "Do you have something particular in mind?"

"Several things, I think. But if you have a few minutes to spare, I also have some questions."

"I'm ready for a cup of tea. What about you?" At Verity's "Sure," Liz said, "Come along then. Ally, I'll be in back if you need me," she said to the girl at the desk as they passed.

The small back room was made smaller by stacks of cardboard boxes—of books, no doubt. A long counter running along one wall bore electronic equipment and piles of papers. The far end of the counter was a tea station, with electric kettle, teapot, tea bags, several mugs and spoons. Even, Verity noted, a lemon.

Liz filled the kettle in the rest room, plugged it in, set out two mugs. "Let's see. Darjeeling, Earl Grey, Irish Breakfast."

"Earl Grey, please."

"Coming right up. Have a seat," said Liz, gesturing toward the corner where a low table stood between two wicker chairs. In short order she set two steaming mugs on the table, took her own seat, and fixed an inquiring gaze on Verity. "Shoot."

"Thanks. Liz, I'm working right now for a woman named Christina Larson."

"I believe I've heard something about this job."

"I bet you have." Verity had a cautious sip of tea. "Chris lived here briefly as a small child, with her parents and her grandfather, Edgar Larson. After her father died recently—"

"That was sad news. He'd been missed in the book groups, but no one knew he was ill. Andy Larson was a truly nice man."

"I know. He was my soccer coach here, summers." She took another

sip, and explained Chris Larson's situation. "I should say that I'm fairly new at this game, probably not yet up to speed. I found out only yesterday that Edgar Larson was a parking-lot supervisor at the high school during his last few years. What I'm doing now is talking with people who were students then. Can you remember anything about him?"

Liz ran a hand through her curly hair. "I thought about this some, after seeing what I guess was a preliminary obit for Andy last week. Old Mr. Larson was very tall, with a bass voice that could rattle your bones. He called us 'young lady' or 'young man.' He hardly ever smiled and he hardly ever needed to yell." She paused to try her tea. Verity waited quietly, attentively.

"I lived out in the county; my dad was a vet with a large-animal practice. I drove to school in an old truck that I mostly used to pull my horse van. I was one of those horsey girls. Still am," she added with a smile, "and my daughter's the same, we have two Morgans and a foal on the way.

"Anyway, I had—have—no feel for engines, and that truck was always tricky to start. One afternoon when I couldn't get it going, Mr. Larson saw that I was having trouble, came over, and started it for me. He said I was flooding the engine, and showed me how to avoid doing that. He said—I just remembered this—he said some things took patience, and this truck was one of them." Liz buried her face in her mug of tea.

"This didn't turn us into friends," she went on after a moment. "He treated us all the same, firmly and from a distance. But after the word of the accusations got around, a couple of girls were going on about 'Ooh, I always knew there was something creepy about him,' and I told them to shut up."

"Do you remember whether they responded with anything specific?"

She shook her head. "They were just dumb sophomores being dramatic."

"Okay, here's an unpalatable question you may not care to deal with. Did you know any student, or hear of any, who'd had trouble with him?"

"Some of the kids—the ones who thought they should be able to have sex or get high in their cars—resented all the supervisors. But I don't recall hearing him singled out, and I never saw anyone in an

altercation with him. I should add, though, that I was more interested in my horses than I was in school, particularly during that last boring stretch of senior year.

"Then came graduation," Liz went on, "and everybody went off to summer stuff. My mother and I were in Canada visiting her relatives all of August, got back just in time for me to leave for college in September. I think that's when he died?"

"It was, yes," Verity told her. "So you don't know how the town or your former schoolmates responded to his suicide?"

"I don't think even my parents talked about it, at least in my hearing. I got very busy at college and didn't return here for anything more than a brief visit until, let's see, nine years ago. I was divorced, my father died suddenly, and I moved back with my daughter to take care of my mother. This was her store."

"Smaller, as I recall from summer book-hunts."

"It was. But I bought the building and expanded into the adjoining space."

"You've done a good job with it." Verity put her empty mug on the table and got to her feet. "Liz, thanks for your time. I hope you don't get rocks through your window for talking to me about Edgar Larson. I'm told that some of Port Silva's citizens think Christina is out to harm the town."

Ushering her guest back into the store, Liz gave an unladylike snort. "So screw them. The few comments I've heard about your investigation have been interested and for the most part friendly. In fact, the mystery reading group that I lead at the senior center, mostly elderly women, got to work on plot and motive and decided that a smear attempt against a healthy, well-off widower in his seventies probably came from a woman his own age whose advances he'd rejected."

At Verity's startled look, Liz said, quickly, "Sorry, I don't mean to be flip and they didn't either, really. But this is not quite the stolid, old-fashioned small town it was thirty years ago."

"I'm glad to hear that. Now, a professional question—your profession," Verity added quickly. "I've adopted an extremely bright, articulate, assertive little girl, now eight years old, whose reading primer was the Bible."

"King James, I hope," said Liz.

"I think so." Verity had a quick memory flash of the commune-

like setting called Christian Community, where seven-year-old Sylvie, who had misbehaved, was sent off with her Bible to read Proverbs for an hour. "Anyway, she loved *The Secret Garden*, but she was just a degree or two above lukewarm about Harry Potter. Could you suggest something?"

—————//—————

She left the store with a cheerful spirit as well as two books for Sylvie and two for herself: Margaret Atwood's *The Blind Assassin* and Richard Russo's *Empire Falls*. And time enough, she decided, for one more stop. She had an odd wish to get a look at the person that interesting-looking Janacek girl had become. Had she opted for horticulture over music from lack of talent? Of nerve? From family or economic necessity? Perhaps she made her plants happy by playing the cello for them.

The Janacek Nursery was on Miller Street in the third block off Main, and the building and its rows and rows of plants occupied most of that block, with the street in front marked for head-in parking. The sign on the front door read OPEN.

Verity stepped into a low-ceilinged room cluttered with a gardener's view of life's necessities. Seed packets and gardening books were on swivel racks, digging/planting/pruning tools of many kinds hung on a Peg-Board-covered wall. A stepped table displayed half a dozen small fountains, two of them burbling; another table was a kind of fern-island, with plants from tiny to enormous.

When no proprietor appeared, Verity decided she—or he—might be outside watering or otherwise plant-tending. She ambled past long tables lined with trays of bedding plants, trekked through rows of healthy-looking shrubs and baby trees, stopped to examine a group of big planter-boxes in which good-sized woody stems twined high around support poles or spread out over small wooden lattices.

She reached out to turn over a name tag and found that she was in a small forest of wisterias, as yet unleafed and unblooming but surprisingly expensive. Patience had been talking for ages about putting a wisteria beside the front steps. And she had a birthday coming up.

"I'm sorry," said a soft voice from behind her, and she turned to see a tall woman in jeans, denim shirt, and gardener's apron. "The girl who works here was called home unexpectedly, but if there's something that really interests you, perhaps I could help?"

With lank gray-brown hair straggling over her shoulders and blue eyes peering timidly from under the bill of a baseball cap, the woman looked ready to take flight at any loud noise. The compelling Slavic face had become gaunt and weathered, but its basic structure was still identifiable; this was definitely Teresa Janacek.

Verity donned a friendly smile and the stance and demeanor of a smaller, less assertive person. "I *am* interested in a wisteria, as a gift for my mother. Is it too early to plant one of those?"

"Oh no. Best to get it in before the rainy season is over. If you have a good sunny exposure for it, that is. Some gardeners will tell you this or that variety will bloom in shade, but mostly it's not true. Here, I'll show you what we have in the Chinese purple variety; it's wonderfully fragrant."

Verity trailed behind the the woman, listened to the virtues of age and training in such plants, and finally settled on a tall vine that had, said Ms. Janacek-presumably-Finch, been nursed and guided and pruned and generally cosseted for five years, which was why its price was two hundred fifty dollars. Verity blinked and nodded.

Inside the store, Ms. Janacek-Finch stepped behind the counter and Verity dug in her bag for her wallet. "Will you be able to take the plant with you?" asked the other woman. "If we have to deliver, there'll be a charge."

On top of that price? "I can come back tomorrow, or Friday, with a pickup truck," Verity told her.

"Fine." She ran the card through the machine, handed it back to Verity, filled out the receipt, and was about to hand it over for signature when she took a good look at it.

"Oh. Mackellar." She put the slip down on the desk and set a pen beside it. Then she stepped back and folded her arms across her chest, the bill on her cap shading her eyes.

Did she remember Patience from weeks ago? Or was she more up on local events than her demeanor would suggest? Verity signed for her purchase quickly, took a business card from her bag, and laid it beside the charge slip.

"I'm Verity Mackellar, and my mother is Patience Mackellar, of Patience Smith, Investigations. We're working for Christina Larson, who's trying to put together a memorial for her grandfather, Edgar Larson, as well as for her father, Andrew Larson."

Her listener stood like a statue.

"My original purpose here," Verity went on, "before I got swept away by wisterias, was to talk to you, as one of the members of the Port Silva High School class of 1973, about any memories you might have of him. You are Teresa Innocek?"

"I'm Teresa Finch. I didn't know Mr. Larson. My family lived close to the school, and I didn't have a car to drive anyway."

"But maybe some of your friends—"

Teresa Finch snatched up the charge slip, pulled off the customer copy, and thrust it at Verity. "I'll put a 'sold' tag on your plant, and you can come and get it when you want."

She opened the register drawer, dropped the charge slip inside, and slammed the drawer shut. Without another word or even a glance, she turned and disappeared through a curtained doorway into the back of the building.

And most likely would not be coming back any time soon. Verity went out the front door and found herself easing it quietly shut be hind her. In her car, she pulled her laptop computer from its niche in the rear, settled into her seat with it, and typed a terse rundown of her day's work; this last scene in particular, she felt, should not be left to fallible memory.

There. She turned the little machine off, slid it into its case, and leaned over to lay it on the floor in front of the passenger seat. As she straightened and reached for the ignition key, she glanced at the nursery and saw a hand turn the OPEN sign to CLOSED and pull a blind down over the window.

Verity told herself there was no reason to see this action as ominous. Detectives, private or not, no doubt experienced unpopularity regularly. She looked at her watch, started the engine, and headed not for home but back downtown. On a midweek day at nearly six o'clock, she knew where to find company and maybe even some advice.

THE SPOT, on a nondescript south-end side street along with the likes of a shoe repair shop and a medical supplies store, was a cops' bar in all but name. At this time of day, drinkers lining the bar or sitting at tippy, unmatched tables were mostly people who weren't expected home for dinner, either to cook it or to eat it. Verity pushed the door open, stepped inside, and paused to scan the long room.

"Hey, Mackellar!" Dave Figueiredo stood against the bar between two women, a zaftig blonde Verity thought was a dispatcher and a small, handsome Asian woman. A blocky, fair-haired cop whose name Verity didn't know stood nearby with an expression that said he'd settle for either one. "Buy you a beer?"

"Thanks, Dave, but I'm looking for..." Johnny, she realized. Except he wasn't here. She didn't even know that he came here regularly. "Oh, there she is." She gave Dave's outstretched hand a friendly palm-to-palm slap as she headed for the far end of the bar, where Officer Alma Linhares had stepped forward from a group when she heard Verity's name.

"Hey, Verity, how'd you know I'd be here?"

"Hi, Alma. ESP, I guess. Haven't you been out of town?" Verity greeted two men she knew, was introduced to a woman she didn't, and edged closer to the bar to order a glass of red wine. As she waited, Alma came to join her, beer mug in hand.

"Right, I've been out in the county for four weeks teaching self-defense and brush-up firearms courses. Just got back last weekend. So, what's up?"

"I've had a busy day with a strange ending, and I was looking for company, I guess, and maybe some talk."

"Let's grab a table in the back," Alma said when Verity had her glass in hand. She led the way, and settled into a wooden chair at a

tile-topped table, leaving the bench against the wall to Verity. "Back
here," she said, "if I'm tempted to talk out of line, nobody will hear
but you. So, did you offend somebody with questions about old Mr.
Larson?"

"Why am I not surprised that you know about Mr. Larson?" said
Verity with a grin. "And yes, I seem to have offended—or fright-
ened—Mrs. Finch at the nursery."

"Shit, Verity, don't take it personally. She probably thought you
were gonna blow your hot, frustrated breath on her plants." Alma
tipped up her beer mug for a long swallow. "How come you were talk-
ing to her, anyway?"

"Alma, you sure I'm not putting you in a touchy position here?"

"When you do, I'll let you know."

"Okay. Yesterday we had a break," she said. "We learned that in
the last few years of his life, Mr. Larson was one of several retiree-
volunteers who supervised the parking lot at the high school."

"And you saw some piece of mean teenaged shit behind the calls."

"I saw it as a possibility, the most likely I'd come across."

"And Mrs. Finch was a student then, I bet. Who else?"

Was this ethical or not? Verity wondered. Worse, would Alma's
opinions interfere with her own subsequent personal judgments? She
pulled the list from her bag and handed it over. As Alma scanned the
names, Verity picked up her wineglass and swirled the red liquid
around.

"Huh. Well, you wouldn't want to approach Bobby Mendes with-
out a whip and a chair. Guy has about eight hands and figures he's en-
titled to put 'em wherever."

"Right," said Verity, and Alma looked up with a brief grin.

"Jeanie Verducci, *my* mother has pointed out frequently, is a prime
example of a good Catholic daughter. Quit Humboldt State to come
home and tend to ailing parents, took over the family business and
made it grow, produced grandchildren. Don't know anything really
bad about her except that she's this teensy blonde who has a better
body at forty-plus than I did at eighteen. Fong is kind of a dweeby
guy who runs a very nice, very clean drugstore. Janacek-Finch's nurs-
ery is said to be the best on the coast. She's known to prefer plants to
people, and I bet you hit her on a day when there'd been too many
people."

She paused for breath, and Verity sat quietly in listening mode.

"Liz Feldman you know. And Charlie Garcia. Claire Novak runs a successful outdoor gear store, is not shy with her opinions and I bet she'll share them with you. I don't know Jana Burns Cardoza. All I know about Marty Young is that she tends bar at the Fisherman's Rest, and calls us in every now and then. Billy Galindo works sometimes for my brothers; he's dumb *and* mean. Tom Bagley's so full of brotherly love I'm surprised he can kill fish."

"Alma, thank you."

"Welcome." She glanced again at the list before handing it back. "I gotta say, from instinct and experience, those calls strike me as a female kind of trick."

"But one of the callers was male."

"Females often have male companions who do what their ladies tell 'em," Alma said, and pushed her chair back and got to her feet, empty mug in her hand.

"Let me get that," said Verity, rising as well.

"Trying to bribe an officer?"

"You bet," said Verity, and took mug and glass to the bar.

When she returned to the table in its still-isolated corner, Alma thanked her and said, "Hebert will be turning up here before long; we were gonna go find something to eat. Care to come along?"

Verity had a sip of wine and considered a possibility that had not previously occurred to her. "Alma, do you and Johnny have something going?"

Alma hooted, and looked around to see whether anyone had noticed. "Not bloody likely," she said, her voice low. "Johnny says that whenever the latest of my romances, if you want to call 'em that, goes south, I start eyeing him. But as he points out, that would screw up a good friendship as well as a good working relationship. Far as I'm concerned, you can feel free."

"I assure you *I* have *no* intention—"

"Except…" Ignoring this disclaimer, Alma frowned. "Maybe right now would not be a good time. His ex has just paid him one of her little drop-in visits—I *think* she's left—and he's tired."

Verity sat straighter. "Ex? I didn't know he'd been married."

Alma shook her head. "Not married. They lived together seriously for a while maybe five years back, when he was futzing around in grad school and she was finishing law school."

"And?"

"Johnny says that Nicola Abruzzi's idea of a productive discussion is to rip your arm off and beat you bloody with it and expect you to make up sweetly afterwards. Woman's a born litigator, I'd say. Anyway, Hebert the kind of guy who, if you hit him, doesn't hit back, just says *ouch*—ol' Hebert plain wore out on that kind of life."

"My God, Nikki Abruzzi!" It was Verity's turn to look around, and to cover with her hand the laughter that threatened. "The up-and-coming shark of the San Francisco prosecutor's office! I've met her, and my ex-husband sucks everything up tight at the very mention of her name. Johnny is lucky to have escaped with his life."

"His feeling exactly, so far as I can tell," said Alma with a grin.

"But she comes to visit him?"

"Hey, people are weird. What he thinks, she gets sentimental every now and then and checks back to make sure she didn't get it wrong."

"One of the things nobody tells you about life," said Verity, "is that nothing's ever really over."

"Until you die," said Alma cheerfully.

"Don't let the Baptists hear you say that."

There was a stir in the front of the bar, voices raised in greeting: "How's it going?" "Hey, how bad's the other guy?"

Alma said, "Here he is," standing up to be seen, and Johnny made his way back to their table. "Hi, Alma. Hello, Verity," he said, crinkling his blue eyes and curving his mouth in a smile of such sweetness that Verity knew exactly why Nicola Abruzzi kept checking back. But Nikki, all five feet and one hundred sexy pounds of her, had surely not put those bruises on his face.

"Johnny, what happened to you?"

"Nothing a glass of wine and a meal won't cure," he said. "How about Gino's? It's only three blocks from here, we can walk."

Verity got to her feet, handing him her half-full glass. "Zinfandel," she said. "You can finish it while I go find a quiet place to call Patience and tell her I'll be home when I get there."

———//———

"A group of local young toughs—some of them high school kids, some graduates or dropouts—have been hassling homeless guys here in town," Johnny said as they were working their way through two large pizzas and a bottle of chianti classico.

"Yeah, the little bastards," said Alma. "I collared two last week, but they were on the street again in about fifteen minutes."

"This afternoon, temperature in the mid-fifties and clear skies, it seems the guys heard rumors of a homeless camp on the dunes north of MacKerricher, and decided to drive up for a look. They were not well received." Johnny reached for another slice of pizza.

"The sheriff's people handled it, I was along because I'd been keeping an eye on one particular kid. Fortunately, the only weapons were fists and chunks of driftwood, and I think one guy had a tire iron," he said.

"Sylvie had a hassle with some *very* young toughs yesterday," said Verity. "And defended herself with a basketball." Telling the rest of the story, she caught Johnny's expression and put a hand on his arm. "She's okay and we're dealing with it."

"Mendeses running true to form," said Alma. "Sylvie's what, eight? That's old enough to start aikido. I'll look around and see who's teaching kids' classes."

As Verity reached out to snag the last prosciutto-topped slice, the brick pizza oven at the rear of the room hissed and flared, and she jumped. And remembered. "Johnny?"

He met her gaze. "Something?"

"Information, if you don't mind. Do you know whether there's been a decision on the fire at the Larson house?"

"I guess you could call it a sort-of decision," he said with a shrug. "Nobody saw or heard anything that night. If there was evidence of intrusion by anybody other than Strauss, the fire and the firefighting destroyed it."

"I drove by for a look yesterday," said Alma. "Just a burnt-out, falling-down mess, really sad. If you like old houses, which I do."

"So unless something else turns up, it goes down as mischief or mistake by a sick man who was also very drunk. Poor bastard." Johnny picked up the wine bottle, to split the remaining couple of ounces between Verity's glass and Alma's.

"It's still early," he said. "Anybody up for the movies? *O Brother, Where Art Thou?* is playing at the South Main Cineplex."

———//———

The three cars were parked within a block of each other near The Spot. Verity reached hers first, said good-bye, climbed in and just sat there for a moment. Friends and pizzas and movies, normal pleasures that had become rarities in her life without her noticing. She locked the doors, turned the heater on, gave the wipers a chance to clear

the fog-misted windshield, and circled the block to get back on Main.

She headed north through the quiet of a midweek night, feeling perfectly sober but hoping not to have to prove it in a breath test. Lights behind her, widely spaced; lights coming at her, politely dimmed. A car pulled ahead of her out of the Safeway lot; another pulled in behind her from a side street and soon turned off again.

North end of town now, traffic lighter still. From a side street to her right, a truck shot across in front of her and turned to head south, braked with a squeal of tires, and she thought made a U-turn. Yes, the lights behind her now, a high old pickup, white or anyway very light in color. Under the streetlight at the next intersection she could see two sets of heads and shoulders in the truck, one higher than the other, both short-haired, probably male.

Ordinarily she didn't think of Port Silva as plagued by rowdy teens, but Johnny's tale tonight was uncomfortably fresh in her mind. The truck was staying close behind her own much lower vehicle and the occupants seemed to be leaning forward, watching for her reaction. She increased her speed, thought about swinging off in the direction of the police station, decided not to be a wuss, and simply continued on her route, shoulders square and tight, gaze straight ahead. She took her right hand off the wheel just long enough to fish her cell phone from the bag on the passenger seat.

The truck came closer still and she braced herself as its lights flooded the Subaru's interior and glared off the mirrors. No contact yet, but she could imagine the crunch she'd feel at the first road-bump or pothole. She resisted the urge to brake, to swerve, to stomp the accelerator, and instead increased her speed just slightly. She'd whip off to the right at whatever the next... The big cedar tree surprised her, loomed like a lighthouse, and she swung hard right onto Raccoon Lake Road, floored the accelerator and heard the bray of a horn and a blast of raucous laughter as the truck shot past the turnoff and rattled away north.

Verity braked, slowed, turned into her own yard and turned off the engine and sat there for a minute, maybe two minutes, taking deep breaths and waiting for her pulse to slow. What the hell was that all about?

Teenage stupidity, probably. She gathered up her belongings and purchases and got out, and since there was light in the living room, headed for the house rather than the studio.

"A pleasant evening, I hope?" Patience, on the couch with a book in her lap, looked up with a smile that faded at once. "Oh, dear."

"I had a dandy time until the drive home, when some asshole teenagers in a pickup tried to scare me to death." She dropped into the wing chair. "Unfortunately, the little bastards were so tight on my back bumper that there was no way I could see a license number. Not," she added with a sigh, "that I gave it much thought at the time.

"Anyway, I promised you I'd take care of Sylvie tomorrow, and I came in to tell you I'll have the entire day to do it, since Ronnie fired me today. Not her choice, her ma-in-law insisted," she added quickly.

"Sylvie will be pleased," said Patience. "And to be honest, so will I. Make sure you find time to call in a description of that truck and its occupants."

CHAPTER 13

"THAT'S A BRIEF rundown of what I've found out so far," Patience said. "If you like, I can put it into the form of a preliminary report and you can pick it up."

There was no hesitation at the other end of the telephone. "No, don't bother with that," said Carolyn Duarte. "I'm real pleased with what you've told me, makes me pretty hopeful. I'd rather you just keep digging."

Patience resisted the temptation to caution her client about those hopes. The Laytonville connection was still to be explored. "Thank you, Carolyn. I'll do that, and probably call you on Monday."

She hung up the phone and checked her watch. After two days at home, Sylvie had pointed out forcefully that she was supposed to go back to school today, Friday. It was now almost noon, and so far as Patience knew, there'd been no trouble at school. So far, so good.

Time to clear the decks here. Patience made it a point to avoid both the downtown office and the professional telephone on weekends; her ad in the Yellow Pages listed her hours as ten to four Monday through Thursday, by special arrangements on Friday, and she stuck to that schedule for anything except emergencies.

A knock at the door startled her, since she'd made no special arrangement for this afternoon. As the knock was repeated, she went reluctantly to answer.

The woman standing outside was taller than Patience only because of her spiffy high-heeled boots. They went nicely with a Burberry all-weather coat, trim leather gloves, and smooth blond hair. One of the gloves came off to permit the caller to reach out a manicured hand.

"Good afternoon. I'm Jeanie Verducci. If you're Patience Mackellar, of Patience Smith, Investigations, I believe you left a message on my machine this morning. May I come in?"

A hackle-raiser, this one; Patience felt her own neck-hairs bristle just a bit. She touched the extended hand briefly with her own and stepped aside. "Please."

Ms. Verducci came in and cast an assessing look around before sitting down in the visitor's chair. "This building is one of my company's properties. I can see that some renovation, or at least freshening up, might be in order."

And how long would that take, and what would it cost? Patience moved back behind her desk and sat down. "It's a bit drab, but my business isn't one that benefits much from window-dressing, and the rent and location suit me very well."

The other woman pounced. "Your 'business' has some unsavory aspects my property manager didn't anticipate. The work Christina Larson has hired you to do is a witch hunt and will produce nothing but turmoil and ill feeling."

"I find 'witch hunt' a poor choice of words," said Patience. "Ms. Larson believes her grandfather was driven to suicide years ago by false accusations of child molestation, and she wants to see his good name restored."

"And she has the money to pay for that."

"She hasn't yet offered a reward," said Patience sharply. "But perhaps she will."

"Oh, Lord. That will surely put us right on the map."

"Possibly. Of course, although she doesn't believe it will happen, Ms. Larson is aware that an investigation might turn up corroboration of the accusations."

Jeanie Verducci winced—prettily, thought Patience. "The result hardly matters to the town once the media is involved. Your city council, Mrs. Mackellar, has been working hard on proposals for grants for civic improvements, and we have a Small-City Governments conference scheduled here for September. Groups handing out money tend to flee any scene where there's public blood-letting going on, and conventions go elsewhere."

Patience wasn't interested in a civics lesson. "Ms. Verducci, did you know Edgar Larson?"

"I knew who he was, because he was a friend of my grandfather's. I may have spoken to him a time or two in the high school parking lot; I'm sure you've learned that he worked there as a volunteer."

"Were you surprised by the accusations?"

"I've been thinking about that, and I don't believe I even heard of them until long after school was out. There certainly wasn't any noticeable buzz among my friends. The second semester of senior year is a crazy busy time, and I don't remember much about it." She got to her feet, and Patience did the same.

"Mrs. Mackellar, I think your quest is bound to be fruitless as well as troublesome. Even if the accusations were false, or malicious, the person who made them is probably long gone, or even dead."

"Like Mr. Larson, and his reputation? It's possible."

She settled her shoulder bag into place. "Well, you're within your legal rights to pursue the matter."

"Yes, I know."

This drew a tooth-baring grin, the most direct reaction Jeanie Verducci had shown yet. "I'm sure you do. And you have a perfectly good lease on this office, although NorCoast could probably get relief from that in order to deal with seismic problems."

"No doubt. In that event, NorCoast should contact Fred Lundberg, my attorney. I appreciate your coming by, Ms. Verducci. Yours is another name I can cross off our list." Of what, she didn't say, and Verducci didn't ask.

Patience ushered her to the door, closed it after her, and stood there a moment, wondering. How busy would you have to be to miss noticing that a friend of your grandfather's had been accused of being a pedophile?

———//———

In the parking lot facing the estuary and its breakwater, Verity finished the last bite of deep-fried halibut, scraped the take-out box for two elusive chips, then rubbed her fingers clean with the half dozen napkins she'd sensibly brought along. Maybe she could look at reduction of her list as the whole point of this operation. By that standard, she was making a lot of progress even after taking Thursday off to spend with Sylvie.

Greg Fong of Fong's Pharmacy was a slim, cheerful man with very clean hands who had only vague, pleasant memories of the single year he'd spent at Port Silva High School. The students were friendly but busy, the parking-lot guards older gentlemen doing a needed job. Verity put Fong down as someone who'd had no problem with authority and seemed incapable of malice.

She'd found Jana Burns Cardoza on a bench behind Safeway

snatching quick puffs from a joint, and her "Fuck off, I'm on my break!" set the tone for the rest of the exchange. Tall and near-gaunt, she had a face older than her forty-five years with malice written all over it. The school had been the pits, the students sucked, the old limp-dicks in the parking lot were always looking to cop a quick feel—all of them one no-name gray face, and she'd never heard about any molest accusations. Scratch Cardoza.

Scratch Billy Galindo. At home with a bottle of beer in hand at eleven-thirty in the morning, he'd remembered very little about his senior year at high school, describing himself as "wasted most of the time." He didn't recall hearing the accusations against Edgar Larson—he had no specific memory of Edgar Larson—but if he'd known about it, "I'd have beat the shit out of the old perv."

And then she'd driven here to the wharf to look up Tom Bagley, where a man hosing down a boat told her that Tom and his *Mona May* were working off the Washington coast currently and would probably not return to port here for several weeks. Alma had considered Tom an unlikely source, and Verity didn't think he was worth a trip out of state, at least not at this point.

She drew actual lines through those names on her list, and looked at her watch. She'd drive back up to Cap'n Jack's on the wharf, where she'd bought lunch, and use the rest room there before proceeding to the next interview.

———//———

"I wondered when you'd get around to me." Clare Novak was about five feet tall, and khaki pants and a plaid wool shirt did nothing to flatter her broad hips and heavy breasts. Probably they weren't meant to, thought Verity; the woman looked as if she could run straight up a mountainside and was prepared to teach soft-bellied flatlanders to do the same.

Now she tucked Verity's card into her shirt pocket. "Come on back to the office. Jeff?" she called, and a tall man helping a smaller one buckle on a backpack turned with a questioning glance, caught her gesture, and nodded. Verity followed Mrs. Novak past parkas and rain gear, hiking socks about ten thousand pairs, stacked boxes of boots and Teva sandals, and finally into a small office. Mrs. Novak closed the door and turned to face her visitor.

"I am not the person who accused Mr. Larson of molesting children. If I'd seen him do something like that, I'd have grabbed the kid, kicked the old guy in the nuts, and hauled ass to the police station.

And no, I do not have any idea who might have made those charges.

"Port Silva was a small school," she added, "and while we were probably at least average in percentage of assholes, I didn't know anyone I'd have suspected of that kind of malice. Unless, of course, it was true."

"There's always that possibility," said Verity.

"After I heard about your quest, I guess you might call it, at the Small Business Owners meeting Tuesday evening, I gave some thought to 1973, not one of my better years," Mrs. Novak told her.

Not Edgar Larson's, either. Verity held her tongue with some effort.

"What I remembered is that I liked—no, appreciated is a better word—Mr. Larson, because nothing got past him. I was an unattractive teenager with a high I.Q. and a big mouth, natural prey for teenaged boys. When Mr. Larson was on the job, nobody grabbed my ass or lobbed eggs at my windshield." This said with a quick grin.

"How does anyone survive high school?" Verity wondered aloud. "Mine had around twenty-five hundred students, and I always had this dream that smaller would have to be better."

"In towns or schools, smaller isn't necessarily better or worse, just more goddamned personal," Mrs. Novak said rather grimly. "Which makes it unlikely that real animosity toward Mr. Larson would have stayed beneath the radar on our little campus. I can only wish you well while feeling that you and Miss Larson are most likely wasting your time."

"You're probably right," said Verity. "Thanks for *your* time and thought. And I'm glad you've had better years."

Another grin, broader. "I spent some time working with Outward Bound before going to college. Did wonders for my self-confidence as well as my skills."

Nothing new there, thought Verity as she returned to her car, nothing at all to account for her almost cheerful feeling—except that Novak was somehow a clincher. One more connection to attempt, and then she'd call it a day, and a job.

A cell phone call to the number listed for Marty Young produced the same message Verity had heard earlier: "Hi. Leave a message for Jase, Sam, or Marty." She put the phone away. Maybe she'd drop in later at Fisherman's Rest, a local bar of shady reputation that she'd never had occasion to patronize.

—*//*—

At home, Verity loaded the CD player with what she thought of as Big Girl Music—Dixie Chicks, Shelby Lynn, Lucinda Williams—and went to work pulling together her final, or almost final, report to Chris. The "almost" was not stated, but a silent memo to herself; she had not yet talked with Marty Young or, more importantly, one Robert "Bobby" Mendes; according to his father, Bobby and Ricky were visiting relatives in Sacramento. And so far as she knew, Patience had not yet connected with Jeanie Verducci.

Looking over the whole, she had a brief flash of guilt: not much here for her expenditure of time, and of Chris's money. She could console herself only with the fact that she'd told Chris from the start that success was not likely. As she hit "Save," it occurred to her that she'd not heard the school bus, although it was almost four.

"Shit!" This very morning Sylvie had come to the studio door to remind a half-awake Verity that today was Friday, chorus day, and there would be no bus after. Verity had promised to be there to pick her up, and if she got her ass in gear immediately, she wouldn't be late, or not very. She closed down the computer, snatched up her leather jacket and bag, and hurried out to her car.

The school was weirdly quiet when she pulled up in front: no buses, no crossing guards, few lights in the building. Three cars in the parking lot. As she parked and got out, two figures appeared from the recess of the entryway, where they'd apparently been sheltering from the brisk and chilly wind.

"Verity, here we are! Robby said he bet you forgot, but I knew you wouldn't." Sylvie's jacket was zipped high, her nose and cheeks pink. The figure beside her, several inches shorter, was huddled deep in a too-large padded jacket, looking like nothing so much as an upright turtle. A turtle with very red ears, she noted.

"Hello, Sylvie," she said with a hug, and then, "Hello, Robby. Is your ride late, too?"

Robby Mendes cast a quick, agonized glance at Sylvie and then pulled his head even deeper into his shell.

"Robby walked home, he says it's really close, but there wasn't anybody there."

"My mother was supposed to get home today," he said in a near-whisper. "Or my brothers would come and get me. But she didn't, and they didn't."

Now what? Verity felt sorry for the poor waif before her, but she

was deeply reluctant to assume any responsibility for a child of Bobby Mendes. Trouble would surely ensue. "Should we go in and ask Ms. Rankin to help?"

"Ms. Rankin isn't here," said Sylvie cheerfully. "She usually goes home before chorus is over."

Verity glanced at the parking lot. "There are cars. Somebody must be here."

"Janitors," said Robby. "And a guy who's working on the roof. It leaks."

"Verity, I said he could come home with us and have a snack. We're both really hungry."

"Sylvie…" Verity began, and unwillingly looked again at Robby. He looked cold, and hungry, and miserable and abandoned. Damn his people anyway, and they'd probably charge her with abduction.

"Okay, kids. Let's get out of the cold." She ushered the pair to the car, where Sylvie showed Robby into the backseat and then climbed in after him. "What we'll do," said Verity as she settled behind the wheel, "is go by Robby's mother's house again. And if she's still not there, we'll go to his grandfather's service station and try to find out what's happening." A glance over her shoulder showed Robby still miserable, Sylvie on the edge of argument but deciding not to plunge over.

"Buckle up," Verity ordered, and didn't move the car until they had obeyed.

Robby's mother's house, a white-painted wooden bungalow with a wide porch, was dark and silent; Verity was not surprised when her ring was not answered. "Next stop, Grandpa's place," she said on her return to the car.

The service station was awash in Friday-afternoon customers, presumably all gassing up for a weekend trip. Verity pulled up near the door of the garage, said, "Both of you stay right here," and went inside to find two men hovering over a late-model sedan with its hood up.

"Excuse me?"

The man in wool slacks and a toggle-fastened woolen jacket paid no attention; the man in coveralls wiped his greasy hands on them and came forward. "Uh, ma'am, we're kinda tied up right now, but if you'd like to wait—"

"I'm looking for Mr. Mendes."

He shook his head. "Manny's out with the big tow rig. There was a

bad smash-up just south of the bridge, and he's helping the highway cops pull the pieces apart."

"Look, Mr.…." She read the name tag on his coveralls. "Eddie. I'm Verity Mackellar, and I have Mr. Mendes's grandson, Robby, in the car with my own little girl. Someone was supposed to pick him up at school and didn't show."

Eddie was shaking his head even more firmly. "Sorry, ma'am, but this is no place for a kid right now. There's just two of us here, and we're ass-deep in work, with more on the way."

Verity bit her tongue against a retort. A look around the place made it clear that Eddie was quite right, and a glance at her car showed her Sylvie's now-very-worried face. "Eddie, please give Mr. Mendes this when he comes in." She dug out a card and scrawled the home phone number on the back. "Ask him to call me, so I can make arrangements to bring Robby home."

"I'll sure do that. And I'm sorry for your trouble, and the boy's."

"Robby, your grandfather is out helping clear up a wreck," Verity told him when she'd settled back behind the wheel. "I left a note asking him to call me when he returns. For now, if it's okay with you, we'll take you home with us."

"Sure, that's okay."

"Good." She edged out of the busy lot and into end-of-day, end-of-week traffic on Main Street, which was also State Highway One. As she saw the sign announcing the next intersection as Miller, she remembered the nursery, and her recent purchase. Perhaps she could arrange to have the wisteria delivered tomorrow, Saturday. "Hang on, kids," she advised her passengers, and turned onto Miller. "We're going to make what I hope will be a quick stop."

The head-in parking area in front of the nursery was totally empty. Verity pulled into the space nearest the door and saw that the CLOSED sign was in the window and the blind was once again—or still?—down.

Friday afternoon did not strike her as a sensible time for a nursery to be closed, not with what looked like a good gardening weekend coming up. Some kind of family emergency, perhaps. Putting her own sense of unease down to the fact that she had two hundred fifty dollars invested in a plant inside this shuttered establishment, she turned off the engine and reached for her bag.

"It's closed," said Sylvie.

"So it is. But I think I'll leave a note for Mrs. Finch and ask her to call me."

"Tessa's a nice lady," said Robby. "My daddy knows her."

"Really?" Verity wrote, "Wish List? Call me," and the number on the back of her card.

"Yeah," said Robby. "I think she maybe used to be his girlfriend or something, a long time ago. He's had lots of girlfriends."

"Is one of them named Lori?" The question came unbidden from somewhere in the far reaches of her mind, and when Robby said, glumly, "Yeah. I don't like her," she felt like a rat for having taken advantage of a child. But at least she now knew the reporter was the likely source of Mendes's information and attitude. "Be right back," she said, as she climbed out once again and went to wedge the card between the nursery's door and its frame.

———*//*———

Shortly after six o'clock Patience came in the front door, several bags in her arms. She dumped her burdens on the kitchen table with a sigh of relief, hung up her coat, and sank with a gusty sigh into the nearest chair. "I think I'd rather scrub floors than go shopping."

"Agreed," said Verity, who was stirring a pot at the stove. "What were you shopping for?"

"Oh, this and that. New walking shoes. A new bathrobe. A couple of silk turtlenecks to wear under sweaters. Could you take time to pour your poor old mother a drink?"

"A real drink?"

"Indeed."

Verity put ice cubes in a stubby glass, opened the door of the old-fashioned ice-box now serving as a liquor cabinet, and picked up the bottle of The Macallan. She poured some over the ice, swirled it a bit, and handed it to her mother.

"Aaahh," said Patience after a sip. "Help yourself if you like, dear."

Verity shook her head. "I'll settle for a little vino later, thanks. What's the occasion for the new stuff, Ma?"

"Oh, dear, I should have cleared this with you. I have a line on the most recent whereabouts of Miss Duarte's niece, and I've talked Hank into driving to Laytonville with me tomorrow to check it out. He's good friends with the deputy who runs the sheriff's substation there."

"This needs a new bathrobe?"

"Hank has another friend who runs a nice motel and restaurant further up the highway, in the redwoods. We thought we might have dinner there, maybe spend the night and come home Sunday."

Motels yet. Verity hadn't seen the inside of a motel in the company of a male in—she couldn't remember how long. Too long. "I gather," she said carefully, "that you and Hank are, um, friendly again?"

"Hank and I were never *un*friendly," said Patience. "Hank's youngest daughter got married at eighteen and now has three children under five and a fourth on the way. For the past several weeks she's been staying with Hank while the husband...well, something's amiss with the husband. I don't ask."

"Wise of you."

Patience had a sip of scotch. "Anyway, Molly's terrified that I, or someone like me, will snatch her father away. She told him he should keep himself pure in loving memory of Ellie."

"Good God."

"That's *her* line. And here's *my* problem," she added, with a sweeping gesture at the space around them, her comfortable but quite small house whose two bedrooms were separated only by a bathroom, all three opening onto the same tiny hall. "When Hank stays overnight I feel like a misbehaving teenager, which oddly enough is not a lot of fun at my age."

"Well, I don't have anything interesting lined up for the weekend, so you go off and have a blast."

"Thank you, dear." Patience had another sip of scotch. "Where's Sylvie?"

"Out in the studio playing with a friend."

"That's nice. What friend?"

"Robby Mendes."

Patience sat bolt upright and put down her glass. "Mendes? Verity, is that wise?"

Verity flinched. "I almost forgot about Friday chorus, so I was late. By the time I got to the school, Robby and Sylvie were huddled in the doorway like two little waifs, the whole staff had left, and nobody had come for Robby."

"So you kidnapped him?"

"Come on, Mother! For one thing, Sylvie was determined to rescue him. We went by his house and there was nobody home. At Mendes Chevron, we learned that his grandfather was at an accident

scene and the two very busy men at the station didn't want the responsibility.

"So," she said with a helpless shrug, "I left our number and asked Mr. Mondou to call. And right now I'm about to feel the implants."

"Forgive my tone. I'd have done just what you did. But it makes me edgy." Patience got to her feet and took her drink to the fridge, to set it in the freezer. "This will keep. Hank says that Bobby Mendes and his first wife were regulars on the department's domestic disturbance list, and the two original sons were often left to their own devices. Mr. Mendes told me they live somewhere near Boonville now, with *their* mother, and are—troublesome.

"So Robby's odds aren't good," she added. "Is there anything I can do to help with dinner?"

"No, thanks. Fortunately there's always pasta sauce in the freezer."

"Then I think I'll go have a long soak in the tub."

In the kitchen forty-five minutes later, Patience met Robby Mendes. Half a head shorter than Sylvie, he had a round face with a dusting of freckles over a small nose, and wide hazel eyes with a worry-line between them. He ducked his head upon being introduced and muttered, "H'lo."

"I just had a call from Mr. Mendes," Verity said. "He thanked me for my help and asked me to bring Robby to him at the station. So let's go, kids." She handed the little boy his jacket, and he put it on with a silent obedience that somehow conveyed despair.

"It was nice to meet you, Robby. Come again," Patience said, and watched him trail Sylvie and Verity out the door. Poor little mite.

CHAPTER 14

"SEE, I PUT IN everything in case I get really wet." Sylvie held out her backpack for inspection. When Ronnie Kjelland called to invite Sylvie to join Jessica and her father on the Saturday-morning tide-pools walk at MacKerricher State Park, she had advised bringing a change of clothes.

"Fine," said Verity. "Now the main rule is: Never turn your back on the ocean. Beyond that, be sure to do what Russ and the ranger tell you."

"Verity, I know how to be good."

"Oh, sweetie, of course you do." Verity hugged her and planted a kiss on her cheek, where Tuesday's scrape was now only a faint red mark. "You just have a good time. Ronnie will give you and Jess lunch afterwards and I'll pick you up at the restaurant."

"Okay." Sylvie shrugged the backpack on. "I hear a car. "

Verity followed Sylvie out the front door as a big red Jeep pulled up. Russ Kjelland got out, Sylvie climbed in, Russ leaned inside, prob-ably to make sure of seat belts. Then he waved, called out, "I'll take good care of her," and away they went.

"Bless you," Verity said aloud. Russ Kjelland was a tall, quietly observant man who clearly adored his daughter. In Russ's care, Sylvie would be safe from anything but a tidal wave or an earthquake.

When the Jeep had disappeared, Verity went back inside to take a final look at her report for Chris Larson, to which she'd just added Patience's observations about Jeanie Verducci. It was time to ship the whole thing off, with a phone call first. Miraculously, the phone was answered not by a machine but by Chris herself.

"Hey, I was going to call you. How are we doing?"

Verity took a deep breath. "I think we've almost run out of options."

"How so?" demanded Chris.

"It's not going anywhere, Chris. We've talked to a lot of people, and if your grandfather wasn't generally loved, he was respected. By older people, by the kids at the high school when he volunteered."

"But somebody…"

"Right. Somebody made those accusations for private reasons, honest and misplaced or just malicious. But we can't question every local person as well as those who no longer live here. There's no trail."

"What about the bastards who burned down my house?"

"Apparently the fire was set, accidentally or not, by the mentally ill man who was found dead there."

"Bullshit," she snapped. "Your fire department is about as efficient as your police force. And what if I want you to keep trying? There must be more people to talk to, people you haven't found yet who knew my grandfather."

"Read the report, Chris, and call me tomorrow. Patience will be back by midday, I think, and she's more experienced than I am. On a positive note, I got some nice anecdotes from people who did remember your grandfather, including the students. I think they'll be a fine addition to the memorial you promised."

"Yeah, I haven't gotten around to that yet. Verity, don't think I'm giving up. I plan to come back up there, maybe Monday."

Please count me out. "Fine, Chris. I'll look forward to seeing you." Verity hung up, considered doing thirty laps around the table and twenty push-ups, decided instead to log on and get the thing sent. Then she'd have time for a real run before going to collect Sylvie. "Hurrah!" she said loudly to the world at large.

———//———

"The girls had a great time," Russ Kjelland told Verity as he handed her Sylvie's backpack. "That kid of yours is a sponge for information; you're going to hear more about sea creatures than you could possibly need to know. And the ranger says Sylvie broke the universal rule today."

Verity grimaced. "I'm sorry."

He grinned. "No, she's apparently the first little girl who did one of these walks and didn't say 'eeuuw' even once."

"Bye, Jess. Thanks, Ronnie," Sylvie called over her shoulder as she came out the door of Pure and Simple. "Hi, Verity! Oh, Russ, thank you for taking me, it was really interesting."

"We saw everything," Sylvie said as she buckled herself into her seat. "Sea stars, that's what you're supposed to call starfish. And jellyfish, the ranger says they're a lot more interesting in the aquarium in Monterey and we should go see them there. Could we? And a whole lot of little guys that look like teensy blue boats with white sails. They're called by-the-wind sailors or—wait a minute—*Velella velella*. Isn't that neat? Sometimes a whole bunch of them, hundreds and thousands, get blown in to shore and can't get back to the water and they die. Poor things. But then they stink."

"Wonderful." Verity drove around the block and headed off toward home.

"Verity!"

"What?" She hit the brakes, bringing an indignant honk from the car behind her.

"Please, could we stop here? All these people, I bet it's what Jess told me about."

The morning's brisk but sunny weather was beginning to gray around the edges, but people were out and about on Main Street anyway. In the block ahead, where the sidewalk widened into a kind of mini-plaza before a bookstore and a big hardware store, a small crowd had gathered around a forest of large cardboard boxes, small cages on tables, temporary wire pens. Weaving in and out through all this were dogs of various shapes and sizes, on leashes with humans attached.

"Oh, right," said Verity. "It's the once-a-month thing about homes for pets. Why not?" She found a curb spot in the next block and pulled into it.

"Jess really likes cats, but they can't have one because her dad is allergic. So she goes to the animal place, the Humane Society, to play with the kittens, and some of her kittens will be here today looking for people. Can I go see?"

There were children running about from toddler size to probably ten or eleven years old, and adults were mostly standing around keeping an eye. There was also, Verity noted, a sidewalk sandwich cart. "Okay, go have a look. I'll stay here and get myself a sandwich." Turkey and smoked provolone on focaccia was what she got, and she ate it leaning against a warm brick wall, watching Sylvie's shiny black hair as she moved from one cage or box to another.

Did Sylvie like cats? Did she want a cat? Might not be a bad idea, since she missed Ralph the terrier greatly but was oddly resistant to replacing him with a puppy.

Verity was finishing the last bite of her sandwich when Sylvie ran up, eyes shining. "There's something you have to see."

"Okay." She tossed the sandwich wrapper into a trash can, had a final swallow, and did the same with the plastic water bottle.

"Come *on*, Verity!" Sylvie grabbed her hand to tow her, past three tiger kittens trying to climb out of their box, past a teenaged girl with a blue-eyed Siamese on a leash, around a wire cage where a pantherish mother cat nursed a row of equally black kittens. "Cute," said Verity.

And on to the dogs. One box held three small sleeping puppies, smooth-haired and spotted, next to a pen containing a rolling tangle of fuzzy brown larger puppies with long ears and big feet.

"Sylvie. Wait a minute. You said you didn't want another dog yet. And Hank promised to save you a yellow Labrador puppy from Bess's next litter if you're ready then. Bess is a wonderful dog, and she has lovely puppies."

"I don't want a puppy."

"Then what...?"

"Over here." Sylvie moved down the wide sidewalk past a gray-muzzled but trim Beagle, past a medium-sized shaggy mix of some kind.

"Here." Sylvie marched up to the dog she'd apparently fallen for, and Verity winced. Tallish and muscular, with a big head, furrowed brow, pointed muzzle, large upright ears. Chesty, with narrower hindquarters and a tail that half curled over his back. Male, definitely. The short but faintly plushy coat was mostly dark brown on his head, mottled brown-tan-white over the rest of him. To Verity's worried eye, he was neither handsome nor particularly friendly-looking.

On a leash held by a rangy, gray-haired woman in jeans and sweatshirt, the dog had his head up, as if testing the air. He ignored other dogs, looked briefly at each human passerby and looked away. When he caught sight of Sylvie, the head lowered, the tail waved in dignified fashion, and the whole tight body quivered just slightly.

"See?" said Sylvie. "He needs me."

"Sylvie," said Verity, and with no idea what to say next, turned to look at the dog's owner, or handler.

"Zak is a bit over three years old, neutered, healthy, housebroken, and obedience trained," said the woman. "I'm Karen Selby, by the way. Part of the group that works with the animals."

"Verity Mackellar. And this is Sylvie. What is the dog, anyway?" Apart from big and fierce-looking.

"He's half Akita, the other half not known but something smaller and lighter-boned. Zak weighs only seventy-five pounds. He belonged to a ten-year-old girl whose family moved to England and decided it would be too difficult to take him."

Only seventy-five pounds? "Akita. Isn't that a Japanese guard dog?" said Verity, her eyes on Sylvie, who had her arm around the dog's neck and seemed to be whispering in his ear.

"Right," said Karen. "But not particularly inclined to get out of hand. And Zak here is a gentleman, never caused any trouble except for moping and having to be coaxed to eat since his people left." She, too, looked at the dog and Sylvie. "I don't mean to push. It's our policy to never do that because it can result in misery for everyone, particularly the animal. But Zak and your little girl have obviously connected. If you have a bit of outside space for him, and don't have another male dog, I think he could work out for you and your family."

"You do?" said Verity unhappily.

"Verity? He really does need me. Could we please take him home? Please?"

"Sylvie, I think we should talk to Patience about this."

"Patience will like him, she *likes* dogs. And I'll take care of him, I'll feed him and clean up after him. I *promise*."

As the three of them—the four of them—looked at each other, a deep voice broke into their silence. "When you're looking for somebody in a crowd, it's good that she's tall and has bright hair."

Verity spun around and found herself facing Johnny Hebert, in uniform today. He was grinning, but his eyes were tired and a bit bloodshot.

"Hi, Verity," he said. "Hello, Mrs. Selby. You and your troops having a good day?"

"Not bad," said Karen Selby. "Are you looking for another addition to your household?"

"No, ma'am, not me. Two's a good number when it comes to dogs. A pair instead of a pack, you might say." Johnny looked past the women, and said, "Ah, Sylvie. You helping out here?"

"I came to get my dog." The words were forceful, the tone tremulous.

Verity took a deep breath. "Karen, could we take him home on trial? I can't make a permanent commitment without checking with my mother; it's her house, after all. But she'll be back tomorrow."

"Well, we don't usually…"

"Mrs. Selby, Verity and Sylvie are good friends of mine. I'm sure they'll agree to get him back early tomorrow if necessary, so he'll have the day to look for another person."

Karen Selby eyed Johnny, and then Verity, and nodded. "Fine. If you'll wait a few minutes, there's some gear goes with him, plus a copy of his vet's records and a list of what he eats."

Verity was about to protest that these things could be collected tomorrow if needed—well, except for maybe the food list—when Johnny took her arm. "Sylvie," he said, "will you please stay right here for a minute or two with Mrs. Selby and…"

"His name is Zak," Sylvie said.

"And Zak. I need to have a word with Verity."

"What?" As he led her a short distance away, she looked back over her shoulder at the alliance she had more or less approved. Did Patience really like dogs generally? They'd not had dogs when she was a child, and Ralph was a lost dog found by Patience for a client who then didn't want him. "How did you know where I was?"

"When there was no answer at your house, I thought you might be working today, and tried the restaurant. Ronnie said you'd just left for home, and on the way out there, I saw your car and figured you'd never get Sylvie past this show."

"That's right, you're a detective. Are you detecting something that needs my help?"

"Nope. I have a message from Chief Gutierrez. He'd like to talk to you."

Verity stiffened. "You're here to arrest me?"

"Nobody's arresting you. The chief told me to *ask* you to come to see him. Something has come up that he thinks might connect with the Larson job you're doing."

"And what if I decide I don't care to talk to him about that?"

"Your choice, of course," he said, and stood looking at her with something less than his usual warmth.

"Well, shit. And just what am I going to do with Sylvie and that— that dog? While I'm being interrogated."

"Bring them along."

As Verity parked in front of the police station ten minutes later, Johnny pulled his black-and-white close behind and came to open her door. "Do you want me to come in with you?"

"Just a minute, Sylvie," Verity said and then, to Johnny, "I can manage, thanks. But why is Chief Gutierrez doing the work on this himself? Why not...?"

He gave her a wry grin. "Who, me? I've been dating you, or trying to. And Mackellars have a certain clout around here, what with Hank..." He let that trail off with a shrug.

"Oh, right. Captain Svoboda, the next-to-top cop, is sleeping with my mother."

"Is he?" Johnny brightened for a moment. "I thought maybe so, but he's not exactly into locker-room gossip."

"Actually, it's none of your business. Forget I said anything. You, please, help Sylvie take that dog for a walk; I'm not at all sure she can handle him by herself. And I will go negotiate the murky social and professional waters on my own."

Inside the station, a uniformed man Verity didn't know nodded at her name and ushered her down the hall to the chief's office, where the head man himself came from behind his desk to greet her.

Verity had seen Chief Vincent Gutierrez around town and had been introduced to him a time or two. Almost exactly her height, with a trim, straight body, graying black hair, and a dark-skinned face that might have come directly from the Yucatán, he had an air of innate authority that stiffened Verity's spine. Definitely her least favorite quality in a man. "Chief Gutierrez," she said crisply, after he'd directed her to a chair, "Johnny told me you want to talk to me about the job I'm doing for Christina Larson. Or the job my mother and I are doing. Patience Smith, Investigations."

"I know Patience," said Gutierrez.

"I'm sure you do. Unfortunately, she's away at the moment, and I haven't been in this business very long. But I don't think I have to give you information about an investigation unless we break a law or find ourselves involved with someone who has."

A small smile, not unfriendly. "My understanding is that you're looking into some almost thirty-year-old accusations against Ms. Larson's grandfather, accusations that apparently caused his suicide. And you've been asking questions around town."

"Did Johnny tell you that? Anyway, it's not illegal to talk to people."

"Detective Hebert draws a finer line than I might between illegal activity, which he's required to report, and activity that doesn't break any law but may cause trouble."

Verity took a moment to grasp the meaning of this sentence, and

another to paste a figurative gold star on Johnny Hebert's forehead. "Chris Larson is trying to keep a promise she made to her father when he was dying, and she hired me to help her. I'm asking questions to learn the truth, and to cause trouble. But if there'd been a serious investigation of those accusations in 1973, there'd be no need for questions now."

"True, but beside the point. Ms. Mackellar, Port Silva is a—"

"A small town," she finished for him. "But not as small as it used to be."

He sat back in his chair and regarded her from narrowed black eyes. "Do you know Meg Halloran? My wife?"

"I beg your pardon? I've met her several times when I picked up Katy to baby-sit for my little girl. Why?"

"You remind me of her. Of Meg, not Katy," he added.

Big deal, she thought, and began again. "Chief Gutierrez..."

"Let me tell you what's happened to bring your investigation to my attention. Today I had a visit from Ben Finch."

"Finch. Is he Teresa Janacek's husband?"

"He is. What he came to tell me is that Mrs. Finch has disappeared."

Verity felt a brief, shivery chill, remembering how an uneasy but determinedly businesslike woman had turned into a wary animal poised for flight upon learning Verity's identity. Now it seemed she'd *taken* flight. "Disappeared? I saw her just, let's see, Wednesday afternoon."

"You may have been the last person to see her. When Ben Finch got back from Ukiah midmorning Thursday, she wasn't at home. He checked at the nursery, and she wasn't there, nor was her truck. Your charge slip for some plant..."

"I bought a wisteria, for my mother."

"That was the last sale she made. Ben found the charge slip, and found your card on the counter. He knows about your work for Ms. Larson, and he thought you might have frightened Mrs. Finch."

She had a quick defensive response to the word *frightened*. "Mrs. Finch was quiet but businesslike when she helped me find the plant— which cost two hundred fifty dollars. We had a bit of talk about delivery; there'd be a charge for the nursery to do that, so I said I'd come for the plant with a truck next day or so. When I gave her my credit card, she seemed startled by my name."

He raised questioning eyebrows.

"Anyway, Mrs. Finch wrote up my purchase and…I'm trying to get this in the right order. I think she put the charge slip on the counter to be signed. Then I introduced myself and gave her my business card and told her I was making inquiries about Edgar Larson for his granddaughter."

"Did Mrs. Finch seem upset by this?"

"I…I thought she was troubled by it, yes. She said she hadn't known Mr. Larson, shoved my copy of the charge slip at me, and disappeared into the back of the store. May I ask a question?"

Before he could respond, she asked it. "Does Mr. Finch know whether his wife had heard, or read, about the investigation?"

"He says that she'd read the Larson obituary last week, and was upset. But she, they both, knew Andy Larson because he'd taught their three children algebra."

"I knew him, too. He was my soccer coach, summers. Chief Gutierrez, I have a child waiting for me. And a new dog," she added. "If there's nothing else I can help you with?"

"When you left the nursery Wednesday—afternoon?"

"It was latish afternoon, I think. Getting close to six."

"Was there anyone else there when you left? Or did you see anyone else coming in?"

"There was no one else while I was there. She said the girl who usually worked for her had been called home. I sat out front in my car for a few minutes, making notes. While I was there, someone inside, I assumed it was Mrs. Finch, put the 'Closed' sign in the door window and pulled the blind. Then I drove off.

"Oh," she added, remembering. "I did go by late yesterday afternoon, hoping I could arrange to have the wisteria delivered after all. The nursery was still closed, so I stuck a card in the door with a question and a phone number."

She got to her feet and settled her bag over her shoulder. "Chief Gutierrez, is that all? I do need to take my crew home."

"For the time being, that'll do." He got up as well and came around the desk, to open the door for her. "Thank you for coming in."

She paused, trying to frame a question without revealing how troubled she was. "Could I ask you, please, to let me know when she comes home? I really would like to pick up the wisteria I bought for my mother for her birthday, but I don't want to bother Mr. Finch about it."

"I think I can do that. Please say hello to Patience for me, when she gets back."

"I'll do that."

Outside, she stood still under a darkening sky and drew several long, deep breaths of very damp air. Yes, rain soon, she told herself, and looked around for a moment before spotting Johnny, and Sylvie and the dog, in a small grassy park across the street. She gave a shrill two-fingered whistle; they heard, and saw, and set off briskly in her direction, the dog leading the way.

"Zak here has had some good training," said Johnny. "With a little instruction, Sylvie should be able to handle him."

"Look at him, Verity! Isn't he beautiful? Sit, Zak."

The dog sat promptly, and offered his paw to Verity, who took it a bit gingerly.

"Hello, Zak. Good dog." She thought he nodded at her as she released the paw. "Okay, let's put him in the car and head for home. It's going to rain before long."

Johnny supervised this effort, putting Zak in back and Sylvie in front. "Sylvie, I have a book at home you might find useful. Verity, Wednesday night was fun but I was so beat I was barely functioning. Can I take you out for a drink and dinner tonight?"

"I don't think so, sorry. Patience is away, and anyway I'll need to keep an eye on our new friend in his new home." She registered Johnny's disappointed look and realized it mirrored her own thoughts. The brief moment of euphoria following her conversation with Chris was a distant memory, and the prospect of an evening conversing with an eight-year-old and a dog didn't cheer her.

"But why don't you come to us? I think I can find something to cook."

"I'd be pleased to, thanks. But you're going to be busy. Let me bring dinner."

A FAINT "WOOF" brought Verity out of her doze, and to her feet. She picked up the novel that had slid from her lap to the floor, saying, "It's okay, Zak," to the dog, who had come from Sylvie's bedroom to stand at attention, ears pricked and tail up. As the sound of the approaching engine grew louder, he made a sound that was not really a growl, more the suggestion of a whine.

"Good boy, Zak. Sit." He obeyed, and she added, "Stay," moving first into the hall to shut Sylvie's door, then to the front door of the house, to open it. The outside light, motion-controlled, came on to illuminate the figure of Johnny Hebert as he nudged his car door shut and started forward, head bent and shoulders angled forward over whatever he was carrying. The light mist Verity had observed an hour earlier had become fine but serious rain, a silvery scrim billowing now and then as gusts of wind tugged at it.

"Hi, Verity. Sorry for the delay. Hello, Zak," Johnny added as he reached the shelter of the covered entryway. "Remember me?"

Zak remembered, taut body relaxing, tail waving politely. Inside, Johnny handed Verity two paper bags before following her through to the kitchen and shedding his raincoat. "How are things going? Does Zak like it here?"

She set the bags down on the table. "Zak adores Sylvie, and is glad to be wherever she is. I think he likes me, and he's clearly willing to accept you. Harley came over to tell us he was having a party tonight, and Zak made it clear that this is *his* territory. There's a hook for your coat beside the back door."

"I see it," he said, and hung the damp coat there before brushing both hands over his hair and beard, causing a small rain-shower of his own. "Have you had a chance to talk to Patience about the new family member?"

"Yes. She's absolutely delighted. What have you brought that smells so good?"

"Because I don't cook, I make friends of those who do. Like Mama ᴊᴜᴍᴉᴇᴤ, ᴏf ᴌᴀ Ꮲᴏᴤᴀᴅᴀ." Ꮒᴇ ᴌᴇ ᴦᴀᴨ ᴩᴜᴌᴌᴉᴨᴦ, ᴉᴛ ᴏᴦ ᴦᴦᴏᴨ ᴛᴦᴇ ᴦᴀᴦᴤ "ᴎᴦᴇ tells me that the enchiladas can be reheated in the oven, but the tamales will need to be steamed. Oh, I didn't think to ask if Sylvie likes Mexican food."

"She wanted to wait for you, but she was too tired. Too much big day. You can get a couple of beers from the fridge, and I'll get this lovely stuff ready to eat."

"Here's a pair of books for you and Sylvie," he said, pulling a separate plastic-wrapped bundle from the bottom of the second bag. "And Zak. One is by the Monks of New Skete, who breed and train German shepherds. The other is by the woman who developed the service dog concept."

"Thank you, I think. I'll have a look at them later."

———//———

"Here's the funny thing," she told him when they were seated with full plates. "Sylvie was right, Patience really does like dogs. It turns out that it was my father who preferred cats, and we always had at least one; big, furry guys who'd sit on his lap or drape over his shoulders. Mom says he couldn't connect with dogs from his wheelchair."

"Cats are fine, too," said Johnny in the bland tones of someone intent on avoiding a conflict.

"True." Verity had a bite of tamale, said, "Wonderful. I may purr," and caught sight of Johnny's right hand, extended on the table. "Hey!" she said, reaching out to lay her fingers on freshly skinned knuckles. "What happened here? Honestly, Hebert, every time I see you, you've been in another brawl."

He turned his hand over to clasp hers briefly. "Ouch. Saturday night on the waterfront, remember? They were breaking bottles and heads at the Fishermen's Rest tonight before it was even full dark."

"Was Marty Young there?"

"Marty? Yup. She's a savvy lady, talked some people into behaving themselves and then got out of the way when talk stopped working."

"She's on my list of 'seventy-three grads to interview, but I haven't been able to connect with her. Should I try again?"

"Probably not," he said as he picked up his fork. "She told me once that she's the original girl who can't say no—had a string of no-hoper

boyfriends that left her with five kids to raise. Her kids seem to be turning out well enough, and my judgment is, there's not an ounce of meanness in her."

"Good. I'll cross her off."

They ate for some minutes without conversation, ignoring the pleading eyes of Zak, who had come to sit near the table but made no sound.

"That was excellent," said Verity as she was first to push her empty plate away. "Now I need to ask you about something, but I'll understand completely if you don't feel you can answer."

"Uh-huh, and then you'll never again let me steam tamales in your kitchen."

"Johnny, I wouldn't..."

"Sure you would," he said with a shrug. "But never mind. I know where my loyalties lie."

About to ask where, she clamped her lips shut, and he grinned.

"Before the chief left this afternoon, I told him I was interested in the Finch disappearance and might take a look at the file. He *looked* at me—he's a guy who doesn't seem to blink—and then said no problem. So what do you want to know?"

"Is she still missing?"

"Yes." The humorous edge to Johnny's voice was gone. "No one, at least no one in her family, has seen or heard from her since Wednesday afternoon."

"Shit."

"Yeah."

Verity got up to clear the plates away and put the remaining food in the fridge, to get Johnny another beer, to get herself a glass of wine instead. She suggested they move out of the kitchen, and he picked up his beer and followed her into the living room, where the embers of a fire still glowed with warmth.

As Johnny poked the fire to life and added a small log, Verity sank into a corner of the couch, tucking her legs under her. "Johnny, even before she reacted to my name and then my question, Teresa Janacek Finch struck me as less than comfortable in her own skin. 'Fragile' was the way I put it in my notes right afterwards, although on reflection I think 'spooked' might have been a better word."

He shoved a hassock close to the other end of the couch, sat down, and stretched his legs out. "Her husband says she's always been

reserved, but she had a bout of what he called 'sadness' after her youngest kid, a daughter, went away to college two and a half years ago."

"Depression, sounds like."

"It does," he said. "But she doesn't trust doctors and takes no medicine except the occasional herbal supplement. What she did do was start going to church again—she was raised Catholic—and her husband thought that helped for a while."

"A while?"

"Eventually she took to driving off by herself for a day, a day and a night. First time, Ben Finch got worried and reported her missing. From then on, he says, she always left a note, something like 'Need a break, be back soon.' There was no note this time; he says he's looked everywhere and couldn't have missed it."

"And this time it's been three days," said Verity softly. "Where does she usually go, does her husband know?"

"She likes to camp near the ocean, maybe on a bluff or at the edge of a beach. She has a small truck with a shell on the back and usually sleeps in that. She told him the sound of water cleanses her soul."

"Is anyone actually looking for her?"

"Ben has talked to all her friends, none of whom has seen her. All agencies have been notified."

"He must be terribly upset."

"He's a nice, ordinary guy, usually upbeat, but he's beginning to show the strain. His oldest son is here from San Francisco, and the daughter's coming home from school in L.A."

Verity shivered and wrapped her arms around herself. "I really wish I hadn't…" She broke that thought off, and leaned over to pick up the Port Silva High School yearbook from the coffee table, where it lay beside the novel she'd been reading.

"An old yearbook is a sad reminder of the difference between aspirations and achievements," she said. "Jana Burns, now Cardoza, was going to be a dancer. Turns out she's a tall, skinny Safeway checker smoking pot in the parking lot on her breaks. And I didn't mean to say that so please forget it."

"Pot-smoking adults are not a major interest in our department, unless they're also dealing. But she'll sure as hell lose her job if the manager finds out."

"I'd guess she's lost others, for other reasons. Oh, here's one who

persevered. Liz O'Malley, now Feldman, planned to raise and train Morgan horses, and I found out she's doing that, along with running her mother's bookstore. But Jeanie Verducci, who was aiming for Wellesley and Georgetown Law, dropped out of college and came home to take over the family business. Seems a local habit."

Johnny shrugged. "Maybe they're like plants. Some flourish only in their native soil."

"According to our quick survey, only fifteen percent of the 'seventy-three grads stayed here," she said, flipping pages idly until she reached the end of the senior pictures. "Here's one who didn't, Adam Zalinsky. He looks a lot like Hugh Grant and planned to write the Great American Novel. I don't believe anyone by that name has done that."

"He still has time. What about Teresa Janacek?" Johnny's voice was soft, his eyes on Verity's face.

Verity turned the pages reluctantly, stopped. "Shit, Johnny, she looked spooked thirty years ago. Deer-in-the-headlights eyes, and this worried little smile. She was planning to go to Juilliard, with her cello." She slammed the book shut. "In a brief rebellious phase, I refused to have a picture taken for high school graduation. How smart I was."

"So what do you plan to do about your investigation?"

"Declare myself emotionally incompetent, I guess. I hear what people have to say about Edgar Larson, and understand why Chris wants revenge. I look at these kids and think, wait, eighteen years old, give somebody a break here. Besides, nothing leads firmly—or to be honest, even loosely—to anybody of any age, which is what I've told Chris. I'm hoping she'll agree to let it go and appease her father's ghost by putting together a really nice retrospective of Edgar Larson's life for the *Sentinel*. I can give her material for that, with quotes."

"Chris wants you to continue?"

"Oh, yeah. When I talked with her this morning. I didn't tell her about Tessa Finch's disappearance, because I didn't know about it yet." She tossed the yearbook at the table.

"It may have nothing to do with you or Chris."

"*God* I hope that's true."

Zak, who'd been sleeping neatly nearby with his head on his paws, gave a sudden "woof" and was on his feet, in the alert pose Verity had come to recognize. It was several seconds before engine sounds were

audible to the ears of the human listeners. Three or four seconds later, the engine had faded away, and Zak lay down with a gusty sigh.

"Clearly he's not going to let anybody sneak up on you. But since you and Sylvie are otherwise on your own, maybe it would be a good idea for me to sleep here tonight."

"Thanks, Johnny, but that's not necessary. And for a man your size, I don't think that couch would be very comfortable."

"You mean I could sleep here for you, but not with you."

"I think I mean neither for *nor* with," Verity told him.

"Shoot." His resigned grin was swallowed by a huge yawn. "But it's just as well," he added when he could speak again. "Tired as I am, I'd probably be a disappointment."

"Somehow I doubt that," she said, with a smile that didn't mock.

"Glad to hear it. Seriously, Verity, this wasn't intended as a hustle. I'd be fine on the couch and I think you'd sleep better."

"I'm a big girl, I don't need a guardian. Okay, Zak," she said to the dog, who had nudged her and was doing a little prance with his front feet. As Johnny went to get his coat, she opened the door and Zak shot out into the rainy night.

"I hope that wasn't stupid," she said, standing in the doorway to watch.

"Turning down my offer?"

"Letting that dog out on his own. Sylvie will never speak to me again if he runs away. Do you see him?"

"Yup, over there by that big bush with his leg up."

"Oh, good."

Johnny put an arm across her shoulders, and she leaned against him, putting her face up for what turned out to be much more than the usual peck-on-cheek kiss. It occurred to her that the decision to send him on his way might have been hasty.

Zak trotted up the steps in a manner that said "Got that taken care of" and pushed between them into the warmth of the house. "I'd better go dry him off," she said. "Good night, Johnny. Thank you for being here."

"My pleasure. I'll be here again."

He moved away, and she remembered something. "Johnny?"

"Right," he said, with a glance back and a nod. "If I hear anything at all about Tessa Finch, I'll call you."

"Thanks." She bolted the door, toweled the dog dry, put water in

his bowl. In the living room, she turned out the lights and sat down to soak up the last warmth of the fire. If there was music from Harley's party, she didn't hear it. She heard the soft, mild *whoosh* and sigh of the fire, the rain on the roof. The rain sounded quietly relentless, as if it meant to go on for a long time. She wondered whether Tessa Finch was out there listening to that rain, dry and warm in her truck. She hoped so. Safe and warm there, or somewhere else, she hoped so.

———//———

The outside house lights went off as his car neared the street end of the driveway, and his headlights were suddenly very bright against total dark. He turned them off, lowered his window just a little, and sat listening to the sound of his quiet engine, the steady thrum of rain on the car roof, the rumble of an empty lumber truck on nearby Highway One.

Human noises, fairly close. Johnny lowered his right-side window and listened, hearing young-sounding, cheerful voices: a party or at least a gathering breaking up in the house down the road, the house where Harley Apodaca was staying. He sat quietly, heard another engine start, waited there in the dark as a Bronco or Explorer or one of those rolled past.

He considered driving over to catch Harley before he went to bed, remind him to keep an ear out for his neighbors. But Harley would do that anyway, to the extent of his energy and time. No point in worrying him further.

Johnny couldn't even make much of a case for his own worry. He'd heard of no physical threats to the Mackellars, and Port Silva wasn't experiencing much in the way of house-breaking or home invasion in this chilly, rainy season. Verity had a telephone, a cell phone, a serious dog, and Harley within call next door.

It was the Finch business that was bothering him, at some gut level he couldn't quite get a handle on. He'd shopped at Janacek's Nursery now and then after he'd bought a house and found himself responsible for a yard. He'd been helped a time or two by Teresa Finch; and at other times, in his endless curiosity about humankind, he'd simply observed her. Awkward with people, she was open-faced and relaxed when working with the plants. They were the healthiest plants around, he'd found when looking elsewhere; and the little hand-written care tags on the benches or pots were succinct, direct. This is exactly what you need to do, the tags said, and you'd better do it. He

could imagine Tessa Finch leaving her husband on his own for a stretch; he couldn't imagine her abandoning her plants to casual care.

Verity, too, was deeply uneasy about the situation, although she tried to conceal it. If he'd believed there was a chance in hell that she'd see him as anything but self-serving, he'd have tried harder to convince her that a warm, loving body in your bed can make you feel much, much better.

A chilly wind blew a few drops of moisture in his window, nature reminding him of the benefits of a cold shower. He put one window up, the other nearly, turned his lights on and put the car in Drive. The rain showed no sign of slacking off, and the weather report had promised it would persist, heavily, tomorrow. A rainy Sunday, a fine time for those who could stay warmly at home to read the papers, listen to music. He hoped Verity would get to do that.

CHAPTER 16

WITH VERITY HOLDING out her backpack Monday morning, Sylvie bent instead to hug the dog, who'd been attentively watching her preparations for departure. After he'd licked her face, she straightened and gave Verity a worried glance.

"Sylvie, don't worry. I will talk to him, see that his water dish is full, even walk him. Will it be okay with you if he goes running with me?"

"He'd like that. Thank you." Sylvie slid the backpack into place, tipped her cheek up for Verity's kiss, and headed for the door. "Tell Patience good-bye for me."

"Good-bye, Sylvie." Patience, in her robe, came in from the hallway. "Have a good day."

"I think I just kissed the same cheek the dog did," said Verity as the door closed. "Good morning, Mother. Coffee water's hot, or it was. Who was that on the phone just now?" Receiving no answer, she turned from the stove to look at Patience. "Mom, what's the matter?"

"That was Hank. Teresa Finch was found dead in her truck, in a little lay-by downcoast a ways. The first judgment is that it was suicide."

"Oh, shit," Verity whispered, and sat down at the table.

"I'm sorry," said Patience, and turned to the stove, biting her tongue against *Don't blame yourself.* She made a cup of coffee, set it in front of Verity, and made one for herself.

"Poor, sad woman. Poor husband, and kids."

Patience sat down at the table with her coffee. "Hank told me, Saturday after I'd talked to you, that the Janaceks came here in the 'fifties as refugees. There were the two parents, and a boy of eight or nine, and Teresa, who was a baby. They'd had a bad time, and Mrs. Janacek was never very healthy, mentally or physically."

Verity just shook her head and picked up her coffee mug. She put it down after a sip, to get to her feet. "If it's okay with you, I think I'll go for a run."

Zak got up, too. Patience thought he'd registered the word *go*. He might be a rather odd-looking animal, but she approved of his manner, friendly but not effusive. And Hank had said that he seemed sound and well-trained. "Why don't you take our friend with you?"

Verity blinked, and looked down at the dog. "Oh, right. Sylvie gave me permission to do that. Come on, boy."

"Keep him on lead at first, Verity. I don't think he'd run away, but we don't know yet how he deals with strangers or with other dogs."

"Actually, I know how he deals with strangers. He stopped Harley cold on Saturday, until we'd introduced them. We'll see you in about an hour, probably."

"I'll be right here."

——//——

"Anything happening?" asked Verity more than an hour later as she pulled her windbreaker off. Patience was still in her robe, sitting at the kitchen table with her coffee mug and the accoutrements of her work: laptop, file folders, legal pad, cordless phone. Her feet were nestled in puffy down booties.

"Nothing further from Hank, and there was nothing about Mrs. Finch on the local morning newscast."

"Too soon, I guess," said Verity. "Here you go, Zak," she added, and put down a pan of fresh water for the dog, who gave a polite wave of his tail before lowering his head to drink.

"How is Zak as a running companion?"

"Wonderful, at least for a jogger like me. He didn't break a sweat in three miles."

"I don't think dogs sweat, Verity."

"Well, he didn't even breathe hard."

"Did you keep him on lead?"

"Nope. We met a jogging couple, and then a woman with a dog loose at heel, and he didn't react either time, so I decided to try him loose. He chased seagulls a couple of times, but came right back when I called him."

"Hank says," Patience told her, "that dogs, particularly male dogs, tend to be much less suspicious of strange women than of strange men."

"The map-over of that bit of canine psychology is something I don't care to think about today."

"Just take it at face value. Now, I'll be going to town to meet with Carolyn Duarte about what I learned in Laytonville. Her free time is most often her lunch hour."

"Chris may call; she had tentative plans for coming back to town today. Meanwhile, I think I'll find something mindless but exhausting to do, like cleaning house. Maybe I'll even start with the breakfast dishes," she added, getting up to do that as Patience reached for her telephone. Over the mild clatter of the dishes, and then the sound of running water, she heard her mother speaking softly into the phone. Peaceful domestic scene, causing trouble to recede although not disappear.

A louder clatter spun her around, and she saw Patience still at the table, the cordless phone lying in front of her as if she'd dropped it. "Mom? What now?"

"A message on the office machine," she said, and picked up the phone with obvious reluctance. "I didn't bother to check it over the weekend, since I was out of town anyway. Wait, just let me cue it up."

After a moment she handed the instrument to Verity, who steeled herself for something vile as she put it to her ear. Death threats?

"Miss Mackellar? Miss, or is it Mrs. Smith? I'm sorry, I don't know...I need to talk to you, to one of you. But I'm not where you can...I'll try to call again later. I'm sorry for bothering you." The soft voice trailed off, and the instrument at the other end was replaced quietly. After a moment the quasi-female mechanical voice came on to say, "Saturday, March tenth, four-fifteen P.M."

Verity punched the *off* button and handed the phone to her mother. "As you guessed, that was Tessa Janacek. Teresa Finch." She hugged herself against a sudden chill. "At least I'm pretty sure it was. More than vocal tone, it's the hesitant quality of her speech that's familiar. God, Ma, we could have—*I* could have—helped her!"

"We could have told someone that she'd called," Patience said. "But she didn't call back. There were three messages preceding hers, but nothing after."

"I wonder why she didn't call this number?"

"It's unlisted, remember?"

"Oh, right. And I've been putting my cell phone number on the cards I hand out, but Chief Gutierrez said her husband found the one

I'd given her there at the nursery, along with a charge slip for some-
thing I'd bought." The wisteria, which she'd probably never have the
nerve to claim. "Well, fuck," Verity said, to the world at large.

"Indeed." Patience looked at her watch. "It's ten o'clock, and I need
to shower and dress and pull together the report, and the bill, for
Carolyn Duarte. But the police need to know about this. Could you
go pick up the tape from the office machine and take it to the
station?"

What fun, another lovely talk with our charming chief of police.
Verity registered the meanness of that response and was ashamed of
herself. "Of course."

Patience got to her feet to collect her shoulder bag from its hook in
the coat closet. "Here's a key to the office. Maybe you should simply
unplug the machine and take the whole thing in."

"Good idea."

—————//—————

In non-jeans pants and a nice sweater and her good leather jacket,
hair neatly braided in its single plait and face made civilized with lip-
stick and eye stuff, Verity presented herself at the police station just
before eleven and asked to see Chief Gutierrez. Verity Mackellar,
about Teresa Finch, she replied when a middle-aged male cop, whose
badge identified him as B. Coates, asked her name and purpose. His
immediate response was a tucked-back chin and a disapproving look,
but he showed her in without comment.

Gutierrez got up from his desk to greet her and she said, quickly,
"It's nothing really helpful, I'm afraid, but we had a phone message
from Mrs. Finch." She handed him the tote bag containing the
answering machine.

He directed her to a chair, took the machine from the bag, and set
it on a table against the wall. As he plugged it in, Verity said, "It's the
fourth message. It says—" He held up a silencing hand, and she
obeyed the gesture. As he pushed the button to play the tape, Hank
Svoboda came into the office and closed the door.

The three of them listened, and listened again. "Her husband says
Teresa Finch did not have a cell phone, didn't like them," Gutierrez
said. "So she found a pay phone, or used one in a house or business
somewhere. Was there any message from Mrs. Finch, before or after
this, on your home phone?"

"None. That number is unlisted."

He pushed his chair back and stretched his legs out, keeping his eyes on her the whole time. "Let's run through your visit to Mrs. Finch at her nursery on, Thursday, was it?"

"Wednesday. I told you all about it Saturday."

"Cops have plodding minds and like to hear things several times. Humor me."

Verity gave him a tight grin that exposed clenched teeth, squared her shoulders, and repeated the events she'd outlined for him two days earlier. As she finished she took a quick look at Hank Svoboda, who had pulled a straight chair to one side of the chief's desk, reversed it, and straddled it, his arms resting atop its back. Beyond a brief pat on the shoulder when he came in, Hank had made no effort to connect with her and wasn't making any now. Impartial observer was clearly his role.

"Here's something I should have asked you Saturday," Gutierrez said. "What caused you to approach Mrs. Finch in the first place, apart from the fact that she'd lived here nearly all her life?"

On Saturday she'd have regarded this as none of his business. "I'd learned that Mr. Larson had worked as a parking-lot volunteer at the high school. This struck me as a situation ripe for conflicts and for mischief, like false accusations. So I've been talking to people who were seniors at the school the year he—died. Teresa Janacek Finch was one of those."

He made a note of this on a pad, the first note he'd made. Did he have a tape going, she wondered, and decided it didn't really matter.

"Since our talk on Saturday, have you recalled any other facts, or impressions, that you didn't mention?"

"Impressions, yes," Verity said, her voice tight. "This struck me as mildly odd. When I told Mrs. Finch that I was talking to class-of-'seventy-three grads for any memories of Mr. Larson, she said at once that she didn't know Mr. Larson, that she'd lived close to school and had no car to drive anyway. This *before* I'd mentioned his work as a parking-lot volunteer.

"And the fact that she turned the 'Open' sign to 'Closed' and pulled the blind down while I was still sitting out front struck me as ominous, for no reason I could think of at the time. I wish I'd been more perceptive."

Gutierrez merely looked at her, and after a moment she felt her face flush. "Sorry. I wish I knew more. I wish my mother or I had

checked phone messages earlier. But I don't, and we didn't, and I don't like being grilled."

"Nobody does," said Gutierrez. "But sometimes that's the only way to get all the information. And as far as I can see, there's not much you or anyone else could have done with that one message. I appreciate your coming in today."

She ignored this verbal dismissal and stayed right where she was. "What happened to her? And when?"

Gutierrez raised his eyebrows, but Hank spoke. "This won't be a secret for long; too many people saw the scene. She was found behind the wheel of her truck, dead from a bullet to the head."

Verity blinked several times, quickly. "She *shot* herself?"

"Looks like it," said Gutierrez.

"Her husband says she loved the sound of the ocean," Hank added. "When she was tired or depressed, she'd drive to a quiet place where she could hear it, and stay for a while."

Johnny had told her that. She nearly said as much, but thought better of it just in time.

Now Gutierrez got to his feet. "And that's all the information we have at the moment."

All you mean to share, thought Verity. And clearly Hank wasn't planning to offer anything further. She stood up, zipped her jacket, and settled her shoulder bag into place. "We'd appreciate your returning our machine when you've finished with it. There are other messages on it."

Hank was beside her, his hand on her arm. "We'll take good care of it, Verity. Come on, I'll walk you out."

Verity let herself be led and resisted looking back, lest she snarl something at the arrogant bastard behind the desk that would get her locked up. Or burst into tears, that would be useful.

Hank was close behind her as they moved down the long hall, herding gently but also, she thought, offering moral support. When they reached the door into the reception area, he touched a button that released the lock and pushed the door open for her.

She stepped into a room that seemed crowded with shadowy figures but saw only the person directly before her, maybe ten feet away. Not tall enough, Verity thought in confusion, and hair too dark, but the bone-width of cheek, and the slanted, narrowed blue eyes...

"You bitch! You killed my mother, I'll tear your filthy face off!" The

girl flew across the intervening space and hurled herself at Verity, her reaching hands not fists but taloned fingers. Verity got her arms up and turned a shoulder into the assault, but one clawing hand raked her cheek before her own elbow-thrust sent her attacker stumbling back.

The room erupted into shouts, a uniformed man and one in civilian clothes both reaching to grab the girl. She eluded them and came at Verity with fists this time, but she was small and thin, swollen eyes streaming tears, and Verity, with height and a much longer reach, simply fended her off until the uniform—Dave Figueiredo, she noted from within an odd, icy calm—wrapped muscular arms around the flailing figure from behind and swung her away. In that same motion he handed her to the other man, who embraced her and looked at Verity in sorrow and apology but spoke to the sobbing girl.

"Steffi, Steffi, she didn't. Nobody killed your mother. It was an accident. Come on, we'll see the chief later. Let's go meet your brother."

Another uniform joined Figueiredo in ushering father and daughter out the door. Two civilians she didn't recognize stood staring at her, and Hank Svoboda put an arm across her shoulders. "Verity, I'm sorry. I didn't know the Finches were here or I'd have taken you out the back way."

"It's all right. She thinks I killed her mother. If someone had killed my mother, I'd be mad, too."

"Verity, you haven't killed anybody."

"This time."

Hank's arm tightened. "Look, your face is bleeding. Let me take you back to my office and apply a little first-aid."

She didn't push him away but simply stepped from his grasp. "No, it's fine. I'll take care of it at home. My tetanus is up to date, and—see?" She held a hand out before her. "Steady as a rock."

"Verity…"

"Walk me to my car, okay? It's out front."

———//———

Patience reached home thirty minutes later, parked next to Verity's car, and hurried up the stairs. The front door was locked, but lights were on inside, and music was playing loudly. She unlocked the door, stepped in, and closed it behind her, pausing very briefly to rest a hand on the hard head of the dog at his self-appointed post of doorkeeper. Verity sat in the reading chair in the living room, but she

wasn't reading; her head was back, her eyes closed, and she seemed to be listening intently.

But not only to a Bach partita. "Hi, Mom. I bet Hank called you."

"Right," Patience tossed her bag at the couch, and followed it with her jacket. "He knew I'd have his balls if he didn't."

Verity's eyes flew open. "Hey, what kind of motherly language is that?"

"The kind appropriate to the circumstance." Patience turned off the CD player, turned on the reading lamp, and took her daughter's chin in her hand, turning her head to inspect the wound.

"It's okay, Mom. Only one nail went deep enough to be anything more than a surface scratch; and I washed it all thoroughly."

"Good."

"She's a skinny little thing and would normally have been no match for me, but she looks just like her mother. So I couldn't quite get it up to hit her back."

"Good," Patience said again, knowing the word was a lie. "I'll go make some tea. Or are you hungry?"

"Nope. Tea would be fine."

She put the kettle on and got out the bigger teapot and the Earl Grey tea, Verity's pale face in her mind's eye the whole time. Found a small knife and began to slice lemons, cursing Vince Gutierrez and Hank Svoboda and everyone else at the police station for their stupidity and carelessness.

She'd known about the dreams that haunted Verity after the death of Sylvie's stepfather the year before. They'd discussed the dreams and the hovering guilt that inspired them, though not at length; Verity's sense of herself came far too much from Patience's own German–Scottish–English background, stoical and inward-turned unless modified by religion and sometimes made even worse by that. Possibly she'd have benefited from a good dose of Catholicism.

And things, Verity's spirits, had been steadily improving. The demanding presence of Sylvie had helped. Johnny Hebert had helped, sometimes. But this particular job…

Patience jumped at the railroad song of the teakettle, and turned off the gas. She should have held out more firmly against this particular case; and Hank had been less than helpful, damn him. Stupid, stupid!

She took cups and saucers and a plate of lemon slices in to set

them on the coffee table. Tea table? Added a plate of Lorna Doone cookies. Removed the tea bags and carried the pot in with a cozy, a gift from her mother. Poured tea.

"Verity?"

"Hey, Ma." Verity sat up and reached for teacup and lemon slice. "Don't let this screw up your day, too. I'm okay. Go meet your lunch-time appointment."

Clearly Verity had no wish to talk about her own misery, at least not to her mother. "I can see her this afternoon, or tomorrow for that matter. Why don't *you* go to the city and see your friend Giovanna?"

"My shrink Giovanna, you mean. Yeah, why not? I could do that."

"Do you feel up to driving?"

"Ma, I didn't get beaten up, just scratched a bit. Yes, I can drive. Only problem, I promised Sylvie I'd see her this afternoon."

"Write her a note, dear. Tell her you were called away, and you'll see her tomorrow or the next day."

Verity sipped tea. "Okay, yes. I think that will work. Three hours to the city, I'll be there before heavy commute time. And I'll make sure to be back tomorrow before Sylvie gets home from school."

"Sounds like a plan," said Patience.

CHAPTER 17

WHILE VERITY GOT ready to travel, Patience hovered, brimful of motherly suggestions which she resolutely restrained. Maternal motto number one, Mackellar version: Give advice to an adult daughter only when it is specifically requested by said daughter. Instead she got out the small cooler chest and put in ice, bottled water, a can of ginger ale, a bottle of beer. A plastic bag containing several almond biscotti, the last in the cookie tin. An orange, an apple.

"Mother, I'm not going camping."

"I know, but it's a long drive. You should stop at least once on the way."

"And with all these goodies I'll have a choice."

"Exactly. Life without choices is—uncomfortable. Verity, would you like me to e-mail Chris Larson about Tessa Finch's death?"

"I did that already. Told her one of the people I'd mentioned in Saturday's report, Teresa Janacek Finch, had died, possibly by suicide. And that I'd be out of reach today and tomorrow. If she comes to town during that time, you'll probably hear from her."

"Fine."

Verity put her small duffel in the car, tossed in jacket and raincoat, fitted the plastic chest into place behind the driver's seat. She opened the back hatch to check that the emergency gear was in place, along with the lightweight sleeping bag that always traveled with her; sometimes drop-in guests wound up sleeping on the couch or even the floor.

"All set." She put her arms around her mother for a giant hug that lifted the smaller woman briefly off her feet. "I'll be fine. You get to be mom *and* grandma to Sylvie, who is likely to be royally pissed that I've taken off without her. I'll see you both tomorrow."

Patience watched the green-and-gray Subaru turn out of the

driveway and disappear down the road before looking at her watch: time to get herself in gear if she was to make her rearranged one-fifteen appointment. She whistled through her teeth, a dog-calling skill from her childhood that she hadn't used in years, and Zak, who'd been exploring the yard's edges to make sure nothing lurked there, did an immediate heads-up and came trotting.

"Good boy. I'm afraid you're going to have to stay inside," she told him as they set off for the house. Clearly there would have to be a fence soon, or a dog run of some sort. She'd talk to Harley about that, or Hank.

——//——

The fitful morning sun had yielded to the return of the marine layer and the chilly promise of more rain to come. Patience unlocked the door of her office, stepped inside and closed it quickly, and punched up the thermostat.

Steps sounded on the walkway, coming closer: Carolyn Duarte, predictably right on time. Patience rolled her own chair into place, pulled the client's chair closer to the desk, tossed her coat at the coat-tree, and went to open the door.

"Ms. Duarte, come in. I'm sorry for disrupting your schedule."

"No problem. Doctor decided to have a late lunch today." She took off her coat and hung it on the coat-tree before sitting down.

"I'm afraid I didn't get here in time to make coffee, but I'm sure I can beg a cup from Marilyn Ritter, in the front office."

"No thanks. I'm already past my daily caffeine limit." She set her feet together in front of the chair, clasped her hands in her lap, and fixed an expectant gaze on Patience. Ms. Duarte was here to learn the truth, and Patience took her version of it from the folder on her desk.

"The first part of this I told you about last week," she said as she handed it across.

"Right. No criminal record, couple years of college up in Chico, reputation there as a good student and hardworking person until she disappeared, maybe with a boyfriend. Oh, and a credit card debt; she told me about that, says she's going to pay it off as soon as she gets a job." Ms. Duarte set aside the first two pages and began to scan the remaining three.

"So she did go to Laytonville with the boyfriend, this Barry Gilliam, and his uncle has a ranch out there where a lot of people live and they're…?"

"It's an extended family of Libertarians, constitutionalists, or anti-government nuts, depending on who's talking. They've been there for ages."

"Don't licence their vehicles. Don't pay taxes. Run cows on national forest or wilderness land without a lease." Her voice went higher with each sentence. "Suspected of knocking down microwave relay towers and blowing up Forest Service vehicles? How do they get away with this stuff?"

Ms. Duarte made a face and read on. "Doesn't say Michelle was personally involved in any of this, but... Oh! Her boyfriend beat her up?"

"During an argument in a parking lot, according to a clerk at a local auto-parts store," Patience said.

"The bastard. Michelle, she's just a little bitty thing."

"I'd say she was smart to get away from there, and from him."

"He better not come looking for her." Carolyn Duarte straightened in a way that suggested he'd be sorry if he showed up at *her* door. "I just hope... Do you suppose she did anything with these folks she could eventually be arrested for?"

"As I mention on the last page, Michelle apparently became concerned, or frightened, and asked the sheriff's people for help. Beyond that, all I can say is that the sheriff's department is not currently pursuing any charges against her. I think you're going to have to ask her about future possibilities."

Ms. Duarte thought this over. "Well. I can understand a girl getting swept away by some good-looking guy who has a cause and acts on it. It's exciting. But eventually, if you've got brain cells as well as hormones, you get up and put your clothes on and go back to the real world."

Patience had a quick vision of a younger Carolyn Duarte, pink-cheeked and sturdy, doing just that.

"Seems to me that's where Michelle is, trying to get her life back." Ms. Duarte picked up the report, folded it, and tucked it into her purse. "You've truly relieved my mind. See, first I was afraid she might have been involved with professional druggies, because I know the backcountry in this county is full of pot farms and crystal meth labs. Or she might have joined some kind of religious cult. In my view, religion can do about as much harm as drugs.

"But I'll talk to her, see whether she's going to need legal help and

what we can do about it. Now, just let me have your bill and I'll write you a check." She scanned the bill quickly and pulled out her check-book. "I can hardly wait to tell my friend about this," she said. "She'll be real happy for me."

"Your friend?"

"Ruth Ellis, I told you about her. She had the niece, Toni, that lived with her almost a year in the 'seventies and then just up and left, nev-er to be heard from again." She pulled the check from the book and handed it across the desk.

"Did she try to look for her niece?"

Carolyn Duarte shook her head as she got to her feet. "I don't believe so, but she wishes she had, now that she's coming up on her eighties with no family around. Growing old makes you look at things differently, I'm finding."

Almost as soon as Patience had shown her satisfied client out, the sound of a knock startled her, and she reached for the doorknob before realizing that the sound had come from behind her. She moved quickly to the opposite wall and slid open the bolt on the up-per half-door there, to find Marilyn Ritter framed in the gap.

"Marilyn, how are you? I haven't seen you in ages." She knew why she was seeing her friendly but endlessly curious neighbor now.

"Okay, I'm a snoop. But I wanted to make sure you were okay."

Endlessly curious, but far from stupid. "Why shouldn't I be?"

"Patience, don't be silly. This is Port Silva, not Berkeley. Come in and have a cup of coffee and a cheese Danish."

Looking at the other woman's concerned face, Patience realized with a jolt that she herself was very tired and on the edge of being very sad. Whatever the cause, someone was dead. With Verity's well-being handed off to a professional and Sylvie busy at school for another hour, maybe she had time to sit down in a corner somewhere and come quietly unglued.

Or maybe she should act in personal and professional best interests and find out what talk was going around. "Just a minute, Marilyn," she said, and went back to her outer door, to lock it.

In the adjoining rooms, Marilyn closed the swinging door between outer and inner office while Patience settled into a chair at the table in the corner where she and Marilyn occasionally shared a deli lunch. "Help yourself," Marilyn said, setting a pastry-shop box on the table before pouring two mugs of coffee.

"Mmm." About to break a Danish in half, Patience thought, The hell with it! and put the whole thing on a spread-out napkin in front of her.

Marilyn sat down across from her. "I know something about the job you've been involved in; several people at the Small Business Owners meeting last week were talking about you. Then I heard yesterday from a friend that Tessa Finch was missing, maybe ran off with a boyfriend."

"Really?"

"Then this morning I heard on the local news that they found a Port Silva woman dead in her pickup truck somewhere upcoast. After that a friend called to say she heard it was Tessa Finch and she'd been raped and beaten to death."

Patience folded the napkin over the Danish and pushed it away. "Marilyn, she died from a gunshot wound. The police suspect suicide but they won't know for sure until there's been further investigation and a postmortem. I believe she was found downcoast, somewhere south of Point Arena. None of this is secret; I got it from Captain Svoboda, who is a good friend."

"Right. I'm a stupid ninny, and you need to go home. Here, let me wrap that up for you."

"No, I'll be fine. Did you know Mrs. Finch well?" Marilyn was a Port Silva native who'd "lived away," as the locals were inclined to say, from her college years until her return some ten years ago.

"Not really. I'm no gardener, and she didn't seem to be anything else. She had quite a few devoted followers, though. Some people seemed to think she was a reincarnation of St. Francis."

"I think he did animals, Marilyn."

"Luther Burbank, maybe?"

Patience cocked her head, hearing the sound of her telephone. "I should go get that. My answer machine isn't connected." She got to her feet, hurried to the inner door, and caught the phone on its fourth ring.

"Patience Smith, Investigations. May I help you?"

"You can't even help yourself, you and your killer bitch of a daughter." The voice was coming from low in the man's throat, to disguise as well as to menace. She held the receiver away from her ear, and Marilyn came closer.

"You keep looking behind you, cunt. Somebody is gonna take care

of you and her for what you did. Cut your fuckin' throats, blow your heads off, ram a shotgun up your—"

Patience turned the receiver off and dropped it into its cradle, and the two women stared at each other.

"I'd better get my answering machine back from the police," Patience said.

"Yeah, you better." said Marilyn. She didn't ask why it was with the police, and Patience saw no need to tell her. "Okay, you go on home and what I'll do, I'll catch all the gossip, that's what I'm really good at. I'll let you know what's being said as soon as anybody says it. Not that I think that guy was anything but a miserable, scaly little creep, not that anybody out there is really going to do you harm."

"Probably not. When Mike and I were working in the Bay Area, we had nasty threatening calls every now and then, some of them much more inventive than today's."

"Right." Marilyn wrapped another napkin around the pastry, snatched up a manila envelope, and slid the package inside. "Go home and put your feet up."

———//———

It was almost one o'clock when Verity finally drove out of the yard, and she still needed gas. But not there, thanks very much, she said to herself, and drove past the big Mendes operation to pull into the smaller Shell station two blocks south. She had filled her tank and was about to get back in the car when a black-and-white pulled up at the curb and Johnny Hebert got out.

"Patience said I might be able to catch you. Nothing new about Tessa Finch or her family," he added quickly, eyes on her face. "Just something I came across and thought you might find good road company."

Verity took the small paper bag he handed her, from Schiller's Music Store with contents square and flat: CDs.

"Drive carefully," he said, before she could say thanks or anything else. "I'll see you when you get back." He strode back to his car, fired it up and swung it around in an illegal U-turn, and drove off.

Great. Just when she could really have used a hug. Verity put the bag in the console with the handful of discs she'd pulled at random from the CD tower at home, got into her Subaru, and drove off in the opposite direction, south.

The day was gray, which struck her as appropriate. Her task now

was to point her car down the road, paying attention to the road surface and the signs and lights and any intersecting roads. To gauge the speed of the slowpoke ahead before fetching up against his bumper, to be aware of the speed behind and give him room to pass when she safely could. Without flipping the jerk off as he flew by.

Never mind. It was a pleasant landscape with the green of the trees freshly washed by yesterday's rain, the farmhousey bed-and-breakfast places and spiffier resorts alike with VACANCY signs up, the occasional flock of sheep munching picturesquely on the grassy stretches to the west, land that swept out to bluffs' edges with the ocean out there somewhere but mostly not visible today. Did those sheep, she wondered, ever fall off?

Mendocino Village, a river, more resorts, creeks and another river. Eyes mostly on the road, which was smoothly paved but curvy now and fairly narrow, Verity had a rush of longing for her powerful, responsive Alfa, a machine to engage and reward its driver. The chunky little Subaru, by contrast, chugged along almost on its own and left the mind free for idle thoughts and uncomfortable memories.

The landscape changed hardly at all: gentle hills and trees, headlands dotted with expensive houses that were no doubt second homes and thus wastefully empty much of the time. Everything in view, here and behind her and ahead, too, was very much trimmed and cultivated and designed for human satisfaction, charming almost to the edge of cute. A sweep around a curve took the road low along a stretch of sandy beach, and here for the first time on this overcast day she caught a glimpse of the roiled gray ocean, not at all cute or even slightly charming. She had a sense of loss as the road swept back inland.

At the mouth of the Navarro River, there was a choice: take Highway 128 through the redwoods and the Anderson Valley, or stay on Highway One, a direct but not straight shot along the coast that would be shorter by some thirty miles but longer in time spent. Also dangerously draped in mist and fog before long, she was willing to bet—with somewhere not too far along, a spot marked off in yellow crime-scene tape? She swung left for the redwoods.

Verity usually played music when she made this drive. She reached into the console, pulled out the first CD that came to hand and slid it into place, eyes on the road the whole time. When the first strains of music sounded, she said, "Shit!" and pulled onto the shoulder to jab the *eject* button. Richard Goode playing Schubert's B-flat piano

sonata would reduce her to tears or even sobs. Better to hear—she looked over the possibilities this time, found the Yo-Yo Ma double-decker of unaccompanied Bach on cello, and decided to play it as—gift? memorial? to Tessa Janacek, who had not gone to Juilliard with her cello. Any tears this inspired could spring from honest sorrow rather than self-pity.

The music of Bach, which she loved, and the astonishing artistry of Mr. Ma took her along the river, through the redwoods, past a tiny town and several vineyards and into Boonville, where she often stopped for an ice cream cone but was past and away today before she remembered.

Soon after Boonville the landscape changed from riverbed flat to hills, treed or bare, and up-and-down switchbacks that took more of Verity's attention but not all of it. For company she had the old German and the youngish Chinese, and now and then the wraiths of a stern-faced old man and a sad-eyed younger woman. Tessa Janacek had died because she'd been living on some personal, invisible-to-others precipice and Verity had unwittingly pushed her off. Or from guilt, and fear of exposure.

Much preferring the latter answer, Verity tried to envision a teen-ager damning an old man from anger or pure malice, but it was an expression she was unable to fit to Tessa's face, young or old. "And what about you, old man?" she said in a furious whisper to Edgar Larson, the man with no enemies. "What the hell did you do to set this whole mess in motion?"

Her hands tightened on the wheel as the sign for Highway 101 appeared. No need to drive through Cloverdale now that the bypass had been built; she could pick up 101 South directly and be in San Francisco, at Giovanna's door, in an hour and a half, two hours if traffic got thick. Verity looked in her mirror, flicked her signal, and took the lane for 101 North.

It wasn't until she was some fifteen miles up that road in Hopland, sitting in a roadside brew-pub and sipping a pint of the handmade ale, that she acknowledged the reason for her literal about-face. Giovanna Orsi was a good friend and a superb therapist, managing through some magical blend of instinct and training to help her patients see how to help themselves. Giovanna was also a member of a large extended family and had been in a loving relationship with the same woman for fifteen years, presently raising two children with her

partner. Giovanna represented more mental health than Verity cared to face right now.

She took her time finishing the ale, which was very good, and picked at the not bad fries, but left most of the sandwich of too dry ham, telling the waitress not to bother bagging it for her. Outside, in a chilly wind that blew bits of debris around the parking lot, she waited while a family spilled out from the car that had just pulled in next to hers, two little boys running and yelling while a girl of six or seven followed more sedately.

The little girl's demeanor and her shiny black hair brought Sylvie instantly to mind, and Verity felt panic like a blow from a fist. Suppose the Finch family, maybe the daughter, decided to take anger at Verity out on Sylvie? She scrambled into the car and dug into her bag for her cell phone. She'd call Patience and... She drew a deep breath, expelled it, let her head fall back against the seat. Patience needed no warning. With Patience and that dog, and Hank and probably Harley, Sylvie would be just fine. Another deep breath, and she flipped open the cell phone to call Giovanna's home number, where she left a message to say with apologies that she wouldn't be coming.

For no reason except that she didn't want to go back, she headed on north, through open, rural country with more horses than people observing her passage. Yo-Yo Ma gave way to The Grateful Dead; listening to Jerry sing songs that you could hear a dozen times and still not quite understand, she would just drive hard until she was too tired to keep driving.

Just after six o'clock, Verity surfaced from road hypnosis and was unreasonably surprised to find herself moving through groves of enormous redwoods. On a chilly, gray day—evening—in March, dripping with condensed moisture from swirling fog and mist, the redwood forest was not a cheerful place; and there was a lot more of it to come. Maybe it was time to turn around and head...not for home, where she'd have to explain herself and behave like a rational human being, but at least in that direction.

She pulled her mind off autopilot, began to watch road signs, and within minutes was pulling into the small town of Garberville, where she quickly found herself blinking at streetlights, store-fronts, cars, a few pedestrians—and hurrah, a small grocery store. With that ham sandwich a long time back, she'd get a chunk of cheese, maybe a baguette, a bottle of wine.

Inside the store, where wooden floors creaked and the vegetable display against one wall was limited to items that couldn't wilt, she revised her grocery list. She trekked slowly along narrow aisles and picked up a loaf of San Francisco sliced sourdough bread in a plastic wrap, a loaf of sharp cheddar cheese from Ferndale, a squeeze-bottle of bright yellow mustard. She thought there was an apple in her cooler, courtesy of her mother.

Wine here came in giant bottles with names she'd never heard of, on a narrow section of the shelf devoted to whiskey, gin, and vodka, also in big bottles. She looked down the aisle to the counter, and saw that small bottles of spirits were kept there, sensibly. "And I'll take a pint of gin, please," she said, as the woman was ringing up her purchases.

"Gordon's? Gilbey's?"

Verity was not much of a spirits drinker. A survey of the shelf behind the counter revealed neither the Queen Victoria–labeled Bombay or the green Tanqueray bottle her San Francisco friends favored. "I don't care. Either one."

The woman put a bottle of Gordon's on the counter and looked up at Verity. "Honey? You gonna get something to drink this with?"

"Uh. Sure. Just a minute." She went back down one of the aisles to the cooler, surveyed the possibilities, and picked up a half gallon of ruby grapefruit juice. Good dose of vitamin C couldn't hurt.

"Well, that oughta stretch it out, anyway," said the clerk. "Honey, I hate to say it but you look kinda frazzled. If you don't *have* to be somewhere tonight, there's a good motel up the street, the Bluebird. It's cheap but clean, got good beds. Just a thought."

"Thank you," said Verity, stretching her mouth in what she hoped looked like a smile.

———//———

An hour later she was back on Highway One just north of the abandoned village of Rockport. In full dark, with a light rain slicking the narrow two-lane road, Verity found herself having to grip the wheel hard and lean forward just to stay awake. She hung on grimly, and at last, there it was: the campground above Westport–Union Landing State Beach. A long paved stretch between ocean bluff and highway, it looked to be very sparsely occupied on this rainy March night, motor homes and trailers and the occasional SUV set well apart as if for privacy.

Nobody uniformed or otherwise was moving about in the rain, and she could pay tomorrow. She pulled into the first entrance and drove slowly past two bus-sized motor homes and a truck-trailer arrangement, past some open space, past another big vehicle of some kind. Another stretch of open space, and she chose a spot more or less in the middle of it, with a squat structure that was probably a vault toilet ahead at the very end of her headlights' reach. Far enough away to be within reach but beyond smell, she thought, and parked neatly and turned off her engine. She released her seat belt, fumbled for and found the seat-tilt lever, leaned back, and was asleep at once.

CHAPTER 18

AT JOHN MUIR School on Monday afternoon, several of the buses were late, among them Mrs. Romero's "Seagull." Sylvie said good-bye to Jessica Kjelland and several other girls and then stood near the curb, bouncing restlessly on the balls of her feet. "I need to get home and take care of my dog," she said to Robby Mendes, who had come to stand beside her.

"My mom says I can have a dog someday," he said. "Maybe you could bring yours to school?"

Sylvie shook her head. "Mrs. Lee says no. She says, what if everybody brought a dog to school?"

"Ms. Rankin brings hers, did you tell her that?"

"I think she knows that, Robby." She leaned out and peered down the street. A car whose waiting mom had just collected her two children pulled away from the curb in front of them and a big, rust-marked white pickup truck pulled up into the vacant place.

"Oh," said Robby. "That's my brothers. I guess my mom isn't home yet," he added sadly.

The pickup's door on their side opened, and a big boy got out. He was round-faced, with brown hair, but Sylvie thought he looked more like Ricky than Robby.

"Hey, Robbo. C'mon, get in. Bring your little friend if you want."

"Hey, Luke," Robby said. "Sylvie, you want to come?"

She shook her head.

"You like boats, Sylvie?" asked Luke. "We got a nice sixteen-footer down at the wharf, and a cool trailer where we stay."

"I like sailboats," she said. And then, quickly, regretfully, "But I have to go home."

"We'll just go look at the boat first. Then we'll take you home. Come on." He came closer and held out a hand.

The image of a small, pretty sailboat danced in her mind's eye, and then came Lily's voice: *Do not ever get in anybody's car unless I've said you can. Not ever.*

"No. Thank you." The ʀᴀᴇ ᴄᴀᴇᴡʀ, loud still ᴄᴏᴇᴜᴇ ʀᴏ ʟᴏᴀᴅ, and she backed away. "No!"

"Luke, leave it," called the other boy from the truck.

Sylvie took another step back and saw the yellow bus turn the corner. "Here comes Mrs. Romero. I'll see you tomorrow, Robby." She hurried up the walk to where the other waiting Seagull riders were lining up, and was inside and in her seat when the Mendes truck pulled past and sped away.

"Who was that? They'll get it for driving so fast in the school zone," said her seat-mate, a bossy fourth-grade girl.

Sylvie hesitated, and then said, "I don't know." Poor Robby had enough trouble already.

———//———

Delayed by two necessary errands after leaving her office, Patience still reached home with half an hour to spare before Sylvie was due. She let the dog out, quickly changed clothes, let the dog back in. Then she was free to pursue the notion that had been nagging away in the back of her mind since Carolyn Duarte left her office.

Patience pulled the Port Silva High School yearbook from the living room bookcase, sat down on the couch, and began to page through the senior photos. Many of the faces were familiar to her now, but it was a name, not a face, she was interested in. She'd nearly given up when she found it on the last page.

"Antonia 'Toni' Ybarra," she said aloud. The name had caught her eye briefly in an earlier survey, mainly because of the face it accompanied. Toni Ybarra's mop of shoulder-length, richly curly dark hair framed a vivid face with delicately arched brows over big green eyes, a long, straight nose, a wide, half-smiling mouth. More handsome than pretty, it was a face that said, "I dare you!"

Transfer from Berkeley, said the information beside the photo. Cross-Country, Musicals. And her life's aim: To rule the world.

Patience thought she looked capable of doing that, or trying to. Could this be the niece of Carolyn Duarte's friend Ruth Ellis, the one who had "up and left" sometime in the early 'seventies?

The separate list of graduates' names, tucked in the back of the book, did not include Ybarra, and she decided that this confirmed her

suspicion rather than refuting it. Yearbooks, after all, went to press very early so as to be in the hands of the students, particularly the graduating seniors, well before the school year ended.

She was still puzzling over why this interested her when Zak sprang to his feet and made quickly for the door, where he sat to await his person from the school bus Patience was only now hearing.

She opened the door to let him out, and he met Sylvie in the middle of the yard with a furiously wagging tail and one low "woof!" before falling into step beside her.

"Patience, Zak is really glad to see me!"

"That's what dogs are especially good at, Sylvie, being glad to see you. How was school?" The two of them came inside, and Patience took Sylvie's backpack.

"The reason I'm late is that the bus was late," Sylvie said. "And—"

"Good. You have time for a quick snack. Then we'll all go for a walk before the rain starts. Verity had to go to the city, and said she'd see you tomorrow, but Hank is taking us to dinner."

———//———

"Thank you, Hank," said Sylvie, looking angelic in a nightgown of white flannel printed with tiny blue flowers. "I really like Hungry Wheels."

"You're welcome, ladybug," Hank told her.

"G'night then," she said, coming to kiss Hank and then Patience. "Come on, Zak."

Hank, sprawled on the couch, raised an eyebrow at Patience as Sylvie and the dog disappeared into the hallway leading to the bedrooms.

"He sleeps on the floor," said Patience. "By his own choice. She got him up on her bed the first night, Verity tells me; but he was uncomfortable, or maybe embarrassed, and got right down again. He's a dog with opinions, but he's polite about them."

Hank sat straighter. "First time tonight I've had a chance to say so, Patience, but I'm real sorry about what happened to Verity. Pure dumb carelessness on my part."

"She doesn't blame you, or the Finch girl, either, from what she said to me. She went off to San Francisco early this afternoon, to spend time with an old friend."

"Good for her."

"My thought exactly. Anyway, I really liked Hungry Wheels, too."

"Yeah, who'd think a truck stop could do meatloaf as well as ham-

burgers? Patience, are you going to settle or not? You're bouncing around like a worried flea."

"I'm waiting for Sylvie to be safely out of earshot," she told him, and moved to the hallway to glance in. "Good, the door is closed. Now, do you have time to talk? I can make coffee, or pour you a glass of brandy."

He shook his head. "I've been mainlining coffee from about five A.M., and brandy would put me right to sleep. Maybe a glass of cold water?"

Back in moments with water for him and a glass of white wine for herself, she kicked her shoes off and curled up on the other end of the couch. "Hank, I don't mean to pry into an ongoing investigation, but..."

He grinned. "Since when?"

"Next year, maybe? Without violating confidences, what can you tell me about Tessa Finch's death?"

His humorous expression faded. "She died sometime in the night Saturday—a single bullet to the head from an old Colt .22 revolver. She wasn't found until Sunday night, probably because the rain was so heavy that anybody driving past was concentrating real hard on staying on the road."

"Do you—does the department—consider it suicide?"

"That's still open, Patience. No, I'm not dodging," he added quickly. "The scene was a rain-soaked mess, postmortem's set for tomorrow, lab people are still working over the truck. It's physically possible that someone came up to the side of her truck, shot her, and left the gun there.

"Her family," he went on, "is absolutely certain she wouldn't have killed herself. For one thing, she'd become a regular Catholic communicant again after years away. For another, they insist she was terrified of guns—wouldn't have one at Janacek's even after being robbed there."

"What did they think about the message she left for me?"

"That she sounded normal. Not suicidal."

"I knew her only very slightly, of course," Patience said slowly. "But the second time I listened to that message—after I'd adjusted to the fact that I was hearing the voice of a dead woman—I thought it sounded anxious but not frantic."

"I wouldn't disagree," Hank said. "But how much that means is another question."

Patience, who'd forgotten her wine, picked up the glass and took a thoughful sip. "Would you be interested in a bit of nasty, probably unverifiable gossip?"

"Absolutely."

"This is not something I'd pass on normally. Marilyn Ritter, who has a network of talky acquaintances that would stretch from here to the moon, says a friend thought, before the report of Mrs. Finch's death, that she'd simply run off with a boyfriend."

Hank made a face. "Unfortunately, that's the kind of stuff needs to be explored in cases like this. Speaking of your office, I did go by and put back the answering machine. With a new tape."

"Thank you. I'm not a masochist," she told him with a brief smile, "but if there are more callers like the man today, I'd be better off knowing."

"Maybe." His expression said he was unconvinced but not prepared to fight about it. "How're your feet feeling, after all the walking we did on Saturday?"

For answer, she turned sideways and settled her stockinged feet in his lap. He began to rub them gently, and she sighed.

"Lovely." She took another sip of wine. "Does it occur to you, dear Hank, that there's something—disorienting?—about the two of us sitting here like a pair of grandparents and talking about murder?"

"Loving grandparents. Nope, to me it seems normal."

"Then may I ask one more question?"

"Any time." He took the glass from her hand and drank and handed it back.

"Would you like a glass?" He shook his head. "So, the question. Do you know, or can you find out for me, whether anyone reported a teenaged girl named Antonia Ybarra missing in the spring, possibly early May, of 1973?"

"Doesn't ring the faintest bell at the moment. But I'll check tomorrow. You want to tell me what it's about?"

"I'm not sure. I'll find out more tomorrow, too."

"Okay." He squeezed her toes, moved her feet from his lap, and stood up slowly with a groan. "Time to hit the road."

She rose as well. "You're welcome to stay, if it wouldn't cause problems at home."

"Thank you, ma'am." He bent to kiss her lightly. "But not tonight. However, there's good news I hadn't got around to yet."

She waited.

"Jason came back to town yesterday, with a job and a vasectomy."

"Oh my!"

"Yeah, he figured four was enough. Now he's insisting that his wife and kids belong in Oakland with him, and I think Molly's about to decide that's where her duty lies. And her happiness, I hope."

Patience was able to say honestly, "I hope so, too."

"But he's not staying at the house tonight. So unless you're feeling nervous about being here by yourself…"

"No, I'm fine, and Zak is very watchful. I'll open Sylvie's door after you leave, so he has the run of the house."

"Good idea." Hank went to get his raincoat from the hook in the kitchen.

Patience walked to the door with him, and peered out into a straight-down, steady fall of rain, the kind that would surely go on all night. "I'm going to unplug the landline phone for the night, just in case the unlisted number somehow gets leaked. If you need to get me, call my cell phone."

———//———

How long she'd slept she had no idea—an hour? two?—but it was the cold that released Verity from her dream: Sylvie screaming, "Kill the devil!", a gunshot, a supine body jerking an upraised knee. The familiar dream, she realized as she lurched into wakefulness, with an added scene in which a different body spilled again and again from the open door of a pickup truck to sprawl on its back, blood streaming over the dead-white face from a hole between staring blue eyes.

For a few minutes she sat and shivered, hearing only the gentle rain and the muted roar of the ocean. It was in a place like this one that Tessa Janacek had parked her truck before picking up her gun, although there were other spots more secluded, more private. Surely suicides preferred privacy?

Oookay, Verity-named-for-truth, is that why you stopped here? "No," she said aloud. She was not even slightly suicidal, merely miserable. Maybe she was making a morbid attempt to think her way into the other woman's head, this other person who like herself found solace in being near the ocean.

But it didn't work for you this time, Tessa. Why not, you foolish woman? Why *not*?

———//———

The rap on the window brought her bolt upright, heart in mouth, as she struggled to free herself from the sleeping bag, to grab for the small hammerlike device meant to break windows but the closest thing she had to a defense weapon. Oh God, it was in the other door pocket!

Another rap, and a flashlight bloomed beneath a chin. Jake Jacobs was out there, bending to put his disapproving face close to her window. She couldn't hear what he was saying but she read his gesture: unlock the door.

"Why should I?" But he couldn't hear her, either. She finally got her right arm free and released the lock.

He pulled the door open, and the interior light came on. "What the hell are you doing out here?"

"Uh, resting." She was in the tilted-way-back passenger seat, enveloped in her sleeping bag, not sleeping but listening for the second or maybe third time to ethereal music by a fifteenth-century composer she'd never heard of, with a name that had to sound like clearing your throat. At just past midnight by the dashboard clock. She reached out to turn the music off. "What are *you* doing? Besides letting the rain in?"

He snarled something, slammed that door, and trotted around the car to open the driver's door. "If you're getting in, you should take your wet slicker off," she told him.

He glared at her but obeyed, tossing it behind the seat. "This is a really dumb-ass place for a woman to park alone at night. This time of year, anyway." He dropped into the driver's seat with a thud that shook the vehicle, and closed the door.

"You think rapists are skulking around in the rain?"

"I know they are, along with muggers and carjackers and you name it."

She put her seat into a more nearly upright position. "How did you know I was here? Did somebody call you?"

He snorted. "I live near here, and I'm an old cop, I keep an eye out. I recognized your car. Look, this really isn't a good place for you to spend the night, and it's raining like hell further down the coast. Crawl out of that cocoon and follow me to my house."

Verity considered this. A warm fire would be nice, but over the past hours she'd moved from guilty misery to a kind of connection with Tessa Janacek. Besides...

"I don't think I should."

"Why not?"

"Because I think I'm a little bit drunk." She gestured at the coffee mug in the cup holder.

He picked it up and sniffed. "What is it?"

"Grapefruit juice and gin. Not very good gin, I guess, but it turns out grapefruit juice pretty much masks the taste."

He opened the door and before Verity could protest, he'd poured almost a full measure of her anodyne on the ground. Queasiness touched her, along with a sense of returning paranoia. "Shit."

"Tell you what, Red. You just stay there in your little nest. I'll lock my truck and drive us both home."

Deciding not to embarrass herself with resistance that would prove futile, Verity buckled her seat belt into place over the sleeping bag and shifted to sit more or less straight up in her seat as he drove her car out of the campground, across the highway, and into the black hole of the Branscomb Road.

It was not totally black at the beginning, with lights from the occasional house, but soon there were no more houses, or none close enough to the road for any lights to be visible. The road dipped and climbed and curved, Jacobs driving it with the easy speed of familiarity. How long? she wondered, and after a while couldn't restrain a small groan.

"What?"

"I think I'm going to be sick."

"Hold on, there's a driveway just ahead." Moments later he pulled into it, slammed to a stop, and came around the car to lift her clear of the sleeping bag and out into the rain.

She stumbled two steps from the car and waved him off just before leaning over to spew out everything she'd swallowed in the last eighteen hours. She gagged, got rid of a bit more liquid, gagged again, spit. Jacobs touched her shoulder and reached around her to put a big handkerchief into her hand.

"Gaah." She wiped her mouth, spit again, and returned, shivering, to the car, where she shed her wet and probably stained jacket but decided her jeans were only slightly damp. "Jake? There's a bottle of water in the cooler there."

He fished it out, uncapped it, and handed it to her. "Okay now?"

"More or less. Thanks."

"My pleasure." He pulled out of the driveway, set off at his former

speed, and slowed, slightly. To make up for that dubious phrase, perhaps. With the sleeping bag draped over her shoulders, Verity sat straight and focused her gaze and her attention on the windshield, where the rain ran in crooked little rivers down the spaces outside the wiper-arcs. Be quiet, she told her stomach.

A long fifteen minutes later Jacobs ushered her in through his front door, where the three waiting dogs greeted them with mild interest and returned to their beds. Jacobs plucked the sleeping bag from her shoulders, carried it to the kitchen end of the room to hang it over the back of a chair, and turned to appraise her.

"You look like a drowned rat. A sick drowned rat. How do you feel?"

Verity hunched her shoulders and shivered. "About as bad as I look, thank you."

"First thing you need is a hot shower. Come on." He took her arm to lead her to the doorway in the rear wall, and into a short hall, where he opened the door on the left to reveal a big, well-appointed bathroom.

"I need to get my bag from the car."

"I'll get it. But there's everything you need here. Fresh towels on the shelves, and one of those robes on the hook there should fit, they're clean. Take as long as you want, it's a big hot-water heater." He left, closing the door.

Verity stripped off her damp, dirty clothes and considered stretching out in the nice big bathtub, but thought she'd probably drop off to sleep there, which might lead to embarrassment. Instead she looked into the separate shower, found it supplied with both soap and shampoo, turned on the water, and stepped in.

When she returned to the living room half an hour later, ankle-length white terry-cloth robe belted tightly around her, she found Jacobs standing before a roaring fire, a bottle of beer in his hand. In her absence, he'd changed from corduroys, leather jacket, and boots to worn-thin Levi's and an old Giants sweatshirt, and looked less like an angry cop and more—ordinary. Human.

"Red, I'd hardly recognize you. Want one of these?" He held up the bottle.

Verity made a face. "I'll pass, thanks."

"Sensible." He pulled a high-backed rocking chair closer to the fire. "Here, sit down."

She sat, and leaned back, and after a moment pushed off with one foot to rock gently. Jacobs pulled up a hassock and sat down, cradling the beer bottle in his hands.

"I heard about Mrs. Finch. I guess that's why you're out wandering?"

"Is that what I'm doing?"

"You tell me." When she said nothing, he leaned forward to look directly at her. "Hank Svoboda called me Saturday, said she was known to come to this area hunting for rare plants and asked me to have a look around. When they found her, Svoboda called to let me know. He said her family thought her death was connected with the Edgar Larson investigation."

Verity pushed herself back into the chair, so her spine was against the wooden slats. "Her daughter accused me of killing her."

"And you took off to burn up some highway and think about whether she might be right."

"I guess."

"Southern California desert's the best place for that. Take State 58 out of Bakersfield to connect with I-40 to the Arizona border, you can outrun whatever devil's behind you."

She gripped the arms of the chair so hard she felt her fingernails dig into the wood. "Devil. That's what Sylvie called her stepfather, the devil."

"That's the guy from last summer? The one you shot with his own gun?"

"I…Yes."

"Want to tell me how you did that?" When she shook her head, he grinned. "Red, you must be a whole lot tougher than you look."

"You bet I am, you son of a bitch!"

Another grin. "I'll watch my back, and my weapons. So what did you decide on your run today?"

She sat back in the chair again, and felt fury-tightened muscles ease. "That I certainly didn't kill Tessa Finch, but that my investigation had something to do with it. So I'm not completely guilt-free."

"Hell, who is? What you want to watch out for is the guy who tries to get rid of his by passing it off to you."

Confidentiality be damned, and self-image as well. Except for Patience, who was a rainy past-midnight hour away, the man before

her was the closest to an objective observer she was likely to come across. "I was getting nowhere looking for enemies of Edgar Larson. Then I learned he'd been a volunteer supervisor of the high school parking lot the last several—three, I think— years of his life."

"Ah," said Jacobs. "Where did that take you?"

"Only far enough to get into trouble. Could I change my mind and have a beer, please?"

With the cool bottle in her hand, she talked, and he listened.

"Eleven out of sixty-seven doesn't sound like a lot," she said, after describing her interviews with, and about, the class-of-'73 grads. "But they're a varied bunch. Four are college grads, one of these financially and politically prominent. Five are small-business owners, five are people working at the lower end of the scale. So I think you could call the group a relevant sample."

"And folks were willing to talk to you?"

She nodded. "There are three I haven't approached, but only one of them looks worth pursuing, and I—we—will."

"Who's that?"

"A man named Bobby Mendes," she said reluctantly.

"Hold up a minute, I need another beer." He got a bottle from the fridge, popped its cap, and returned to stand again before the fire. "So what did all this mean to you?"

"That thirty years ago, with one apparent exception, a handful of very different eighteen-year-olds had no hint that a man they saw almost daily was a sexual predator, nor a sense of any plot or vendetta happening right under their noses at their very own school. Which I think is…unlikely."

"If they were being honest with you."

"I'm not a trained interrogator, but I'm not naive or sheltered, either. Do you have an opinion about any of this?"

"Nothing that weighs against what you said. Mendes is a major asshole, maybe worth following up, but I think you're still left with Finch. Janacek."

"I know." Verity took a drink of beer, grimaced, and set the half-empty bottle on the floor beside her chair.

"Any ideas about what really sent her over the edge?"

"Some…thoughts." When he made no reply, she took a deep breath and went on. "Maybe she was the person who made those calls, for fun or spite or because of something he'd done. But she

couldn't possibly have known that her actions would lead to his death."

"Okay."

"She was just a kid then. Now she's — she was — a married woman with grown children and a business she loved and was good at. Remember, before she knew who I was, the two of us spent quite a bit of time together picking out a plant, and she was calm and capable. So sure, she'd have had to be unhappy at having her earlier actions made public, anybody would. But suicidal? That doesn't make sense to me."

"So what would?"

"Funny thing, I had the idea that you were a gun-and-billy-club cop, and it turns out you're the leading-question kind."

"I was both kinds," he said without a smile, and tipped his beer bottle up for several long swallows.

"Oh. Well, helped along by gin and juice, I came up with two other possibilities. One, she tried anonymously to disgrace Edgar Larson because he'd done something awful to her, something she couldn't bear to have anyone know then or now."

"That's not unreasonable."

"Except that nothing anyone has said about Edgar suggests that he was capable of something brutal."

"Okay. Possibility number two?"

"That there was some other crime involved, something that hasn't come to light. And maybe even some other people. My reason for thinking that is her phone message."

"Phone message?" Jacobs, who'd been pacing slowly back and forth in front of the fireplace, now stopped. "That wasn't in your story."

"Sorry, I guess I try not to think about it. It was on the office machine, the only number that's in the book for us. Made late Saturday afternoon. It just said she wanted to talk to one of us, and would try to call later. No number. She apologized for bothering us." Verity's voice ran dry, and she cleared her throat. "Sorry. Patience was out of town, I was at home but didn't think to check the messages. Until Monday morning."

"No way you could have called her back."

"I know. But I could have told somebody, got people looking for her."

"People were already looking for her by then, and hadn't found

her." He put a hand on her shoulder. "Come on, Red, it's past one. Let's get you to bed."

She shook her head. "You go on."

"Look, I sleep in front of the fire more often than not. And if I need it, I've even got your sleeping bag for extra. Come along." He took her elbows and half lifted her out of the chair. "You need a good night's sleep."

Gently propelled by his arm across her shoulders, she moved with him toward the hall, where he opened the door opposite the bathroom and turned on the light. "There, it's a good bed. Clean sheets and everything." He pulled the covers back, and she stood staring at a big, white, empty bed.

"If I sit up in the chair, I won't have those dreams."

"Don't worry." He took her shoulders in his hands and gave her a gentle shake. "If you have dreams, the dogs and I will hear and come wake you up."

With a shudder she stepped forward and slid her arms around him, taking solace in the warmth, the spring of rib cage, the steady thump of heart. "Stay here with me."

She felt a brief shifting of his weight, as if he'd step back, before he pulled her closer. "Red, are you sure?"

What she was sure of was that she didn't want to sleep alone. "Almost." She turned her face to his and as their kiss went on, his hands slid lower to cup her bottom and pull her against his erection.

"Okay." He was slightly breathless when he lifted his head. "Almost will do."

THE MOMENT SHE awoke, Verity knew exactly where she was and how she'd gotten there. She rolled over, stretched, and waited for the expected wash of guilt, which failed to materialize. Instead, she felt peaceful, if not exactly cheerful, and—grateful. Jake Jacobs had proved to be the kind of lover who enjoyed giving pleasure as well as receiving it. He was also the kind, she remembered now with additional gratitude, who kept condoms in his bedside drawer. Jake was not quite the hermit his isolated home might suggest.

There was a rap at the door. "Hey, Red, you okay?"

"I am. Thank you."

His immediate response was somewhere between a chuckle and a snort. "Good. Breakfast in ten minutes."

Verity rolled out of bed, retrieved the terry-cloth robe from the floor beside the bed, and padded off to the bathroom with her duffel bag. There she had a brief splash of shower and dressed quickly, tucking yesterday's dirty clothes into an empty pocket in the duffel. She brushed her hair and braided it quickly, picked up the robe to hang it back on its hook, and observed in passing that the other robe hanging there, also white terry-cloth, was much shorter.

"I'm an old-fashioned cook," said Jake from the stove, as she came into the front of the house. "Bacon, eggs, fried potatoes."

"Wonderful." She put her bag down by the door and was caught by a flash of bright yellow from one of the framed pictures on the wall. "That looks like…" and then, louder, "Hey, you've got one of Angie Apodaca's biker paintings."

"Yup," he said without turning around.

"Wow." She looked at it more closely. It was smaller than the only other one she'd actually seen, maybe ten by fifteen inches; in brilliant acrylics, a sun yellow motorcycle flew down a gray gash of road,

its helmeted black figure somehow radiating both menace and joy.

There was another, larger frame further along the wall. Verity went to look, and said, simply, "Oh my." This was a watercolor of a broad, calm river curving gently around a half-submerged small island, through dead-stick trees and some still green. No, not gently; relentlessly. Angela Apodaca, Harley's mom, having gained wide critical acclaim for her paintings of bikes and their riders, had then turned her attention to rivers.

"Is this the Sacramento?"

"Yup," he said again. "Food's ready, come and eat."

Verity accepted a filled plate, took two pieces of toast from a smaller plate on a shelf over the stove, and sat down. There were glasses of milk already on the table, and mugs for the coffee now spluttering into a coffeemaker carafe on the counter beside the stove. Jake filled another plate, checked that all burners were off, and came to join her.

"From a cook to the cook, everything's perfect," Verity said, and ate. When her plate was empty, she got up to pour coffee into both mugs, and sat back down.

"Harley Apodaca is our computer person and good friend," she said brightly. "Recently, after he had roommate trouble at his apartment, my mother helped him move in next door, to house-sit for a neighbor who's away."

"Uh-huh," said Jake, who was still eating.

"Patience has met his mother, but I haven't," Verity went on. "I've heard a lot about her, though. I guess you know her?"

"I've known Angie for years."

"Uh-huh," said Verity in her turn. "Harley told us his mom is coming home, this week he thought. He mentioned that she'll probably stay some time, at least, with an old boyfriend."

Jake went on eating.

"And here you are, with two paintings probably worth more than your house. And two clean bathrobes, one quite short. And clean sheets on the king-size bed. And, if I may say so, quite a lot to offer a weary woman."

"Hell, you'll turn out to be a detective if you're not careful." Jake's face had reddened, but Verity didn't think he was angry. "Angie and I are two loners. Neither of us really fits in anyplace, but we do pretty well together for a while, when she's home from a painting trip."

"She's a local, isn't she?"

"Born on the family sheep ranch, which she still calls home." He lifted his coffee mug for a tentative mouthful, and then a larger one.

"Is she old enough to have been in high school in the early 'seventies?"

"Along with your ten survivors, you mean? Angie'll be forty-four in October, which would have made her—let's see—sixteen in 1973. I'd assume she went to high school in Port Silva," he added with a shrug.

"From what I've heard of her, and from her work, I'd say she's an iconoclast with a very observing eye."

"That sounds about right."

"Jake, do you think she'd talk to me?" As the words left her mouth, she realized she'd settled her own inner debate. Go on, find out.

"Sure, if you don't tell her where you just spent the night." He noted her reaction, and grinned. "Red, I'm kidding. Angie and I don't have any chains on each other."

"If you say so." Verity looked at her watch, and pushed her chair back. "I'd better get on my way, before my mother calls the person I'm supposed to be visiting, finds out I'm not, and sends out the Highway Patrol."

"Hold up a minute while I get my jacket. I need a lift back to my truck."

When she pulled into the campground a short time later, most of the spaces were empty and there was still no sign of any attendant. "I didn't pay last night," she said to Jake as he got out of the car.

"You didn't stay here last night," he pointed out. He walked around the Subaru, leaned in the open window, and gave her a quick, avuncular kiss. "I won't say be careful, Red. What I do say is, pay attention. You need to remember that suicide isn't the only possibility. Maybe that's the real message Finch left you."

———//———

On Raccoon Lake Road, Patience got a glum Sylvie fed and dressed in time for the school bus. "Remember," she cautioned, "no piano lesson today, so you'll catch the bus home."

Once the bus had driven off, she wrapped herself more tightly in her coat for her next assignment, watching Zak tend neatly to personal business before undertaking a thorough exploration of his territory. Then, pushing worries about Verity to the back of her mind, she

spent a few minutes deciding what approach she should take with Carolyn Duarte.

Carolyn, it turned out, did not require explanations or careful handling. "I know Ruth would be pleased to talk to you," she said. "Let me give you her phone number."

Ruth Ellis was thrilled by the opportunity to speak with a real detective about her long-missing niece. She suggested meeting at ten-thirty at a neighborhood coffee shop, the Gray Gull—named, she said, for the old folks from the nearby seniors' residence who hung around there like gulls at the wharf.

Patience arrived exactly on time and stepped into a large, very warm room with display case and counter along the left wall and a dozen or so tables scattered around. Maybe half of the tables were occupied, all of them by people Patience's age or older. There was no lone woman in view, so Patience went to the counter to inquire.

"Mrs. Ellis?" The woman behind the counter was younger than her clientele, probably middle forties. "Oh, she'll be along, I'm sure. She doesn't move very fast, but she always gets where she's going.

"Here she is now," she added, and moved to open the door for a bundled-up figure who trudged slowly in with the aid of a four-footed cane.

"Mrs. Ellis? I'm Patience Smith Mackellar, and I'd have been happy to pick you up at home."

"If I don't make myself move around some every day, I'll wind up in rigor before I'm even dead. Hello, Marylou. Good, my usual table's free."

Patience followed Marylou and Mrs. Ellis to a table with no particular distinction that she could see. What she did see was that nearly everyone in the room nodded or spoke greetings as they passed.

Ruth Ellis took off gloves, scarf, fuzzy hat, and padded coat to reveal an over-medium-height body compacted and broadened by age, as if nature had put a hand on top of the white head and pressed down hard. "Coffee," she said to Marylou when she'd settled into a chair. "And a glazed doughnut."

"Ma'am?" said Marylou to Patience, who asked for the same.

The coffee came in lightweight mugs with big handles, the doughnuts on small, pretty plastic plates. When Mrs. Ellis had arranged everything to her satisfaction, she took a sip from her mug, looked at Patience, and said, quietly, "Carolyn Duarte is an old friend. We

worked together at the hospital, back before I retired. She tells me you were real helpful to her with her niece, and I believe she told you I had a niece at one time, too."

"She said you took the girl in and supported her and then were hurt and disappointed when she left abruptly."

"I was. And I thought I'd got past it. But with this business of Carolyn's, I got to thinking that I have no single living relative to my name, except that girl. If she's still out there somewhere. Do you think there's any chance you could find her?"

Patience took a deep breath. "When did she disappear?"

"In 1973."

"Mrs. Ellis—"

"Call me Ruth, please."

"Ruth, it's likely to be difficult after almost thirty years. It depends on what kind of trail she left. What can you tell me about her?"

Ruth Ellis picked up her doughnut and broke it in half, scattering flakes of sugar. "My brother was ten years younger than me, and I loved him. But he was a hellraiser from the git-go and never grew out of it, and his daughter was just like him. After he got killed in 1968, his half-witted wife couldn't handle the girl."

"And she came to you?"

"Eventually. You know that story Rosalie Sorrels tells on one of her albums, how she could hardly wait till her son was the age that when he screwed up, the cops would come for *him* instead of her? That age was not too far off for Toni. The social services people in Berkeley, and of course her mother, too, thought that maybe in a different environment, away from bad friends, Toni might straighten herself out. When they approached me, I said she could come here if she'd agree to live by some rules and go to school regularly."

"Did she leave after disagreements with you?"

"I honestly don't recall any that were serious. We were—I *thought* we were—getting along pretty well. We didn't see a lot of each other, because I usually worked second shift at the hospital with a trauma team. But the house was big enough for two people, she was doing well at school and looked to be going to graduate. Even got accepted at Humboldt State. Then I went away for a long weekend in, uh, early May it was. And when I came back, she was gone."

"Did you ask the police to look for her?"

"By then she was eighteen. And she'd left me a note. '*Thanks for*

everything, Aunt Ruthie, but I'm bored with this dumb little town. May-be I'll be in touch later.'" Mrs. Ellis spoke as if reciting a poem. "And she took all her stuff, cleared every blessed thing she owned out of her room. So I didn't think the police would be much interested."

"What about the high school? Or her friends?"

"Somebody from the school called me about a week later, and I just said she'd gone home." Mrs. Ellis, eyes down, pushed a few flakes of sugar around her plate with a forefinger. "Same with a friend— maybe two, I don't remember."

"Did you report her disappearance to her mother?"

This brought the old woman's gaze up, and a twist to her mouth. "I called her about a month later, when it was clear Toni wasn't com-ing back. No news is good news, I think that's what she said."

"And you've heard nothing from Toni since?"

"Not a word. But when you called this morning, I thought maybe it was a sign or something. Would you try to help me on this? I'm not poor, I can pay."

Patience was feeling twinges of guilt. "What's caught my attention here is a possible connection to another case I'm working on," she said. "That same year, 1973, an elderly man named Edgar Larson was ac-cused, anonymously, of being a child molester. He later killed himself."

"I remember." The old woman frowned, and the gray-green eyes narrowed in thought, or memory. "That was after a child had been raped and murdered. I'd met that Mr. Larson a time or two, when his wife was hospitalized just before she died. He wasn't a man I'd have suspected of molesting, and I'd seen a few. But he was very devoted to his wife, and I suppose her death could have cut him way loose from his moorings."

"My agency is working for his granddaughter, Christina Larson. She wants to find out who accused him. The accusations were made on May fifth and sixth of that year."

The white head came up sharply. "That's the day Toni left, or the weekend. Are you telling me you think she's the one made those calls?"

"Absolutely not. We have no idea, yet, who made them. But one possibility is that they might have come from someone at the high school, where he volunteered as a parking-lot supervisor."

"The idea being that he came down hard on some teenager who decided to get even?"

"More or less."

"Well. I hate to say it, but Toni had a real bad attitude about authority. There was nothing on God's green earth she was afraid of, and nobody she wouldn't take on, any way that occurred to her, if she thought she was being taken advantage of or put down."

"She was here for what, most of a year?" At the old woman's nod, Patience said, "Beyond her resentment of authority, what was she like?"

"Well, let me think." Ruth Ellis pushed the doughnut aside, and fueled herself by sips of coffee as she pulled remembered facts together: Good student when she bothered. Reader. Not much for helping around the house. Liked music and performing. "She worked hard for a role in that musical, and she was the happiest I ever saw her when she got it."

A runner, said it kept her thin. Probably did drugs in Berkeley, but promised not to here and so far as Mrs. Ellis knew, didn't. Drank beer, smoked tobacco but not in the house. Admittedly sexually active since the age of fourteen, but if she'd continued that here, she was discreet.

"She refused to go to church. She said she didn't believe in God and wouldn't pretend she did. I prayed about that, but as far as I know, God didn't answer."

"Can you remember any particular boyfriend?"

The old woman's mouth curved in a brief smile. "She was my brother's kid, all right. With Toni, it was more like boyfriend-of-the-month, so after a while I didn't pay any attention to names. The last couple of months, though, there was this very good-looking boy around, tall with black hair. I thought she liked him a lot and he seemed crazy about her."

"If you remember his name, would you please call me? And what about girlfriends?"

"Not as many. One big blond girl whose dad was a fisherman; Toni went out on the boat with them once. And a couple times the Janacek girl, from the nursery family, came in with Toni before I…" Her eyes widened.

"Oh my God. The one that just got killed, her name's Finch now. You think there's some connection?"

Patience dodged that one. "It's hard to see how there could be."

"Well. I suppose that's true."

"Your niece's full name is Antonia Ybarra, is that correct?"

"Her middle name is Marie."

"Do you know her birth date?"

"March seventeenth, 1955."

"Did she have a social security number?"

"If she did, I didn't know it. She didn't take any jobs while she was here. It was our agreement that she'd concentrate on school and maybe do volunteer work. She did help out some with little kids, at the day-care center at the Y."

"Ybarra is the family name? Your maiden name?"

"Yes. My brother was Lawrence—Larry."

"Do you know Toni's mother's maiden name?"

A head-shake. "Something Irish is all I remember."

Patience put away the notebook in which she'd been making brief entries, and was surprised to see that not only was her coffee mug empty, her doughnut had disappeared. Stolen, surely.

"Mrs. Ellis—Ruth—do you still want me to pursue this, for a while at least?"

The old woman gave a great, deep sigh. "Yes, please. Even if there's something I'd rather not know, I think I'd better know it. If that makes any sense."

"It does to me." Patience got to her feet. "It's cold out there, and the wind is coming up. I'd be happy to drive you home."

"I'd appreciate that."

———//———

When Patience arrived at home again, she was pleased to find Verity's Subaru in its usual place, rain-streaked and mud-smeared but apparently intact. She lifted two of four grocery bags from the bed of her truck and was on her way to the deck steps and the back door when the door opened and Verity put her head out. "Oh, good," said Patience. "You can get the other bags, please. Hello, Zak."

"You planning to feed an army?" Verity asked as they unloaded the bags in the kitchen.

Patience cast a quick, assessing glance at her daughter, and decided she looked okay. Not particularly cheerful but okay. "Did I get carried away? I suppose I did. You've been doing the shopping so long that I've lost my eye," she said over her shoulder as she went to the door to whistle up the dog.

"Did you get something interesting for lunch? I had a nap, and did some work on my notes, and I forgot to eat."

"I had lunch with Hank, but take a look in that last bag. There was a special on Campbell's minestrone."

Fifteen minutes later the two of them sat down at the table, Verity to a bowl of soup and a glass of red wine, Patience with a pot of tea.

"Cheers," said Verity, and raised her glass. "How's Sylvie? Is she mad at me?"

"Mildly irritated, but not truly upset. Charlotte Birdsong's little Alice has a bad cold, so the lack of a piano lesson today gave her something more specific to be unhappy about. How's Giovanna?"

"I didn't see Giovanna." In response to Patience's cocked eyebrow, she shrugged. "I love her, but she can be overwhelming, and I was already overwhelmed. So I just went for a long drive."

"Where did you go?"

"Oh, to Cloverdale. Then to Hopland. That brew-pub could use a cook. And then on up the road until I got tired. On the way back, I stopped to see Jake Jacobs."

"Ah. The sexy old cop."

"Did I say that? I wouldn't call him old, exactly. But guess what? In that little brown house in the woods I told you about, he has two of Angie Apodaca's paintings, a biker and a river, the Sacramento."

"He may not be old, but he's obviously well-off."

Verity grinned. "More than you know. He's Angie's local—boy-friend? lover? Anyway, he knew about Teresa Finch's death, and we talked about it and what it might mean, mostly me bouncing my thinking and my conclusions off him. I think he was probably a very good cop."

"I believe he was a rogue cop, in some way Hank hasn't cared to explain."

"He does have that flavor. But he helped me get back on track."

"So you're going to continue the investigation?"

"Do you have a problem with that?"

"Don't snap at me, dear," Patience said. "No problem, merely an observation. I think you have to assume that Teresa Finch will be on the minds of some people, at least."

"As well as on mine. I know, Ma." She paused to spoon more grated parmesan cheese into her soup. "Okay, really big question," she said. "Have the police come to any conclusion about her death?"

"Not to my knowledge. When they do, and the family has been informed, Hank will let me know. And, let's see. There was a call from

Chris on the office machine. She's expecting to arrive at Inn of the Woods early this evening. I called there and left a message saying you'd be available tomorrow."

"Thank you."

"You're welcome. There was also a nasty hate-message on the office machine, and two rather unpleasant anonymous letters in my mailbox—delivered, not mailed. I dropped them off at the station for Hank."

"Mother..."

"But the interesting thing is that I've come upon a—a complication, or a very strange coincidence—with the 1973 graduates. It seems there was an unusual girl named Toni Ybarra...."

"She does look like a gal who'd make waves," said Verity, who'd gone to get the yearbook as soon as Patience finished her tale. "And here's the spread on that year's musical, *Show Boat*. Wow, she played—Julie, was it?—the mixed-race singer passing for white. Best part in the play; I always thought the singing riverboat daughter, Magnolia, was a drip."

Patience's mind was elsewhere. "For Ruth Ellis, and possibly for Chris as well, we're again in need of local insight. Are there any of the graduates you talked with who might be willing to go deeper?"

"Clare Novak," said Verity promptly. "She's tough and not shy, and I doubt she worries about offending anybody. I'll call her."

Patience sipped tea while Verity, rear propped against the sink counter, made the call. After she'd asked to talk to Clare Novak, she simply listened, her face intent. "Thank you. There's no message," she said, and put the phone down.

"So?"

"Mrs. Novak is at a special meeting of the Small Business Owners Association. They're planning a memorial for one of their members."

"Teresa Finch," said Patience.

"Right. For the moment, I'd say we pass on Clare Novak and several if not most of the others. But let me tell you what else might work," she said, and sat down to lay out the possibility of Angie Apodaca as information source. "After all, it's not as though she was part of that graduating class, or has a lot of local political or business clout to protect."

"Good thinking," said Patience. "Angie is due to arrive this after-

noon, according to Harley. You can probably get in touch with her tomorrow."

"Ambivalent" was perhaps too mild a word for Verity's feeling about this prospect. "Probably."

Zak, and then the two women, caught the sound of the school bus. Verity got up to open the door and Zak bounded out, to usher Sylvie in moments later.

Sylvie skidded to a stop, bent to pat the dog, stood straight and said to Verity, "Hello. Did you have a good time?"

Caught by a question she didn't really have an answer for, Verity gave her the so-so hand gesture.

"What does that mean, rocking your hand?"

"It means maybe yes, maybe no. Anyway, I missed you."

"Okay." Her squared shoulders eased. "Boy, I'm really hungry."

"Patience shopped today. I bet I can find you something."

While Verity helped Sylvie decide what she really wanted to eat, Patience glanced at the yearbook, still open to the pictures of the *Show Boat* cast. In one photo, Toni Ybarra as Julie looked adoringly up at the boy playing Steve, her loving but weak husband. "Verity? Would you say this qualified as a tall, really good-looking boy with black hair?"

Verity came to look. "I would. Adam Zalinsky, who looks like Hugh Grant." She flipped to the front section again, to his senior picture. "I noticed him the last time I had this book open. Why?"

"He fits Mrs. Ellis's description of Toni Ybarra's last, and longest-lasting, boyfriend. She couldn't remember his name. I should call her about it. Oh, before I forget, did Johnny catch you on your way out of town yesterday? I think he had something he wanted to give you."

"He did. A pair of CDs, some absolutely wonderful choral music by a fifteenth-century composer I'd never heard of."

"That's nice. Would you like to ask him to have dinner with us tonight? I did buy a lot of food."

"Oohhh, I don't think so," said Verity. "Not tonight."

"RIGHT THERE ON the table. Thank you," said Chris Larson to the middle-aged man in a waiter's white coat. He set the tray down, accepted the two folded bills she handed him, and left Hummingbird cottage without a word.

"They really don't want me here," Chris said with what sounded like satisfaction.

"The waiters?" Verity poured coffee into mugs before sitting down and reaching for the napkin-shrouded basket of warm croissants.

"Oh, *they* don't care, they're probably amused. And I tip very well. No, the managers. Apparently the woman who killed herself was a good friend of one of the owners, and I'm the nasty bitch who caused it to happen."

"Nice of you to arrive to share the blame." Verity busied herself with a butter knife.

"No problem." Chris poured cream into her mug and sat down. "So, tell me. Is this Teresa Finch the actual person who accused my grandfather? When she was Tessa Janacek?"

"If you read my report, you know as much about her as I do. She was a senior at the high school that year, she stayed to run her parents' business and has done well with it, she's—she was generally regarded as odd and unsociable. She left home right after my abortive attempt at talking to her and wasn't seen again until she was found dead."

"Seems like overkill," said Chris, her face suddenly somber. "Oops, dumb. But I was thinking in terms of an apology, not a death sentence."

Verity nodded in silent agreement.

Chris sat straighter, and Verity got a glimpse of the twelve-year-old soccer player, determined to win and never mind the bruises. "However, I still want you to stay on this for me. Maybe the accusations were made by this Janacek-Finch person, maybe not; but there

were two calls, and one of the callers was thought to be male. Let's find that bastard and drive *him* over the brink."

Verity stared at her and Chris stared right back, undaunted. "Hey, I'm not sure you've earned the two thousand dollar bonus yet."

"Keep it, Chris. You have our bill for time and expenses."

"Well, we'll see. I have an appointment with the editor of the local paper, to help put together a more complete obituary. And I thank you for the input on that."

"I was glad to do that part. Chris, how long are you staying this time?"

"Two or three days anyway."

"Fine." Verity swallowed the last bite of croissant, wiped greasy fingers on a napkin, and got to her feet. "I have another appointment, so I'll be on my way."

"Verity?" Chris got up, too, her face more open. "Please say you won't quit. I mean, I know you have other jobs, but I really need to know more about what happened here thirty years ago. Wait a minute, I have a check for you." She dug into an open briefcase beside the fireplace and came up with a checkbook. "Here."

Tempted to mention the odd maybe-mystery of the Ybarra girl, Verity resisted. "Thank you, Chris. If we discover any further leads to information on your grandfather, we'll follow them."

———*//*———

In the kitchen at home, Verity was unsurprised to find a note on the table: *Gone to have lunch with Hank.* "This is becoming a habit, Ma."

Patience went on to say that she'd put Harley and his computer to work on Toni Ybarra. Angie Apodaca had arrived home midday yesterday, weary and irritable according to her son, so it might be well to wait another day before approaching her for information.

"Terrific," Verity muttered, and tossed the note into the wastebasket. Since she was cravenly skittish about approaching the other grads again just now—some detective you are, said her personal conscience-tweaker—she had an afternoon to kill. Maybe she should take the dog for a quick walk; it must be hard on him to be shut up in a small house for hours at a time. "We definitely need a fence for you," she told him as she picked up his leash.

There was an old fence out there, she discovered half an hour later, or at least the remnants of one. She was making an exploratory circuit of the Mackellar property, Zak at her heels, when an engine alerted

the pair of them. "Wait," she said, taking hold of the dog's collar as they watched a dusty, travel-scarred motor home lumber up the driveway and stop beside her Subaru. While Verity stood frozen, wondering uneasily what might have brought this particular caller here, Zak trotted forward to say hello.

Clad in faded Levi's and a loose pink cotton sweater with white shirttails showing below the hem, Angela Apodaca was short, probably not more than five feet two, and sturdily built without being fat. She had Harley's wavy black hair with a few threads of gray, warm hazel eyes, and a makeup-free, olive-skinned face that had spent a lot of time in wind, sun, and probably rain. Clearly, thought Verity, this was a member of the same rather odd human subspecies as Jake Jacobs.

"Angie? Verity Mackellar." She stretched a hand out in greeting. "Happy to meet you. I'm an admirer of your paintings, and also of your son."

Angie moved from handclasp to a quick, vigorous hug. "Isn't he wonderful? He's my absolute best work." She stepped back to look at Verity with an assessing eye. "You were in three of every four messages he sent last summer, and I can see why."

Verity grinned. "He had a bit of a crush, but I think it had to do mostly with my car. This is Zak, incidentally. Would you like to come in for a cup of tea?"

"Hello, Zak. I'd love a cup of tea, thanks."

"My mother isn't here at the moment; she'll be sorry to have missed you," said Verity as they set off for the house.

"Please tell Patience I'll see her later. I'm road-weary and sick of my own company and think I might stay awhile this time."

When Angie was seated in the living room with a mug of tea in her hands and Zak at her feet, Verity settled onto the couch with her own mug and decided to emulate her mother and let somebody else toss out the first line. "Cheers," she said, raising the mug in a gesture of companionship before sipping.

"Cheers." Angie tasted, and sighed. "I should admit that I'm here more out of curiosity than neighborliness—although there's that, too."

"I see," said Verity, hoping she was wrong.

"When I came in to see Harley this morning, he was working on something for Patience, and of course, sweet square boy that he is, he

wouldn't tell me what. But I'd seen the name Antonia Ybarra before he turned off the screen."

Professional excitement washed right over personal apprehension. "Is she someone you know?"

"She is, or was. Is she someone you're looking for? Because Toni Ybarra was my, oh, my hero, I guess, more than twenty-five years ago, and when I saw her name, I realized I haven't heard of her since."

Verity decided that getting information was more important than maintaining confidentiality. "Neither has the aunt she'd lived with here, who's now eighty years old and frail, and feels she should try to reconnect with her only living relative."

"Oh, I'm sorry."

"Did you know Toni in high school?"

Angie's wide mouth pulled into a mock grimace of distaste. "I've always been grateful that for a brief time, Toni Ybarra brought a big splash of sunlight into the daily gray misery of high school." She eyed Verity and shook her head. "Not a problem for you, I bet. But I was this little nobody from a sheep ranch, for godssake. Short, fat, bad skin, the whole bit."

Verity's grin had a painful edge. "At fifteen I was five feet eleven and one-half inches tall, and weighed one-ten. Think broomstick, with red hair."

"Well then, you'd have loved Toni Ybarra. She wasn't conventionally pretty, and she didn't have nice clothes, but she was really smart and she was just full of zip, zing, mojo, anything you want to call it. She came to this little bitty school from Berkeley, I think it was, her senior year, and pretty soon she was on the cross-country team, and playing softball, and just basically having a fine old time.

"She wasn't my buddy, you understand," Angie hastened to add. "Sophs and seniors didn't mingle much. But I played softball, too, not very well, and she was always friendly."

"Her aunt said Toni had her happiest time with a part in the school musical." Verity got up and went to the bookcase to retrieve the yearbook. "She's in at least one of the pictures here."

Angie flipped pages. "Oh, I remember this. It was *Show Boat* that year, and Toni played the sad, sexy singer, the one who was part black. It was a great production."

Verity leaned closer to see. "She looks like a member of Actors Equity stuck in the middle of a church choir."

"Exactly. She played opposite Adam Zalinsky, and I remember being amazed that she could turn a handsome stick into a real, breathing man. You could see guys in the audience holding programs in their laps to hide hard-ons." Angie grinned in happy memory, then sobered, setting the yearbook down on the coffee table.

"Anyway, she was fun to watch on stage and off. At the time I thought it was sooo cool that she got bored and cut out of here before she graduated, an action I myself duplicated a couple years later."

"You did? Why?"

"My dad was insisting on real college, wouldn't hear of College of Arts and Crafts in Oakland, which was the only place I was interested in. Meanwhile I got a little taller, and better-looking in some eyes anyway, and even less interested in calculus and chemistry. Then one weekend during a music festival down in the village a guy came through on this big black motorcycle and hit on me and I was, 'Hey, why not?'"

"And the rest is history?"

"You bet. I have to say now it wasn't the smartest move I ever made, but it was educational." She sobered, and bent her face over her mug of tea for a moment. "God, I hope you find Toni and she's been out there for all these years having a good time. Have you made any progress?"

Verity grabbed this opening. "We've just begun with Toni. But she may possibly be tied in with another case Patience and I have been working on for two weeks, one that also involves the high school."

"Is this the one about Mr. Larson?" At Verity's surprised nod, Angie said, "I heard something about that from a local friend, Jake Jacobs. In fact, he told me you'd talked to him about it."

"Good, then you know the basic bones. I should say right off the top that quite a few people think this old mess should have been left strictly alone, and that it's possible our investigation did lead to the suicide of a person you may remember, Teresa Janacek."

"Jake told me about that, too. I do remember her, because she was one of the royal four, but I didn't know her well. There was this division at Port Silva High between town-dwellers and county kids like me.

"As far as Mr. Larson goes," she went on, "I always rode the bus to school, and while I guess I saw him there, it would have been from a distance. I heard about his trouble when my mother said something

one night at the dinner table about dirty old men, and my father told
her she should be ashamed of herself.

"My father was a very quiet man, you see. He never spoke that way
to my mother or me." Angie looked at Verity with eyes that were see-
ing someone else. "He told me later that my grandfather and Mr.
Larson had become friends when they did business over some timber
on our property."

"Did you ever hear any talk at school about Mr. Larson? People
mad at him, people afraid of him?"

Angie shook her head. "And that's odd, now that you mention it,
because I was a snoopy kid, the original fly on the wall. I knew who
was using, who was dealing. I knew who was fucking who. Whom. I
knew who rushed to the girls' bathroom first thing in the morning to
throw up."

Verity was impressed. "What did you do with all this informa-
tion?"

"Not a bloody thing except enjoy it," she said with a grin. "I wasn't
angry or mean, just bored."

Verity backed up a bit. "Angie, what did you mean, the 'royal
four'?"

"Ah. Part of the small-town high school pattern, as I remember it,
is that each year has a few seniors who sort of epitomize senior-hood
for the lower classes. That year, Toni's year, the rest of us got to watch
and admire, let's see, first of all Jeanie Verducci. Our queen bee, little
Miss Butter-wouldn't-melt. She was pretty, she was smart, her daddy
was rich, and she got anything and anybody she wanted. You'd never
have known that her grandfather started out like mine, raising sheep.

"And then there was poor Tessa Janacek," she went on, "mostly, I
think because she was a good foil for Jeanie. You've seen that role if
you haven't played it."

"Oh yes."

"Tessa was good-looking in a tall, skinny way, but timid, no zip at
all. As I recall, she was a musician of some kind. And then there was…
Oh, God, I forgot about Bobby Mendes, and Tessa! Even after all these
years, he must be devastated by her death."

"Bobby *Mendes?* The raving groper who slaps his wives around
and mistreats his kids?"

It was Angie's turn to look astonished. "Wives? He does? Verity,
I'm sorry, I was still being fifteen. And I know almost nothing about

what's gone on in this town over the past twenty-five years. But honestly, everybody knew he was absolutely crazy about Tessa. I could never understand it, she was such a wimp while he was— then, at least—a truly nice guy and very popular." She spread her hands and shrugged. "So now he's a wife-beater. Everybody changes, I guess."

"I guess," said Verity. "Okay, that's three. Who was number four?"

Angie reached for the yearbook again. "I mentioned him before, Adam Zalinsky. An exceedingly handsome guy said to bring on hard nipples and damp panties far and wide. As a distant unnoticed person, I never found him quite that stimulating. But he was nice enough, I guess. And smart. Anyway, he was Jeanie's main squeeze."

"The boy who played Steve to Toni's Julie in *Show Boat*?"

"Yes, and very well. too. Probably a high point in his life."

"But here's an interesting thing, Angie." Verity leaned forward, intent. "At some point, Toni was friends with Tessa Janacek, because Toni's aunt remembered seeing her at her house, the house Mrs. Ellis and Toni shared."

"Really? Well, Toni made friends."

"And here's the other thing, from Mrs. Ellis again. Toni had a rapid turnover in boyfriends. But for the last couple of months before she left, her new and favorite guy was tall, very handsome, with black hair."

Angie stared at her. "You're thinking Adam Zalinsky? Now *that* I did *not* spy with my little eye."

"Maybe it was somebody else," said Verity with a shrug. "But I wonder what became of him. He's the only one of the four who didn't settle here."

"Which makes him less weird than the other three, in my opinion," Angie said. "Well, as far as I can recall, he didn't split when Toni did. Maybe he caught up with her later?"

Verity could see that she liked this scenario; Jake Jacobs's fellow loner was something of a romantic. "Angie, I have another question. What is Jake Jacobs's actual name? I didn't have nerve enough to ask him."

"Wouldn't have gotten you anywhere if you had; I didn't learn it until I'd known him very well for years. He began life as Ivar Anders Jacobsen."

"I see." Verity got to her feet, to return the yearbook to the book-

case. "Thanks for the additional background. If Patience hasn't put Adam Zalinsky on Harley's search list, I'm sure she will."

"I appreciate that. Harley hates taking money from Mom, even though she can afford it, so we're both happy when he can earn his own."

"And we appreciate him. Can I get you another cup of tea?"

"No, thanks." She frowned, and looked down at the hands she'd clasped in her lap. "This was really about ghosts, wasn't it. There's old nastiness there and dead people, and I shouldn't have been so flip, bad habit of mine.

"Oh, well," she went on with a grimace. "Whatever happens, happens, and we do what we can. I do hope you find Toni, though," she added as she stood up and stretched. "Ugh, too much time sitting the last few days. I think I'll stop in next door to say a word or two to my son, and then go spend some time with Juke. He always manages to restore me."

This Verity could believe. She escorted her visitor to the door, where Angie said, "Thanks for tea, dear. Don't bother to come out with me."

Verity was about to close the door when Patience pulled up beside the motor home in her truck, parked, and got out. The two women exchanged brief greetings that Verity couldn't make out from this distance before Angie climbed into her bulky vehicle and began to back it around with the skill of long experience. Patience, with a last wave, headed for the house, looking at least as weary as Angie had. Or perhaps dispirited was the better term.

"Hey, Ma," she called. "I think that big old truck should be set aside for truck-type work, and you should get something smaller and spiffier, and more comfortable, to drive."

"Good thought. Come inside, I need to talk to you," Patience said, resting a hand on Verity's shoulder as they started up the front steps.

VERITY FOLLOWED her mother inside and closed the door. "Mom, what's up? Something with Hank?"

"Hank? No. Well, nothing personal," Patience added, as she tossed coat and bag at a chair and sat down heavily on the couch. "The Finch family—husband, two sons and daughter, and the Janacek brother—are pushing hard against a verdict of suicide."

"They prefer to see it as murder? Sorry, 'prefer' is inappropriate."

"Harley might say murder is their default mode, since there's virtually no possibility the gunshot that killed her was an accident."

"So, what? Carjacking, maybe? When Jake Jacobs spotted me parked at that wayside beach campground Monday night, he was pretty forceful about the possibility of wandering rapists and carjackers."

Patience got up, picked up her coat and bag, and went to hang them in the hall closet. "If the police know, they're not telling me. What they have said, however—or Vince Gutierrez has, and Hank apparently concurs—is that they don't want us involving ourselves in the case. No more quizzing of Mrs. Finch's friends and peers by Patience Smith, Investigations."

"I see. Okay, Ma, go back and sit in your truck if you want complete deniability; you're not home yet."

"Observe me in a virtual truck," said Patience, and returned to her seat on the couch as Verity went to get the phone. She stayed in the kitchen to make her call, and spoke quietly at intervals for two or three minutes. Patience closed her eyes and made no effort to listen.

"You may come in now," said Verity. "Good to see you, Mom. I just had an interesting conversation with Clare Novak. Talking is thirsty work, so I'm going to have a beer. You want one?"

"Thank you, no. A bottle of Calistoga would be nice."

"So," said Patience, when she had the bottle in her hand, "what did you talk to Mrs. Novak about?"

"Adam Zalinsky."

"I tried to get in touch with Ruth Ellis today," Patience told her, "to ask whether that name struck a chord, but there was no answer at her apartment. However, I did call Harley back later to tell him to add Adam Zalinsky to the search list. That was before the hands-off order from Chief Gutierrez."

"That's prior to prior restraint. Or something. Anyway, we each separately got the same signal and acted on it before the cops spoke. So screw them."

"But quietly," Patience advised. "Did you call Angie after all?"

"No, she…" There was a polite whine from outside the front door, and Verity went quickly to open it. "Oops, we forgot Zak. Sorry, boy."

"Nice to know he's not interested in running off. Angie?"

"She came to talk to us because she'd caught a glimpse of what Harley was working on, and she wondered about Toni Ybarra. It seems Toni was a hero to Angie in dear old high school days." Verity told Angie's tale, pausing now and then for sips of beer.

"She remembered seeing Toni and Adam Zalinsky in the play, but she knew nothing of any further relationship between them. Zalinsky was generally known to be Jeanie Verducci's boyfriend."

"And he did stay to graduate, we know. Verity, why Clare Novak?"

"Because according to Zalinsky's yearbook activities list, he was a cross-country runner and enjoyed orienteering and hiking in the Trinities. That was so right up Clare's alley I figured she might have been friends with him, and she was. Unfortunately, she hasn't seen him since a time or two the summer after high school graduation."

"Did she know his family?"

"She was not happy about getting into that. But she finally said his mother has a different name, Brennan, and used to own the White House Bed-and-Breakfast south of town."

"Verity!" Patience sat up straight. "I know her. Not well, but I stayed there several times when I was trying to decide whether I wanted to move up here, and then once or twice while things were being done to this house."

"Did she talk about her son?"

"Not in any detail. The one time I was in her unit—she lived in

one of the little cottages on the property—I noticed photos on the walls, and she said something about a son and a daughter."

"Do you suppose you could look her up and visit her without incurring official police wrath?"

"I am entitled even in a police state to renew connections with a former acquaintance," Patience said. "Besides, this is a different job, remember? Hand your old tired mother the telephone, please."

Ten minutes later Patience went into the kitchen, where Verity was grating cheese. On the chopping board beside her were small heaps of sliced mushrooms and diced red pepper. "Did you really have lunch with Hank?" she asked. "Or can I fix you an omelet?"

"No, I really ate with him, not much but enough for now. The manager at the White House B-and-B says Mrs. Brennan sold the place three years ago and retired to a small cottage out on Albion Ridge. I got a phone number for her as well as an address, but I've decided to drive out there. A living, breathing body on your front steps is hard to hang up on."

"One hopes. Take my car if you like, Mom."

"Thank you, I will. And I want to get on the road right away, so I can be back before dark."

"Right. We'll be here, Sylvie and I and Zak."

———//———

Catherine Brennan lived well out on Middle Ridge Road, in a small white cottage set amid trees and a garden. When Patience pulled up to park in front of a white picket fence lined with tough old climbing roses, the house was quiet; but a middle-aged Camry was parked in the driveway close to a freestanding garage.

Patience got out of the car and paused to straighten her silk shirt, her gray flannel pants, her jacket, and her attitude. Professional but warm, middle-aged but attentive to personal appearance. She tossed a glance at the side mirror, crossed her eyes and stuck her tongue out at her reflection, straightened and went through the little gate and up the flagstone path to the front door.

She touched the bell, waited, and was about to touch it again when she heard slow movement inside. The woman who opened the door was tall, wearing a long dark skirt, ivory blouse, and paisley-print red wool shawl; she had a cane in her right hand, and the hair Patience remembered as black touched with silver was now mostly silver.

"Mrs. Brennan? You may not remember me. I'm Patience Mackellar,

and I have some questions your son might be able to help me with."

"My son doesn't live here."

"Perhaps you could tell me where he does live?"

She looked at Patience for a long moment, and sighed. "It's cold. You may as well come in."

She closed the door and led the way into a warm, well-furnished living room that smelled very faintly of dog. A small terrier rather like Patience's old friend Ralph trotted briskly up for a sniff, and from a rug in front of the fireplace an aged black Labrador raised a gray-muzzled head for a look and put it down again.

"I do remember you, from my bed-and-breakfast place in Port Silva," said Mrs. Brennan. "Will you sit down?"

When the two of them were seated, Mrs. Brennan tucked her skirt around her legs and clasped her hands in her lap. "Please tell me why you think I should tell you anything at all about Adam."

"Antonia Ybarra's aunt, eighty years old and frail, is trying to puzzle out why Toni left town abruptly in 1973 and hasn't been seen nor heard from since. At that time she and your son were seniors in high school and reportedly knew each other very well. I realize this is all ancient history," she added, "but Mrs. Ellis has hired my agency, Patience Smith, Investigations, hoping to unearth some kind of trail even after all this time."

"Oh, that dreadful girl!" Mrs. Brennan caught herself, and smoothed both hands over drawn-back hair already sleekly smooth. "I'm sorry. I don't honestly feel that way anymore. But..." She shrugged.

"What did Toni do to you?"

"She ruined—I thought, all that long ago, that she'd ruined my son." The other woman took a deep breath. "She certainly seduced him. Oh, he'd had girlfriends, in fact had a fairly long-standing relationship with a local girl. And handsome and popular as he was, I'm sure he was no virgin. But that girl simply overwhelmed him."

"With sex?"

"Sex, energy, attitude. Probably drugs."

"Did he know she was going to leave town? Or where she went?" Patience kept her voice low and even, silently willing this woman to keep talking.

She shook her head. "Poor Adam, he came back from a weekend spent hiking in the mountains and she was gone. He was—he was

absolutely desolate, I was afraid for his health. His father had left us when Adam was five, and my second marriage was a serious mistake, so he had only me and his little sister.

"And we weren't enough," she added, pulling her mouth into a bitter shape.

"What did he finally do?"

"This really isn't any of your business, you know." Another deep breath. The little terrier jumped onto the couch to tuck himself close against her, and she stroked him absently. "He graduated. He went off to college in the east, as we'd intended; his father had agreed to pay for that. He made it through the first year, barely; the second year he got expelled for drug use."

"He came back home?"

"He came, but stayed only a few weeks. Then he moved up to Arcata, and went to college off and on. He worked construction, took off to live in the mountains, worked on fire crews, and after a while came back for classes. And again and again. It took him many years, but he did finally get a degree."

"Has he stayed in touch with you?"

"Yes. Through a failed marriage, dozens of jobs, drug and alcohol rehab. Somehow he managed to avoid jail. And for the last ten years he's been stable. He lives in…a small town, manages a private campground used mostly by fishermen, and works as a veterinarian's assistant. This is the life, at age forty-six, of a boy who had an I.Q. of one hundred sixty and was accepted at Harvard.

"And I have absolutely no intention of telling you where he is." She picked up her cane and got to her feet. "I'm going to have a glass of wine. Would you like one?"

"I would." Patience stood up. "May I help you get it?"

"No. Arthritis is something I have to live with, and I refuse to let it hinder me." She went past a counter at one end of the room into a kitchen alcove and took an open bottle of white wine from the refrigerator. As she carried it to the counter, set out glasses, and began to pour, Patience went to look at the photos beside the fireplace.

Catherine Brennan and two children probably four years apart in age. Snapshots of the children, then high school pictures, the girl a sweet freckle-faced urchin, her big brother classically handsome, dark-haired, blue-eyed. To the other side of the fireplace: the girl in a wedding dress, then with a child and then another. Adam with two

men, dressed for outdoor work; Adam alone, beside a trailer with a river behind him. His hair was less full, gray-streaked.

Mrs. Brennan brought a full glass to the coffee table and set it down. Patience went to the counter, picked up the other glass and the bottle, and brought them in.

"Thank you," Catherine Brennan said to Patience, and "Move over, Buddy," to the terrier as she sat down again.

"Mrs. Brennan—"

"I think you should call me Catherine."

"If you'll call me Patience. Why do you say that you no longer 'feel that way' about Toni Ybarra?"

"Because I've come to understand that no unkindness from a dynamic but after all, hardly demonic young woman could have been wholly responsible for my son's misery. The initial damage was hers; but the fact that he couldn't pull himself out of it has to be a failure on his part. We are all responsible for our own souls."

That was a chillier code than Patience could adopt, but she held her tongue.

Catherine topped off her glass and sat back in her chair with a sigh. "A friend called yesterday to tell me that Teresa Finch, who owned that very good nursery, had killed herself. She was a high school class-mate of Adam's. The friend went on at some length about what seems to be your other current investigation, the one involving the old man who killed *him*self after being accused of molesting children."

Her on-hold investigation. "Mrs. Finch's family is not convinced that her death was suicide."

"They wouldn't be, would they?" she said with a shrug. "I didn't pay much attention to this Mr. Larson's circumstance at the time. But now…I need to know, is this all connected in some way to that old man? My son's misery, that girl's running away, and now a suicide?"

"It's possible, though I've found no evidence and no motive. Could Adam have been one of the accusers? And felt guilty after-wards?"

The suggestion didn't upset Adam's mother. "Absolutely not. For a bright boy, he was absolutely straight arrow, even a bit of a prig. If he'd had occasion to know that Mr. Larson was molesting children, he'd have gone to the police and said so. And he was not capable of purposefully, secretly hurting someone. The only person Adam has ever chosen to hurt is himself.

"Well, and me," she added. "But it wasn't purposeful."

Patience finished her wine, set the glass down, and shook her head when the other woman gestured at the bottle. "No, thanks. It's very good, but I'm driving. Catherine, it seems to me that Adam has to know something, maybe something useful, about what really happened that weekend."

Catherine blew out a long breath. "I'm thinking about it."

"Have you told him about Teresa Finch's death?"

She shook her head.

Patience got to her feet and reached into her bag. "I have another appointment. I'll leave you my card, with my home number, and ask you to call if and when you feel you can tell me where I can get in touch with Adam." She found a card, wrote on it quickly, and handed it to the older woman.

"I'm not sure I'll be able to do that."

"I understand. Thank you for your time."

Outside, Patience buckled herself into Verity's car and looked up to catch her own eyes in the visor mirror. Triumph was what she saw before she turned the visor up. She knew where Adam Zalinsky was.

———//———

"Verity, you're absolutely right, I want a car like... Oh, hello, Harley," Patience said, closing the door behind her. Harley Apodaca, wearing boots, jeans, and heavy sweatshirt, sat upright on the couch like a student giving his report to teacher Verity, who stood before the fireplace.

"Hi, Patience. I was just telling Verity that Antonia Ybarra either changed her name and identity or left the country. Or maybe just the state. She's got no college record, no credit record, no criminal record. Owns no real property, has no insurance. No record of death. Sorry. Well, not about that."

"Harley, it's not your fault," Verity told him.

"My mom will think it is. She's really interested in this Toni Ybarra person." He got to his feet. "And now I gotta go out to the old family homestead and help Mom shift stuff around to make room for more stuff."

"Thank you, Harley," said Patience, and upzipped her shoulder bag. "Let me pay you."

"Just for Ybarra." He handed her a three-by-five card. "I didn't have time to get around to the other guy, Zalinsky. I can do it tomorrow if you want. Thanks." He took the bills Patience handed him.

"Don't worry about Zalinsky," she told him. "I'll let you know if I want you to go on with that."

"Yes, ma'am." With a nod to her and a wave to Verity, he left.

"Well, damn," said Patience, and Verity raised an eyebrow.

"Let me get out of my city clothes," Patience went on, "and I'll tell you what happened out on the ridge. Put on water for coffee, will you? I had a glass of wine with Catherine Brennan, and wine in the middle of the afternoon makes me sleepy."

"Lovely," she said five minutes later, sitting down at the kitchen table before a steaming mug .

"Talk, Ma, before Sylvie gets home."

Patience sighed. "Catherine Brennan believes Toni Ybarra ruined her son, Adam," she said, and went on to tell of the interview.

"Well, there goes the idea that Adam stayed long enough to graduate and then took off to meet her somewhere," said Verity.

"I'm afraid so."

"Maybe he didn't go hiking. Maybe he had a fight with Toni and killed her."

"And hid the body so well it never turned up?"

"Mother, there's a big, deep ocean right out there. Very convenient."

"Not so convenient as you'd think. The coast guard has charts and maps of the tides and the currents. Bodies just tossed in tend to fetch up eventually at a number of predictable sites. Although if Adam was a sailor or a fisherman, with access to a boat, and maybe a helpful friend or two…"

Verity shook her head. "That's too complicated for a love-addled eighteen-year-old who probably wouldn't have intended to kill. But I'd like to talk to this guy. Too bad Harley didn't get around to looking for him." She paused, caught by a sound from her mother. "Ma? What?"

"My best educated guess," said Patience primly, "is that Adam Zalinsky is manager of Anglers Haven campground—assuming it's still called that—on the Trinity River just outside of Lewiston."

"Why 'educated'?"

Patience spent a moment drinking coffee. "Because there's a photograph on Catherine Brennan's wall of a graying Adam Zalinsky standing beside a trailer before a curve of river."

"Uh-huh. A river."

"And across the river is a falling-down lumber kiln. I remember that scene from one of several trips your father and I took to Trinity County, to camp and raft down the river or to fish. Your father fished, I didn't. We stayed in that campground once.

"Don't look so incredulous, Verity," she added. "Lots of Bay Area people, particularly those who don't care for resort atmosphere, go to Trinity County for a vacation. You should try it some time."

"Okay. How about tomorrow?"

Patience looked up sharply. "Oh, I don't think so. Adam Zalinsky may be a murderer. A sad, guilt-ridden murderer who's had reason to think he got away with it."

"You don't really believe that."

"I don't *not* believe it. I'll get a telephone number and call him tomorrow."

"And as you suggested in a slightly different context, be available to be hung up on."

"Verity, do you know the line about 'how sharper than a serpent's tooth'?"

"Sure. Doesn't apply."

They both turned to look at Zak, who had come to his feet from an apparent sleep and was sitting at the door, head up.

"Here comes Sylvie," said Patience with obvious relief. "We can talk about this later."

—————//—————

When the telephone rang at nine o'clock that evening, Verity hurried to grab it before it woke Sylvie, who had gone to bed early with a runny nose and a slight fever. Patience couldn't hear what she was saying, but the tone of her voice was initially dismissive before a silence, a sigh, and a mildly enthusiastic "Okay, ten minutes."

"Johnny," she said as she came back into the living room. "He's just finished work and would like to wind down with a drink, preferably in my company."

"Go enjoy yourself," Patience said with a yawn. "And I'll revel in the solitude. Oh, here's Zak. He'll need to go out."

"I can deal with that."

She was outside with Zak when Johnny pulled into the yard. "Mother is in robe and slippers and not receiving visitors," she told him as he got out of his car. "Just let me take our friend here inside, and get my bag."

"When the weather clears a bit," he said some minutes later, "you should pick a weekend, and Harley and Val Kuisma and I can put up a fence around this place. Dogs need fences, and sometimes people do, too. The Dock okay?"

"Fine."

"Verity, I want to tell you how sorry I am about what happened at the station Monday. I wish I'd been there."

"No, you don't. You'd probably have hurt somebody."

"True. But you look good. I'd say your friend helped you recover."

"Friends do that," she said. "And thank you for the Ockeghem CDs. He helped, too."

"I thought he might." He drove with his usual caution down the steep narrow road to the wharf, and found a parking place nose-up against The Dock. On a quiet night, they scored a table that looked out over the estuary, where an occasional flicker of moonlight penetrated the overcast to light the water.

Johnny ordered draught ale, Verity a glass of zinfandel, and when the drinks were in front of them, Johnny leaned back his chair with a sigh before tasting his ale. He looked weary, Verity noted, his eyes more heavy-lidded than usual and his hair and beard several days past needing a trim. Hard upon her moment of warm concern came a twinge of totally irrational guilt. Stupid! she thought, and said, "It turns out I know your former girlfriend slightly. Nicola Abruzzi is a friend of Ted's, or at least a longtime acquaintance. Did you enjoy her recent visit?"

He stiffened and turned a chilly gaze on her. "Who told you about that?"

"Oh, I just heard it somewhere. She's a brilliant attorney, and good-looking with it. What happened to the two of you?"

"I don't think that's anybody's business but mine."

"Oh, bullshit! You know practically every goddamned detail about the breakup of my marriage, what makes your story so private?" She heard the rank bitchiness in her own voice with astonishment. "Sorry."

"No, fair enough." He sat forward, forearms on the table and beer glass between his hands. "My mother is—was—Norwegian, a lover of peace and quiet and rational discourse and music. My mathematician father is a hairy little French Jew who keeps his metaphorical fists clenched and hardly ever speaks below a roar. I think they loved each

other, but the ten years they were married nearly did her in and were almost as hard on him.

"So one day I looked up and realized I was repeating that scenario with Nikki. And I got out. She's smart, she works hard at her job, in many ways she's a good person. I just can't live with her, or anyone like her."

Verity took a deep breath and blew it out. "I don't know why I needed to know that. But as a good friend, I'd say you made the right decision. On another note entirely, I hear, via the grapevine, that the department is still hanging fire on the suicide-or-murder decision about Tessa Finch."

"True. The physical circumstances just don't give us a clear choice yet. There's no note, which is unusual; but the driver's window was down, so a note could have blown out in the storm. There's been a search, but nothing has turned up. The area is sparsely populated, and the weather kept traffic on the highway low, so we're not getting responses to our requests for information. All this just for your ears."

"Thank you. Especially since we've been told to stay way far away from anything and anyone connected with this."

"Not my decision," he said.

"But I bet you wouldn't disagree with it."

He crunched a pretzel and picked up his beer. "If it turns out that somebody coldbloodedly put a bullet in the head of a defenseless woman, I'm selfish enough to want to keep you out of the line of fire." He drained his beer glass and lifted a hand to signal for the waiter.

"That's nice of you, but presumptuous." Verity looked at her own empty glass and set it forward as well. "Since you're driving," she said to Johnny.

"Driving very carefully," he said when the fresh drinks had been delivered. "Sleeping late, and taking the day off tomorrow. Since you no longer have a case to work, would you like to go someplace tomorrow? There's a rumor it will be sunny and warmer."

"I, um, think I'm going to be busy."

"Really? What with?"

She looked at him, and looked away.

"Come on, you've been pumping me. What have *you* got going? Oh, sorry," he said, looking flustered. "If it's personal…"

"It's not. We're looking for a girl who left her aunt's home here unexpectedly many years ago and never came back or communicated

in any way. The aunt is now old, frail, and sorry she never tried to find the girl. So she's hired us."

"And you have a lead?" She could almost see his cop's antennae quivering.

"We think we have a line on a guy who was the missing girl's boy-friend."

"Where?"

"Trinity County. Patience found out he works as a veterinarian's assistant, and manages a campground called Anglers Haven in a small town called Lewiston."

"Which is off 299 east of Weaverville," he added. "My uncle lives there, or near there."

"Really?"

"Really. And it's a five-hour drive, depending on conditions along 299. I'll come with you and share the work."

"Don't be silly, I can drive myself. And I don't think this guy will talk to a cop."

"I won't be a cop, just a friend."

"Right, a friend with muscle."

He snorted. "More like with bulk."

They finished their drinks and headed for home, bickering more or less amicably the whole way. As they pulled into the driveway, Verity was surprised to find lights still on in living room and kitchen.

"Patience was on her way to bed when we left," she said. "Some-thing must have happened." She was out of the car as soon as it stopped, headed for the front door with Johnny close on her heels.

"Mother? What's up?"

Patience came in from the hallway, in robe and slippers still. "Shh," she said, finger to her lips.

"I just got Sylvie back to sleep," she said when they were in the liv-ing room. "She apparently caught that cold the kids on her bus had last week. Fever, tight chest, runny nose, cough—the works. Plus the bad attitude of someone who's hardly ever sick."

"I guess I won't be traveling tomorrow," said Verity. She noted her mother's hesitant reaction. "What?"

Patience tossed a cautioning look in Johnny's direction, and Verity shook her head. "We've been talking, so don't worry. Johnny knows the bare bones of our Toni Ybarra case."

"Well, there's a complication," said Patience, sinking wearily to the

couch. "I tried again to call Ruth Ellis, just after you left, and when I got no answer, I called the manager of the complex. Mrs. Ellis is in the hospital, victim of a hit-and-run just before full dark tonight."

"Somebody hit an eighty-year-old woman and drove off? *Jesus*," said Verity.

"Have you talked to anyone downtown?" asked Johnny. When Patience shook her head, he headed for the door. "My cell phone's in the car. I'll find out what's up."

"You're thinking this wasn't an accident?" Verity's voice held a note of skepticism.

"Probably it was, but I'd like to know a bit more about it." Patience ran both hands through her hair, and squared her shoulders. "But I think you should go to Trinity County tomorrow. I believe I can remember how to deal with a sick child."

"Johnny has a day off tomorrow and has been pushing me to let him come along. He has an uncle in Lewiston."

"Lovely, two levels of help. Take him."

They were waiting impatiently when Johnny finally returned. "Mrs. Ellis is in stable condition so far, that's all they know. They have one witness, the guy who called the cops. He thinks the hit might have been intentional. But the intersection is poorly lighted and unmarked, and Mrs. Ellis was wearing dark clothes. They're looking for other witnesses."

"Thank you, Johnny," said Patience. "Verity, what about it? Are you willing to go look for Adam Zalinsky tomorrow?"

"If you're sure you can manage here. So, Johnny, are you still game for a long drive?"

"Absolutely."

CHAPTER 22

"*MY* CAR," said Verity at eight o'clock Thursday morning. "Where we're going, we might need four-wheel drive."

"Okay by me," said Johnny, and tossed his duffel bag next to hers in the back of the Subaru. "I'll go in and leave my keys with Patience, in case she wants to move mine."

As he headed for the house at a trot, Verity squeegeed the fog-misted windshield and windows, tossed the squeegee inside and closed the hatchback and was in the driver's seat with the engine running when Johnny returned.

"Sylvie wouldn't talk to me," he said as he settled into the passenger seat.

"She's angry with me. Every now and then the memory of her mother's leaving her surfaces, and she can't quite trust me not to do the same thing. And there's really nothing to do about that," she added, "except call her later. What's your favorite route to Trinity County?"

"Usually Coast Highway to U.S. 101 to Arcata and State 299. I like the scenery. But the weather-guessers were wrong yesterday, and there's foggy rain developing upcoast. So maybe that little state road—I think it's 20—to Willits and on across to I-5 North."

"Which is shorter?"

"It's a wash, but the I-5 route is probably quicker. For one thing, there's not much to look at, except maybe a glimpse of Shasta just before we turn off."

"I'd like that." She concentrated on getting through town to pick up the route east, and he settled back into his seat and kept drowsy eyes on the road. When she was cruising along Highway 20 through the diminishing scatter of homes and businesses that would soon give way to forest, he said, "I called my uncle this morning. He knows Zalinsky.

"Not well," he added quickly. "But Uncle Max takes his dogs to the Trinity River vet clinic, and he's met Zalinsky there."

"Any opinion?"

"He says the guy is quiet, efficient, not inclined to say much. Great with the animals, not much interested in people, according to Uncle Max. It's an attitude he'd recognize because he shares it. Anyway, Zalinsky's a valued employee there and has been for nine or ten years."

"I think his mother told Patience he'd been 'stable' for ten years. I hope we don't send him into a panic."

"Verity, you have valid questions to ask, and they don't have to be threatening."

"Well, that depends. Was there any news about Mrs. Ellis this morning?"

"Hank talked to her, and to her doctor. She has a broken collarbone and wrist, a wrenched shoulder, some bad bruises on ribs and hips."

Verity winced. "It's a wonder she survived."

"She was using a wheeled walker, and when she heard the car coming, she launched herself and the walker forward as hard as she could."

"She must be a tough old lady."

"Hank says she's mostly upset that she didn't manage to get a better look at the vehicle and the license plate." A big yawn caught him by surprise, and he said, "Sorry."

"Don't be. Put something in the music system, please, and then go ahead and have a nap. I'm wide awake and I have a full mug of coffee."

Johnny was pleased to find Richard Goode and Schubert in the console; Verity was pleased to find that she could enjoy the B-flat sonata today. They made a pit-stop in Clearlake Oaks; a longer stop for lunch and a call to a slightly more affable Sylvie in the river town of Red Bluff. Then came the short leg to Redding under a slate gray, lowering sky that obscured both Mount Lassen to the right and Mount Shasta ahead. In Redding they swung west on 299, and reached Lewiston just after one-thirty.

"It's a little mining town from the mid-eighteen hundreds," said Johnny, who was driving. "Has a river, a lake, nice scenery, not much happening—just what the residents prefer, if my uncle is any example. What do you want to hit first, the campground or the vet clinic?"

"Let's drive on to the clinic. This time of day, Zalinsky should be at work."

The Trinity River Veterinary Clinic, on Highway 3 just north of Rush Creek Road, occupied a low-slung white frame building with a parking lot in front, pens and outbuildings strung out behind. Johnny parked under an enormous, winter-naked tree of some kind.

Verity unbuckled and got out to stretch in a bitter wind that nipped at exposed skin. Probably came right off the ridges and those remaining patches of snow, she thought as she zipped up her jacket. Or off the higher peaks around them, still decidedly snowcapped. "Pretty. But cold."

"Right. Want me to come in with you?" Johnny asked as he joined her.

She looked her companion over. In jeans and boots and the big down jacket he was presently snapping shut, he looked mammoth. "Maybe not, if you don't mind waiting in the car. I don't want to go in looking as if I've brought backup."

Inside, Verity found a waiting room with benches lining two walls. The room was empty of people or animals, but she could hear voices from the rooms behind the desk, and the barking of at least two dogs followed by the yowl of an affronted cat. After a minute or two she touched the bell on the desk, and was rewarded by the appearance of a middle-aged woman wearing a flower-print lab coat.

"I'm Verity Mackellar, and I was told Adam Zalinsky works here?"

The woman's mouth tightened. "He does, usually. He's not here right now."

"Do you expect him? I don't know him myself, but I have a message from a friend of his in Port Silva."

The thin face softened a bit. "Well, he'll be glad to see you, I'm sure. He called in sick this morning. He lives in a trailer at Anglers Haven in Lewiston, along the river just off Rush Creek Road. You can tell him we hope he gets well real soon, because we need him here."

"I'll do that. Thank you."

"Next stop, Anglers Haven," she said to Johnny moments later. "Back toward town, along the river. Adam called in sick today, and is much missed by his colleagues.

"My take on this," she went on as he backed the car around, "is that his absence is unusual. I bet his mother called him, and I hope he hasn't taken off."

"Hold that thought," he advised.

The campground was a grassy, tree-sheltered expanse on a low bluff above the Trinity River, which was broad but placid-looking. Probably because of the time of year, thought Verity, before major snowmelt.

"Nice-looking place," said Johnny as they drove through the gate and past a small, shuttered building wearing a weathered sign that read STOP/REGISTER. Campsites were ranged in two tiers along the river, with a cinder-block building at the far right housing rest rooms and showers. Perhaps a dozen of the thirty-some sites contained trailers or motor homes, although many of these had the air of being currently unoccupied. An arrow-shaped sign on a stick pointed left to CAMPGROUND MANAGER.

"Eureka," said Verity. In the site at the far end was a medium-sized trailer with an awning and ground mat along the door side, a broiler and a lantern on the picnic table, a stack of firewood beside the fire ring. A movable metal pen, presently empty, stood against the rear of the trailer; a row of four young bushes marked the line between this site and the unoccupied neighboring space, tiny buds on bare branches just beginning to show color. A well-kept 'seventies-vintage pickup truck was parked at the front edge of the site, near another CAMPGROUND MANAGER sign.

"If this is Adam Zalinsky's, he's made himself a home," said Johnny as he pulled into the empty site.

"It's...nice," Verity said. "I'll try this alone, too, Johnny, same reasoning."

"Yell if you need me."

Verity hitched her bag up on her shoulder and strode to the door of the trailer, where she rapped her knuckles first on the plastic surface of the door, and then, after a moment, on the metal frame. There was no reply, but she sensed movement inside and heard somebody—something?—breathing loudly.

"Mr. Zalinsky?" She rapped again, tugged at the door handle, and found it unlocked. As she pulled the door open, two nondescript small dogs shot past her to a gravelled patch nearby, where they squatted. Females, obviously. Finished, they trotted over to her with one waving tail, one twitching stub, and what she read as grateful faces.

"Okay, ladies. Let's go in the pen, okay?" When she folded back a section of the metal pen, they bounded inside and made for the water dish and the bowl of dry kibble beside it.

She returned to the door and stepped cautiously inside. The loud breathing she'd heard came from a body—a man—sprawled face-down on the couch along the far wall. From the smell, the snores, and the litter of bottles on the dinette table and the sink counter, he must be very drunk.

"Mr. Zalinsky? Adam?" She took hold of his shoulder to shake it, but he pulled away with a wordless grunt and without lifting his head. He'd be tall, she noted, his hair black going gray. Eyes were hidden, presumably closed.

"Well, shit." She didn't know much about stages of drunkenness. Could he be in serious trouble? She fled the smell and the problem to get Johnny.

He came quickly, surveyed the scene and the body, and shrugged. "Neat as this place is, he's not your standard everyday alkie. I'd say something set him off, and he decided to put away every ounce of booze he had on hand." Johnny shed his jacket, tossed it at the single armchair, and followed it with the sweater and T-shirt underneath. "Help me get him turned over, and I'll take him to…there's a bathroom here, I guess? Cross your fingers he doesn't let go on the way."

Johnny got the limp body more or less upright and hauled it off. Verity sat down on the dinette bench and listened to vile noises coming from the bathroom, followed by groans and what sounded like a brief scuffle. "Johnny, do you need help?"

"Nope. Well, yeah. Slide by into the bedroom and see if you can find him some clean clothes. These are gonna to be very wet."

With the sound of the shower punctuated by more bumps and groans, Verity located underwear, jeans, and sweatshirt and laid them on the unmade bed. Back in the living area, she gathered up wine bottles, beer bottles, and one small brandy bottle and lined them up on the counter. Coffee? No, tea; there was a box of tea bags in the cupboard, a teakettle on the stove.

A detective's work is never done, she thought, and had a look around. This main area was well-kept and clean, with lined curtains in a muted print, a couple of framed pictures on the wall, extra pillows on the couch. Zalinsky had a small TV and a radio-CD player. A long shelf was crammed with books on various aspects of veterinary medicine, biographies and works of popular history, a handful of paperback mysteries.

"Here we go." Johnny propelled a pale and shaky Adam Zalinsky

into the room, guiding him to the dinette bench. "Mr. Zalinsky, meet Ms. Mackellar."

"Hi. What are you…? God, I need a beer, is there a beer left in the fridge?"

"No beer," said Johnny. "How 'bout a little water? Or tea, I believe I observe the makings of tea." He pulled on his T-shirt and sweater.

Two cups of sweetened tea later, Zalinsky was slightly less shaky, noticeably more aware. "That was dumb. I used to drink, but that was years ago. Can't handle it anymore. Not that I ever could." He lifted his head and turned his gaze on Verity, then Johnny, and back to Verity. "Girls that look like you don't just turn up in the neighborhood of guys like me. What're you two after, anyway?"

Okay, thought Verity, fair enough. "We're from Port Silva, and we're looking for Antonia Ybarra."

He recoiled as if she'd struck him. "Did my mother send you?" he asked in a bitter whisper. "I told her to leave me alone, I don't know any of those people anymore."

"She didn't send me. Did she call you yesterday?"

"This morning," he said automatically, "but it wasn't about Toni, it was…" He glared at her from bloodshot blue eyes. "What are you trying to do to me? You get out of here." His effort to rise failed, nearly pitching him to the floor before he grabbed the table and pulled himself back onto the bench.

Johnny stayed an arm's length away, an intent but silent observer.

If not Toni, then what? So screw the police prohibition on this, Verity decided, and sat down across the table from Zalinsky. "Did your mother tell you that an old friend of yours, Teresa Janacek, had killed herself?"

"Yeah, she… That's what made me feel so bad, I guess. Tessa, she was a…a good person but always kind of worried, unsure of herself. Not tough."

"I met her only once, so I couldn't say. She'd returned to the church, did you know that? She was a Catholic communicant again."

"I hope it made her feel better." He looked up, and his eyes filled. "I guess it really didn't, huh? Or she couldn't have done that."

Gotcha! she thought, with only a twinge of regret. "So it must have been something pretty awful, I guess. Something that had bothered her for years."

"What was?"

"Whatever made her ignore her faith and her family and kill herself."

He simply stared, mouth open.

"I've heard," she said slowly, feeling her way, "that Tessa Janacek was a friend of Toni Ybarra's. Do you know anything about that?"

"Shut up!" he snarled, scooping up the empty teacup to throw it at her, but his aim was poor and the cup bounced off the carpeted floor. Johnny had shifted to move forward, but Verity gave him a quick, slight shake of her head.

"You and I have another acquaintance in common, Adam. I think you know Mrs. Ellis, Ruth Ellis."

This deflected him, and he looked puzzled for a moment, running the name through old memory. "Ellis. I don't think... Oh. Aunt Ruth," he added in a whisper. His face had gone pale green, the flesh around his lips white.

"She's eighty years old now, and before she dies she wants desperately to find her last living relative, her niece. Toni Ybarra."

Only his eyes moved, from her face to empty space behind her.

"Her need became even more critical last night, when she was struck and badly injured by a hit-and-run driver."

Zalinsky leaned forward, stretched his arms out on the table, and put his head between them.

"Adam, do you know where Toni is?"

There was no sound but his ragged breathing. Verity was about to repeat her question when she caught Johnny's eye. Enough.

A long, shuddery breath. "Oh, yeah. I know where Toni is." Once, twice, and a third time he lifted his head an inch or so and let it fall, bouncing his forehead against the table top with a dull thud. Finally he groaned, pushed himself upright, and managed to get out from between table and bench. "Don't!" he said as Johnny reached to help him.

Johnny moved to block the outside door, but Zalinsky staggered past him to the tiny hallway and the bathroom. The gagging sounds from there made both his visitors wince.

Verity looked at Johnny, to meet a penetrating blue gaze: he knew exactly what was going on. Later, she promised silently. "I'm sorry to have disturbed his cozy little retreat, but there are things that need to be dealt with by grown-ups in the real world."

"I couldn't agree more."

Zalinsky appeared in the doorway again, holding on to its edge with one hand, using the other to press a towel against his mouth. "Okay. Just who *are* you people and what do you want with me?"

"I'm Verity Mackellar of Patience Smith, Investigations, a private agency Mrs. Ellis hired to try to locate her niece. And this is..." She looked at Johnny.

"Detective John Hebert of the Port Silva Police Department. But I'm here out of jurisdiction with no official standing."

"I don't have to talk to you." Zalinsky sat down heavily on the couch and crossed his arms on his chest.

"True. But we hope you will. If you know where Antonia Ybarra is, you should tell her aunt."

"Oh, sweet Jesus. No I shouldn't. It couldn't possibly do her any good to know."

Verity sat down in the armchair. "Why? What happened to Toni?"

He shook his head and refused to look at her.

Although she hadn't met Zalinsky's mother, Verity had read the notes Patience had made of *her* interview. "Your mother says you were crazy about Toni and were deeply upset when she left town."

"I...we were...Toni was different. From other girls I knew."

"She also says you were away hiking the weekend Toni disappeared. Was there anyone with you who can verify that?"

Another head-shake.

Verity leaned forward, intent. "But you told us you do know where Toni is. Why is that, Adam? What did you do to her?"

"Take it easy, Verity." Johnny stepped closer and put a hand on the other man's shoulder. Zalinsky shook him off and folded in on himself, one hand over his eyes.

"Okay." Johnny hooked a small footstool close and sat down on it. "Adam, the bare facts are that there's been a death that so far looks like suicide, followed by a questionable accident. You were fairly close friends with Tessa Janacek, right?"

Zalinsky gave a quick up-and-down assent.

"And you knew Mrs. Ellis?"

"Was...did the person who hit Toni's Aunt Ruth do it on purpose?"

"We don't know for sure. The man who saw the incident and called the police thought so."

"Jesus, I wish I had a beer." He said this not blasphemously but prayerfully.

Verity got to her feet. "There's some in my cooler chest." She was back in moments with a tall brown bottle, opening it with her Swiss Army knife before handing it to Zalinsky.

"Thank you!" he said in fervent tones, and tipped the bottle up for a long draught. "Toni really liked her aunt, you know? Said she didn't take any shit but didn't hand any out, either. And Toni's parents, they drank and doped and figured work was for jerks, but Aunt Ruth was a hard worker at a useful job. Toni admired that."

"Adam," said Verity, "it would make Ruth Ellis so happy if you could tell her that."

"Uh-uh, no. No, I can't. You tell her for me, okay?"

Verity clenched her hands in her lap, resisting the urge to slap this forty-six-year-old baby. "Adam…"

"We can do that for you, Adam." Johnny's deep voice was soft, his gaze intent. "And if you want us to, we can tell her where her niece is, too."

"God, yes, I couldn't look at her and… Toni Ybarra is in an abandoned well on a former sheep ranch northeast of town, on the middle fork of the Tenmile. Anyway, that's where she was twenty-eight years ago."

He took a deep, ragged breath, tears spilling unchecked down his face. "I didn't have anything to do with it, I would never have hurt Toni. It was a…an accident. I found out about it after I got back to town, and there was nothing I could do."

As his two listeners sat quite still, Adam Zalinsky clutched his beer bottle in both hands and raised it to his mouth now and then when he took a break for breath or to find words.

He was a quiet kid who like to read and play chess and spend time in the woods, until he suddenly got a foot taller and everybody decided he was good-looking. So girls started hanging around him, which was okay, and then the best-looking girl in school decided she wanted him and he couldn't believe his luck.

"She was smart and pretty and had money and a Mustang convertible. And she had this old house out in the county on their old sheep ranch, we'd go out there with a couple friends, picnic and drink beer and mess around. Shoot at tin cans. Have sex," he added, lifting the bottle as if to drown the memory.

She, Jeanie Verducci, was homecoming queen and when he was chosen king, he figured she'd somehow arranged it. They spent all

their free time together. She was going east to college, too, and was planning how they could arrange to live together somewhere in between the two schools, and where they might both go to grad school. She said her father could help with the money if his own father didn't come through.

"She was wonderful and she was killing me, and then Toni came along." He tipped the bottle again, and kept it up until it was empty before dropping it to the floor.

Toni was tough, funny, unwilling to control or be controlled. They kept their involvement quiet for a long time, but then, somebody, he had no idea who, saw them someplace.

"Jeanie thew a fit, and then calmed down and said we'd work it out, and there I was with two women after me, which should have been heaven, right? Thing was, I didn't want two, only Toni, and I knew Toni wasn't going to play this kind of game for long."

He leaned his head back and closed his eyes. "Doesn't this sound like some, what do they call 'em, young adult romance novel? Juicy crap, everybody having a blast crying and screwing all over the place until finally they're matched up? God, I can hardly believe it happened, that we were all so stupid.

"And if you want to hear the end of the story, you better get me something to drink."

Johnny looked at Verity, who hesitated, then nodded and got to her feet. She stepped out the door into the waning afternoon and was back quickly with another bottle of beer. "Last one," she said, and opened it and handed it to Adam Zalinsky.

He sat straighter, took the bottle, and drained half of it. "Finally I went off to the Trinities—right up here, my own private mountains, there's a line someplace about 'my heroic mother hills'—for a weekend by myself. Jesus *Christ*, I needed a weekend by myself. And I thought things were okay.

"When I came back, on Sunday night it was, and went to see Toni, she wasn't there. Then they...my friends came to get me, and said there'd been an accident. They'd been out having a beer bust at the usual place, the sheep ranch, and Toni turned up uninvited and there was a blow-up and when it was over, Toni was dead.

"It was nobody's fault. Everybody said there'd be other lives ruined and nothing to be gained if we told anybody. Everybody said they'd...arranged things so nobody would ever find out.

"And they reminded me I had no way to prove I wasn't there when it happened. So that's it, and you can go fuck yourselves and I'm going to lie down." He lurched to his feet, drained the bottle, walked with careful steps to the counter and set the bottle down in far moving even more carefully through the door to the bedroom. The trailer shuddered as he hit the bed.

Verity moved quickly, quietly to close the sliding door between bedroom and living area. "Johnny, how much shit are we in for being here? You, in particular."

"I suppose that really was the last beer?" At her nod, he sighed. "Too bad. Okay, I'll find out for sure when I call in. But when you got to the trailer, did you knock?"

"I did."

"Any answer?"

Verity thought for a moment. "No. But there were noises, and I could hear loud breathing or snoring."

"So you went in to make sure there wasn't somebody in trouble?"

"In fact, there were two somebodies, two little dogs who really needed to be let out for a pee. I'd better bring them back in."

Johnny stood in the doorway while she said, "Come, ladies," opened the pen for them, and followed them back to the trailer door. Inside, they hopped onto the couch and curled up next to each other.

"Okay, dog rescue should qualify as reason to enter. And then dealing with a semi-comatose drunk was reasonable behavior. And we made our status, or lack of it, clear." Johnny pulled a small spiral notebook from his shirt pocket and flipped it open to a clean page. "These 'friends' of Adam Zalinsky, using the term loosely. One was no doubt Jeanie Verducci. And one was Teresa Janacek. Do you know who else?"

"Probably Bobby Mendes. He was Tessa Janacek's boyfriend."

"Okay. I need to call Hank or the chief." He dug into his jacket pocket for his cell phone, punched the power button, and said, "Shit. Out of service area."

"I saw a landline phone in the bedroom." She put a shushing finger to her lips and moved quietly to the sliding door, and quietly inside.

"He's dead to the world," she said on her return, and handed him a cordless phone.

"This may go long and get noisy, so I'll do it outside. *You* stay right here and make sure Zalinsky doesn't go anywhere. There's no exit door up in the bedroom end," he added, "just an escape route through a window. I'll keep an eye on that."

CHAPTER 23

WHEN JOHNNY came back in after a long conversation with Hank or whoever, Verity was on the couch with the two dogs, making notes. "If we let him, he'll probably sleep for hours," she said with a nod toward the bedroom. "What did your boss or bosses have to say?"

Johnny started to speak, and reconsidered. "Let's go sit in the car to talk."

"Give me a moment first, and the phone. I need to call Patience."

Verity was surprised and briefly worried to get not her mother but the answering machine. Had Sylvie's cold turned nasty, requiring a trip to the doctor?

Probably not. And if so, Patience would cope. Keeping her voice low, she said, "Ma, it's Verity. We're in Lewiston, and we've been having an interesting session with Zalinsky. I'm not comfortable going into specifics for a machine message, but the situation is...tricky. Johnny is talking to Hank for advice and direction, so you can probably learn more from him.

"Anyway, we'll head for home maybe this evening, maybe tomorrow morning. I'll be in touch when I can. Don't worry. Tell Sylvie I love her."

—————//—————

"Hank and I kicked around a number of possibilities," he told her when she had joined him in the Subaru. "One was having Chief Gutierrez ask the local law—the county sheriff's department—to arrest and hold Zalinsky for Port Silva."

"Would the sheriff do that?"

"He might not like it. Adam Zalinsky has been a job-holding, law-abiding resident of Trinity County for ten years. And Trinity County likes to do things its own way, according to Uncle Max. So it would probably happen, but it might take time."

"Can you arrest Zalinsky yourself, on a warrant from Port Silva?"

"Same answer. Eventually, perhaps."

"Okay," she said sharply, "let's hear what you *did* decide."

He tipped his seat back slightly. "If he's still agreeable when he comes to—not clamming up, not demanding a lawyer—we take him back to Port Silva with us. Preferably literally with us, in this car."

"This was okay with Hank? Isn't he upset about my ignoring the wave-off?"

"So long as no real laws or real bones get broken, Hank doesn't worry much about protocol, just results. We agreed that having Zalinsky an immediate willing witness would be best case. Meanwhile, he'll set up the paperwork for getting a look at an abandoned well on private property."

"Does he know the place?"

"He says it's almost surely the Verducci property. He also says he vaguely remembers a family fuss over that property some years back, some kind of disagreement between co-owners Jeanie Verducci and her brother, Thomas. He figures this might give him another way in."

"But that's his problem," Johnny added. "What one of *us* should do, while we wait for our friend to finish his nap, is go out and round up something to eat or cook. Believe me, that guy's stomach is empty."

"I'll shop, you baby-sit. He likes you better than me."

"That's because I'm nicer," he said as he got out of the car. "Oh, get a few, a very few, bottles of beer as well as food."

When Verity came around the back of the car, Johnny had the hatch up and his duffel open. The sight of his revolver there in its belt holster gave her a healthy jolt: we are not playing games here.

He caught her response, and tucked holster and gun beneath his extra underwear. "I'm leaving it right here. If Zalinsky gives us a problem, we'll deal with it."

"Johnny, do you ever think a gun is necessary?"

"Hardly ever."

——//——

Patience returned from a quick drugstore trip to find Verity's cryptic message. As the afternoon wore on into early evening with no further word from Verity and none at all from Hank, she fretted uselessly. She paced from room to room in her too-small house; she took the dog out for a walk and brought him quickly back; she put Bach's *The Art of Fugue* on the music system and halfway through removed that and substituted *Workingman's Dead*.

Sylvie, no longer feverish and generally less miserable, kept mov-
ing from place to place with her box of tissues and her book in order
to stay out of Patience's way. Finally, at around five o'clock, she put a
bookmark in *The Wizard of Earthsea* and trailed Patience into the
kitchen, where she was staring into an open refrigerator.

"Sylvie, what would you like for supper, scrambled eggs? Chicken
soup? Macaroni and cheese?"

"I don't care. Macaroni and cheese maybe? Patience, can I go
down to the studio to read?"

"It's cold there, dear."

"I know how to turn the heater on. I like the studio, it makes me
think of a cave."

Zak, who'd rolled to his feet quickly at Sylvie's "go," pranced his
front paws to indicate his enthusiasm for travel, however brief.

"All right, but put on shoes and a sweater. And take along a can of
ginger ale; it's what my mother always gave me when I was sick."

"I know, you told me."

Sylvie departed, with Zak. Patience looked at the telephone,
looked at the clock, and decided it was time for a grown-up drink.

———//———

In the studio Sylvie turned the heater on, put down the bathmat for
Zak to lie on, arranged the pillows on Verity's bed, and climbed in
with her book. When Zak gave his alerting "woof" some time later,
she said, "Quiet, Zak," and went on reading until someone rapped at
the door. Patience, already?

Sylvie slid from the bed, padded to the door, and opened it to see
the anxious face of Robby Mendes, a bicycle lying on the patchy grass
behind him.

"Hi, Sylvie, I saw you through the window. I missed you at school
today so I came to see if you're okay. What's your dog's name?" He
reached out a hand, the dog sniffed it and moved back.

"His name is Zak. I have a bad cold, probably you shouldn't come
in."

"I don't ever get colds." He came forward so determinedly that she
stepped back. "I brought you some candy, to make you feel better," he
said, and pulled a large Butterfinger bar from his jacket pocket.

Butterfinger, her total favorite. "Oh, all right. Thanks. You can
have half."

"No, that's okay, I got it for you. What're you reading?" he asked
eyeing the book she cradled in her right arm.

"It's one of my new books, that Verity got for me. There's other stuff to read in the bookcase over there," she added with a wave of her candy bar.

He glanced briefly at the books. "Would it be okay if I play the piano?"

Sylvie was delighted with this solution. "Sure. I'll show you the book I used when I started lessons."

———//———

Adam Zalinsky slept for more than two hours, snoring loudly, now and then turning over in his bed with a force that shook the trailer. When he finally appeared in the doorway, yawning and scratching, he mumbled something unintelligible, blinked, and then sniffed. "What's that good smell?"

"Garlic, mostly," said Verity from her seat at the dinette table. "The little market in town had a nice produce section, so I'm making a roasted tomato sauce for pasta. I bought sausage, too, if you'd like some meat in it."

"Not for me. I'm a vegetarian except for fish." He bent to rub the heads of the two little dogs, who'd run up to greet him. "Good girls." And then to Verity and to Johnny, who was on the couch reading one of the paperback mysteries, "I'm gonna have a shower."

He turned away, closing the sliding door behind him. Verity went to the stove to turn on the burner under already-hot water, and to pull the panful of tomatoes from the oven. When she heard the shower start, she said, over her shoulder, "He doesn't look any *more* spooked. Possibly less so."

"He just wants to get fed," said Johnny. The two of them had agreed that they'd pursue their course with Zalinsky over the meal or right afterwards. "And I don't blame him, I'm certainly salivating."

Zalinsky took his time in the shower, now and then singing, sometimes talking to himself. Or maybe praying, Verity thought, recalling the worn Bible she'd seen on his bedside table. When he finally appeared again, he was clean-shaven and almost clear-eyed. The two men sat down and Verity played waitress.

"Is there any beer?" asked Zalinsky.

Verity got him a bottle, and poured small glasses of red wine for herself and Johnny. "You had a visitor while you were sleeping," she told Zalinsky when he had demolished most of what was on his plate. "A tall woman with fair hair who introduced herself as Carol. She asked me to have you call her."

"Carol's my best friend from church. She's a good person. She probably wants to know whether I'm going to prayer meeting tonight."

"I told her I was a friend of your mother's," said Verity.

Zalinsky ate the last bite and put his fork down with a sigh. "That was really good. Thank you," he said to Verity. "So what do you people intend to do with me, put me in irons and haul me off to jail?"

"We could do that," said Johnny. "Or rather, ask the sheriff to do that. I have no authority to arrest you here."

"So you said."

"But we thought we'd start by asking you to come along with us to Port Silva."

"And talk to the police there?"

"Right. But I have one unpleasant question first."

"You mean like, was I telling the truth? Because I was, as much of it as I know. I'd swear that on my Bible."

"Fine. The other thing I need to know is this: so far as you know, is the body of Antonia Ybarra still in that well?"

Zalinsky blinked several times, and swallowed. "They were too scared to do anything else with…it. They said they were going to seal the well off. So far as I know, they did." He picked up his beer bottle and drained it. "Now I have a question. A couple questions, but here's the first one. Are you—are the police in Port Silva—sure that Tessa Janacek killed herself?"

"Fairly sure, but the investigation is ongoing," Johnny said. "There were some confusing elements about the death scene, and her family is insisting that she wouldn't have committed suicide."

Verity, having heard again and again inside her own head the quiet tone of Tessa Finch's answering-machine voice, had serious doubts about the woman's suicide, and she knew Patience felt the same. Now she waited to see whether the danger Johnny's words implied would strike Zalinsky, even deter him.

"I see," Zalinsky said, and was silent for a long moment. "Okay, next question. If I go with you, am I going to be arrested?"

"Probably," Johnny told him. "You did help conceal a death. But it was twenty-eight years ago, you'd be coming in voluntarily now, and you've been gainfully employed in the same place for some time. I don't think you'll have trouble getting bail. Or even OR—release on your own recognisance.

"All this is just my opinion, you understand," he added.

"I'd like to see Toni buried, you know? In the ground and in my mind. I'd like to live out from under that shadow. Then I'd like to come back here." Zalinsky looked around at his small, neat home. "This isn't much by my mother's standards, but I like it, and my job, and the people I work with and the people at my church."

"I don't see why that shouldn't happen," said Verity, adding to herself silently, If your mother will let you.

"I've been praying hard about this, asking Jesus what I should do. I believe He wants me to tell the truth in every way I can, and accept whatever happens.

"So," he went on with a shrug, "when do we leave? Tonight?"

"That would work for us," Johnny told him.

"Then let's do it, while I still have the nerve." He got to his feet. "I'll call Dr. Hanrahan and tell him I'll be away from work for a while. And Carol, to ask her if she can keep my girls for me."

Zalinsky hurried off toward the bedroom, and moments later could be heard talking in a low voice.

"This," said Johnny, "could take a while. Might as well relax."

——//——

The oven timer went off just after six, and Patience went to inspect the macaroni and cheese, which needed a few minutes more. She set the timer again, put more ice and another splash of scotch in her glass, and decided to toss a green salad before going to collect Sylvie. If she hadn't heard from Hank after supper, she was going to call him.

Approaching the studio some time later—maybe this household needed an intercom system?—she was startled to see an unfamiliar bike lying there. "Sylvie?" She opened the door, saw Sylvie on the bed with a book and another figure at the piano. That person turned with a wide, anxious grin, and Patience bit back an expletive. "Robby Mendes. What are you doing here?"

He closed the keyboard and stood up. "I missed Sylvie at school, so I came to see if she was okay."

Sylvie rolled her eyes. "He brought me a candy bar. I told him thank you."

Robby's face glowed, and Patience was caught between worry and amusement. She had forgotten one of life's oddities: that very young boys could fall helplessly in love with very young girls, who rarely appreciated the honor.

"That was nice of you, Robby. Does your father know where you are?"

"I don't think so. I don't know where *he* is."

Well, that was something. "Are you staying with your grandfather?"

"Sort of."

"It's time for Sylvie's supper, so perhaps you should be on your way."

Sylvie looked up in surprise. "Patience, can't Robby stay for supper?"

As the freckled face registered both hope and resignation, Patience reconsidered with an inward sigh. There was plenty of macaroni and cheese, and anyway she herself didn't like the stuff much. The point was to get him on his way before anyone came looking for him. "Of course. Both of you come right now, before it gets cold. Sylvie, you'll need to feed your dog."

The two children, of course, managed to make a mildly silly social event out of their meal, enjoying the food and the circumstance. By the time they'd had enough to eat, it was past seven o'clock and fully dark. Patience stepped out the front door hoping that her judgment was premature; but it was clearly too late to let a small boy pedal off on his bicycle.

And she herself, she realized belatedly, was not strictly in shape to drive. She'd had two—well, two and a half—drinks of scotch, and had eaten very little. Maybe she should call Harley?

"Robby? It's too dark for you to ride your bike home. Could you call your grandfather for a ride?"

"He's probably busy, but I can call my brothers."

The brothers, Patience recalled from remarks by Hank, were less than winning or wonderful, but Robby seemed comfortable depending on them. She pointed him toward the telephone and waited. His brothers, he told her on his return, said they were sorta busy but they'd come to get him in a little while.

"Fine." As Patience cleared away the remains of supper, music swelled through the house; one of the CDs Johnny had given Verity, she thought, Renaissance choral music by a fifteenth-century composer whose name she didn't remember. Strange choice for children, but a glance into the living room showed them listening with apparent pleasure.

She put the last few dishes in the dishwasher, added detergent, and turned the machine on. She looked at the clock, looked at the telephone. If she hadn't heard from Hank by, say, eight-thirty, she would call him. Where was Verity by now? Why hadn't she called? Where were the Mendes brothers, come to that? She glanced toward the front door and was surprised to see Zak there, attentive; if he'd barked, she hadn't heard him, but the outside lights had come on.

Patience was prepared to deal with a pair of adolescents, but the face she saw in the small upper pane of the door was that of a grown, angry man. The handle for the deadbolt lock was in upright, open position; she reached for it, but the man outside was quicker, turning the knob and pushing the door open.

"You can't come in here!" she snapped, pushing back hard against someone much stronger than she was.

"Out of my way, you fat old bitch!" he snarled, and hit the door with his shoulder. Flung wide, it hit her hard and sent her flying, and Bobby Mendes charged inside, stumbled, caught himself and glared around. "Where's my kid?"

The room exploded. Zak, roaring, launched himself at the intruder and knocked him flat. Robby, crying, "No no no!" threw himself across his father's legs, fists flailing, while Sylvie shrieked, "Get him Zak! Get him Zak!"

"Quiet!" Patience scrambled to her feet and ran for the kitchen and the canister on a high shelf. "Zak, off! Off!" The dog, who was worrying furiously at arms Mendes had crossed protectively over his face, continued to snarl but surprised her by abandoning physical assault and backing off a step or two.

"Sylvie, hush and take hold of your dog! Robby, shut up! And you, you son of a bitch, stay right where you are or I'll hit you with pepper spray!"

As Sylvie pulled Zak away, Mendes dropped his arms, lifted his head and let it fall back. "Shit, I'm bleeding. I'll have that goddamned dog shot!"

Patience pointed the canister at him and he shut his mouth and lay still.

"Sylvie, go call 911 and report that we've had a home invasion and we're holding the intruder."

"Oh, Jesus, no. Don't do that! Please. Look, can I sit up?"

"Slowly. And then stay right there."

"Patience?" Sylvie had the phone in her hands.

"We'll wait while Mr. Mendes tries to explain his actions."

Mendes, now upright, sat awkwardly with his legs splayed, bracing himself with one arm and holding the other close across his chest. "I came back to town to get Robby there and take him to his mama."

Robby whimpered. Patience waited.

"When Luke and Jimmy told me he'd come out here to your place, I guess I lost it. Sorry," he added with obvious difficulty.

"Did you see Mama? Where is she?" Robby's voice was high, his face flushed.

"She's in Ukiah, with your Aunt Susie. Look," he said to Patience, "can I get up? I need to wash this arm and see how bad the bite is."

Patience eyed him. He wore khakis and a blue flannel shirt with its left sleeve now tattered. "Are you armed? You can stand up and turn out your pockets."

"Oh, come on. The only guns I own are long guns." He got slowly to his feet.

"Empty your pockets onto the table," she instructed, nodding toward the kitchen. "Then you can go to the sink and flush that wound with water. And *then* you can tell me again why I shouldn't call the police."

"Okay, but I'm gonna be a little shaky. Blood makes me nauseous." He moved slowly to the kitchen table, dropped wallet, keys, change, and a pocket knife there and pulled out his empty pockets before trudging on to the sink. Torn sleeve pulled high, he thrust his injured arm under the faucet and turned the water on, yelping as it hit. Patience followed him at a distance, and reached out to set a paper towel holder within his reach.

"Here's what it is," he said, as he watched the water run pink and then clear. "Looks like it's all gonna hit the fan pretty soon. Sandie— Robby's mom—doesn't want any part of the mess, or of me." He pulled off a couple of paper towels and patted his arm carefully.

"But she's okay where she is. She's got a job, she's filing for divorce, and she wants Robby with her."

Robby and Sylvie, Zak between them, were now sitting cross-legged on the floor like an attentive audience, Sylvie with the telephone in her lap. Patience looked at them, looked back at the miserable man hunched there over his injured arm, and tried to decide how to balance safety and decency. "Kids," she said, "Mr. Mendes and I

need to talk. You go back into the living room and listen to your music. Sylvie, I'll call you if I need help."

"Mr. Mendes," she said very softly when the children were out of sight, "you are a known troublemaker, wife-beater, and rotten father. I'm not sure I should turn your poor little boy over to you."

He wadded up two more paper towels, pressed them against his wound, and came to the table, to nudge a chair free and sit down on it. "I never—hardly ever—hit my kids, the twins anyway. My wives, it was fighting, not 'beating.' Sometimes I just…get mad."

"What did you mean when you said it was going to hit the fan?"

"Hey!" he said, in what looked like honest surprise. "I'd of thought you'd know more about that than me, I been out of town. But when ol' Adam says he's found Jesus and needs to bare his soul, I figure yeah, his soul and my ass."

"Adam says…?"

"Well, I think that's what he said. Maybe he was drunk? So," he went on, lifting the paper towels to peer and grimace at his arm, "you happen to have any big Band-Aids laying around? I'd like to get my kid to his mama while I still can."

He held out the arm, to display a wound that was more puncture than tear, and not as bad as she'd feared. "I think so. You stay right there."

Five minutes later an extra-large plastic bandage covered the bite mark. "Our dog is healthy and his rabies and other shots are up to date," Patience told Bobby Mendes. "But you should probably see a doctor and get a tetanus booster."

"Shit, the way my life is going, it's probably not worth the trouble." He got to his feet and collected his belongings to return them to his pockets. "Could be Tessa had the right idea after all, doing what she did."

"If she did," Patience said, and immediately wished she hadn't.

He straightened and stared hard at her, and her hand felt empty without the canister that now stood on the counter ten feet away.

"What's that about? You trying to dodge a guilty conscience? Or…or maybe not. Never mind." He turned away and headed for the front door. "Robby? Come on, it's getting late and your mama'll be waiting."

Robby came eagerly, pulling his jacket on. "Thank you for supper, Mrs. Mackellar," he said. "G'bye, Sylvie."

"You're welcome, Robby. Take your bike along." He had not, Patience noted, asked about his troubled and troublesome twin, nor had his father mentioned the other boy. This struck her as sad.

Mendes put a hand on his son's shoulder and urged him along. In the open doorway, he paused, shrugged, and glanced briefly skyward. "At least one person up there is probably feeling real good about payback."

CHAPTER 24

ADAM ZALINSKY dithered. He couldn't decide how much clothing to stuff into his big, shapeless duffel bag. He had several telephone conversations with the owner of Anglers Haven about potential problems during his absence. He wondered whether it might not be a good thing to take his "girls" with him to Port Silva and was dissuaded only by Johnny's calm suggestions about the dogs' comfort and welfare.

And he dithered about the trip itself. Maybe he should drive his own truck; but the engine *was* running a little rough lately, and one of the tires was almost bald. Or he could share the driving of the Subaru in a three-way rotation. Not bloody likely, thought Verity as she observed his shaking hands and near-spasmodic movements. Whether he was hung over or merely frightened at the prospect of leaving his snug harbor, he was in no condition to be behind a wheel. With Johnny, mostly, finessing these problems, it was after eight P.M. before the Subaru was packed, the dogs tearfully delivered to Carol, and Adam ensconced in the rear seat.

With coastal weather much improved, they'd decided on that route; and Johnny drove, because of his familiarity with winding, two-lane Highway 299 and because he felt like it. Verity buckled herself into the passenger seat, put her head back, and tried unsuccessfully to catch a nap before it was her turn to drive. Zalinsky, with the help of a small flashlight, was reading aloud to himself from his Bible in a soft but clear voice. It was not the sonorities of the King James version she was hearing, but familiar material more colloquially expressed.

Whatever the translation, Zalinsky seemed to feel secure in the guidance he was finding. She wished she felt so sure about the guidance she, and Johnny, had given him. Maybe Vince Gutierrez's police

force would deal with him reasonably, but what would his former friends do when they found out what he was up to?

———//———

"I always thought private detectives were kind of sleazy," said Zalinsky. "You don't look like a sleaze."

"Appearances can be deceiving," said Verity. They had stopped for a bathroom break and a change of drivers at a rest stop between two tiny highway wide-spots, Burnt Ranch and Salyer. Now Verity was behind the wheel, Johnny resting in the back, and Adam Zalinsky upright and edgy in the passenger seat.

"So how did a good-looking girl like you get into the business?"

Suppressing a sigh, Verity gave him the short version of her family history. "But my grandmother is a Baptist minister," she added.

"Really? That's wonderful."

"She thinks so." She reached over to turn the radio on but found no reception here along the gorge of the Trinity River. The river was down there, she knew, but she caught only occasional glimpses of it when the curve of the road and a rare shaft of moonlight collaborated.

"So what kind of stuff do you usually investigate?"

"Missing persons, mostly. And we're working for a woman who wants to know who accused her grandfather of child molestation—also in 1973, oddly enough. You may remember the man, Edgar Larson; he was one of the parking-lot supervisors at the high school."

"I knew him to say hi to, and I guess I must have heard about the accusations at some point. But I was too wrapped up in my own miseries to pay much attention to anybody else's. Did you find out who did it?"

"Not yet." She reached over to open the console where the CDs were stored. "Would you like to find something to play?"

He flipped through the discs, selected Glenn Gould playing the *Goldberg Variations* and slid it into the slot. Verity concentrated on the road and tried to let the music smooth the rough edges of her mind; as she recalled from the map, 299 had some fifty miles to run, and then they'd turn south at Arcata.

Beside her, Zalinsky was still twitchy, shifting position every few minutes. After maybe ten miles, he turned the music lower and said, "How did you get onto looking for Toni?"

Okay, she'd tried to be pure and not probe, but if he was going to insist on raising the subject… "We handled a case for a woman who

was a friend of Ruth Ellis. This friend was looking for *her* niece, and she and Mrs. Ellis compared notes."

"Did you find the niece?"

"Yes."

"And Aunt Ruth decided to hire you."

"That's about it."

"And she remembered me?"

"She did," said Verity. Not all the truth, but close enough.

"Is she rich?"

"Mrs. Ellis?" Verity was startled by the question. "I don't think so. She worked as a nurse for years, and now she lives in a senior citizens' complex right there in Port Silva."

Zalinsky shifted position again, stretching his legs out and crossing his ankles. "For a while, when she didn't make a fuss about Toni's disappearance, I thought maybe they'd paid her off, like blackmail."

"I think she found a note, supposedly left by Toni."

"Oh. Sure, that makes sense." He slid further down in the seat. "Another thing I wondered sometimes, how did Toni get out there?"

"To the sheep ranch?" At his grunt of assent, she said, "Is it far?"

"Maybe twenty miles. Toni never had a car, and she didn't use her aunt's except for emergencies."

"Maybe she caught a ride with someone else who was going."

"I don't think it was that kind of...well, I don't know."

Verity couldn't stop now. "Adam, your friends said Toni's death was an accident. Did they say what kind?"

"I think she fell in the river." He turned to look out the window into darkness. "I saw your cooler chest in back. Is there any beer?"

"No beer, and if there were, you couldn't drink it in my car." His sigh was so eloquent that she added, "We'll be in Arcata and then Eureka before long, less than an hour. We can all get coffee there."

Zalinsky retreated into silence, and Verity concentrated on the road and the music, which she turned up just a bit. From the back there was no sound, no snoring; apparently Johnny was not sleeping but listening.

———//———

Just north of the little college town of Arcata, Highway 299 joined U.S. 101, which curved south past the wide part of Humboldt Bay to arrive quickly at the larger city of Eureka. Here Verity was pleased to find a big gas station and mini-mart still open.

"Pull up to the pump and I'll gas up," Johnny said.

She did as instructed, unbuckled, and climbed out and stretched. "Okay, guys. Be right back," she said, and trotted off toward the rest rooms. When she returned, she found that Johnny had moved the car from the pumps to a parking area.

"So, how are things?" she asked as he got out.

He grinned down at her and shook his head. "I have several well-planned scenarios where you and I spend a night together, but none of them plays like this."

"Glad to hear it. Where's our friend?"

"Gone to the can, he said. Ready for me to take over?"

"The driving, or the talking?"

"Both, I guess, but I think he's relaxed with you in a way he won't be with me, now that we're headed back toward the cop shop."

"You may be nicer, but I'm smaller."

"And prettier."

"I'd hope so. Johnny, he's scared."

"I don't blame him. You want to pick up some coffee while *I* go to the can?"

"Sure, but I bet... Here he comes now."

Zalinsky looked around, spotted them, and came slowly in their direction. He had a big, foam-topped paper cup in one hand and held the other up, palm out, before Verity could speak. "I'll drink it right here, okay?"

When Verity got back with the two travel mugs full of coffee, Zalinsky had nearly finished his beer. "Good, let's get moving. We're not halfway there yet. And I'll think I'll ride in back for a while," she said, handing one mug to Johnny.

She climbed into the back seat, reached behind it to find one of the small duffel bags to use as a pillow, and settled into a corner, cradling the mug of coffee. Johnny pulled out onto the highway and headed south, past the bay and toward the redwoods where she'd been ages ago, way back...Monday. And today, tonight, was only Thursday, for another hour or so. She was trapped in some kind of time capsule, condemned to travel the same roads forever and ever.

But the coffee was good, and the driver was skillful. After a while she relaxed and let the voices from the front filter in. Zalinsky was talking about his life in Lewiston. About Carol, who was apparently his lover or good friend, fiancée, whatever kind of relationship their

mutual church permitted. Carol was a good Christian woman raising two little boys by herself. And now two dogs, thought Verity.

Johnny wasn't saying much; he was a very good listener. Zalinsky's ramblings went on to the vets he worked with, the animal patients he had known. Verity snapped the cover of her coffee mug shut, put the mug in the cup holder, and closed her eyes.

Had Toni Ybarra crashed the private party, or had she been invited? And if so, why and by whom? Tessa Janacek had apparently been a friend or at least an acquaintance of Toni's, but she'd also been a friend of Jeanie Verducci's, who'd been… Gaah.

What kind of blow-up, Adam Zalinsky's term, resulted in a strong young woman's falling into a river? Some kind of awful chase, a pack of eighteen-year-olds baying after the fleeing Toni with tongues lolling, teeth glistening? But from what Angie had said, Toni didn't sound like the kind of girl who'd run, or who'd be unable to swim. Late spring, northern California rivers would have been running full from mountain snowmelt; was the Tenmile much of a river? She'd seen it only at coast edge, getting no sense of its character further inland.

She didn't sleep but drowsed, voices from the front seat mingling with the voices in her own head. At the real, not imagined, sound of one of the familiar names, she stirred, found her neck stiff and one foot asleep, and reached for her coffee mug.

"…Bobby was my best friend from third grade on."

"He has a bad reputation," said Johnny.

"Oh, he always had a temper, even at eight years old. But he got over it fast, and he was always sorry afterwards," Zalinsky said. "Everybody liked him, they forgave him. And Jeanie, well, she was just born to be in charge, I guess, and didn't realize how that could make somebody else feel. I know she's done really well for herself."

Johnny said nothing, but Verity, thoroughly awake now, could almost hear his mind reassessing possibilities. It sounded as if Zalinsky was having qualms about ratting out his friends, which could make the hours ahead difficult.

———//———

They stopped again at a recreation area just before the cutoff to Highway One, because Adam Zalinsky needed to get rid of all that beer. "Would you like me to drive the rest of the way?" Verity asked Johnny.

"Sure."

"Where are we headed, to the station?"

"Nope. Adam's decided he wants to go to his mother's house, out east of Albion."

"At, what will it be, three in the morning?"

"It's what he wants to do, and short of arresting him, I don't see that I can stop him. Verity, you don't need to go all the way to Albion. I could drop you off at home on the way."

"No thanks," she said, and headed for the driver's door just as Adam Zalinsky trudged up.

It was a quiet sixty-plus miles, west through forest and fields and then south along the coast, past the state beach where Verity had parked Monday night, past dunes and headlands and the estuary of the Tenmile River, past scattered little groups of houses and finally past Port Silva, and Mendocino, and on to the river-mouth hamlet of Albion. Following Adam Zalinsky's directions, they drove out Middle Ridge Road to a garden cottage behind a white picket fence.

There were no lights in the cottage or on the road. Verity pulled into the driveway behind the midsized sedan parked there, and Zalinsky leaned over to put a hand on her shoulder. "Thanks, but you don't need to get out. I have a key. Johnny, I'll be in touch tomorrow morning, I promise." With that he was out of the car, through the gate and at the cottage door before either of them had said a word.

It took him only a moment to open the door and disappear inside. As a faint light appeared behind the curtains of the front window, Verity put the car in reverse. "Well, let's *us* go home, too."

She backed out of the driveway, started forward, and realized belatedly that she was headed the wrong way. "My mind is on auto-pilot," she muttered, and was shifting into reverse again when Johnny said, "Wait."

She followed his gaze, and saw that a chunky dark vehicle had been tucked in against the far side of the garage, where it was almost hidden under a stand of tall old rhododendrons. "Somebody's Merc SUV," Johnny said. "There was room for us in the driveway; there'd have been room for it."

Verity moved forward slowly, looking for a place to turn. There were no houses ahead within range of her high-beams, but another vehicle, a big light-colored pickup truck, had been driven across the shallow roadside ditch to rest between a couple of trees. "Johnny, Bobby Mendes has a truck like that."

"Right, he does. And I've seen Ms. Verducci behind the wheel of a black SUV. Drive on and find a place to turn around."

"Yessir." She drove on at a crawl, rounded a curve, and spotted a construction site some hundred yards further along. She turned into its rough driveway, reversed, headed back slowly the way they'd come.

"Okay, stop here and let me out," he said when the cottage came into view. "I need to have a look at what's happening in there. You can pull off just ahead, up close to the bushes. And turn off your lights."

"And I'll do *what* there in the bushes?" she snapped.

"Sit quietly and pay attention," he said. "If I'm not back in, say, ten minutes, call the shop and have them either get somebody out here or ask the sheriff's office to send a deputy. Here, take my phone; the station is zero-one, and Hank is zero-three."

"Fuck you, buster!" She pushed the phone back at him.

"Verity—"

"*You* can call the station right now. And then we can go take Zalinsky his bag, which you may not have noticed he forgot."

Johnny touched the power button on the phone, squinted at the result, turned the power off and tucked the phone away. "Once again we're not in a service area, probably because of the ridges. Okay, let's work this out. What do you know about Adam's mother?"

"According to Patience, she's about seventy, very sharp but uses a cane to get around because of arthritis. Fond of Adam but pretty clear on his failings."

"I think we have a fair handle on Adam," said Johnny. "Mendes, assuming he's in there, is a loose cannon. Jeanie Verducci?"

"An Italian-American princess with money and political ambitions. And that's four people in a small house. Two more people ought to make things either safer or more confused. Two better than one."

"Good point. Okay, let's take our friend his belongings."

None of the three vehicles had been moved. In the cottage, more lights were on behind closed curtains. Verity pulled into the driveway to park behind the sedan.

"Here's how we'll do this," said Johnny. "I'll take the bag to the door. You stay here, engine running and lights on. If they open the door I should be able to get a look at what's happening, or not happening. And then you can join me or take off fast, depending."

Moments later Verity realized she was holding her breath as he approached the door. She counted seconds: one thousand one, one

thousand two…and at "five" outside lights came on to flood the steps and yard, and the door opened. For what seemed a long time Johnny's bulk hid whoever it was he was talking to, and then it didn't, as if he'd been pulled abruptly inside.

Standing in the doorway now looking her way was a smaller man, and she recognized Bobby Mendes. She put the car window down as he flourished a handgun. "Hey, your friend says you should come join the party."

Two better than one. She got out of the car and slung her bag over her shoulder, wishing for the briefest moment that it held the weight of Johnny's revolver. Through the gate and across the grass on well-spaced flagstones, and she was at the steps and the door, where Bobby Mendes stepped aside to admit her.

As she passed him, he reached out to pull the bag from her shoulder. He hefted it, handed it back, and said, with a leer, "Gotta pat you down."

She caught a glimpse of Johnny, Adam Zalinsky beside him, before turning to face Mendes. "I don't think so."

His face reddened, but Zalinsky said, "Leave her alone, Bobby, she's a friend of mine."

She stepped from the entryway into a living room where the tension was almost audible, like a sound pitched just above the range of human hearing. Bobby Mendes, behind her but not touching her, was breathing noisily and shifting his feet; she could smell his sweat. Across the room, a thin woman with silver hair rocked steadily in a high-backed rocker, hands clasped in the lap of a dark blue wool robe and an ugly red splotch marking the left side of her face. Mouth set so tight as to appear lipless, eyes narrowed to glittering slits, she had to be Zalinsky's mother and she was furious.

Zalinsky fluttered like some wing-damaged bird to a stance beside his mother's chair. A smaller, younger woman clad in black pants and sweater was hunched, legs crossed and booted foot swinging, on a love seat at the far end of the room. As Verity entered, she shot to her feet, raked the room with a malevolent glance, and went to stand before the fireplace.

Verity, senses keyed so high she felt as if she were absorbing the scene through her pores, found the still point of the room: Johnny Hebert. Backside propped against a long counter separating living room from kitchen, arms folded on his chest, he met Verity's glance

with his own bright blue gaze and a gesture of his shaggy head so slight she thought for a moment she'd imagined it. End of the room, the blond woman. Jeanie Verducci. Gotcha.

"Verity, I'm sorry about this." Adam Zalinsky seemed to have come unglued in the short time since he'd arrived: hair rumpled, shirt pulled loose, eyes blinking as if to ward off bugs or blowing dust, hands fretting. No help in whatever this turned out to be, but not much of an obstacle either.

With a small shrug Verity moved to perch on the edge of an armchair set against the long outer wall, beyond Mendes's immediate reach and closer to Verducci. She unzipped her leather jacket but pushed her hands into the slant pockets; what had been a fire was only embers now, and the room was chilly.

"It seems Adam called his friends as well as his mother, to let them know he was coming to town and why." Johnny's voice was dry. "Verity Mackellar, meet Catherine Brennan…" with a small bow to the older woman, who ignored it and him "…and Robert Mendes and Jeanie Verducci."

"I was…I was trying to be fair," said Adam.

"Hey, buddy, *fair* would've been calling us *before* talking to the police," said Mendes. "Giving us a chance to convince you not to mess us up."

"If something happened thirty years ago to that trashy girlfriend of yours, *you* did it," Jeanie said, lifting her chin and crossing her arms over her breasts. "And then made up some insane story to cover yourself."

"Don't be ridiculous." Catherine Brennan's harsh voice startled everybody. "And shame on you, Bobby, you know Adam better than that."

Verity watched Mendes roll his shoulders loose, exhale deeply, and then lift his free hand to rub the back of his neck. He has no idea what he's going to do, she realized, and he's holding a semi-automatic pistol. Nine shots? Thirteen?

The old woman might have caught Verity's thought. "And by what right, Bobby, are you standing here in my living room with a gun?"

He glanced down as if surprised to see it. "Hey, Jeanie's the one forced her way in here with a gun. You should be glad I took it away from her."

"Put it down," said Mrs. Brennan.

"No, ma'am, not just yet."

Good try, Verity noted. At least we're on the same side.

Mendes yawned suddenly, broadly. Verity thought he was not just tired, but on some thin edge. Booze? Drugs? She looked at Johnny but his gaze was on Mendes, and she relaxed slightly. Right. That's the big one and he's yours.

All heads came up at the sound of fist pounded into open palm. "I'm telling the truth!" said Adam. "Just the truth. It's what I have to do to get right with Jesus."

"Bullshit!" Jeanie Verducci took two steps forward. Verity pulled her feet closer to her chair, ready to move.

Adam paid no attention. "My mother called to tell me about Tessa...that she'd killed herself. And I thought, if we'd all dealt with Toni's death at the time, told the truth, Tessa might not have...she might still be alive."

"You shut up about Tessa." Mendes's voice was a snarl.

"And I was scared I might have that same impulse some day, one of those times when I get way down. I don't want to be dead. I have things I want to live for." He dropped onto an ottoman beside his mother's rocker and put his head in his hands.

"Tessa suffered from chronic depression for most of her life, Adam," Jeanie said in chilly tones. "Just like her mother. Did you call her and tell her you were coming home with all these lies?"

"I didn't. I wasn't."

"Or maybe it was the harassment from this *detective* that pushed her over." Jeanie tossed her head in Verity's direction. "As for me, I'm going to the chief of police first thing tomorrow to make my own statement, and we'll see who's believed."

"Sounds good," said Johnny. "Now why don't we all go home and let Adam and his mother get some sleep."

"Fine," said Jeanie. "If Bobby will just return my pistol."

"I don't think so."

Mendes's tone rang warning bells for Verity. She glanced at Johnny and saw his stance tighten, weight fully on his feet.

"Bobby—"

"Fuck you. I don't like the way you're talking about Tessa. And I just decided I don't like laying the whole load on Adam." He stood in front of the door with legs braced wide and head thrust forward, glaring at Jeanie.

"Don't be stupid. Do you want to spend the next however-many years in jail and leave your kids on the street?"

"They won't miss me," he said. "And I bet yours won't miss you."

"They told me," Adam broke in, "that maybe Tessa didn't kill herself."

Oh, great timing, Adam.

"*Who* told you?" Mendes demanded.

"Him." He waved a hand in Johnny's direction.

"They're just jerking you around," said Jeanie. "I told you, she'd been depressed for years."

Mendes shifted his stance so that he could see both Johnny and Jeanie, and pointed the pistol in Johnny's direction. "How did Tessa die?"

"She was found in the driver's seat of her truck with a bullet in her head." When Mendes winced and then made a gesture with the pistol, Johnny went on. "The driver's window was down. There was no note."

Johnny, don't do this, Verity begged silently. Let's get out of here and then solve the murder. What are you thinking, what will you want me to do?

"She loved the sound of the ocean, she must have opened the window to hear it," said Jeanie.

"Where was she?" Mendes asked.

Johnny made a waving-off gesture at Mendes, who snorted but turned the muzzle away. "She was parked on a bluff below Point Arena," Johnny told him.

"Tessa really hated guns," Mendes said, as if to himself.

Johnny shook his head, spread palms-up, empty hands. "As I told Mr. Zalinsky, the investigation is ongoing."

Jeanie broke in. "Didn't the police do tests on whether she'd fired a gun?"

"They did. She had."

"What kind of gun?" asked Mendes.

"Long-barreled .22 Colt revolver, very old."

Verity, seeing Mendes's shoulders and gun-hand swing suddenly in Jeanie's direction, yelled, "Look out!" but Johnny was already in motion. A chop from his left arm sent the pistol flying, and as the full impact of his big body slammed the smaller man against the door, Verity caught motion from behind her and spun around to meet

Jeanie in a bone-crunching collision that knocked them both to the floor.

Jeanie rolled into a knees-and-elbows scramble for the pistol not fifteen feet away. "No!" Verity rolled, too, and flung herself side-ways from her knees to drop the other woman flat.

"Get *off*, bitch!" On her back now, Jeanie lashed out with knees and feet and fists, a knee catching Verity in the belly, a boot toe hammering her thigh. As a fist or maybe an elbow sliced across skull into eye socket, Verity lost touch with everything but pain and an engulfing red haze of rage.

"Stop!" She smashed the heel of her hand under the chin of the twisted, snarling face beneath her. "Lie *still!*" Captured the flailing arms and slammed them down against the floor. "Shut *up!*" Grabbed one now-limp arm and shoulder and flipped the woman over. "Just *shut up!*" Dropped amidships on the prone body and threw her whole weight forward on stiffened arms to pin her enemy in place.

"Okay, Verity, okay." Johnny's voice was soft.

She gulped a breath, rolled her head back on her neck and forward again. Took another breath, and blew it out. "I hear you." She looked up at him, saw that he had the pistol in his hand. "Okay." Remembered what had started this whole business and looked past him. "Where's...?"

But Bobby Mendes remained slumped against the door, eyes half closed. "That's Jeanie's gun you're talking about," he said. "Her grandfather's gun. She used to take it out to the old place and shoot tin cans and crows and jays."

At a shriek of rage from Jeanie, Mendes opened his eyes wide and turned his head to stare at her. "I know in my gut Tessa couldn't shoot anybody. Just like I know Jeanie could."

"THAT IS A goddamned lie, Bobby Mendes! You rotten piece of shit, you're just trying to save your own misbegotten ass! I'll kill you myself, I'll cut off your fucking balls!"

Johnny bent to grasp Jeanie's right arm and snap a plastic cuff around the wrist. Verity, once again in her own skull and skin, grabbed the other arm to pull it back and down, and when the woman's hands were restrained behind her, got to her feet and stepped clear of the still-bucking body. Across the room, Bobby Mendes sat quietly against the door with his eyes closed. His wrists, she saw now, were bound by another pair of these useful plastic cuffs.

"Jeanie Verducci, I'm arresting you—" Johnny began.

"Bastard cop, god*damn* if you are!"

"—for attempting to interfere with an officer, and for resisting arrest. That'll do for now."

"And for armed home invasion," put in Mrs. Brennan. "And physical assault. She hit me…" she raised a careful hand to the bruise on her face "…with that gun."

"Right. That, too. Ms. Verducci, you have the right to remain silent—"

"Silent would be good," said Verity, when Johnny had finished his set speech.

"Wouldn't it," he said over Jeanie's curses. "Here, help me get her up."

The two of them pulled the resisting woman to her feet and more or less carried her to the love seat at the far end of the room, Verity dodging a shin-kick from a booted foot in the process. "I've got nothing to say to you, *nothing!*" Jeanie said in a voice hoarse from shouting. "I want to call my lawyer!"

"As soon as I'm through with the phone," Johnny said. "Tell him to meet you at the Port Silva police station."

"Don't be ridiculous! I want him to come here, now!" She got her feet under her and lurched upright.

"Sit down or I'll put restraints on your legs, too."

She dropped back into the love seat, glaring.

"The telephone is in the kitchen," said Mrs. Brennan, who had come across the room with the aid of a cane. "Go do what you need to do and I'll watch her."

"Thank you. Where's Adam?" he asked, after a glance around the room.

"I'm afraid he had to go throw up. Adam doesn't handle stress well. At least, not human stress," Catherine Brennan added.

"Mrs. Brennan, I'm going to need a statement from him."

"Of course. And I'll see that you get it." Jeanie Verducci growled something and made as if to rise again, and Mrs. Brennan's cane cracked her smartly on one knee.

"Sorry," she said, but to Johnny rather than his yowling captive "Could you give him time for a shower and a nap first?"

"I think we'll be busy for a while. Ten A.M., at the Port Silva station?"

"Thank you. He'll be there. Oh, my chair?" She glanced back at her rocking chair, and then at Verity, who fetched the chair for her as Johnny moved off to speak with Mendes.

"...threatening a police officer. And a civilian," he added as Verity joined them. "That's just for starters, you understand."

"Oh, yeah, I understand."

"Okay, I'll get back to you as soon as I've talked to the boss and arranged for transport. It may take a little time." He helped Mendes to his feet, guided him into the kitchen, and pulled out a chair for him at the table there. "Verity, you want to keep an eye here?"

"Sure."

Johnny, the butt of the pistol protruding from his jacket pocket, picked up the telephone and headed for the porch. Verity took a stance well out of Mendes's reach, eyeing him for potential problems.

"No trouble from me, none at all, I swear to God," Bobby Mendes assured her, resting his bound hands on the table. "I am purely past giving grief to anybody."

"Glad to hear it."

"Hey, I lost a fight to your mother already tonight, I know better than to take *you* on."

"What did you do to her, you—"

"I gave her one little push, to get in her door to collect my kid, and then her dog damn near tore my arm off and she came at me with pepper spray. At least that's what she said it was. I didn't give her cause to prove it."

"What was your kid—I assume it was Robby—doing there?"

Mendes gave her a sad grin. "Poor little fucker's in love with that tall, skinny girl of yours. He rode his bike out to see her and your mother fed him music and supper. I'm in debt to the Mackellars, I guess."

"Good." Verity pulled out a chair across the table from him and sat down. "First, you should know that Ms. Verducci is wrong about my 'harassing' Mrs. Finch. I spoke to her briefly, she was clearly upset at the mention of Edgar Larson's name, and I went away. That's it."

Mendes's face twisted with anger, and Verity took a quick breath but stayed where she was. "Since you're in debt to the Mackellars, tell me this. Was it Tessa Janacek who made those accusations against Edgar Larson?"

The ruddy anger faded to paler misery. "No way, not Tessa."

"Do you know who did make the calls?"

"Shit yes I know." He closed his eyes for a moment. "Jeanie and me, one each."

Verity sat back in her chair. "But...why?"

———//———

Forty-five minutes later, Alma Linhares half lifted a loudly complaining Jeanie Verducci into the back seat of a squad car. "You can bounce around back there, or you can let me belt you in. Your choice," said Alma.

"Just take these goddamned cuffs off!"

"You mean those nice comfortable ones I brought along just for you? Nope."

With a hiss of fury, she subsided and Alma secured the seat belt over her. "I'm suing your bitch girlfriend's ass for assault!" Jeanie yelled out at Johnny. "And if there's a mark on my Mercedes when I get it back, the Port Silva Police Department will pay for it."

"Yes, ma'am," said Alma, and closed the door.

"She'll want to call her lawyer from the shop," said Johnny. "She tried from here, but got a machine."

"I bet that tuned her right up," said Alma. "You guys up to the

drive? You both look like the leftovers of a long night. Maybe you should just toss Mendes in the back here with her highness."

"Put those two in the same vehicle," said Johnny, "you'd get one out alive at the end of the trip."

"Well, take it easy and take care. See you in half an hour." She sketched a salute, climbed into her car, and drove off.

"One down," said Johnny, more cheerfully than seemed reasonable to Verity at something like four A.M. "Let's collect Mendes and get on our way." As they reached the front steps, and the lights, he looked more closely at his companion. "Verity, your eye is going to be… God, I'm sorry! The two of you were locked in combat before I knew what was happening, and I couldn't see a way to get a hand in."

"I don't think there was a way. Anyway, I stopped her," she said with satisfaction.

"That's true, you did. Are you sure you're up to driving?"

The agreed arrangement was that she would drive, leaving Johnny free to keep an eye and if necessary both hands on their backseat passenger. This still seemed sensible to Verity. "I'm okay. Just sick of the shitty things people do to each other." And to oblivious innocents who happen to be in the vicinity, she added to herself.

He put an arm around her shoulders for a brief hug. "Me, too. But I gotta say, we do good work. You go get in the car, I'll bring our passenger out."

Several minutes later Mrs. Brennan closed her door and turned out her lights as Bobby Mendes, hands cuffed behind his back now, trudged along with Johnny toward the car. He settled awkwardly into the rear seat, made no resistance to being buckled in, and greeted Verity, watching from behind the wheel, with a grimace and a shake of his head.

"Sad thing is," he said, "I truly don't believe I ever set out to do harm to anybody."

Unable to think of an appropriate response, she turned away and started the engine, reaching out to slide Glenn Gould into the CD player again and crank the volume up high. She hoped this much-loved bit of Bach would not settle into her memory as music to transport criminals by.

When they reached the police station, Johnny directed her to the well-lighted parking lot at the rear of the building. "If you don't mind waiting, I'll take Mr. Mendes in and get the process started," he said as

he got out. "Then I'll come back and ride out with you to pick up my car."

"Fine." As cop and prisoner departed, she turned the music down, reclined her seat and closed her eyes.

———//———

A gentle rap on the window woke her, and for a confused moment she was back in the roadside campground, blinking at the face peering in at her. A different face. Oh my, she thought, and sat up.

Johnny opened the door. "You want me to drive?"

"No. I'd rather drive than get out."

He went around to the passenger side and she drove the short distance to Raccoon Lake Road, made vaguely uneasy by the silence of her companion.

"Wait here and I'll go in and get your keys," she said, as she finally pulled up to park next to Johnny's Volvo.

"No need right now, I have an extra set."

He didn't move, and she could feel him looking at her although she really couldn't see him in the near-total dark. "What?"

"I'd like you to tell me what Mendes said to you while I was on the phone."

"I don't... Shouldn't you question him yourself?"

"Oh, I have. I will. So will several other people."

"Then why...?" Her weary mind couldn't produce a reasonable finish to that sentence.

"Verity, did you promise him secrecy?"

"Of course not!"

"Well?"

"It's depressing. And I'm cold."

"Turn on the engine and the heater." This was more than a suggestion, she realized, and made a point of delaying her response. But she was cold, and he did have a right to this information. She supposed.

"He said Toni's death was an accident."

"That word covers a multitude of sins."

Verity sighed loudly. "Here's the way he told it. He and Tessa Janacek and Jeanie Verducci left school on the first Friday afternoon in May in Verducci's Mustang, for a beer bust at her family's old sheep ranch up on the Tenmile. And Toni Ybarra went with them."

She waited for questions, but none came. "He didn't make clear whether she was invited, or invited herself. He said Adam wasn't

there, he'd left for the Trinity Alps that morning. And he said Adam was involved with both girls, and was 'being a jerk,' his words.

"I'm trying to keep this distinct from the story Adam told us," she added quickly.

"Just do the best you can."

"Thank you, coach," she snapped. "Anyway, they had a few beers—except Tessa, who didn't drink. Then Jeanie and Toni got into a fight, actually punching and screaming. He said...he said it got really bad and he tried to break it up."

She stopped for a long breath. "You saw her in action today. That woman truly wanted to kill me, and if she'd been younger and stronger and nobody there to stop her, she might have. And I bet she killed Tessa Finch."

The only other sounds in the car now were the heater and Johnny's breathing.

"Anyway, twenty-eight years ago it was Toni who 'wound up dead.' That's just how he put it."

When she didn't go on, Johnny waited several beats and then said, softly, "And then what? They panicked?"

She made a face he couldn't see. "He said they *decided* to protect themselves. And they had very good luck, because Mrs. Ellis was out of town and they managed to make it look as if Toni had taken off on her own. Good-bye note and all, Mrs. Ellis told Patience about that."

"*Jesus,*" said Johnny.

"No wonder talking about it still makes Adam throw up. And you, and Hank and whoever, get the pleasure of listening to Jeanie's story, too, and trying to figure out what the truth is.

"Oh, one other thing," she said. "Bobby Mendes is adamant that Tessa was only an onlooker and they had to browbeat her into cooperating in the cover-up."

"Uh-huh."

Her eyes now adjusted to the dark, Verity could see as well as feel Johnny stretch his legs out and reach for the windshield with extended arms and clasped hands.

He settled back into his seat with a groan. "Anything else?"

"Nothing that should concern the police."

"Why don't you let me decide that?"

"Because I don't think it's necessary."

He waited.

"I don't want to talk about it. It makes *me* feel like throwing up."

"Edgar Larson," he said, softly.

"Johnny, you are a...a pushy damned *cop.*"

"I know." He put a hand on her shoulder, in apology or affection or both. "Tell me."

"Bobby Mendes and Jeanie Verducci made the accusing calls about Edgar Larson."

That brought Johnny squarely upright in his seat. "Why?"

"That was my question. The answer was, 'To distract him.'"

"I beg your pardon?"

"Mr. Larson saw them leave the parking lot that Friday, even spoke to Jeanie and Toni by name. Mr. Larson was known to be *very* alert and attentive. When Toni's disappearance became news, he'd surely remember that sighting. And report it."

"But it didn't—"

"Become news," she finished for him. They sat in silence for several moments, contemplating the darkness beyond the windshield rather than each other.

Verity sighed and took up the story again. "It turned out that even the other students who noticed Toni Ybarra's absence assumed she'd taken off on her own. Then maybe they decided they couldn't safely repudiate those calls. Maybe they just breathed sighs of relief and got on with their lives and forgot all about that old man.

"I don't know whether you saw his suicide note, Edgar Larson's," she added in a rush, "but in it he said they'd left him nothing. And he said, 'I damn them to hell, whoever they are.' That seems about right to me, and now I don't want to talk or even think about this anymore. Until I have a chance to tell Chris Larson, anyway."

"I'm not sure you should do that just yet," Johnny said.

"Don't *give* me that shit! I got that information myself, and I have a commitment I intend to honor." She turned the engine off and got out of the car. Johnny followed more slowly, and went around to the rear to collect his duffel bag.

He pulled a set of keys from a pocket of the bag, unlocked his car, and tossed the bag inside before turning to face her. "You may get a call from the chief on this. If so, please don't be mad at me."

"I won't. I'm going to bed now to sleep for several years. Maybe I'll talk to you tomorrow."

CHAPTER 26

"WHY CAN'T I come with you? I'm tired of being here."

"Sylvie, I have a business meeting. Besides, when I was a kid, the rule was that if I was too sick to go to school, I was sick enough to stay in bed. Or at least at home."

"Oh, I think that rule is a bit old-fashioned," said Patience. Verity looked at her mother, and saw a middle-aged woman who had spent twenty-four hours and then some in the company of a bored and restless eight-year-old.

"I could walk around and look in windows while you have your meeting," Sylvie suggested. "We could bring Zak, and he could walk around with me."

Oh, well. It was a sometimes-sunny day edging toward warm. She looked at her watch. "Okay, but you both have to be ready in ten minutes. My meeting is at noon."

———//———

Friday's relatively good weather had many Port Silvans out and about. Finding the small lot behind Patience's building full, Verity swung around the block and parked across the street from the office.

"Okay, kid, don't wander too far. And hold your dog on a short leash; you don't want him nipping somebody."

"Zak doesn't nip," said Sylvie.

"You make sure of that. Oh, there's Chris. Sweetie, I'll see you in about thirty minutes. Or less." She dropped a kiss on the top of Sylvie's head and set off across the street, pleased to note that her appearance was drawing no special notice from passersby. Maybe the news about a local bigwig's arrest hadn't become public. Maybe nobody cared.

"You aren't late, I'm early," said Chris Larson, as Verity led the way down the path to the office entrance. "Hey, the eye's not as bad as it sounded."

"The miracle of makeup." Verity opened the door and ushered her client inside, closed the door, and turned on the lights. "Stuffy in here. But we shouldn't be long." She pulled the visitor's chair into place and laid her manuscript case on the desk, and as Chris sat down, took a folder from the case and handed it over. "My report's right on top," she said, and went to open the window before sitting down on the other side of the desk.

"But that's disgusting!" Chris Larson said two minutes later, voice ringing with indignation. "I'll get my lawyers on this *today!*"

"Better not, not just yet." Verity leaned back in her mother's surprisingly comfortable office chair and stifled a yawn. Six hours of often uneasy sleep had not met her body's needs, and her mental processes were functioning at about half speed.

"Listen, that kind of purposeful injury to another person has to be worth something!"

"About that I have no opinion. But I think you'd be wise to wait until Mendes and Verducci have actually been charged with—whatever they're charged with," she said, deciding to avoid specifics. "If that's been decided, I haven't heard about it."

"But your report says this Robert Mendes *told* you he and Verducci made the accusations against my grandfather."

"He did. But I'm not a sworn officer or anybody official, and once he's talked with a lawyer, he may deny having said anything at all."

"Bullshit! You're a citizen, you can testify to what was said to you." Chris was vibrating with anger.

"I can. I will. But let's give the police a chance to deal with their part first. That's what Johnny suggested last night, and this morning it made sense to me."

"I owe nothing at all to the Port Silva police." Chris sliced the air with a leveled hand: off with their heads. "If they'd had their asses in gear in 1973, my grandfather would have lived another ten or twenty years and my father's life, and mine, would have been—better."

"That may be true." Verity looked at the furious face and took a deep breath. "But if your mother and father had stayed with Edgar despite his telling them to leave, stayed and supported him, he'd probably have lived to see the child-killer found and the accusations come to be viewed as the malicious mischief they were."

Chris's face reddened still further. "Listen, my father wanted… My mother wouldn't let… Who the hell are you to be making big moral judgments?"

"Someone who has recently developed a serious commitment to truth-telling." Verity reached for the folder that lay open now on the desk, extracted a sheet of paper, and handed it across. "Here's an addendum to our bill."

Chris glanced at it, and looked up at Verity. "Look, I don't want to make trouble for you. Maybe I'll wait a day or two; I've booked the cottage through Sunday. And I'll pay your bill," she said, and took a checkbook from her bag. "But there might be a holdup on your ten-K bonus."

Verity recalled having said, maybe at their last meeting, that no bonus was expected. Another of her insights upon awakening this morning was that she'd earned that ten thousand. "Not too long, I hope."

"Oh, maybe a day." With a brief, mean grin, Chris tore the check out, handed it over, and stood up. "I'll have to call my broker, and he'll wire you the money. If you'll give me the necessary information."

"I can do that," Verity said cheerfully, reaching for her bag.

"I bet. Then how would you like to go find some lunch?"

"Since you're going to be here another day or two, can I have a rain check? Sylvie and her dog are waiting for me."

"Sure." Chris took the slip of paper Verity handed her. "Seriously, I'm grateful to you. I'll be in touch."

Five minutes later Verity pulled the office door shut, checked to make sure it was locked, and set off into an afternoon that was still warm, with intermittent sunshine and no wind. Scanning the opposite sidewalk but seeing no sign of Sylvie, she ambled a short distance south, gazing in the occasional window. She hadn't heard from Johnny this morning, nor from anyone at the station; maybe, when they got home, she'd call him. He must have been at least as tired as she, and he'd had work still to do when he left her the night before.

In fact, she might just call the cop shop. After all, she'd been personally involved in yesterday's events; she felt entitled to know where their discoveries had led. Whose story had held up?

She reached the corner and scanned both sides of the street again. Waiting for the red light to change, she caught sight of Zak, and then Sylvie, approaching the opposite corner. "Sylvie," she called, and waved.

The light changed, Verity stepped off the curb, and heard Sylvie scream, "Verity! Look out!" over the roar of an engine. As her peripheral vision caught a huge black shape hurtling right at her, Verity

stretched her long stride and threw herself forward with all the strength she could muster, to land belly-down on the hood of a blessedly stationary sedan, slide across and crash to the road on her shoulder and then the side of her head.

She blacked out for…seconds? a minute or two? and found herself stretched flat on her back there in the street, squinting up into the sunlight and a circle of worried faces.

"Are you okay?"

"Don't move her, you shouldn't move her."

"Somebody call an ambulance."

"Verity?" Sylvie's voice was soft, right against her ear. "Verity?"

"I'm okay." She reached to put her arm around the crouching child and realized that her left shoulder was definitely not okay, that arm not cooperating. And her head was ringing.

"I called the police," said another familiar voice, and she looked up into a familiar face, Charlie Garcia's. "Let me put this under your head, and then you can stay where you are until the paramedics get here."

Verity felt pain but no wavering of consciousness as he lifted her head just slightly and slid folded fabric of some sort under it. "Thanks, Charlie. I think I'm okay except for a crunched shoulder." She lifted her right hand to touch the opposite shoulder, thought better of it and laid testing fingers against that side of her face instead. "Ouch," she squeaked, and lifted the hand to stare at blood-streaked fingers.

"Well, we'll wait and find out," he said, taking her hand in his own to restrain it with a gentle squeeze. "Did anybody here see anything useful?"

"It was black, and big," said one voice.

"It didn't stop," said another.

"It was an SUV of some kind, and it didn't even slow down," said a gray-haired woman who was on her knees beside Sylvie. "I think the driver was a woman."

"It was Becca's mom," said Sylvie.

There was a moment of silence.

"I saw the license," she added, and reeled off the numbers-and-letters combination of a California license plate.

The sound of a siren swung heads around. "Here come the paramedics," said Charlie.

"Charlie, I hate to bother you…"

"Don't be dumb. You want me to take your kid home? I guess this is your kid?"

"Charlie, this is Sylvie," Verity said with a one-handed gesture intended to include them both. "Who just saved my life. Could you take her *and* her dog?" Zak was sitting in a rather militant pose right next to Sylvie with his eyes on Verity.

"I want to go with *you*," said Sylvie in tones indicating imminent rebellion.

"Sylvie, you need to tell Patience what's happened. Charlie will help you. And I'll be fine."

"And I'll call the little girl's information in to the police," said the gray-haired woman, getting to her feet and taking a cell phone from her bag.

Wheels and brakes squealed, doors slammed, and two uniformed men pushed through the growing, buzzing crowd. "Make room, folks."

Verity's protests that she could walk if they'd just help her to her feet met with "Uh-huh," and "Yeah, sure," as they checked pulse and blood pressure, shone a light in her eyes, finally eased her deftly onto a stretcher. Although her head was clear, the pain in her shoulder, her left arm, indeed her whole upper body caused her to close her eyes and set her teeth. What the hell was Jeanie Verducci doing out of jail? This angry thought was followed by a more agreeable one: Never mind, she'd be in again very soon.

CHAPTER 27

VERITY TURNED OFF the hot water, stepped out of the shower, and toweled herself off very gingerly. By the time she had finished, the fan in her small bathroom had cleared the condensation from the long mirror on the door.

"Eeuuw," she said with sincerity. Her left shoulder—she turned to see the worst of it—was coloring up nicely and would not be available for shrugging any time soon. The left side of her face was scraped and swollen; her breasts and ribs and the point of one hip bone bore splotches of various shades. The smear of bruise on her left calf she thought of as a badge of honor; it was the result of contact with the SUV's side mirror as it tore a gash in her jeans and left a piece of its plastic backing caught in the fabric. Verity studied the whole image as an objective observer, and decided that it looked worse than she felt.

Saved by long, strong legs and soccer-field and drama-class experience in how to fall, curl, and roll: that was her grateful analysis. And by youth; eighty-year-old Mrs. Ellis, tossed about in the same fashion—and surely by the same vehicle—had fared much worse. Verity made a mental note to look up the owner of the car she herself had scraped across, to thank the driver for being there and to inquire about damage to the hood.

She made a one-handed job of wrapping a towel around her head, eased into underpants and a pair of sweat pants and a new, thick, soft sweatshirt, and was looking for socks when a knock sounded on the studio door and Sylvie came in without waiting to be invited.

"Verity? Are you feeling better? You slept a long time, it's six o'clock."

"Just don't hug me, okay?" Verity said quickly.

"Okay. Can I dry your hair for you? I used to do that for Lily."

"What a good idea, Sylvie. Thank you." Verity sat on the piano

stool and Sylvie, after wielding dryer and hairbrush for a minute or
two, said, "Hank came while you were asleep."

"What did he want?"

"He wanted me to tell him about the black car." She brought the
brush down in a long, smooth sweep. "You have really pretty hair. I
wish mine was this color."

"I don't. I like yours the way it is. What did you tell Hank?"

"That while I was walking around earlier, on your side of the street
by the office path, that car drove by and slowed down, and the lady
put the window down and looked out. That's how I knew who it was."

Verity clenched her teeth. Had Jeanie Verducci been looking at the
office, or at Sylvie?

"Then when you were starting across the street, there it came
again."

"What did Hank say?"

"That I was a smart girl with good eyes. He wrote some of it down,
and said I'd probably need to tell somebody else about it. I told him I
could do that."

"I bet you can."

"Want me to braid your hair?" Sylvie's voice was determinedly
matter-of-fact, putting aside the intolerable for the ordinary.

"I don't think so, thanks. Let's go see what's up with Patience."

———//———

"You're looking...alive," said Patience. She stretched up to kiss
Verity's uninjured cheek. "For which I'm very grateful. How do you
feel?"

"Better than I look. That vile woman, I *told* Johnny she wanted to
kill me." Verity's attempt at a grin reminded her that her face was sore.
"I wish I'd thought, while I was at Emergency, to ask about Mrs. Ellis.
Have you talked to her?"

"Verity, come into the living room and sit down. It makes me hurt
to look at you standing there." Verity did as ordered, easing her body
into the wing chair.

"I went to see Ruth while I was waiting for you to be x-rayed,"
Patience went on. "She's recovering, slowly, and glad to be alive.
She's...sad," spreading empty hands in a gesture of helplessness.
"About Toni. Or somewhere between sad and relieved. She's making
plans for a funeral and a memorial."

"Isn't she angry?"

"Oh my, yes. She wants to go down to the jail and say some serious things to Jeanie Verducci."

"Hey, they got her?"

"They did," said Patience. "Hank and Johnny will tell us all about it, when they come for dinner." She turned to the fireplace, to give the logs burning there a nudge with the poker. "I'd better have them bring in more wood."

Verity's first panicky thought was that she didn't want either man, or at least Johnny, to see her face. Her second was that she had no idea what was in the kitchen. "Mom, what are we going to feed them?"

"They're bringing food from Pure and Simple. Ronnie's making coq au vin just for us."

"That will be a treat. Ronnie's coq au vin is almost as good as mine."

"And it has the virtue of requiring no work here." Patience glanced at her watch. "Guests are coming at seven. I think I'll go change."

"I think I won't," said Verity. "Mom, has Hank told you what—"

Patience held up one hand. "He's told me very little; we've spoken only by phone the last day or two, and usually he was in his office. I'm sure that he'll be much more forthcoming over the dinner table. As will Johnny, I assume."

"Oh yes."

Before Patience had returned, the doorbell rang and Sylvie ran to admit Hank Svoboda, neatly turned out in khakis, blue button-down shirt, and tweed sports coat. Even a tie. "Hank, how spiffy you look."

"Don't you move, Verity. How're you feeling?"

"Better and better."

"Let me put these down," said Hank, carrying a bottle of red wine and a six-pack of beer to the kitchen. He set them on the table as Patience came in from the hallway, and he lifted her off her feet with a hug that looked just short of bone-crunching. "Hey, lady. Good to see you."

Yes indeed, thought Verity. The doorbell sounded again, and she got carefully to her feet to answer it. Hair and beard still shaggy, eyes hidden behind dark aviator-style glasses, Johnny Hebert loomed there like a pirate on serious pirate business until he got a good look at her. Then his face relaxed into a grin that bared all those white teeth. "God, Verity, I was afraid you'd be…but you look okay. Wonderful, in fact."

"Bloody but unbowed." When she closed the door and looked up

at him, she realized that the dark glasses were more than image-enhancer. "Johnny? What happened to you?"

He tipped the glasses up to reveal an impressive shiner, then dropped them back in place. "Alma and I got Verducci and Mendes booked last night and sent off to cells and told the booking officer we'd deal with court appearances maybe this afternoon, maybe Monday. Or to call me."

"Oh-oh."

"Right," he said, baring teeth again in a non-grin. "When her lawyer turned up at eight A.M. and insisted on immediate action, Brad Coates took it on himself to rustle up a judge for her. She pleaded not guilty to the original charges and was let go OR. Coates—who's maybe fifth generation here and snotty about it—didn't call me, nobody called me or you, and so Verducci was free to hunt you up and run you down. For which I am truly sorry. So—am I still welcome here?"

"What does Coates look like now?"

"A hell of a lot worse than I do."

"Then you're quite welcome to stay for dinner. Did you bring it?"

"Yes, ma'am. I thought I'd get Hank to help carry it in."

———//———

Dinnertable topics were mild and general, geared mostly to Sylvie's bright-eyed presence and her status as heroine. By the time the meal was over, the little girl was stifling yawns and occasionally rubbing her eyes.

"Sweetie, why don't you get ready for bed," said Verity. "You can read for a while if you like."

"It's hard to get to sleep with people talking," she said. "Can I go to bed in the studio, in the sleeping bag? I can have a shower instead of a bath. And Zak can sleep with me."

"Beside you. Oh, why not. I'll get your clothes and slippers, you get your book. And Zak."

When Verity came back, the group had adjourned to the living room, where Johnny was coaxing the fire back to life and coffee waited on the low table. Too bad to have to shift gears, she thought. But that's life. She settled gratefully, carefully into the wing chair, put her feet up on its hassock, and said brightly, "Okay. Was there a body in that well, and if so, was it Antonia Ybarra?"

Hank and Johnny exchanged glances, Hank on the couch beside Patience and Johnny in the other armchair. Verity kept her mouth firmly shut, and after a moment Hank gave a small nod. "There were

skeletal remains, with leather bits and rubber soles of a pair of san-
dals. From the sandals, but mainly from an earlier, healed break in
both bones of the left forearm, Mrs. Ellis feels sure it's her niece. We're
waiting for the dental records from Berkeley."

The vivid, green-eyed face in the yearbook picture was now a
chalky, grinning skull. She took a sip of coffee and wished she hadn't.
"Excuse me," she said, "but I need another glass of wine."

"Are you sure you should?" asked Patience, and Johnny, on his feet,
paused.

"I am not concussed. I have not had a pain pill since one, only one,
in the emergency room. This is going to be the kind of conversation
that needs lubrication."

When Verity had a glass in her hand, Patience said, to Hank, "I'm
surprised you got permission to search the well."

"We got right on that yesterday afternoon," he said with a shrug.
"The Verducci property out there is owned jointly by Ms. Verducci
and her brother. Turns out her brother is not her good friend."

"What did Ms. Verducci say about the body?" asked Verity.

"Pretty much what Mendes did, that the death was an accident
and they all panicked," said Johnny. "And she's felt bad about it ever
since, but they were young and foolish and just made a mistake."

"After twenty-eight years, I suppose Verducci will claim just that,
and hire a very good lawyer and get her wrist slapped?" said Verity,
making a question of it.

"Possibly," said Hank. "But the skeleton and the skull may reveal
more to the medical examiner than they did to me."

Verity took a bit of hope from this, but chose not to dwell on it.
"Did anyone talk to Ms. Verducci about the anonymous calls?"

"Oh yeah. Absolutely not, had nothing to do with anything like
that. If Mendes, well-known local fuck-up, made such calls, it was
completely on his own and without her knowledge. There was a faint
hint that Tessa Janacek could have been the other caller." Johnny got
up to get a glass of wine for himself.

Verity made a face. "And I suppose between her and Mendes, it's
just, he says, she says. *Damn* but I'd like to see her, oh, maybe drawn
and quartered. Publicly."

"Well, there is this little problem she has with running people
down," said Hank. "That'll keep her where she is for a while, possibly
get her some real prison time."

"Mendes, too," said Johnny. "For reasons not clear to anyone but

himself, he confessed to setting the fire at the Larson house. He says he's sorry."

"Maybe he took a good look at Jeanie," said Verity, "and decided he'd rather be like Adam."

Patience, who had left her seat on the couch to stand before the fire, spoke slowly now, choosing her thoughts and her words with care. "An old 'accidental death,' and an old false charge against an innocent man, could, as the woman claims, be called reprehensible but understandable actions by a group of rattled teenagers." The others waited.

"But that leaves Teresa Finch, who wanted to talk to one of us, and logic suggests that was in connection with our investigation. If Verducci killed her, it was not in a sudden fit of anger, but by the deliberate act of digging out her old unregistered gun and hunting her old friend down. The question is, what are you going to do about *that*?"

Hank held up a shielding hand. "What we can. I agree with you. Her brother says he believes it's Jeanie's gun, originally belonging to their grandfather and given to her when she was fifteen."

Verity pounced on this. "Believes?"

"It's just an old revolver like any number of others. We're checking around in gun shops, to see whether it was ever repaired."

"Maybe Bobby Mendes will be able to identify it positively. Or…" Verity looked at Johnny "…when Bobby was talking about the gun, he said Jeanie used it a lot, out at the sheep ranch."

"Right." Johnny leaned forward in his chair. "Mendes says she took that gun out there regularly, liked to pop off at birds, squirrels, tin cans, trees. Zalinsky mentioned shooting at tin cans. Thomas Verducci says there's been no farming, no building, nothing but nature and the occasional picnicker or hiker happening to that land since.

"So," he went on, "we've got a watch on the place tonight, and tomorrow we'll send a couple of guys out with a metal detector and see how many bullets we can collect."

"I will keep my fingers crossed," said Verity.

"Hey, bullets are fairly durable," he said. "There's a decent chance we'll find something we can match."

"Which won't put the gun in Verducci's hands last Saturday," said Patience. "She can say she lost it years ago."

"Or gave it to Tessa Finch," Verity added.

"So," said Hank," we check phone records, we knock on doors, we find people who were on the roads that night. Serious police work. That's how we make our living."

"We do. We will," said Johnny, getting to his feet. "And as an example of responsible police behavior, I told Zalinsky that I'd drive him home when he's ready to go."

"To Albion?" asked Hank.

"To Lewiston, I bet," Verity said with a grin. "Johnny, you're a good person. May I come along?"

"Yes, ma'am."

"You'll have to spirit him out of his mother's house in the dark of night," said Patience. As she and Hank collected coffee things to carry them to the kitchen, Johnny opened the front door and stood there for a moment, stretching and breathing deeply.

"It's stuffy in here. And it's nice and crisp out, with a moon," he said to Verity. "Are you too sore to go for a little walk?"

"Not if we walk slowly," she said. "Preferably on the beach. Let me tell Patience."

—*//*—

An hour later Johnny towed Verity by her good arm up the sandy slope to the flat space where the Subaru was parked. "That's a long beach," said Johnny.

"At low tide it is. This is where I sometimes come to run."

"Well, you did okay tonight, for a wounded warrior." He settled her in the passenger seat. "I'm getting used to this funny little car. Maybe I should trade in the old Volvo for one like it."

"No, you should get something wild. Like an Alfa Romeo." She put her window down for another breath of the cold sea air. When Johnny pulled into the driveway on Raccoon Lake Road some minutes later, the house was dark, but the bright moonlight shone on only two vehicles parked there, Patience's truck and Johnny's Volvo. "Hank's gone home."

"Looks like it." When he'd parked, she gave thought to sore muscles and waited for him to open the door and hand her out. "Listen. Peace and quiet," he said, and pulled her very carefully into his arms for a long, deep kiss.

She noted how soft his beard was. How, held inside his open jacket as she was, she could catch the faint tang of healthy male sweat. How he was so big he almost enveloped her, and how strange it was that she didn't mind.

"Johnny—"

"Shh." His mouth on hers again, he slid a hand under her jacket

and sweater to reach for her breast, and she gave a yelp of pain as his fingers pressed bruised flesh.

"Sorry," he muttered. "I forgot, I…" He stepped back only a half pace, took a deep breath. "Verity, I promise I'll be careful. Let me stay tonight."

She looked at him, and past him at the house, at the studio, and giggled.

"I don't see anything funny."

"Oh, I do. In the studio, where my single bed would be inadequate anyway, Sylvie and her dog are presently asleep."

She swallowed another giggle. "And in the house, where there *is* an empty bedroom at the moment, my mother is no doubt asleep in her own bedroom right next door. If that wouldn't inhibit you, it certainly would me."

He sighed. "I can see your point. Will you come home with me?"

"Johnny, I'm honestly too sore. Not tonight, thanks."

"Okay, there's something I need to say. I'm in love with you. But I'm a big boy, I can get over that if I have to. Is that what you want me to do?"

If lust had weakened her knees, panic now turned them to water, and froze her tongue.

In the moon's cold light—whoever said moonlight was romantic?—she couldn't see the color of his eyes or read his expression. He stood very still, arms hanging loosely, head tipped to one side. Holding his silence and maybe his breath, watching her, listening…

She held silence, too, and heard his words again and beyond them the words and melody of Eight Voices:

Madam, I have vowed to love you,
Would you have me change my mind?

Stopping just short, Verity decided, of any mention of church bells. She took a deep breath and sang, softly:

"Oh, no John, no John, no-oh John, no."

His grin was incandescent.

—*//*—

Jerry Bauer

ABOUT THE AUTHOR

Janet LaPierre came to northern California from the Midwest via Arizona, and knew that she was home. After raising two daughters in Berkeley, she and her husband began to explore the quiet places north of the Bay Area: the Mendocino region, the Lost Coast, Trinity County. Often working on a laptop computer in a travel trailer in the company of her dogs, LaPierre has tried to give her books a strong sense of these far-from-the-city places.

LaPierre's mystery novels and short stories have been nominated for the Anthony, Macavity, and Shamus awards. She welcomes visitors and e-mail at www.janetlapierre.com.

MORE MYSTERIES
🙂 FROM PERSEVERANCE PRESS 🙂
For the New Golden Age

Available now—

Tropic of Murder, A Nick Hoffman Mystery
by Lev Raphael
ISBN 1-880294-68-5
Professor Nick Hoffman flees mounting chaos at the State University of Michigan for a Caribbean getaway, but his winter paradise turns into a nightmare of deceit, danger, and revenge.

A Fugue in Hell's Kitchen, A Katy Green Mystery
by Hal Glatzer
ISBN 1-880284-70-7
In New York City in 1939, musician Katy Green's hunt for a stolen music manuscript turns into a fugue of mayhem, madness, and death. Prequel to *Too Dead To Swing.*

The Affair of the Incognito Tenant, A Mystery With Sherlock Holmes
by Lora Roberts
ISBN 1-880284-67-7
In 1903 in a Sussex village, a young, widowed housekeeper welcomes the mysterious Mr. Sigerson to the manor house in her charge—and unknowingly opens the door to theft, bloody terror, and murder.

Silence Is Golden, A Connor Westphal Mystery
by Penny Warner
ISBN 1-880284-66-9
When the folks of Flat Skunk rediscover gold in them thar hills, the modern-day stampede brings money-hungry miners to the Gold Country town, and headlines for deaf reporter Connor Westphal's newspaper—not to mention murder.

The Beastly Bloodline, A Delilah Doolittle Pet Detective Mystery
by Patricia Guiver
ISBN 1-880284-69-3
Wild horses ordinarily couldn't drag British expatriate Delilah to a dude ranch. But when a wealthy client asks her to solve the mysterious death of a valuable show horse, she runs into some rude dudes trying to cut her out of the herd—and finds herself on a trail ride to murder.

Death, Bones, and Stately Homes, A Tori Miracle Pennsylvania Dutch Mystery
by Valerie S. Malmont
ISBN 1-880284-65-0
Finding a tuxedo-clad skeleton, Tori Miracle fears it could halt Lickin Creek's annual house tour. While dealing with disappearing and reappearing bodies, a stalker, and an escaped convict, Tori unravels the secrets of the Bride's House and Morgan Manor, which the townsfolk wish to hide.

Slippery Slopes and Other Deadly Things, A Carrie Carlin Biofeedback Mystery
by Nancy Tesler
ISBN 1-880284-64-2
Biofeedback practitioner/single mom/amateur sleuth Carrie Carlin is up to her neck
in snow, sex, and strangulation when her stress management convention is inter-
rupted by murder on the slopes of a Vermont ski resort.

REFERENCE/MYSTERY WRITING
How To Write Killer Fiction:
The Funhouse of Mystery & the Roller Coaster of Suspense
by Carolyn Wheat
ISBN 1-880284-62-6
The highly regarded author of the Cass Jameson legal mysteries explains the differ-
ence between mysteries (the art of the whodunit) and novels of suspense (the hero's
journey) and offers tips and inspiration for writing in either genre. Wheat shows how
to make your book work, from the first word to the final revision.

Another Fine Mess, A Bridget Montrose Mystery
by Lora Roberts
ISBN 1-880284-54-5
Bridget Montrose wrote a surprise bestseller, but now her publisher wants another
one. A writers' retreat seems the perfect opportunity to work in the rarefied compa-
ny of other authors...except that one of them has a different ending in mind.

Flash Point, A Susan Kim Delancey Mystery
by Nancy Baker Jacobs
ISBN 1-880284-56-1
A serial arsonist is killing young mothers in the Bay Area. Now Susan Kim Delancey,
California's newly appointed chief arson investigator, is in a race against time to catch
the murderer and find the dead women's missing babies—before more lives end in
flames.

Open Season on Lawyers, A Novel of Suspense
by Taffy Cannon
ISBN 1-880284-51-0
Somebody is killing the sleazy attorneys of Los Angeles. LAPD Detective Joanna
Davis matches wits with a killer who tailors each murder to a specific abuse of legal
practice. They call him The Atterminator—and he likes it.

Too Dead To Swing, A Katy Green Mystery
by Hal Glatzer
ISBN 1-880284-53-7
It's 1940, and musician Katy Green joins an all-female swing band touring California
by train—but she soon discovers that somebody's out for blood. First book publica-
tion of the award-winning audio-play. Cast of characters, illustrations, and map
included.

The Tumbleweed Murders, A Claire Sharples Botanical Mystery
by Rebecca Rothenberg, completed by Taffy Cannon
ISBN 1-880284-43-X

Keepers, A Port Silva Mystery
by Janet LaPierre
Shamus Award nominee, *Best Paperback Original 2001*
ISBN 1-880284-44-8

Blind Side, A Connor Westphal Mystery
by Penny Warner
ISBN 1-880284-42-1

The Kidnapping of Rosie Dawn, A Joe Barley Mystery
by Eric Wright
Barry Award, *Best Paperback Original 2000.* Edgar, Ellis, and Anthony Award nominee
ISBN 1-880284-40-5

Guns and Roses, An Irish Eyes Travel Mystery
by Taffy Cannon
Agatha and Macavity Award nominee, *Best Novel 2000*
ISBN 1-880284-34-0

Royal Flush, A Jake Samson & Rosie Vicente Mystery
by Shelley Singer
ISBN 1-880284-33-2

Baby Mine, A Port Silva Mystery
by Janet LaPierre
ISBN 1-880284-32-4

Forthcoming—

Face Down Below the Banqueting House
by Kathy Lynn Emerson
Shortly before a royal visit to Leigh Abbey, home of sixteenth-century sleuth Susanna
Appleton, a man dies in a fall from a banqueting house. Is his death part of some
treasonous plot against Elizabeth Tudor? Or is it merely murder?

Evil Intentions
by Denise Osborne
Wealthy socialites and a group of recovering substance abusers benefit from Salome
Waterhouse's Feng Shui practice. When one of them, the former fiancée of Salome's
nemesis, Duncan Mah, finds a body on her estate, Salome becomes embroiled in a
world of evil intentions.